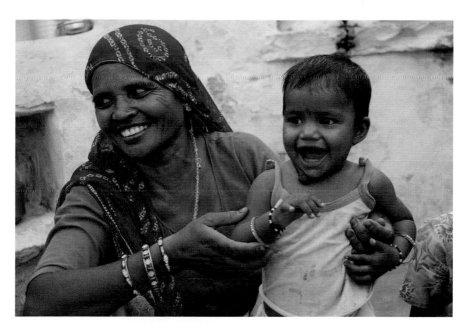

Grandmother
POWER

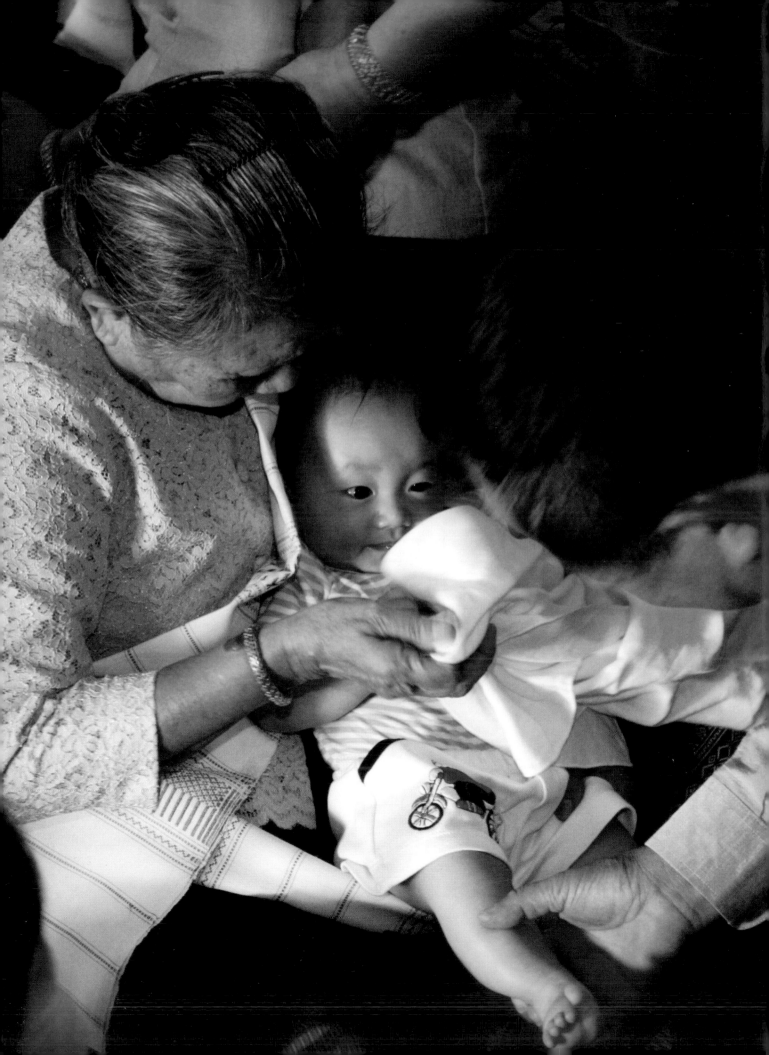

Grandmother
POWER

A Global Phenomenon

PAOLA GIANTURCO

 powerHouse Books

Brooklyn, NY

Grandmother Power:
A Global Phenomenon

Published in the United States by powerHouse Books, a division of powerHouse Cultural Entertainment, Inc.

37 Main Street, Brooklyn, NY 11201-1021

telephone 212.604.9074, fax 212.366.5247

e-mail: grandmotherpower@powerhousebooks.com

website: www.powerhousebooks.com

First edition, 2012

Library of Congress Control Number: 2012940048

ISBN 978-1-57687-611-4

Book design by Patricia Fabricant

A complete catalog of powerHouse Books and Limited Editions is available upon request; please call, write, or visit our website.

10 9 8 7 6 5 4 3 2 1

Printing and binding by Pimlico Book International, Hong Kong

Contents

POLITICS

USA: A complacent public results in a flaccid democracy, which is why the Raging Grannies don flowery hats and dowdy aprons, write witty songs to sing at demonstrations and garner enough media coverage to enhance awareness of the political issues they care about.

ENERGY

INDIA: In dark villages, midwives cannot see to deliver babies at night; children get black lung disease studying by the light of kerosene lanterns. Hundreds of grandmothers learned solar engineering at the Barefoot College in Rajasthan, then brought light to their villages—and everything changed. The United Nations is sending grandmothers from Africa to learn from the Indian grandmothers.

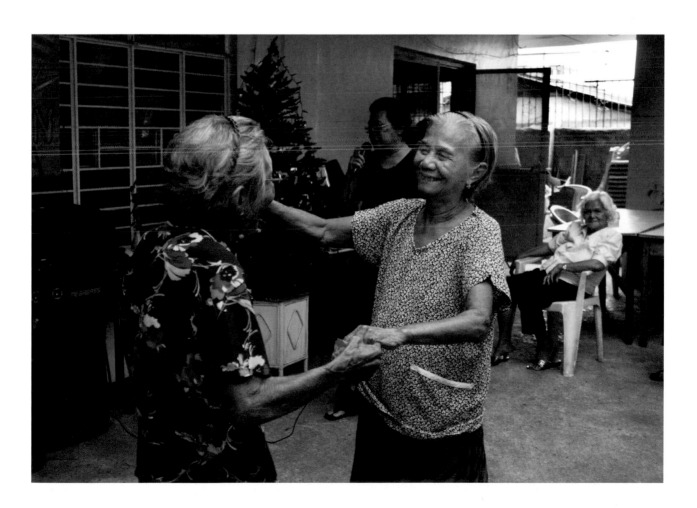

Introduction

Insurgent grandmothers are fighting the status quo, successfully seeding peace, justice, education, health, human rights, and a better world for grandchildren everywhere.

While working in Kenya, Cameroon, Swaziland, and South Africa, I met so many grandmothers raising AIDS orphans that it seemed to me the future of that continent rests with its grandmothers. It was they who inspired this book.

They also inspired me to wonder what other grandmothers around the world are doing.

Grandmothers in India are learning solar engineering and bringing light to their villages.

In Argentina, grandmothers have searched out more than 100 grandchildren who were kidnapped during the military dictatorship, and returned them to their families. Their search continues.

Israeli grandmothers are monitoring military checkpoints to prevent human rights abuses against Palestinians.

In the Philippines, grandmothers who were forced into sex slavery during World War II are demanding a place in history books so their experience will never be repeated.

Irish grandmothers are teaching their grandchildren to plant and cook, encouraging good nutrition, and reducing child obesity.

These heroic stories cause me to ask:

*If I were an illiterate grandmother, would I have the gumption and intellectual discipline to master solar engineering?

*If I were HIV positive, would I have the energy and spirit to support a dozen AIDS-orphaned grandchildren while I grieved for their parents, my children?

*Would I have the courage and moral clarity, as Israeli grandmothers do, to protect the human rights of the people whose land my country occupies?

*Would I be tenacious enough to fight a foreign government after more than 60 years, as the Philippine grandmothers do?
Would you?

This is the first time in history that grandmothers have campaigned universally and vigorously for political, economic and social change.

Grandmothers all over the world are forming and joining groups, 17 of which are featured in *Grandmother Power*. As a grandmother myself, I suspect this activism is stimulated by our tightly-connected, troubled world, which impels us to improve the future for our grandchildren.

The grandmothers in this book are teaching important lessons about values and character. Canadian grandmothers are teaching generosity and collaboration. In the Philippines and Argentina, grandmothers exemplify patience, perseverance, and justice. The South African and Swaziland grandmothers are modeling resilience and mercy. In Ireland, Peru, Laos, Thailand, and the United Arab Emirates, grandmothers are sustaining traditions—while their sisters in India, Senegal, and the United States catalyze change. Indigenous and Israeli grandmothers are seeding hope and peace.

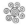

A worldwide grandmother movement is underway even though grandmother groups in different countries are not aware of each other.

The grandmother movement results, in part, from demographics. There are more grandmothers on the planet than at any other time in history. For thousands of years, there were none: people simply didn't live beyond the age of about 30.

Now, at least in the developed world, grandmothers are healthier, better off, and younger than ever before. And there are lots of them: in the United States in 2012, there were 38 million grandmothers. There will be 42 million by 2015.

One third of the entire U.S. population is grandparents, the majority of them between 45 and 64 years old. In 2011, Baby Boomers, aged 47 to 65, made up more than half of all grandparents in the country.

Everyday, 4,000 people in the United States become grandparents for the first time, and they can expect to be grandparents for the next 40 years. Thanks to quality healthcare and longer life expectancy, by 2030, five or six generations may be alive at the same time and the majority of children in the United States may have eight great-grandparents and four grandparents.

More than demographics drive the grandmother movement. It may be an expression of the Grandmother Hypotheses, an evolutionary biology theory that women live past their reproductive years to help their grandchildren.

Many grandmothers are raising their grandchildren. In the United States in 2008, close to two million children lived with grandmother caregivers, an arrangement that crossed ethnic and racial lines: 50% of those grandmothers were white; 27% African American; 18% Hispanic; and 3% Asian.

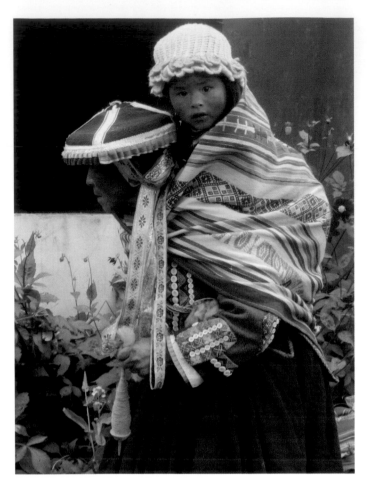

Even if they are not primary care givers, grandmothers often help care for their grandchildren, and they definitely care *about* them. In 2009 the Pew Research Center surveyed 1,300 U.S. grandparents about what they valued most in life. "Time with grandchildren" topped the list.

It should be no surprise that Baby Boomers (called Boomies in Canada and The Bulge in the U.K.) expect to make the world a better place; they are experienced at it.

In the 1960s, United States university students redefined civil rights for Blacks, Hispanics, Chicanos, gays, people with disabilities, and women. They lofted the environmental, population, and anti-nuclear movements.

In the U.S., Canada, England, France, Germany, and Italy, students catalyzed public opinion against the war in Vietnam. Students in Poland, Czechoslovakia, and Yugoslavia rose up against Communist restrictions on free speech. French students participated in the largest general strike ever. Students demonstrated in Greece, Holland, Japan, Argentina, Bolivia, Brazil, Chile, Mexico, and more. Those students are grandmothers today and are not about to stop agitating for change.

Many individual grandmothers play highly visible roles in today's world. The 2011 Nobel Peace Prize Winner, Ellen Johnson-Sirleaf, grandmother of eight, is President of Liberia. Michelle Bachelet, grandmother of two, was President of Chile and now heads UN Women. Grandmothers Whoopi Goldberg, Mia Farrow, Jessica Lange, and Vanessa Redgrave are all UNICEF Goodwill Ambassadors. Jane Goodall, world expert on chimpanzees, says, "I am saving the world for my grandchildren."

Grandmothers' impact lasts a long time. My Italian grandmother, Remigia, helped when her husband ran for parliament; she wrote his speeches, to his constituents, and letters to newspapers. My American grandmother Emma saved the sugary, sizzling doughnut holes for me, stocked a candy drawer with surprises, and let me play under her bushes where violets grew. Both women, born in the 19th century, live in me, in the 21st.

Similarly, our grandchildren will experience our impact for a long time. Laura Carstensen, Director of the Stanford Center on Longevity, anticipates that half—half!—of all girls born in the U.S. in the year 2000 will reach age 100, "the first centenarians to live into the 22nd century."

The grandmothers I interviewed for this book are pragmatic problem solvers. They love their grandchildren in many ways. Their wisdom is expressed through vision, energy, creativity, and passion. Determined to improve the present and future, their lives have purpose and meaning. Since I am a grandmother, I met them as peers but they are also my heroes.

It was a surprise to meet those whom I had imagined would be most burdened. When I greeted the African grandmothers who are raising their AIDS-orphaned grandchildren, I asked, "How are you doing?" The response was: "I am strong!"

Grandmother Power tells the stories of 120 activist grandmothers, members of 17 groups in 15 countries on 5 continents. I hope you will feel, as you read each grandmother's words, that you are having an informal chat, just as I was lucky enough to have.

I visited the grandmothers between June 2009 and February 2011. Each chapter is a snapshot of the time I visited; by the time this book is published, the grandmothers will have more grandchildren and years than the text says.

Working with interpreters, I interviewed the grandmothers in their own languages and recorded our conversations, then later sent the chapter drafts back to the interpreters to fact check. Because the grandmothers were so engaged in helping create it, I consider this "our" book, even though my name is on the cover.

If you would like to join or support these grandmother groups, they are listed at the back of the book and on the project website, **www.globalgrandmotherpower.com** where you will also discover an internet trove: videos; news updates; more photographs; audio interview excerpts; behind-the-scenes snapshots; resources for more information; recommendations about how you can take action.

One of the grandmother groups you will read about is Grandmothers and GrandOthers in Barrie, Ontario. They are among the more than 245 Canadian grandmother groups that are advocating for, and raising money for African grandmothers caring for AIDS orphans.

The Canadian grandmothers' philanthropy is part of an ambitious program coordinated by Toronto's Stephen Lewis Foundation, called the Grandmothers to Grandmothers Campaign. Two of their grantees are featured in the Swaziland and South Africa chapters.

You have already helped the Foundation's grantee grandmothers because 100% of my author royalties will go to the Stephen Lewis Foundation's Grandmothers to Grandmothers Campaign. I am grateful for your collaboration.

An additional way you can help is to give *Grandmother Power* as a present. It comes in both hardcover and e-book form. It's a great gift if you are a grandmother, know a grandmother, have a grandmother, have good memories of a grandmother, plan to become a grandmother someday or, as the Stephen Lewis Grandmothers would say, if you are a GrandOther.

My dream is that this book will inspire grand people to use their wisdom, experience, energy, and power on behalf of grandchildren everywhere, all of whom deserve to live in a better world.

I dedicate this book, with love, to my granddaughters, Alex and Avery, and to all grandchildren around the globe.

Paola Gianturco

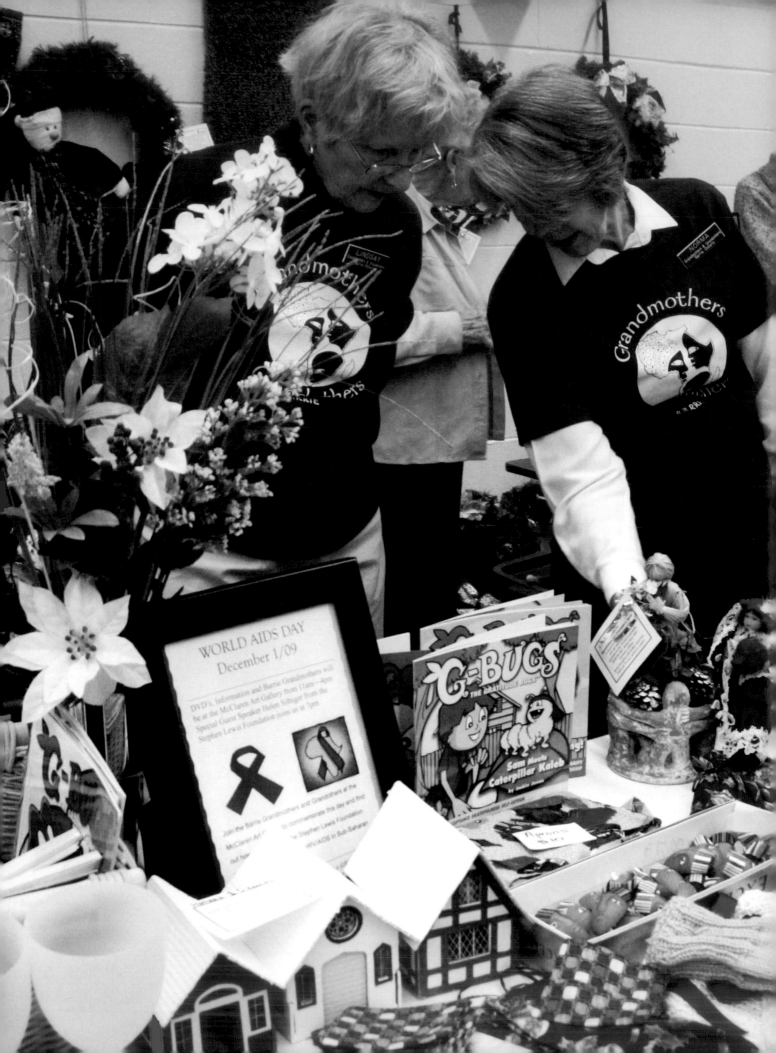

HIV/AIDS: Canada

The idea for this book began percolating in 2006 when I documented a women's group in rural Kenya. I asked how many children each woman had: "Five and ten adopted." "Six and twenty adopted." "Four and fifteen adopted." Suddenly, I understood the code. The word "adopted" really meant, "I adopted my grandchildren who are AIDS orphans."

Forgetting to be an objective reporter, my eyes swimming in the realization that these women had lost their children, I said: "My God. So much sadness. What do you say to give each other solace?" Silence. Finally, one woman spoke, "We say God is taking care of AIDS. We are alive to care for the children."

I met women like these all over the continent and left convinced that Africa is glued together by grandmothers who adopt their grandchildren even though they themselves are too old to earn money, too weak to carry water, too poor to buy food, and too sad to provide comfort. When the funerals are over, the children run to their grandmothers and those heroic women care for them. Somehow.

The statistics are overwhelming: 14.8 million children younger than 15 are AIDS orphans in sub-Saharan Africa. In some countries, 60% of them live in grandmother-headed households.

One person who understands the grandmothers' predicament well is Stephen Lewis, the charismatic humanist who was Deputy Executive Director of UNICEF, and then the United Nations' Special Envoy for HIV/AIDS in Africa. Profoundly disturbed by the pandemic's effects on African families, in 2003 he founded the Stephen Lewis Foundation to work at the grassroots level.

Another who understands the situation well is his daughter Ilana Landsberg-Lewis, a former human-rights lawyer who worked for UNIFEM and is Co-Founder and Executive Director of the Stephen Lewis Foundation.

Travelling in Africa, Stephen Lewis visited orphan care projects and at every one saw grandmothers sitting outside, talking and making crafts. Concurrently, Ilana was receiving grant proposals requesting parenting and grief counseling workshops for care giving grandmothers. "I had just given birth to my second child," Ilana says, "and my strong, feminist, journalist, activist mother was just smitten with my children." Ilana was sure the African grandmothers' plight would resonate strongly for Canadian grandmothers.

The Grandmothers to Grandmothers Campaign launched with a press conference that included an African grandmother and program director, plus 2 prominent Canadian "elder stateswomen," Shirley Douglas and Adrienne Clarkson, who had been the Lieutenant Governor of Canada.

In 2006, the Foundation called a grandmothers meeting in Toronto. Ilana says, "We wanted them to become acquainted, pool their wisdom, and just possibly put an end to the suffering." One hundred grandmothers from 11 African countries joined 200 self-funded grandmothers from across Canada. During the 3-day meeting, the women told their stories, laughed and cried, sang and danced, discussed the problems, and made plans.

They became friends and they told the truth: African grandmothers were afraid of being charity cases; Canadian grandmothers were afraid of just being The Bank.

The African grandmothers needed "enough" money: "enough" to buy seeds to plant a community garden so they could feed the children. Or "enough" to buy a swing set so they could run an after school care center. Or "enough" to buy a coffin to give a loved one a dignified funeral.

The Canadian grandmothers wanted to be connected in a deeper way to grandmothers in Africa. They wanted to educate Canadians about African grandmothers, orphans, and AIDS; wanted to improve foreign policies about medicine and aid; wanted to raise "enough" money.

Canadian grandmothers create and sell crafts to benefit grandmothers
in 15 African countries who are raising AIDS orphans.

Their *Toronto Statement* (see sidebar) documents the grandmothers' solidarity and commitment. The Canadian grandmothers went home to start their groups with names like Ooomama!; Grassroots Grammas; The Van Gogos (Gogo means grandmother in isiZulu). The groups set to work as ambassadors, educators, advocates for social justice, and fundraisers.

They sold baked goods, paper dresses, and jewelry; sponsored tea parties and dinner parties, home and garden tours, concerts and canoe parades. They organized all sorts of competitions: bicycle races and bingo games, chili cook offs and penny rolling contests, triathlons and Scrabble tournaments.

They auctioned off quilts, stuffed animals, and tote bags. They painted for art shows. They walked across Canada and climbed Mount Kilimanjaro. Together, they began to achieve the Stephen Lewis Foundation's aim: to provide a continuous flow of small infusions of cash.

The Foundation newsletter published successful fundraising ideas, which ratcheted up the women's creativity. One group sponsored an aqua fitness party. Another sold a calendar in which the grannies were photographed wearing, well, pretty much nothing. A group sold tickets to a 6-acre cornfield maze mowed to look like an African grandmother and child.

Grandmother groups proliferated, sometimes joined by GrandOthers: grandfathers, grandmothers-in-waiting, grandchildren, and others who were seduced by the importance and meaning of the work.

Teens got involved. The winner of one raffle gave a haircut and shave to a teacher in front of the high school student body. An 11th-grade member of the Blackfoot tribe taught friends to make purses, invited their grandmothers to help finish them, then donated them to one of Calgary's Stephen Lewis Foundation grandmother groups to sell.

In 2007, the Foundation newsletter carried this story:

"Our garage sale sign said...

A GENERATION OF CHILDREN IN AFRICA IS
BEING RAISED BY THEIR GRANDMOTHERS
BECAUSE THEIR PARENTS HAVE DIED OF AIDS.
THE MONEY FROM THIS SALE WILL GO DIRECTLY
TO THEM THROUGH THE STEPHEN LEWIS
FOUNDATION. PLEASE BE GENEROUS.

"A teenaged boy rode up on his bicycle, read our sign, turned to us and said, 'I'll walk home. Sell my bike.' We did."

The Foundation wires funds straight to the bank accounts of approved grassroots groups in 15 African countries.

As requested, "the right amount" goes to the African grandmothers for bedding; food; housing; school fees, uniforms, and supplies; medical care; HIV counseling, testing, and support groups; job skills and parenting training.

Almost every year, African and Canadian grandmothers visit each other's countries. In 2010, 3 sets of African grandmothers and their AIDS orphan granddaughters travelled to 40 Canadian cities to participate in fundraising events.

And more than 500 Canadian and African grandmothers met in Swaziland at the first-ever grandmother gathering in Africa and published the *Manzini Statement*: "We are now seeing the growing impact of our joint efforts. We are strong, we are visionary, we have faith, and we are not alone."

In 2006, there were just 6 groups of Canadian grandmothers. Today there are more than 245 groups with 8,000 members. In the first 6 years, the Canadian grandmothers presented petitions to Parliament, wrote Op Eds and articles, held press conferences —and after engaging in constant fundraising, earned $13 million.

"Grandmothers," Stephen Lewis says, "have become the most auspicious, most formidable, most loyal, and most overwhelming advocates against HIV/AIDS."

I was honored when the Stephen Lewis Foundation asked permission to print some photographs I took of girls in Zimbabwe on their donor cards. As a grandmother myself, nothing could have made me happier —except to contribute more to their important work.

As a result, 100% of my author royalties from this book will go to the Stephen Lewis Foundation's Grandmothers to Grandmothers campaign. Your purchase of *Grandmother Power* makes you a donor, too, and I thank you. In fact, I am doing a "gratitude dance," a jig I learned from the GrandMothers and GrandOthers in Barrie Ontario, whom you are about to meet.

Excerpts from the *Toronto Statement*, August 13, 2006

We have within us everything needed to surmount seemingly insurmountable obstacles. We are strong, we are determined, we are resourceful, we are creative, we are resilient, and we have the wisdom that comes with age and experience.

As African grandmothers:

In the short term, we do not need a great deal, but we do need enough: enough to safeguard the health of our grandchildren and of ourselves, enough to put food in their mouths, roofs over their heads and clothes on their backs, enough to place them in school and keep them there long enough to secure their futures.

For ourselves, we need training because the skills we learned while raising our children did not prepare us for parenting grandchildren who are bereaved, impoverished, confused and extremely vulnerable. We need the assurance that when help is sent, it goes beyond the cities and reaches the villages where we live.

In the long term, we need security. We need regular incomes and economic independence in order to erase forever our constant worry about how and whether our families will survive.

We grandmothers deserve hope. Our children, like all children, deserve a future. We will not raise children for the grave.

As Canadian grandmothers:

We are arriving at the end of our gathering enlightened, resolved, humbled and united with our African sisters. We stand firm in our commitment to give of ourselves because we have to so much to give—so many resources, such a relative abundance of time, so much access, so much influence, so much empathy and compassion.

We recognize that our African friends are consumed each day with the business of surviving, and so we have offered...and they have accepted...the loan of our voices. We pledge to act as their ambassadors. We promise to apply pressure on government, on religious leaders, and on the international community.

We are committed to mobilizing funds and recruiting more ambassadors among our sisters in Canada. We are acutely conscious of the enormous debt owed to a generation of women who spent their youth freeing Africa, their middle age reviving it and their older lives sustaining it. We will not rest until they can rest.

We Canadian grandmothers worried that our capacity to help might be reduced to fundraising alone. We African grandmothers worried that our dire straits might cast us as victims rather than heroes. We were emboldened to face our fears by the wisdom of our years.

May this be the dawn of the grandmothers' movement.

JoAnne O'Shea, 62
7 GRANDCHILDREN

It's November in Barrie, Ontario. Outside, red and yellow leaves blow off the trees around Lake Simcoe. Inside are indications of JoAnne's 2 great loves (2 in addition to her twinkly-eyed, Irish husband Mike, that is).

First passion: her grandchildren. One bedroom contains a crib, 2 twin beds, and a bassinette. Children's art adorns the walls of the kitchen, hall, and basement playroom, which looks like a preschool at recess, strewn with a bug mobile, books, ships, a dollhouse, and Legos. Four grandchildren live in Barrie, 1 in northern Ontario, and 2 in Nova Scotia.

Second: GrandMothers and GrandOthers, the Stephen Lewis group JoAnne named and leads. ("'GrandOthers' can be anyone. I wanted the group to be inclusive.") It's only Wednesday but JoAnne's guest room is already crammed with handmade crafts for this weekend's sale: stuffed teddy bears, elephants, and monkeys; quilts, scarves, children's clothes, jewelry, wreathes, and paintings. She says, "I am not crafty. But I can carry all this to the fair. Everyone can do something and everyone is valued, even if they just bring a member to a meeting."

Barrie grandmothers begin arriving with food for a potluck welcome dinner in my honor. Within minutes we are bubbling with laughter about their most embarrassing moments. One woman, a teetotaler, raises money by collecting wine and beer bottles that are recyclable for cash in Canada; while putting them in boxes in her garage, she tripped. "I wasn't hurt," she says giggling, "but just imagine what my neighbors thought seeing me flat on my back in that mound of bottles!"

Another grandmother reports that she had been munching on an apple in her car en route to a Grandmothers' fundraiser: "When I tossed the apple core out the window, my lower dentures went, too!"

Now I understand the Stephen Lewis Foundation's secret behind the Grandmother to Grandmother campaign's power and effectiveness: these are not just any volunteers. They are a community of unpretentious, smart, funny, activist grandmothers that works passionately for the African grandmothers. For most, this is a second career. They seem to make money from the air.

JoAnne's doctor son who works periodically in Uganda was the one who introduced her to the Stephen Lewis grandmothers campaign. "I went to the original gathering in 2006 as an observer," JoAnne says. "From the first minute, I was captivated by the grandmas. By the end of the event, I was crazed to do something. There are more AIDS orphans in Africa than the entire population of Ontario.

"That November at Ten Thousand Village's Just Gifts Fair, I sat at a table and invited people to form a group.

Now we have 100 members. Leading the group is a full time job," JoAnne admits. "We meet together once a month. Then there are meetings of our Speakers Bureau, Advocacy Committee, Crafty and Book Groups. And we do fundraising events all the time.

"My philosophy is 'just say yes' so if someone has a fundraising idea, I post a signup sheet and anyone who is interested writes her name. We cater weddings, sell ice cream at the beach, serve coffee, hold talent shows (with ukuleles, Elvis Impersonators, belly dancers)...just about anything we can think of. The Just Gifts fair happens this weekend and there's a jewelry sale next week."

At first, "I had no idea how to do this," JoAnne confesses. "I was a retired educational assistant in special education. Those children had taught me how to smell the roses." That accounts for her admirable calm I conclude, asking how she shifted gears.

"It turned out that everything I've ever done prepared me for what I do. I asked advice from a fundraiser for the art center and he gave me tips on setting goals. I thought, 'Oh, if we could ever get to $10,000!' Since April 2007, we have raised $87,000. It's truly a blessed thing. Someone is helping us.

"The first time I did public speaking was on International Women's Day. I thought there would be several speakers but I saw a poster saying I was the keynote speaker. The woman in charge asked how long I would talk. I said, 'About 30 seconds!'

"I realized that I had to step up. I re-read Stephen Lewis' *Race Against Time* and my speeches got longer. If I have to do something difficult, I always think of the African grandmothers and say to myself, 'They bury their children.' Thinking about that, nothing is hard."

JoAnne has no title. "We didn't vote; I became the leader because nobody else wanted to. I've never been a boss of anything. If you have an idea and everybody is going along with it, that's what I want... to let everyone have a say and be important. I love grassroots, ordinary people. That's us.

"I don't have a bucket list. I have a house, a yard, I can see my grandchildren, I have everything I want. We have such abundance. All 100 of us have more than enough. At one garage sale, we had so much stuff that it went into the next yard.

"On birthdays and anniversaries we ask people to give us donations. We donate as gifts to our families. We keep blessing jars. When you have 100 people doing that, it's amazing.

"Next week, I will be 63. I will give 2 speeches that day about the African grandmothers and then have some cake with my family."

JoAnne urges me to deliver a message to the grandmothers I am about to visit in South Africa and Swaziland, who receive funds from the Stephen Lewis Foundation. "Tell them what a gift they are to us," JoAnne says. "Tell them how much they help us. For us, everyday is Thanksgiving. Thanks. Giving."

As I talk with members of the group, I begin to understand how profoundly the Canadian grandmothers benefit from the opportunity to do such important work.

Eleonore Gould, 83 (4 GRANDCHILDREN, 2 GREAT-GRANDCHILDREN)
Donna Goodeill, 57 (2 GRANDCHILDREN)

Donna's handsome, 1-story, ranch-style home has rooms painted slate grey and mulberry so I'm not surprised to find myself in the company of artists. As we talk, she and her mother, Eleonore, are finishing products for Just Gifts. Donna is sewing a baby quilt and Eleonore is crocheting a teddy bear using the skill she learned when she was 4 years old.

Both women were nurses before they retired, so were well aware how pernicious HIV/AIDS is. Donna adds, "As grandmothers, we also know how tiring it is to take care of grandchildren even for one afternoon, so we can imagine the African grandmothers. We won the lottery, being born Canadian."

Donna's family and JoAnne's are close. When JoAnne described the grandmother project, Donna, then retiring at age 55, signed on. "JoAnnne was marching down the street in Toronto with the African grandmothers and one said, 'I wonder if you'll forget us when we're gone.' JoAnne said, 'I will never forget you.' She tells us those stories.

"Our group is coming up on 3 years. More and more friendships are coming from the group. And we bring friends in: nurses, retired teachers. They have given me a different world. I'm interested in

women's issues. I grew up in the 60s so this project is a good fit."

Donna is a member of the Grandmothers' Crafty Group. "We nurses made crafts on nightshift when there was time. I took a quilt making course 30 years ago. Now, I might work 10 hours a week on a quilt while watching TV in the evenings; I got that habit from my mother.

"The Crafty Group sorts out who's going to make what with which fabric. Makes sure we have enough saleable products for this season." Donna smiles at her mom, who lives 20 miles away and is an honorary member of the group. "My mother is a one woman show. The Crafty Group calls me 'The Bag Lady' because every month I bring a big bag of things my mother made."

Eleonore is putting the finishing touches on her teddy bear. "At first, we made bears for the children to play with in Africa," she explains. "That started the teddy bear movement. I made more than 100; each takes about a day and a half. We used to send them to

Africa with anyone who was going; JoAnne's son used to shrink wrap them into bundles and carry them.

"But few people go back and forth, and bears are quite bulky and expensive to ship, so we started selling them locally. My husband suffers from Alzheimer's. While he was at home, he needed watching, but I could still do other things. Making teddy bears is a win-win situation. It's so nice to have a project that somebody can use. I really need that," Eleonore confesses.

Eleonore, Donna, and Donna's grandchildren all keep blessing jars. Donna explains that it's customary when people put coins in, to "write a note naming something we are grateful for. Once, the kids said they were grateful for spending time with Grandma. And I said, 'That's funny because that's what I was going to write!'"

When I ask Donna what she hopes and dreams for her grandchildren, she says, "I'd like them to have an education, be healthy and safe, have a social conscience, a world view...and always to come see their grandma and grandpa."

Ingi Gould, 67
3 GRANDCHILDREN

Ingi's whimsical, colorful dolls, each sculptured and stitched by hand, captured my imagination the minute I saw them in the museum shop at the MacLaren Art Centre: angels with gaudy earrings; fairies with snazzy star wands; floozies with feathery hair. In her studio now, I am surrounded by her creatures that make me smile.

When Ingi joined GrandMothers and GrandOthers, she designed a doll twosome, an African grandmother and a Canadian grandmother holding one bunch of flowers, which the grandmothers sell for $40. Naturally, there will be some at Just Gifts.

"I heard Stephen Lewis speak on the radio and was inspired. I am not a joiner, but you just go and say, 'OK, I can do this or that.' Many people I knew were in the group. The more I go, the more involved I get. Since my husband has been sick, they feel compassionate toward me in a way other people don't. They feel my uncertainty and pain."

John, her husband of 35 years, has had a series of strokes. She spends every afternoon with him in the nursing home. His paintings and drawings (including some of Ingi) cover the walls of their home; others are exhibited in museums and private collections all over the world. "Marcel Marceau commissioned John to draw him backstage," Ingi says proudly as she shows me around.

Over a cup of coffee in her kitchen, I ask how she began making dolls, a question that provokes her life story. "Years ago, I was an actress," she begins. "I did CBC television, then summer stock. Zazu Pitts, Edward Everett Horton, and June Havoc performed the major roles. We would do the small parts but if there were no small parts, we would do sets, sounds, lighting or box office. I was Tallulah Bankhead's personal dresser, which was a riot. Then I apprenticed at the Stratford Shakespeare Festival."

After a stint dressing display windows, managing boutiques, and selling clothes for a fashion designer, Ingi "took a sculpture course and began manipulating fabric faces, drawing patterns, painting on cotton, and stuffing dolls. I made a lot of cats and wall hangings. I entered some huge 'Angels with Attitude' in competitions. I did craft shows and became involved with stores all over Canada."

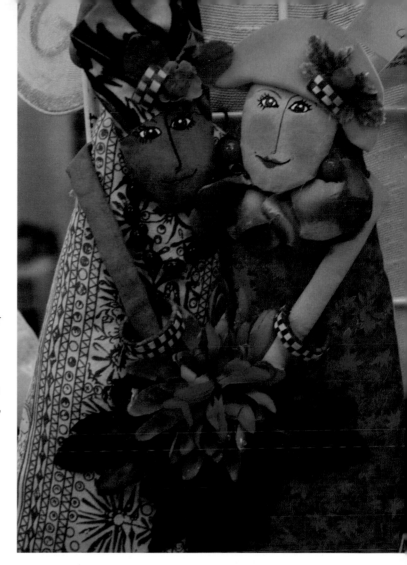

During World War II, Ingi's family fled from Estonia to Poland to East Germany. "My father was shot after we left Poznan. In East Germany, we were told, 'Better get out because they are going to send you to Siberia.' We left everything except our dog and ended up as refugees in West Germany. We had no money. We improvised. My mother was very stylish. We had wool bathing suits and when there were holes, she used color to make polka dot patches. I wish she were here so I'd be stronger now."

In 1951, we came to Canada and worked on farms. There was an Estonian church not far from where we lived. One day, my mother said, 'There is no way I am going back there; all I do is cry and think of the past. What's important is to have a future.'"

Ingi continues, "Two of my 3 grandchildren live in Barcelona. I haven't seen them for 6 years. My granddaughter Allison, who is 22 and lives here, is going to Europe next year. I don't know what will happen to my husband, but maybe I will go with her." Remembering her mother's polka dot patches and focus on the future, I can't help thinking that Ingi's mom would be proud of her now.

Sheila Nazerali, 68 (4 GRANDCHILDREN), Cherry Robinson, 64 (1 GRANDCHILD), Anita Macfarlane, 67 (3 GRANDCHILDREN) Photo by Damien Lopes

 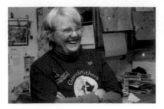 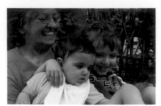

We eat leftovers for lunch at Sheila's kitchen table. Elegant leftovers! Last night she and Cherry hosted an African dinner party fundraiser. Sheila says, "I've never done anything like that. Cherry did the decorating and I cooked." Their printed menu included: kukupaka (East African chicken in coconut); bobotie (South African ground lamb in spices); sweet potatoes, green beans, and coconut rice; mango mousse; and Zanzibar coffee.

We savor the food and chat. Sheila was a family physician for 40 years while her sister Cherry taught school in Jamaica. After their husbands died, the two decided to share Sheila's house in Barrie. "We were shopping at the Saturday Farmers Market and saw JoAnne handing out literature about the grandmothers group," Cherry says.

"This seemed the perfect thing: to be active in our retirement and do something we knew was worthwhile," says Sheila. Every year, she visits her son in Mozambique and, as a healthcare professional, she understands exactly how calamitous the African AIDS pandemic is. "Stephen Lewis came to talk. We were blown away; he is an inspirational speaker."

Anita adds, "He is totally incorruptible, has a huge heart and wonderful sense of humor. He reminds us that these grandmothers are not hopeless, pathetic cases. They are wonderful, strong, powerful, dynamic people." Sheila reflects, "When I have my 4 grandchildren for a month in the summer I love it but it's exhausting. Think of these women with all the adversities, doing that 365, forever!"

Anita chimes in: "I co-founded Barrie's Raging Grannies group. JoAnne asked how to start a grassroots organization from the ground up. I helped her put it together. She didn't need a whole lot of help. When you put women together, things happen!"

An artist, Anita designed the logo on the t-shirts that the Barrie grannies wear. Three female profiles form the shape of the African continent. "I suggested that we introduce GrandMothers and GrandOthers with aplomb. I did a dozen designs and this is the one they picked. It's very in-your-face when we are all wearing it. Even at our regular meetings, most of us wear our t-shirts." (In fact, all 3 women are wearing them at lunch today). Anita smiles, "We are proud to be in this group."

Sheila agrees, "Somebody will come up with an idea and immediately, sparks fly: 'Yes, we can do that,' 'Yes, we can do this.' We all come from different life experiences and we stoke each other." Cherry elaborates, "Things seem to fall out of the sky for us. A senior's home loans us a meeting room. They said, 'We will plan at least one fundraiser for you a year.' They adopted us, and have become our home base. Some of them are grandmothers and some are just grand."

On the subject of grands, I ask about their grandchildren and it becomes clear fast, exactly how international this trio really is. Cherry: "My granddaughter lives in Trinidad, West Indies." Anita: "One grandson is Canadian-Indian; one is Canadian-American, and the third is Greek-Australian." Sheila: "Two grandsons are Indian-Irish and 2 are Indian-Portuguese living in Mozambique. These children are citizens of the world." Cherry explains, "We are not unusual. Toronto is very international."

I muse, "You have ties to many countries, why help an organization working in Africa?" Cherry says, "There is poverty and there is poverty. Go to a village in Africa. What strikes you is how clean everything is. You realize they have nothing to throw away: no tins, no wrappers, nothing. The houses they live in are built with wattle-and-daub construction" (woven sticks spread with clay). "and have grass roofs. If there's a leak they can't repair it until the rain comes and the grass grows to mend the roof."

Anita adds, "I'm a strong feminist. Old women in Africa have to pick up the pieces and raise all the children at the end of their lives. They have no pensions, no free primary education, no food. At least in India (where I am from) the family is strong; women and widows are abused, but they do get to eat. I can't sit by. I was already busy with the Raging Grannies,

but this is something that really touches the heart."

Cherry says, "There are about 400 children's aid workers in Barrie. Makes you realize what grannies in Africa have to contend with. Water, housing. Blows your mind." Sheila expands, "Water has always been my headache. We went to a small village in Mozambique that just got a well. I walked along a track to see birds but it was so muddy I was losing my shoes. I asked, 'Before the well, where did you get water?' Answer: 'Along that track.' It was a muddy swamp!"

I invite them to tell me about the Grandmothers' advocacy activities. Sheila says, "A previous prime minister took a lot of interest in Africa. The Canadian Access to Medicine Regime promised to allow companies making generic drugs to manufacture for the developing world.

"Big pharma, which is very strong here, put up huge roadblocks. When Rwanda requested drugs, it took the company that made them 2 years of fighting red tape to make one shipment. If Rwanda wants another shipment, they have to start the process again. If Mozambique wants drugs, start all over again. It is a mess.

"This has been the main thrust of our advocacy efforts. There are bills going through the House and the Senate now but neither is likely to pass. In Canada, charitable organizations like the Stephen Lewis Foundation are not allowed by the government to spend more than 10% of their funds on advocacy."

Cherry shows me holiday wreathes and floral arrangements she's made for the Just Gifts Fair. Anita shares her original paintings of African people and scenes.

Sheila will contribute slave beads that she brings back from Ilia de Mozambique, the center of ivory trade in the 1700s. "When ships from Europe sank, their hulls were full of trading beads that ultimately washed ashore. Small boys sift through the sand and string the beads to sell. Some Mozambique villages have nothing, but grass grows—so the women make grass beads that we sell. Some use mud from the ground to make beads. We sell those, too."

After lunch, Cherry shows me her Gratitude Jars. "I've decorated about 200 mason jars," she says. "People love them. We've already raised $3,000 this year with the jars. People drop in a note describing what they're grateful for, maybe 'It's a sunny day,' then

pop in a coin. Or 'Opened the cottage and all was well.' Or 'Lovely emails from friends.' At the end of the year, you have positive memories and you've collected some money for the African grandmothers. And you teach your grandchildren how lucky they are."

Sheila sums up, "Giving to others, you actually get back much more than you give. The Grandmothers' work has given focus and meaning to our lives."

Kathy Dunn, 72 (2 GRANDCHILDREN), Alix Lipskie, 72 (4 GRANDCHILDREN), Liz Macadam, 78 (7 GRANDCHILDREN, 5 GREAT-GRANDCHILDREN), Briar Hepworth, 70, (GRANDOTHER) Barbara Sikorski, 71, (5 GRANDCHILDREN)

Five women gather at Alix's new, sky-high condominium that overlooks the lake. "I used to live half an hour up the highway. Two summers ago, I went to Ottawa for a march and 2 grandmothers from Africa spoke and sang. I looked at those women and...the spirit! I thought, 'Alix, you can start a group in Midland. There must be women who'd like to help.' When I moved here, I left that group and joined the Barrie grandmothers."

Kathy says, "I met the African grandmothers in Ottawa, too. They are so alive! If it were me, I would be down in the dumps. How could we sit back and do nothing?"

Barbara, who is making monkeys for Just Gifts, checks in: "I moved to Barrie from Ottawa and saw a notice in the newspaper: the inaugural meeting of Barrie grandmothers. I went. Kathy was making teddy bears for orphans in Africa. During my childhood in Poland, I had a very precious teddy bear and I had always been interested in Africa. I thought, 'Africa. Teddy bears. This is it; this is me.' I couldn't stop talking about that meeting."

As we talk, all 5 women are industriously busy. Briar is making stuffed elephants out of socks. "We just put these elephants out and away they go! I was standing next to a lady at the last fair who said, 'Go over there and see the ant eaters!' I looked for the anteaters. She meant elephants, but whatever she wants to call them is fine!"

Kathy is stapling labels to bags of M&M's. The labels read: "Old Age Pills. Green is for forgetfulness. Yellow is for insomnia. Pink is for sex."

The Grandmother group works because, "We accept each other, thanks to our age and life experiences. We are united by a common cause. And JoAnne's 'just-say-yes' philosophy helps. When I told her that I got us into a 3-day expo right after she just said it was time to wind down for December, I thought, 'She's going to have a fit.' But she said, 'That's great.'"

"What do you get from this?" I ask. One woman says, "You're getting older and the body's starting to age. You think, 'Where am I going now with my life?' You go through grieving and regrouping when your husband passes. This work is absolutely therapeutic. We feed off each other's enthusiasm. There's always something you can be part of, if and when you want."

Another says, "I moved here 3 years ago. Without the grandmothers, I don't know how I would have met people." Another says, "This group has given me so much more than I can possibly give back."

"Thinking of all the things you've done...selling ice cream, serving coffee and cookies, making crafts to sell... which has been the most fun?" I ask. There is universal agreement: the Santa Claus parade when the grandmothers rode on a flatbed truck they decorated, pulled by a tractor. Each "waved like the Queen."

As they work, the women reminisce about their own grandparents.

Briar: "One of my grandmothers had a gift for reading stories. I loved listening to her voice. She read for hours and hours. She taught me how important it is to be close to your grandchildren."

Kathy, orphaned at 5, grew up in a cloistered convent. "I was a single mother. I know getting support is crucial when you need it." She has cared for 76 foster children. "One thing the nuns said was, 'To whom much has been given, much is expected.'"

Liz: "My grandfather told how they shared with the people next door. At Christmas, they brought whatever they could, even just an apple. He went to see a family with 9 children every weekend to drop off turnips or potatoes."

Briar: "My parents split up when I was an infant. My mother, sister and I shared my grandmother's house on the Isle of Scilly, 25 miles into the Atlantic off England's lands end. We didn't have much, but my grandmother was always there for us. Making a cake. Making tea. Playing word games around the fireplace. There was no better place to be."

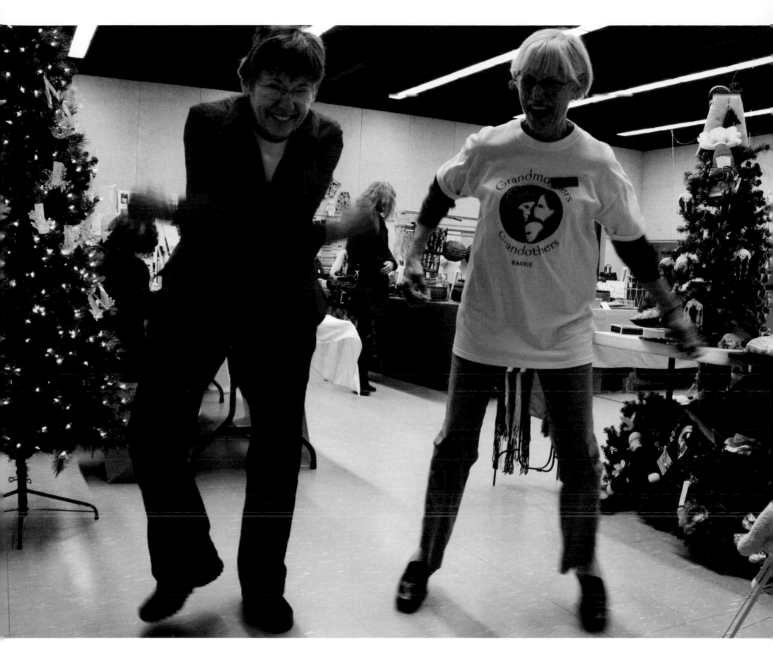

Barbara: "I was born just before the war. My parents owned a large estate just outside of Warsaw and we spent the war years there. Bombings. Shelters. My mother worked in the underground movement; my father was taken prisoner of war. We escaped to England and I was sent to boarding school even though I didn't speak English. I always relate to people who make new beginnings."

The values these women learned from their grandparents serve them well in their roles as GrandMothers and GrandOthers working with and for their sister grandmothers in Africa.

The women gather to stock their Just Gifts stall on Friday, then take a break to attend one member's 50th wedding anniversary party.

On Saturday and Sunday, their booth is swamped. The grandmothers sell in shifts, spelling each other every few hours. Children, elders, and all ages in-between inspect, select, and stagger away with bagfuls of presents.

When the doors close Sunday afternoon and they count what's in the till, the GrandMothers and GrandOthers discover they have made so much money that they burst into a spontaneous gratitude dance. (Check out "Gratitude Dance" on YouTube, and celebrate with them.) I think: these Barrie grannies deserve our gratitude!

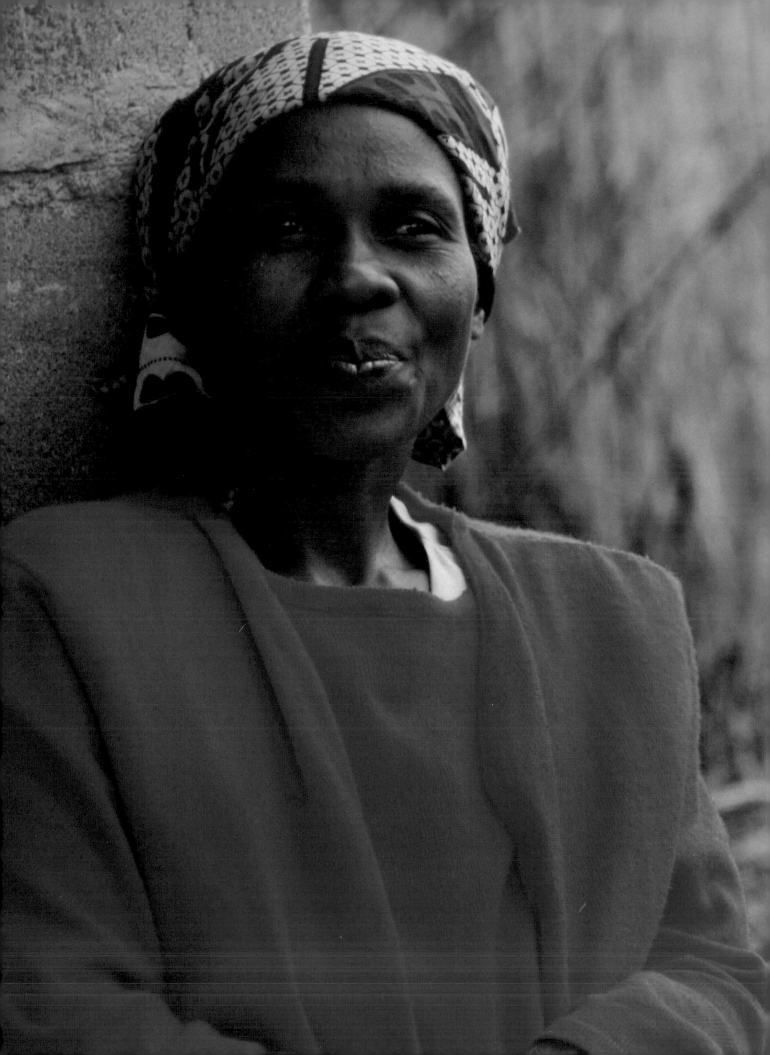

HIV/AIDS: Swaziland

When I was in Swaziland in 2001, I documented the annual Reed Dance, a colorful pageant during which 25,000 maidens honor the Queen Mother.

On the final day of that festival her son, the king, announced the reinstatement of Umchwasho, a chastity rite that prohibits men from touching virgins. The ban was to last 5 years, during which the young women would wear tassels to signal their virgin status. Village chiefs were ordered to fine men 1 cow if they violated Umchwasho, an expensive penalty in a poor country.

The strategy was intended to curb Swaziland's burgeoning HIV/AIDS pandemic. Like every effort to enforce abstinence that has been evaluated, it failed. As of 2011, 1 out of 4 people in Swaziland has HIV/AIDS, the highest incidence in the world. More than 26% are infected. In specific demographic groups rates are far higher: pregnant women, 42%; men age 35 to 39, 45%; women age 25 to 29, 50%.

The pandemic has been devastating for Swazi children. Fifteen thousand are HIV positive; another 130,000 are either already orphans or their parents are sick. At this rate, such children will soon comprise 15% of the country's population.

Grandmothers are heroically caring for their sick sons and daughters and later raising their orphaned grandchildren. Both tasks are overwhelmingly difficult given that most Swazis live far from medical centers and survive on less than $1.25 a day.

When I travel in Africa, women often ask me why HIV/AIDS are so catastrophic in their countries but comparatively less so in mine. It's a question with a surprising answer.

Almost all HIV transmission in Africa occurs by heterosexual contact, yet people on that continent generally have fewer sexual partners over a lifetime than people in Western countries.

High HIV/AIDS rates in Southern Africa result from what is considered normal sexual behavior: many men and women have 2, sometimes 3, long-term partners at once. These relationships might last months, years, even a lifetime. Men are 10 times as likely as women to have concurrent partners, but many married women also do. Couples in committed, long-term relationships do not use condoms. Between 50% and 65% of new HIV infections in Swaziland occur among long-term partners.

As Helen Epstein writes in *The Invisible Cure,* the network of relationships creates a "superhighway for HIV." Pretend that my husband has a mistress who has a boyfriend who has a girlfriend who has a boyfriend who is HIV positive. The virus spreads quickly through the chain and suddenly, seemingly without reason, I test HIV positive.

The situation is exacerbated because in Swaziland polygamy is not only legal, but is personified by the king, whose obligation it is to unify the country by marrying women from many regions. King Mswati III currently has 14 wives, the first 2 of whom were chosen for him by the Swazi National Council. His father, King Sobhuza II, had 70 official wives, plus, it is said, enough mistresses to double that number.

Swaziland's government has tried to deal with the HIV/AIDS pandemic. The king declared AIDS a national emergency in 1999. The government gave out free (male and female) condoms. But the use of condoms remains controversial and unpopular; some religious and traditional leaders consider condoms "unSwazi."

Rural grandmothers farm together, earning money and growing food for their AIDS-orphaned grandchildren.

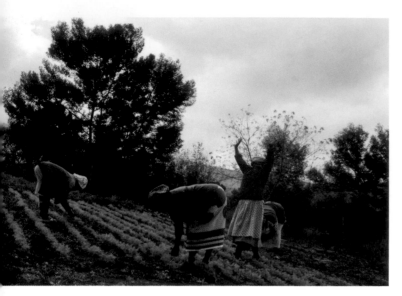

When the government began distributing free antiretroviral drugs nationwide in 2005, demand was so great that some hospitals were out of stock for 3 weeks at a time, a disastrous disruption of patients' regimens.

In 2011, the Swaziland government announced a 1-year program to circumcise, voluntarily, 80% of all Swazi men between the ages of 18 and 49. Recent, large-scale studies in Kenya and Uganda showed that circumcision can decrease men's chance of contracting HIV by 60%. The Swazi initiative is not a solution but may be a start.

Although Swazis believe that being loyal to a couple of concurrent partners is acceptable, many assume that people get HIV because they are disloyal to those partners, a transgression that is considered reprehensible and immoral.

A series of World Health Organization studies showed that 20% of HIV positive African women were held responsible "for bringing the infection into the relationship." Others were beaten or thrown out of their homes. Forty percent were afraid to (and didn't) tell their partners.

Siphiwe Hlophe was a woman who experienced such stigma. This 40-year-old mother of 4 won a scholarship in 1999 to do graduate work in agricultural economics at Bradley University in England.

When she learned she was HIV positive, her scholarship was denied, her husband left her and her in-laws, with whom her family had been living, became so hostile that she and her children had to move out. Siphiwe had not been with another man and her husband had not had an AIDS test. Never mind, there was no discussion.

Siphiwe became one of the first women in the country to acknowledge her status publically. Few people talked about HIV/AIDS then, but she soon discovered other HIV positive Swazi women who were similarly stigmatized.

In 2001, Siphiwe and 4 other women launched SWAPOL (Swaziland for Positive Living) to help educate families about HIV/AIDS; reduce the social stigma associated with the disease; help HIV positive women live with the illness; and increase their options to earn money and support their families.

Swaziland has only 2 doctors for every 10,000 people. Transportation to hospitals costs money and energy, both in short supply for people living with AIDS. Therefore, SWAPOL runs mobile clinics where people can be tested, get counseling, and get medicine.

SWAPOL has a variety of other activities: a legal clinic for widows whose property has been taken by their in-laws; neighborhood Care Points where members tend large community gardens, cook 2 homegrown meals a day for local AIDS orphans, and sew school uniforms; and micro-credit programs to provide funds for women to start businesses.

Siphiwe is an AIDS activist. She is against polygamy and in favor of condom use. However, she has always known that "HIV is not just a health issue. Stigma and discrimination related to HIV remain acute

problems. HIV is a human rights issue." This is what she told the United Nations General Assembly in 2010 when she spoke in New York City during hearings on the Millennium Development Goals.

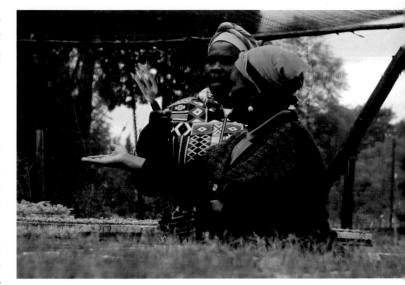

Today, SWAPOL has 9,500 members all over the country. Like Siphiwe, who personally provides food, shelter, clothing, and school fees for 4 grandchildren plus 5 orphans, most SWAPOL members are care-giving grandmothers.

SWAPOL members are HIV positive so providing for their grandchildren is a struggle. Forty percent of the children do not have one pair of shoes, 2 sets of clothes, and 1 meal a day, the things experts consider "basic necessities."

Despite their ages and illnesses, the grandmothers run households, tend cattle, raise crops and arrange for their grandchildren's educations. As a 60-year-old who tends 5 grandchildren asked a local newspaper reporter, "If we don't, who will?"

In 2006, Siphiwe attended the Stephen Lewis Grandmother Gathering in Toronto where the Grandmothers to Grandmothers campaign was born. Today, Swaziland is one of 15 African countries that benefit from Canadian grandmothers' fund raising.

In 2010, SWAPOL hosted the Stephen Lewis Foundation's first-ever African Grandmothers' Gathering in Manzini, Swaziland. Forty-three Canadian grandmothers joined 200 grandmothers from Swaziland plus 220 grandmothers from Botswana, Ethiopia, Kenya, Malawi, Mozambique, Namibia, Rwanda, South Africa, Tanzania, Uganda, Zambia, and Zimbabwe.

The African grandmothers' agenda went beyond HIV/AIDS. They were emphatic about needing safety and security. Swaziland's Queen Mother acknowledged, with a rebuke to men, that "the rape of grandmothers is common; thugs are likely to attack and rob elderly women of what little they have."

In other countries, discrimination against older women is a key issue. The United Nations Rapporteur on Violence against Women reported: "Concentration camps in Ghana have confined up to 2,000 accused 'witches,' most all of whom are indigent, elderly women. In Tanzania, as many as 1,000 women, mostly elderly, are condemned and killed as 'witches' every year."

Delegates agreed that their governments should provide grandmothers with pensions, social security, and property rights, without which grandmothers who "inherit" AIDS orphans inherit nothing else.

Counterpoint to the serious working sessions was the joyful dancing and singing every evening. A cultural program was sponsored by the Swazi government during which Ntombi Tfwala, Queen Mother of Swaziland, embraced Siphiwe. "We are all grandmothers," she said. "What brings us together is our love for children." Then, defying her horrified bodyguards, the Queen Mother joined the dancing.

On the final day of the meeting, 2,000 grandmothers paraded in solidarity through the streets of Manzini. Ninety-year-old Judith Simelane read the mandate they had hammered out, *The Manzini Statement*:

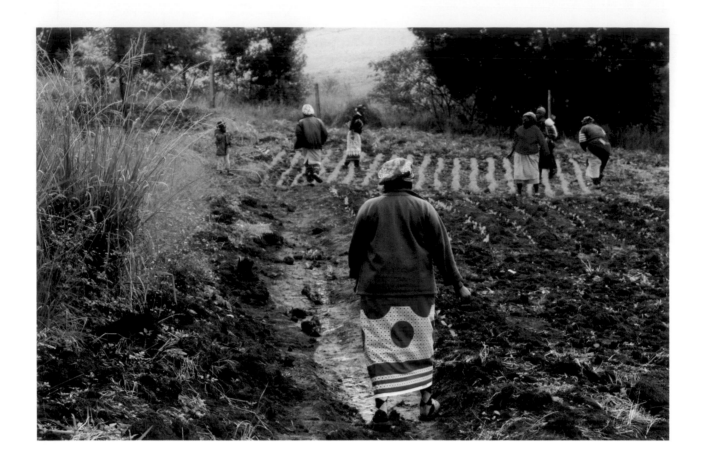

We stand here today battered, but not broken. We are resilient, unwavering in our resolve to forge a vibrant future for the orphans and grandmothers. African cannot survive without us.

Equal urgency and passion must now come from our Governments...in these priority areas:

1) Violence against grandmothers. These egregious acts, whether domestic violence, elder abuse, or accusations of witchcraft, must cease and be sanctioned.

2) Grandmothers must have meaningful support in the form of pensions and social security.

3) Laws must be passed and implemented ensuring the safety and rights of grandmothers and grandchildren.

We are leaders in our communities and countries. We will continue to come together until such time as we and our grandchildren are secure and able to thrive. We will continue to stand in solidarity with one another throughout Africa and with our Canadian sisters. We are strong, we are visionary, we have faith, and we are not alone.

Several important people paid tribute. Graca Machel (the only woman in the world to be First Lady to 2 countries' Presidents, Samora Machel of Mozambique, then Nelson Mandela of South Africa) responded to the grandmothers: "All of us in Africa owe you a huge debt of gratitude."

Ilana Landsberg-Lewis, Executive Director of the Stephen Lewis Foundation, read her father's tribute to the grandmothers. (See sidebar on the next page)

The Deputy Prime Minister of Swaziland, Mr. Themba Masuku, said in heartfelt closing remarks, "I am going to be part of the Grandmother Movement till death do us part."

Siphiwe Hlophe, 51
3 GRANDCHILDREN, 5 ADOPTED GRANDCHILDREN

Downtown Manzini has only a few main streets and no street numbers. I am to meet Siphiwe ("Sip-he-way") at "Ngwane Street, Mcozini Building," which turns out to be a 2-story structure across from a small open market where women sell eggs, tomatoes, and bananas. I climb dark steps and the receptionist asks me to wait on a couch where springs pop through the upholstery.

Corridor walls are plastered with newspaper stories. One with a double banner headline dramatizes SWAPOL's angry street protest of the King's profligate spending. Two years ago he rented a private jet to fly 8 of his wives to Dubai, Bangkok, and Singapore on a shopping spree, even though his people were desperate for antiretroviral drugs and food.

A white scale stands in the hall between 2 nurse's offices. In the conference room, shipping cartons are heaped high, full of condoms and pills from Italy, India, and China. Nobody would call this office fancy, but it is an upgrade. Siphiwe used to run SWAPOL out of her car.

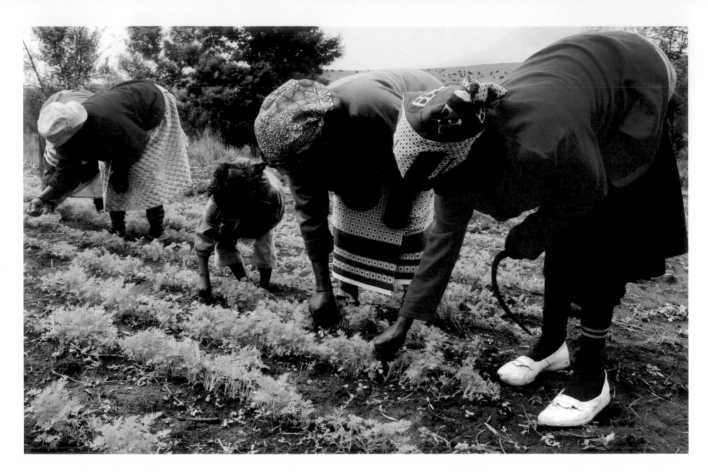

"Sometimes the government gets mad at SWAPOL," Stephen Lewis will say later. "Sometimes even I lose patience with it." But "of all civil society organizations of people living with AIDS, SWAPOL ranks amongst the top 2 or 3 in all of Africa. It's uncompromising and it's principled."

He continues with a confession: "I love Siphiwe. I'm crazy about her. I have a crush on her. If I were there now, I'd grab Siphiwe and swirl her around in the air. Well, maybe Siphiwe would swirl me around in the air. But whoever's doing the swirling, the fact of the matter is that Siphiwe is a giant in the battle against AIDS."

No doubt about it, Siphiwe is a force. Her personality and rich, resonant laugh fill the room. Over tea and cookies, she remembers, "I was born in a polygamous family in Lundzi, a western, rural community. My father's first wife had 12 children. My mother had 7. The third wife had 6. There were other children from illegal relationships. We were many.

"My father worked as a mechanic earning 10 Rand ($1.50) a week. When I started school, I never had any shoes, not even a uniform. We 3 of the same age started together and my father told the teacher, 'Make these children sit together. I don't have money to buy each a book.' In high school, I had no school shoes or uniform. I was the only one in class without them."

Teenaged Siphiwe went to see Zondle (now Save the Children), which arranged scholarships from families in Europe. She marched up the steps and asked for the director.

"I outlined my plight: my father could not afford to have me continue school. To my surprise, the director was so sympathetic. 'We don't allow children to come here to ask for funding for themselves,' he said, 'but I see how dedicated you are.' That was February. By May, he had attached me to a family in Finland. I was able to have school shoes and a uniform like the other children. I was very happy."

"Today most of my dedication goes to families that are vulnerable, or orphans. I know what it is like. I experienced all that hardship right up to where I am now," she reflects. As a child, she walked Monday through Friday, 9 miles to Manzini, then took a bus to school. "I had no money to eat lunch because I had to save for the bus back to Manzini, so I could walk home."

The Finnish family put an end to her commute by sending her to boarding school. "It was so amazing, something I couldn't have ever thought of in my life. How could I go? In boarding school students have good clothes. I had a school uniform and 2 or 3 skirts to change off. But due to my eagerness for education, I said 'It's fine. At least the problem of walking up and down is cut off.'

"When I finished in 1979, I went to the University. To my surprise, the Finnish family continued to support me. I got my diploma in 1984 in agriculture. Zondle would not give me the name of the family in Finland or I would find them now and say, 'Through your heart and your sponsorship, I am like this.' I am so thankful to them."

The first day of her first job, Siphiwe had a run-in with her supervisor at the Ministry of Agriculture. "He told me about my duties, referring always to his wife. I said, 'You know, this is a workplace where policies are to be applied. I don't think your home policies are applicable.'" She cracks up, relishing the memory. "That! On the first day!"

Over time, she organized workers at the Ministry of Agriculture to advocate for better working conditions, benefits, and salaries. "I was in the office of the Director every week fighting for our rights," she laughs so triumphantly that I find myself laughing. Next she organized all civil servants and began doing labor negotiations, obviously enjoying (and mostly winning) her battles. She was Vice President of the union for 5 years.

"So the government thought I was a trouble maker. The Principal Secretary, my boss, said, 'I need to get rid of this trouble. What can I do?' They decided to send me to school in Zambia. I was very happy."

Siphiwe finished another agriculture degree in Zambia 1998 and was accepted at Bradley University in the UK to earn a Masters degree the following year. The university scholarship sponsor required a medical exam and unbeknownst to Siphiwe, if applicants tested HIV positive, they were ineligible for financial aid.

"In 1999, AIDS was still a confidential thing. The doctor was not supposed to give me the results. But he was so amazed to discover that I was HIV positive that he said, 'Sorry, you are not eligible for this scholarship.' His words told me my status. It was a terrible blow," Siphiwe recalls.

"I was preparing to leave for the UK the next month and had told my family I would be back in 2 years. Everybody was excited, my children, everybody. I didn't know what to do. There was not enough information about AIDS then. It was a horrible moment, a terrible experience.

"My husband and I were sitting and chatting in the bedroom. He asked me about school. I told him I was no longer going and why. There was a dark cloud inside that room. For almost 30 minutes he didn't say anything. I went into the kitchen to drink water. When I came back, he asked me to say again what I said, as

if he didn't understand it. I told him again, needing his love and support.

"He said, 'If you are HIV positive, you are the one who has come home with the disease because you were out of the country for a long time.' He was trying to shift the blame to me. I had never had an affair. In the morning, he went to work without talking to me. He wouldn't eat the breakfast I prepared for him. He came in the evening and told me he was moving out.

"My in-laws blamed me because I was in and out of the country. My mother-in-law said, 'Oh that disease has come from America from gays and lesbians.' I had to move away with my children and find a government house to stay in."

When she went to women's meetings, "Someone would come and say, 'You know, Siphiwe, I have a problem. They have chased me from home because I am HIV positive.' I said to myself, 'I am not the only one experiencing discrimination. Why not start an organization for women living with HIV and AIDS?'"

SWAPOL launched in May 2001 with a small grant from UNICEF. By December, 600 stigmatized, HIV positive women had joined. Not surprisingly, given Siphiwe's agricultural expertise, SWAPOL's first projects focused on farming, which provided both nourishment and income.

"By 2004, we were engaged in vegetable production, capacity building, and income generation. Stephen Lewis, then the UN Special Envoy for HIV/AIDS in Africa, was coming to Swaziland. UNICEF's representative suggested he visit SWAPOL."

The government did not like the fact that such a high profile visitor was spending his time with SWAPOL.

"The government knew me from the trade union movement. They thought SWAPOL was not really for women living with HIV and AIDS, it was an organization of opposition to the government. Even today, they don't trust me!" She laughs a deep, mirth-filled laugh. Nothing, I decide, could derail this woman.

And on the day Stephen Lewis visited, nothing did. "We were on our way to a rural community 50 miles away. They phoned and said, 'The king wants to meet Stephen Lewis. You must turn back and come here.' It was so horrible that they ordered him to turn! He said, 'Tell the king to wait, I'll be back.' Siphiwe's laugh rings out. "'I'll be back!' I was very, very happy. He is tough!

"So he saw everything and said, 'OK, Siphiwe, we are going to give you $30,000. Tell me what you want to do with the money.' I said, 'I want an office, a telephone, and people to assist me because right now

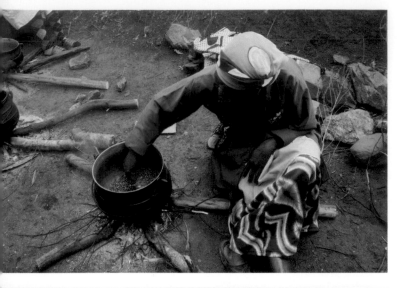

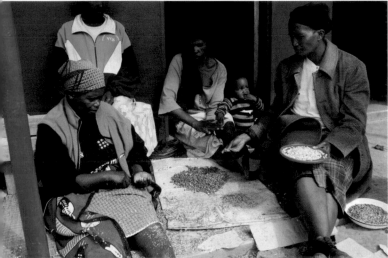

I am a government employee and my organization is operating in my car!"

Siphiwe's continuing passion is fueled by the pandemic. "Last week, I went to check on my mother-in-law's brothers and sisters in their rural community. I was very touched. Her 2 brothers are old men, HIV positive. Their wives are HIV positive. Their children are positive, sick from the first-born to the last-born. The grandchildren are positive.

"To find 5, 6, 7, 8, 10 in 1 family! I thought, 'My God, all the families will be closed down.' The government should take the lead on this. But they argue about circumcision versus condoms. It is horrible. We will all die."

"What gives you the hope and energy to continue?" I ask. Siphiwe admits, "I usually forget that I am HIV positive because I am focused on others. You know, it is wonderful to get someone on antiretroviral drugs and see them coming out of a dying bed, beautiful again. It is a miracle. These are the things that keep me going."

As we walk out past the wall of newspaper articles, I ask about the march that protested the king's wives' shopping trip. Siphiwe shakes her head. "We said, 'My God, we are not going to allow this to happen. We don't even have a painkiller in the hospital and the government can sanction such a trip? This is not allowed!' We put our petition with the Minister of Finance because the money comes from his department. Then we went to the Prime Minister.

"We were called all sorts of names for disrespecting the king. But you can say anything you want about me, as long as I can fight for my cause. I believe in my cause. It is right."

It is a relief that SWAPOL will loan us a truck and driver to visit their projects in the high veldt. My friend Joan Chatfield-Taylor and I have already learned that when it rains here, country roads turn into mud slicks, torrents engulf us and overwhelm our rental car's windshield wipers. Plus, shifting with the left hand while driving on the left side is counterintuitive; I mutter as I go around corners, 'Turn right, stay left.'"

Now, safely travelling in SWAPOL's white Toyota truck, we speed south on MR4 past Georgia-red fields, spring green vegetation, morning glories, sugar cane, cows, calves, and chickens. A 3-unit concrete block strip mall advertises "investments, groceries, spare parts." A stand-alone store has a multi-tasking hairdresser/butcher who sells trucks. There are too many signs for funeral services and coffins.

Zowda Ndzinisa, 44

3 GRANDCHILDREN

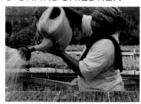

We're heading for the Isemba Lekuphila seedling project in Mankayane. The women in the group have gathered in the net-covered greenhouse to greet us.

A few, holding trowels and hand cultivators, pose for pictures.

But a woman in a yellow SWAPOL t-shirt is working so hard that she seems oblivious. She mixes fertilizer, adds it to water, and carries her watering can to flat after flat of sprouts.

She is Zowda Ndzinisa, recently elected as the group's chairperson. Continuing watering, she says, "I am always here. There is a lot to do. Plant, irrigate, fertilize, sell." The sprouts will ultimately produce beets, green peppers, spinach, cabbage, tomatoes, and onions.

Some of the seedlings will end up in members' kitchen gardens. Still watering, Zowda gives us an HIV/AIDS nutrition tutorial: "Vegetables protect people who are HIV positive from getting other diseases. Proteins from legumes repair tissues. Starch from grains gives you energy. If people grow oranges or nectarines at home, they should add those to their diet."

This group, which started with 35 HIV positive women, now includes 50. If the market is good, the group earns $75 a week, which they currently reinvest in seeds, fertilizer, and flats. They have made no distributions to participants yet.

Income will be welcome. Zowda's lifestyle is typical; she uses candles for light, has no refrigerator, and pumps water in her yard. She is proud to have a generator for her television set.

We give Zowda a ride home. On the way, she tells us that she cares for her 3 grandchildren because her daughter works in a kitchen in town. Zowda is glad that the children are all in school. She buys the girls' $30 school uniforms from SWAPOL's local sewing group.

She also looks after 10 sick people, ages 12 to 50, "mostly HIV positive but a few are just old." If no one in her charge had died, she says, "There would be 20 people, not 10."

"I like gardening and caring for sick people," Zowda says with pride.

Esau Kunene, a SWAPOL corporate officer, is acting as our interpreter. He conducts business on his cell phone, making himself heard despite the Christian Rock music that blasts from the truck radio.

Villages, further apart now, have clusters of 1-room cement block houses interspersed with rondavels. Jabulani Tsela drives us higher into the gentle, green mountains where expansive views of valleys and rivers take our breath away.

Suddenly, Jabu veers off the highway into a field. We are window-deep in wheat as we cross one steep hill, then another. "Bridge is out," Esau laughs as we bounce through a stream. "It takes a lot of imagination to drive in Swaziland," I observe. "Yes," Esau cackles, "Jabu is imagining the road!" We stop at the edge of a cultivated field, a SWAPOL community garden.

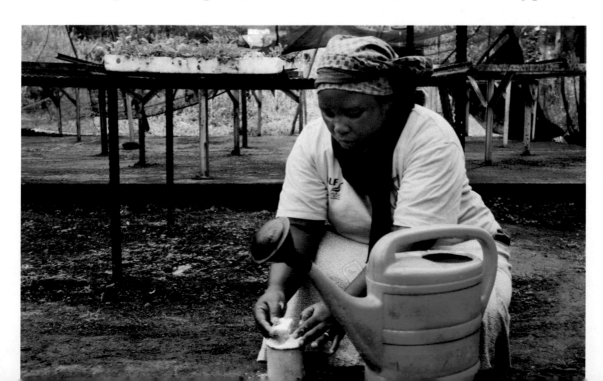

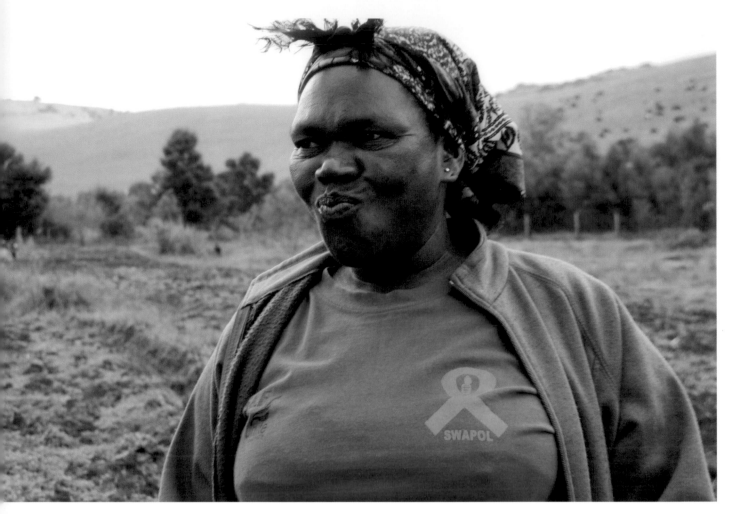

Margaret Ntando, 47

5 GRANDCHILDREN

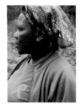

Margaret unlatches the wood gate in the wire fence. She is chairwoman of this project. Today her 5-year-old granddaughter is helping her. The little girl has pigtails tied with yarn bows that match her pink OshKosh jacket. We walk single file along the edge of the field, passing perfect, straight rows of young plants.

Four of the 6 women hoeing and weeding are grandmothers. Two younger HIV positive women carry their babies on their backs while they work. Altogether, 22 SWAPOL members share gardening responsibilities.

The carrots, lettuce, spinach, beets, and onions they are growing will nourish their grandchildren, provide a healthy diet for those who are HIV positive, and earn group members some much-needed income. "We make about 500 Rand ($7) a month from the garden," Margaret says.

Given the garden's isolated location, I ask how the women transport their vegetables to market. "We hire cars to carry them," Margaret explains. I'm impressed that cars can reach this distant plot.

Esau calls the group together for a training session. The women listen attentively, standing in the fertile, muddy field. On the far side of the garden, cows graze on the green, gentle hills. The sky grows dark with the promise of rain.

Sphalele Khumalo Mdluli, 65

7 GRANDCHILDREN

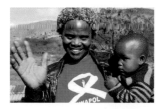

Mgomfelweni is a village in the hilly Shiselweni region due south of Manzini. The Silwa Neligciwane group has 30 members, 23 of whom are grandmothers. They manufacture and sell peanut butter to local customers.

The group makes peanut butter once a month. We have arrived on that day and the community center is a hive of activity. Some women stir peanuts roasting over open fires. Others sit on the floor of the front porch shelling and sorting nuts.

Inside, women crush the nuts into butter, a process that's made doubly difficult because the handle has broken off their only grinder. They sell peanut butter in half liter and 1 liter jars for $2 and $4. Proceeds help support orphaned and vulnerable children, including the members' grandchildren.

In the kitchen, a group cooks lunch for the youngsters who are about to descend from school. One woman stands outside ready to scoop water from a bucket with a cup so the boys and girls can wash their hands before they eat. The kids line up obediently. Only a few of them wear school uniforms. Some are barefoot. All are full of fun and energy.

Sphalele, the chairwoman of the group, tells me, "We think we should help orphans go to school. The government makes it free for grades 1 and 2, but we must pay half tuition up to grade 7." Obviously, earning money is key. "We need another peanut grinder and the first one needs repair; having 2 grinders would increase production. Maybe we will buy a sewing machine, so we can sew and sell school uniforms."

The local government has recently donated some land, for which she is grateful. "We will use it to cultivate peanuts so we don't have to buy them. SWAPOL will donate the seeds," Sphalele says.

We give Sphalele a lift to her compound down the road. Her almost-2-year-old grandson accompanies her everywhere. She hands me the little boy as she climbs into the truck. Even though I am a stranger, he sits on my lap without complaint. As we drive, I ask if Sphalele has a favorite song, and she sings a quiet hymn in SiSwati.

Sphalele has a flourishing vegetable garden and is raising several big white pigs. As we walk around her place, I ask what hopes and dreams the women have for their grandchildren. "Our project makes life a little better. If a person makes peanut butter, they help their grandchildren go to school." In addition to learning ABC's, Sphalele says, "All grades, starting with first grade, are learning about AIDS."

Everything comes back to HIV/AIDS. People in Swaziland do not just say, "Hi." They greet each other with an emphatic, "Good morning! How are you?!" They wait for the answer. It is important.

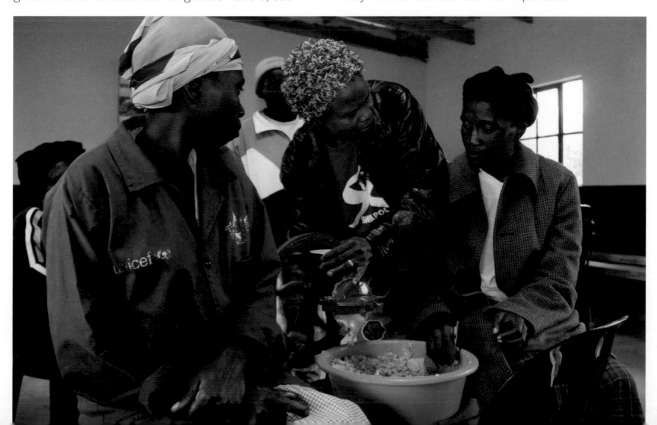

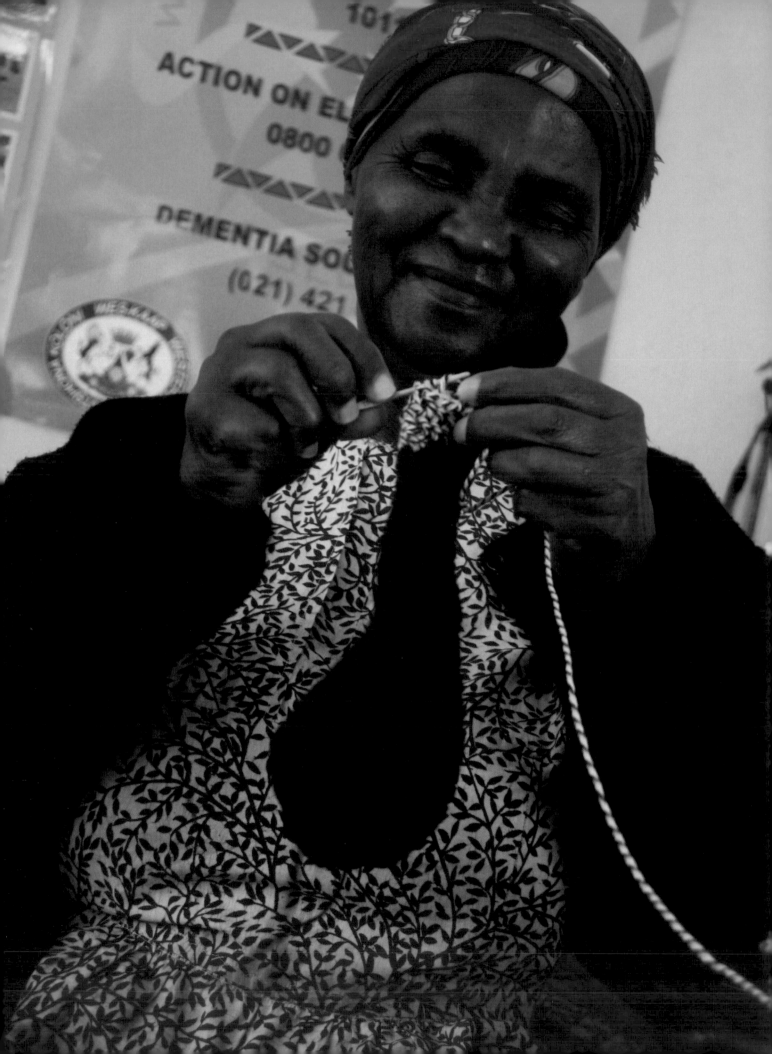

HIV/AIDS: South Africa

Tin houses tilt together as if they have melted in the heat. Jerry-rigged electrical wires form black knots against the sky, carrying illicit power from the main lines to the shacks. Laundry flaps on the fences. Barbershops, hair salons, and convenience stores operate from ramshackle stalls. Three men are building a prefab house of corrugated metal: one 9 x 12 foot room with 1 window and 1 door.

Almost a million people live in Khayelitsha, 12 miles from Cape Town. Ninety percent of the population are black and 40% are unemployed. Khayelitsha means "New Home" and here, if your new home is a shipping container, you live in a castle.

The Group Area Act of 1950 prohibited blacks from living in cities. Townships like Khayelitsha sprang up to provide places to sleep for men who did day labor in the city. For 30 years, the government periodically plowed the shacks under to destroy the informal neighborhoods. Residents rebuilt.

In 1983, when then-Prime Minister Botha established Khayelitsha officially, it was an apartheid slum with virtually no infrastructure. A steady stream of people began arriving from the Eastern Cape, building small houses of tin, wood, or cardboard, cooking with kerosene and using candles for light.

Today, goats and cattle wander freely in some Khayelitsha districts but there are also brick houses, water and electricity, shopping centers, clinics, fire stations, churches, and schools. And there are shacks barely large enough for a mattress. Gangs and crime are rampant.

Exiting N2 through the traffic on Spine Road, we drive toward Qabaka Crescent in J Section. There, in a 5-year-old concrete block compound between a school and a church, is GAPA: Grandmothers Against Poverty and AIDS.

GAPA is run by and for grandmothers. They make up the management committee, the staff, teachers, facilitators, and participants. Each of some 500 members takes care of her grandchildren and/or at least 1 relative with HIV/AIDS.

Thabo Mbeki (President of South Africa from 1999 to 2008) denied that the HIV virus caused AIDS, and his Minister of Health urged people to eat beetroot and garlic to ward off the disease. The Cabinet overruled Mbeki in 2003 and made antiretroviral medicines available, but the delay was catastrophic.

Today, 5.6 million people live with HIV/AIDS in South Africa, more than in any other country in the world. Swaziland has a higher incidence of infection (26.3% vs. 17.8%) but the numbers in South Africa represent staggering suffering. South Africa has 1.9 million AIDS orphans, more than the entire population of Swaziland.

The sign on the fence around GAPA's compound proclaims, "Together, we are strong." Inside, grandmothers are sewing, crocheting, and cooking. Kathleen Brodrick, GAPA's founder, and I sit in the midst of the activity. I ask, "How did strong grandmothers emerge from such terrible sickness and poverty?" She starts at the beginning.

In 2001, the Albertina and Walter Sisulu Institute on Ageing in Africa at University of Cape Town hired Kathleen for 4 months. The Institute had done a study about ways Khayelitsha grandmothers were coping, and wanted to give back rather than "just do research and run." Kathleen, a white Zimbabwean, worked with older people as an occupational therapist.

"I set up a group of workshops that I thought might be helpful," Kathleen says, "and put out an alert. You couldn't mention the word AIDS. It was so stigmatized in those days that nobody would have come. So

Grandmothers in a violent township outside Cape Town run after-school
programs for children who have been orphaned by AIDS.

we sent messages to various seniors clubs inviting grandmothers who were heads of households and left it at that.

"Seventeen grandmothers came. I discussed the whole thing with them and asked what they would like to know about AIDS. They were tight lipped. Nobody knew what they wanted to know because nobody knew anything. So I said, 'Next week we'll start and I'll have this program for you.'

"Everybody was kind of shocked that this was being brought out in the open, but 33 grandmothers came. They had turned completely inwards, isolating themselves because if it were known that someone had THAT, the house would be stoned.

"As the workshops continued, more and more grandmothers would stand up and tell their stories, sharing and talking very plainly in isiXhosa, their home language. Everyone would be in sympathy. Or they'd ask questions and somebody else would answer. The most magnificent change came over the group. They all looked sick and miserable, but they started taking charge of their own lives. It was mind blowing." Kathleen shakes her head as she remembers.

"At one workshop, a woman stood up who was in such a state, my goodness. She was grey and crying and wanted to kill herself. Her daughter had just died. I spoke to the social worker from St. Luke's Hospice and said, 'I think we need a bit more.' So we started a support group for people who had lost someone or were about to.

"I facilitated these groups. It's very good to facilitate if you cannot speak the language. The group had to talk together because they were not going to be talking much to me. I took all sorts of fabric, paper, needles, thread and scissors, and said, 'We can make patchwork' and showed them how. They sewed. Slowly, slowly, they started to talk to each other about family matters.

"I was 100% hooked on the power of getting a group of people together who are dreadfully depressed who can actually talk to somebody else: 'You understand me, I understand you, we're in the same boat.' It healed them.

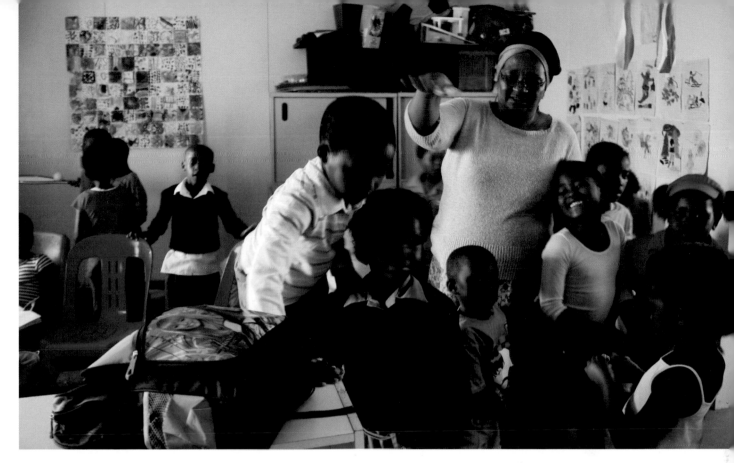

"At the end, workshop number 10, they asked, 'What's going to happen to us when these workshops are finished?' and I said, 'I don't know. The university is pulling out. What do you want to happen?' And they, said the famous words, 'You stay with us. We'll find a way to bring this to everybody else.' I said, 'Fine. Done.'"

The grandmothers arranged to hold sessions at the Seniors Center and recruited so many more grandmothers that the original group began holding support groups in their own homes. In 2003, elders in J Section suggested buying a vacant lot that was supposed to become a park. Kathleen got the land rezoned, then found a corporate sponsor to buy it and build a building, GAPA's permanent home.

A representative of the Stephen Lewis Foundation visited and said, "This is a wonderful program. Could you send some grandmothers to Toronto?" Kathleen responded, "Sure, as long as somebody else is paying." Two GAPA grandmothers went to the first Grandmother Gathering in Toronto in 2006 and helped create the Canadian-African grandmother collaboration.

"The Stephen Lewis Foundation started to advise us how to become more professional. Without them, we would be flat bang on the ground. They made it possible to start an after school care program, the only one in Khayelitsha. And they made it possible for us to employ Vivienne Budaza, the leading light and star who is now Director."

Vivienne is an energetic woman whose hair is in cornrows, whose eyes smile, whose laugh is infectious, whose spirituality is strong and whose singing voice would bowl you over. She had known Kathleen as her mother's employer for 20 years.

During that time, Vivienne worked for the Health Department, so she was professionally qualified to be GAPA's Executive Director. As important, her life experience qualified her to be empathetic. Born into a family of 8 children, Vivienne was sexually abused when she was 6 and raped at age 16 by her schoolteacher.

Now a divorced mother of 2, she says, "I have tasted poverty, heartache, pain and rejection. I know very well how it feels being unloved. I vowed that I will make a difference in every soul I meet by giving love, the greatest gift of all."

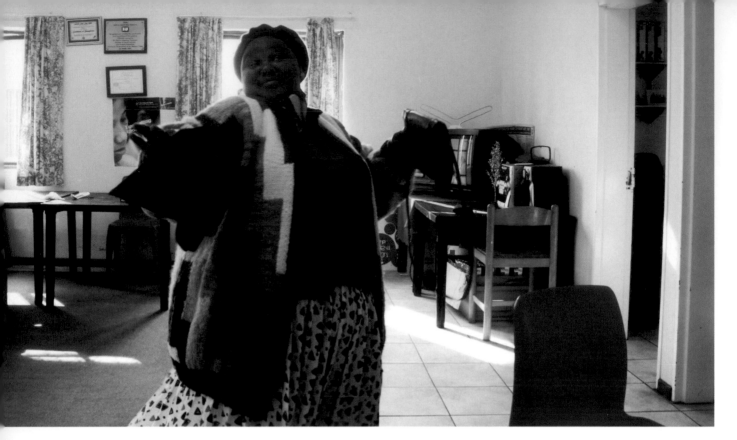

Most GAPA grandmothers have little education and live on about $100 a month. The youngest is 47 and the oldest, 86. Vivienne estimates that 80% care for AIDS orphans, 15% are HIV positive themselves and 30% care for a relative with AIDS.

In 2006, researchers asked how many GAPA grandmothers had recently experienced a new diagnosis of HIV in their families. Two thirds had. That survey also asked whether and how GAPA had affected their lives. One woman answered, "I shifted from crying, darkness, and fear, to strength and insight."

New GAPA members attend a 3-day workshop that focuses on practical responses to poverty (how to start businesses and co-ops, keep records, and handle finances) and AIDS (how it's transmitted and prevented, how to recognize symptoms, how antiretroviral therapy can help, how to accept death, how to parent orphaned grandchildren). Workshop graduates form small support groups that meet weekly in members' homes to talk and make crafts to sell. Currently, there are 25 support groups, each with 10 or 20 grandmothers. One recently-formed group includes 5 grandfathers.

Although the grandmothers' crafts fulfill contract orders or are sold in the community, there is also a tourist shop on GAPA premises.

GAPA sets an example for other countries. There are 24 grandmother groups near Dar es Salaam, Tanzania, which GAPA helped launch. Kathleen reports, "They were sitting around in rural areas saying 'Woe is me, what am I supposed to do, we have no money.'

"We said, 'You've lived for 40, 50, 60 years. You would never have got to this stage if you didn't have power. Work with what you have. You can make mats, teach your neighbor, make them in your groups.' So they began earning a little money and their self-esteem increased. They came to the party and decided, 'Well, we must get on with it because we can.'"

In many countries, the future lies with the children but Kathleen says, "Older people hold the future of Africa. Full stop. With the middle generation gone, they truly hold the future of Africa in their hands."

I ask what Kathleen has learned from the GAPA grandmothers. She reflects, "People who have been suicidal have become leaders of their community. It doesn't matter how poor or how low the self esteem, everybody has the power to heal themselves. Everybody."

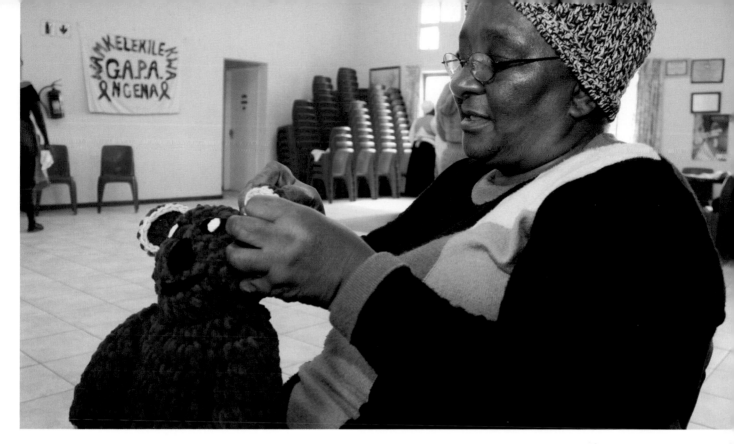

Sylvia Nontobeko Ngewu, 65
5 GRANDCHILDREN

 Sylvia is crocheting a red teddy bear. School gets out at 1 PM, and within minutes, 135 boys and girls will pour into GAPA's sandy yard and swarm over the swings and slides, laughing, shouting, and hungry.

After lunch, 25 5-year-olds will come to Sylvia's classroom. She is well qualified to handle this brood. Having worked as a nanny and had 4 children, she now takes care of 3 of her 5 grandchildren. Twenty-five is manageable, she says. "I love them and they love me."

"First you have them put their school uniforms in their bags. We read stories. Play games. Dance. Twice a year we take them for an outing to Cape Point, the museum, the beach. Yo! They can't believe it!"

Sylvia began coming to GAPA when it opened in 2001. "My sister's daughter got that disease. She was so embarrassed and sad, not knowing what it was about, so lonely and isolated. My sister thought they must put the girl in her room alone.

"I went to her and said, 'OK, my sister, this disease does not pass to others by sitting or eating together, only by sex or when you have a cut. I told her all those things, the tricks of HIV. I said, 'You must just give love to your daughter; show her you are supporting her. Let her be happy as before.' Now, she is doing very well, nice and fit, using her ARV medication."

Sylvia serves on the GAPA management committee and gives me an overview of the organization's activities. "The grannies say, 'Whatever comes, we are ready,'" Sylvia explains. "We've got a lady who comes and exercises us. Fitness for grandmothers. You would be very much amazed to see us jumping in our tights. We feel very free. We dance like the little ones.

"We also have the Golden Club where the grannies are running. GAPA grannies are winning races against other granny organizations. We go for competitions!" she laughs. "We started a big garden at a school. GAPA grannies grow veggies there and sell to the community so the kids eat healthy. "

Sylvia is the lead singer for a group of grandmothers who are producing a CD of lullabies to make money for GAPA. She was interviewed in the local paper saying, "I wanted to make it big in the music industry. At least I have fulfilled one of my dreams. I will provide so many things for youngsters on this CD. That's an amazing achievement for a granny!"

"I am happy! I am really happy. And very much excited," Sylvia says. "I never thought I could do things like this. Now I know what to do. I can teach what I learned to others. GAPA made me brave."

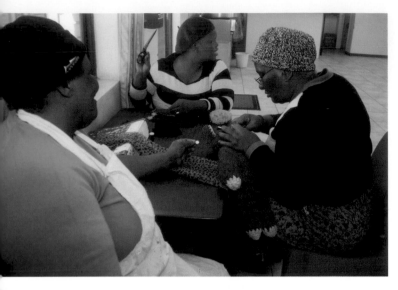

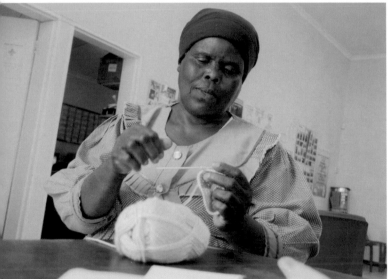

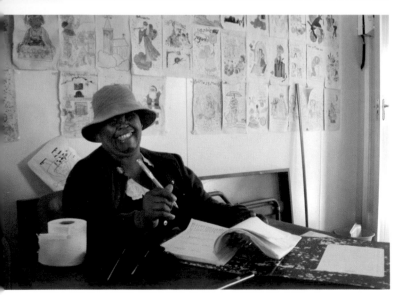

Rita Nomthandazo, 63
5 GRANDCHILDREN

Like Sylvia, Rita crochets as we talk. But instead of a teddy bear, Rita is making a hat.

"I was born in the Eastern Cape, the oldest of 8 children—but 5 died. I went to school until standard 6. I was very clever. The teachers said they were going to get money so I could finish my studies but my parents were drunkards. They said, 'Just go to work.'"

Rita earned enough to send her 2 siblings to school, then enrolled herself in night school and finished standard 8. "I was all by myself, doing my own things," she remembers. "I decided to come to Cape Town from the Eastern Cape, to work as a sales lady in a shop.

"I lived in a shack without a toilet, without water, it was horrible. When I got back from work one day, the door was open and everything, everything inside had been taken. Taken! Wow. I said, 'This is terrible.' Five years of crying.

"There was a strong women's organization, Homeless People's Federation. In 1999, they found a piece of land for me. They said, 'Water is there, all you must do is build with your own money.' I managed to put away a little money every day. I bought some windows and doorframes. Somebody loaned us each $67. My house was about 600 square feet. But there was no roof and the money was finished.

"We found a gentleman who agreed to roof our houses. It was fortunate, the government brought subsidies; we just transferred ours to the guy who helped us with the roofs. We built 4 houses. I am staying there now. I am very happy. There is water, a toilet, a roof. We did it. Wow!

"But still, I was 50-something without a pension. I was sick and stressed. I am a single mother with 5 kids who were crying all the time, 'Bread, bread, bread.'

"The woman next door was crying, crying, crying. She had buried 4 children because of this terrible HIV and AIDS. One day, I saw women from GAPA, the first 10 grannies. They pricked my finger and told me I was HIV positive. I was afraid of the stigma. They said, 'Come to GAPA. This is the Granny place. Come for information and peace of mind. Come and cry and then you'll see there is a way.'

"I took a 3-day workshop and joined a support group of 10 grannies who crochet. I became perfect at crocheting. One day, they said at GAPA, 'We need

some who are creative with their hands.' I was so creative!

"I made hats. Hats were the end of poverty in my house. Now I make and sell hats and there is bread in the house, there are eggs in the house, I am so happy! I am working now. I've got something in my purse. I've got no worries now.

"Even at my house, they call me 'Hats Mama.' That's my name in the community. People say, 'Where's this Hats Mama?' My house is full of hats. I get $6 a hat. I can make 2, 3, 4, 5 hats a day. I am very quick on it. Oh, my dear, without GAPA, I don't know where I would be. Thanks God I came here. I've got power.

"One of the ladies who took me to GAPA was going to the Grandmothers Gathering in Toronto and was to bring 2 other grannies. We got tickets and flew to Canada. It's a lovely country. The people were very kind. I stayed with one of the Stephen Lewis Riverside Grannies who gave me a book. I went to Ottawa. There were white ladies with black children who said, 'This is my baby.' I said, 'Your baby? A black baby?' Oh my, I wish I was born there. Wow! It's another place, I'm telling you. I didn't know if I was dead or dreaming or what."

I ask about her children. "One is HIV positive. I told her, 'Don't worry. You will have your own treatment now. We only need to change our style. If you smoke, don't smoke. If you drink, don't drink. Eat vegetables.' I was so lucky because I was trained here. You must tell them there is nothing wrong with being sick. Give them hope. Give them power." Rita's daughter is now 38 and living successfully with HIV/AIDS.

Rita's son, who was shot when he was in standard 8, has recovered, grown, and is entering technical school to study business. "At GAPA, I got a scholarship application for him. He's now like a gentleman! He's got a laptop from the school. Brilliant!" Rita stops crocheting long enough to give me a high five.

Her youngest daughter will finish standard 10 this year. "Then, I am going back home where I was born. They don't even talk about AIDS in the Eastern Cape. People die from lack of knowledge. The next generation is looking up at us. Before I die, I want to teach grannies there what I learned here: 'You must wake up. Do the wash. Work. Don't stay with the negative and expect your husband to help you; no, he's going to run away. You've got hands. You've got brains. Put those things to use for you!' The grannies there need someone with a little candle to light their way. I think I will be a good inspiration to them."

Gladys Nompumelelo, 65
5 GRANDCHILDREN

 Gladys, Vice Chair of GAPA's Management Committee, gives me a tour of the compound. We poke our head in the door of a shipping container and interrupt grannies making crafts. Their products, displayed for sale in a container nearby, include beaded belts, decorated Vuvuzela horns for the World Cup, hot pads, cushion covers, teddy bears, aprons, jewelry.

The community garden includes plots of carrots, spinach, onions, and tomatoes. In the main room are worktables near windows with clean cotton curtains. Two prefabricated buildings serve as after school care classrooms, both stocked with games and books. The playground is full of colorful swings and slides. The kitchen has industrial-sized pots, big enough to serve many youngsters.

Gladys, born in Transkei, grew up to become the mother of 4. Her husband was a philanderer so she spent 24 years as a single mother. When 1 of her 2 daughters died of AIDS 3 years ago, a friend brought Gladys to GAPA. Her 7-year-old grandson, an AIDS orphan, is now in the after school care program.

She, like all members of the Management Committee, has been elected for a 3-year term. "We are the top of GAPA. We must look at the teachers and the staff. Do we have too many children? If so, we get more teachers. We have to be sure teachers are nice to the children and give them the right food. We give guidance to the Executive Director."

I ask Gladys to look into her crystal ball and tell me what GAPA will be like in 3 years. "Bigger, with more grandmothers and children engaged in the programs. We recruit by speaking with friends and being supportive."

"How do you convince grandmothers to come?" I ask. The grandmothers just tell the truth: "GAPA keeps us so happy and busy that we don't cry everyday."

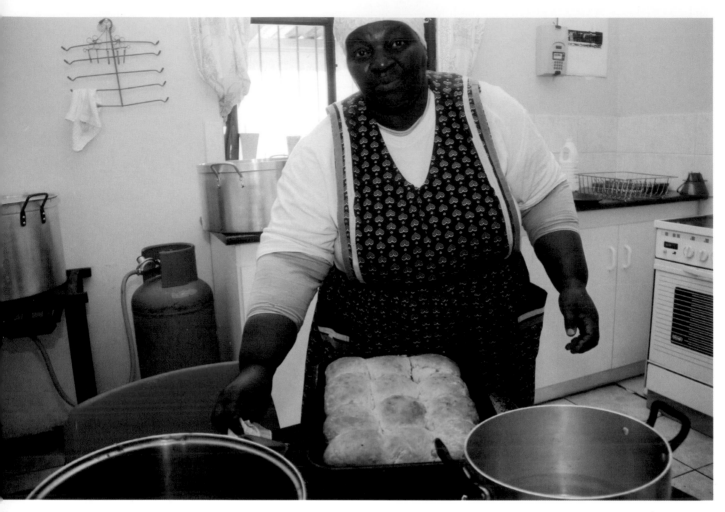

Eunice Yoliswa Mase, 63

4 GRANDCHILDREN

Eunice was the oldest of 14 siblings (including 3 sets of twins). She married at age 16 and had 5 children. Her husband, an alcoholic, provided no money so Eunice earned $71 a month as a domestic worker. "That wasn't enough for school fees. Neighbors gave us bread and butter when I couldn't feed the children," Eunice remembers.

About 10 years ago, 2 of her children died of AIDS. Her husband died in 2001. During this period, Eunice was under such stress that she had heart problems. She attended Kathleen's bereavement classes and joined GAPA in 2002.

"I discovered that everyone had the same problems. Their husbands had no money. Their children were sick. At GAPA, you feel free. I have been happy from then to now.

"Nine people live in my house, which has a bedroom, a kitchen, and a toilet. There are my 2 sons who drink like their father and do not work, 4 grandsons, and 2 granddaughters."

"Money comes from my hands. I do crochet and knitting. I make bags, hats, and scarves. Ten grannies come to my house on Mondays to make hats and cushions and to teach others to do it."

GAPA pays Eunice a stipend of $90 to cook lunch for the children who attend the after school care program. She and the other grandmothers turn fresh vegetables and meat into nutritious meals. Today, there are homemade buns filled with carrots, meat and potatoes. Yesterday, the menu was red meat, rice, corn, and carrots.

In addition to cooking, Eunice facilitates workshops, teaches about gardening, abuse, business, bereavement, and HIV. Her teaching philosophy is based in reciprocity: "I'm teaching you," says Eunice, "And you're teaching me."

Winifred Mangxilana, 70
13 GRANDCHILDREN, 3 GREAT-GRANDCHILDREN

Winifred is not only the fastest runner on GAPA's running team, she is 1 of the 5 singers who are recording the CD of lullabies. Like the other grannies, she has overcome obstacles.

She grew up in Eastern Cape, 1 of a dozen children in a polygamous family. She was married when she was 15. Although her parents agreed to a bride price of 10 cows, her husband paid only 6, a bad sign. At 17, Eunice's first child was born; at 19, another. Then her husband decided to leave the children in the Eastern Cape and move Winnie to Cape Town. Soon, he left for Springbok to work in construction.

"He sent me $6 to come. I looked so nice: black hat, black dress from my sister. Nobody believed I was Cameron's woman, I was so nice." But he didn't meet her when she arrived because "he was with his colored wife." ("Coloreds" are people of mixed race.) Winnie slept in a tent with spiders, burned her arm trying to bake bread, and cried. She finally called her sisters for help. "They sent me money. I came back. They found me a job."

"I worked as a domestic. I worked hard for my children. When I earned $1, I sent sixty cents to the children. The woman I worked for fixed me up with the milkman who gave me 4 children and was good to me. But he turned out to be married." She left him and returned to Khayelitsha. Winnie nods to herself, "In 1994, I started my life."

"My friend Eunice said, 'We've got a group, GAPA. Show them how to sew. You have a skill.' In 2003, I came to where people are nice to me and I am nice to them. I made patchwork blankets, cushions, skirts, aprons, bags, dresses, everything. Now, I make things Monday to Friday, and on Saturday I sell door to door. I have got a profit. I was so bad (before) but now you can't say so!"

"What worries you now?" I ask.

"I live with 3 grandchildren in Site B, Mandela Park where a 45-year-old man raped a 5-year-old girl. He is now in jail. But that is why the children must be in after school programs." Khayelitsha is notorious for crime. Guns, drugs and alcohol breed violence in the township. People steal to sell. It is not safe for little kids to play outside unsupervised. GAPA grandmothers run the only after school care program in Khayelitsha.

Impressed by Winnie's energy and determination to overcome obstacles, I shake my head, "You are amazing." She laughs out loud. "Of course!"

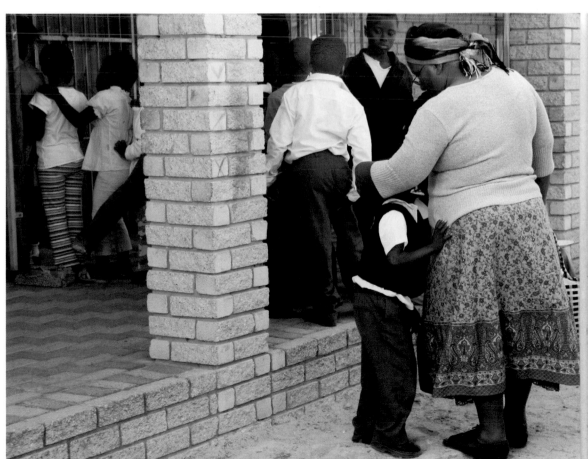

Nofenishala Sigcodolo, 53

7 GRANDCHILDREN

Nofenishala is living with AIDS. "I got sick in 2007. I was living in the Eastern Cape. My husband beat me. I left him and he remarried. I couldn't get medicine where I was living, so in 2008, my brothers came to get me and brought me to Khayelitsha. Seven of my 10 children are alive. Three are living with me here and 4 with my husband."

A GAPA group leader invited Nofenishala to come to the center. "Since then, everything is simple. I have sisters and friends here.

"Before GAPA, I couldn't do anything. Now, I've learned some things. I can make skirts and patchwork blankets. I can bead although I can't see very well. I go to a GAPA support group every Tuesday and do exercises: singing and dancing routines.

"Sometimes the grandmothers go on outings. For example, we went to Cape Point. All the grandmothers went on a bus. We got hats with a springbok on the front, and water bottles."

I imagine Cape Point's steep, jagged cliffs rising above the sea, the lighthouse, and the wild ostriches. What a remarkable adventure that field trip must have been for these grandmothers from the Cape Flats.

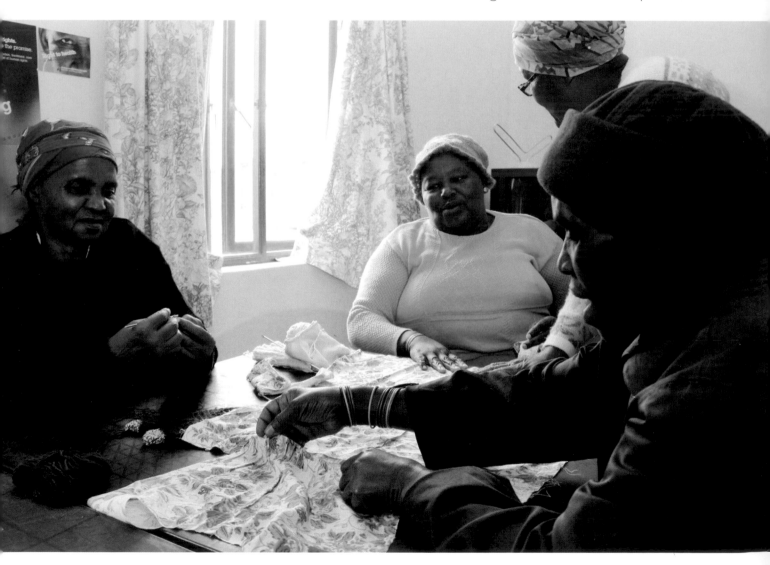

Memory Sishuba, 49
2 GRANDCHILDREN

Memory slept on the floor of her husband's hospital room last night, just to be with him. He is 14 years her senior, has epilepsy and diabetes, plus, "He is a drunk. He gets disability but the money goes to drinking."

Two of Memory's 3 children are HIV positive. So is her sister. She herself has high blood pressure and arthritis. Her 2 infant grandchildren and her 30-year-old son are healthy.

With all the difficulties, how can she look so fresh and chic? "It's my life, I must accept it," she says. "It helps to have people to talk to at GAPA."

Memory earns $89 a month teaching singing and dancing to the children in GAPA's after care program. Like all the grandmothers, she has multiple responsibilities. "I am a TB Treatment worker in the community, so I share here about TB and HIV."

Memory is 1 of the 5 grandmothers who will sing lullabies on GAPA's CD, all of whom have beautiful, strong voices. Since she's a Methodist, I ask if she will sing her favorite hymn, which turns out to be *Jerusalem, My Happy Home.*

Her voice soars above the noise of children playing outside: "Why should I shrink at pain and woe? Or feel at death dismay? I've Canaan's goodly land in view, and realms of endless day."

Standing in the GAPA center, I suddenly remember an African proverb: "If you want to go fast, walk alone. If you want to go far, walk with others." Each GAPA grandmother walks with others. As the sign on the front fence says, "Together, We Are Strong."

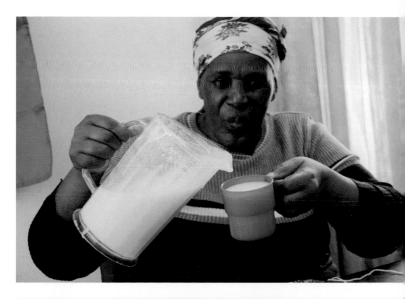

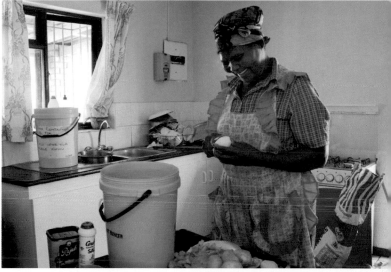

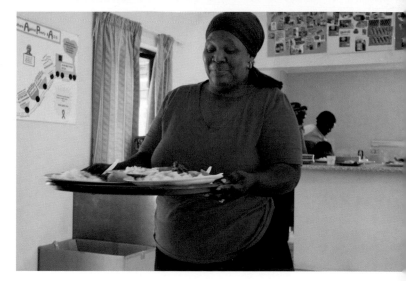

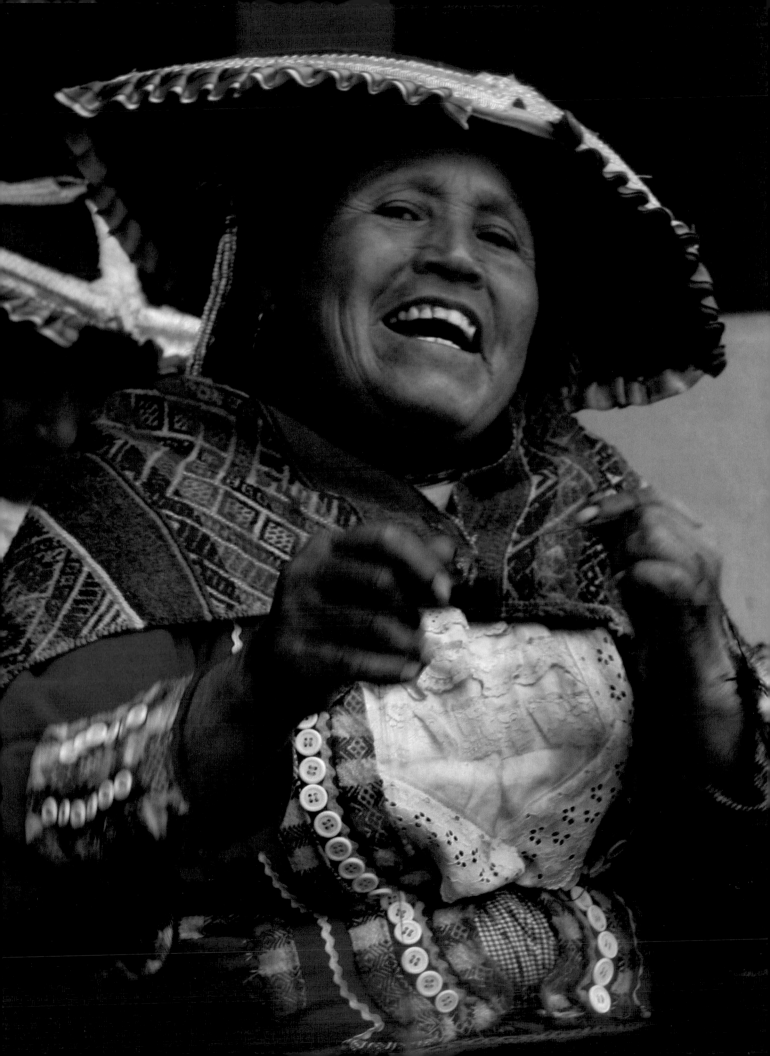

Cultural Preservation: Peru

As soon as my feet hit the tarmac, I realize it is difficult to walk around where the altitude is 10,800 feet. At my hotel, the room service menu lists oxygen. I don't yet know that Cusco is closer to sea level than any place I will visit for the next 10 days.

Cusco was the capital of the Inca Empire, which spanned Peru, Ecuador, Bolivia, Argentina, Chile, and Columbia from 1200 until 1532 AD.

Almost 500 years later, the past is still present. Rocks that weigh tons form Inca walls throughout the city. The cathedral's largest painting, *The Last Supper*, depicts disciples eating the Inca delicacy, guinea pig. The restaurant where I have dinner serves guinea pig ravioli.

I amble downhill from the epicenter of Inca religion and power, Qoricancha, the Temple of the Sun, and turn left. The first modern, white building on Avenida del Sol houses the Center for Traditional Textiles of Cusco.

From the outside, it looks like a fashion boutique. Inside, 2 village weavers, artists-in-residence this week, demonstrate at backstrap looms. Five rooms comprise a well-curated textile museum. The walls and furnishings in the retail gallery are bursting with bright, traditional weaving: pillows, rugs, and wall hangings. None of this would exist without master weaver Nilda Callañaupa and the Andean grandmothers.

Nilda grew up in nearby Chinchero during the 1960s when traditional clothing signaled illiteracy and poverty, and inspired discrimination. Public ridicule shamed the Quechua people into stopping weaving and wearing the handmade clothes that used to identify them by region, district, and community; marital, occupational, and economic status.

In the 60s, girls learned to spin wool when they were about 6. Then they were taught to weave with bright acrylic yarn that appealed to tourists. Chemical dyes had replaced natural dyes a hundred years before. Weaving traditions that had existed for centuries were not only endangered, they had almost vanished.

Gone were the small, intricate, designs woven for Inca royalty from vicuña wool by the Chosen Women. Gone were the rich natural dyes that pre-Inca weavers had created: indigo blue, cochineal red, and Qolle-flower yellow.

Nilda decided to ask grandmothers about the weaving patterns and processes that *their* grandmothers used. She convinced secondary schools to give academic credit to students who asked Nilda's questions: Which designs were considered old, new, Mestizo? Why were textiles important? What songs and stories did they know about weaving? What dyes did their grandmothers use? What colors identified their communities?

"Their answers illuminated my work," Nilda remembers. And started a renaissance.

The Center for Traditional Textiles of Cusco (CTTC) launched in 1996. The organization now includes weavers in 9 villages where 650 adults create, wear, and sell traditional weaving with pride—and teach children to weave so traditions can continue.

Many designs created today are similar to those of pre-Inca, Inca, Colonial, and Republican times: Andean fields, landscapes, the stars and the sun (the principal god of the Incas).

Weaving provides income to individual weavers, has rekindled ethnic pride, and is crucial to rituals and ceremonies.

Grandmothers all over the world sustain tradition. In Peru, they saved it.

Grandmothers' knowledge has helped revive lost traditional Peruvian weaving patterns and processes.

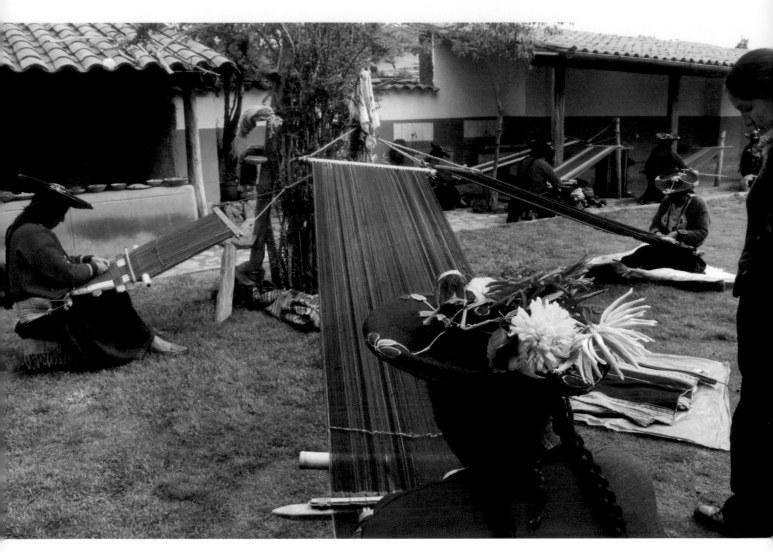

Chinchero

Vertiginous, spring-green mountains pitch toward a tumultuous river at the bottom of the canyon. Over the past week, heavy rains dislodged red mud and boulders. This morning, vehicles stand abandoned while drivers move rocks. I wait in the car with Nilda, who (with luck) will soon introduce me to CTTC grandmothers.

We drive into Chinchero past a statue of a weaver wearing traditional regalia, instead of the typical general-on-a-horse. Women wearing indigenous clothing are walking home from the market. The rainbow flag flies above the adobe walls that surround the CTTC Weaving Center, a large, grassy courtyard.

Inside, 40 women are at work, all wearing blue-and-red patterned shawls, voluminous skirts, and flat, black-and-red felt *monteras* (hats).

They spin while walking around; throw balls of yarn between warping stakes; stir wet yarn in steaming cauldrons of natural dye; and weave at backstrap looms. The scene is gorgeous: so colorful and industrious that I wonder if it has been staged for me to photograph. But no, this is what a CTTC Weaving Center looks like.

I pass the flower-filled shrine of Saint Anne, who gave birth to the Virgin Mary so late in life that her face is wrinkled like a grandmother's. She is the Chinchero weavers' patron saint.

Nilda Callañaupa Alvarez, 50
DAUGHTER OF GUADALUPE ALVAREZ VALENZUELA

When she was 6, Nilda tended sheep in fields where sacred Inca ruins sat silent. Nilda remembers how Dona Sebastiana, a grandmother, taught her to spin: "She did spinning like the Milky Way. A dream for me. I wanted to be a spinner like her. Dona Benita, another elder, encouraged me. I used to love her weaving. Right now, I can see her fingers picking up the threads and weaving with good humor and heart."

Nilda was the first Chinchero girl to graduate from high school and the first person from the town to attend university. After graduation, she studied for 6 months at the Pacific Basin Center of Textile Arts in Berkeley, California, where she learned about weaving in many countries and cultures.

Of course, it was Inca weaving that interested her most. The Inca language, Quechua, was her first language (she also speaks Spanish and English) and Inca history was in her bones. As a child, she played on the village green where the second of the great Inca rulers reviewed his troops.

Chinchero was changed forever, Nilda says, when Manco Inca, the king, fled from Cusco in 1536. Appointed by the Spanish conqueror Pizarro, Manco mutinied; his 100,000 soldiers fought and lost to the Spanish in a ferocious battle at Sacsahuaman.

As he retreated through the Sacred Valley, Manco Inca burned his army's *qollqa* (storehouse) in Chinchero, sabotaging Spanish soldiers' prospects for renewing their resources and following him to Vilcabamba where he was about to start a new Inca kingdom.

Manco Inca had intentionally destroyed his people's weaving. The storehouse held cloaks, cloth and wool, which went up in flames along with food and equipment. Nilda explains that textiles were considered sacred; probably the Incas didn't want them to fall into enemy hands. The storehouse fire ignited the entire village.

"People built on top of the ashes and stone foundations, and started to live here, in the same environment with the same spirits. The energy of the mountains, the springs, the land, the landscape:

everything comes from the Inca time, even before. We are surviving in that sacred landscape. For me, it's like continuing their life."

When she grew up, Nilda set an ambitious goal: to bring back traditional weaving.

Nilda's grandmother, a widow, had supported her family by weaving so Nilda knew that "grandmothers are the great source of what survives in textile tradition. Grandmothers are 'the book.'"

She asked school students to help her leap back 5 generations by interviewing their grandmothers about *their* grandmothers' weaving. As she reviewed the questionnaires, it took all Nilda's scholarly skills to analyze the findings, sort out exactly what the elder women meant by "old," and decipher how weaving had changed chronologically.

After additional research, she understood that quality weaving done on backstrap looms (then viewed as "low class") had at one point evolved to such a high level that it exceeded the quality of the tapestry weavings created for the Inca elites. Yet both fine backstrap and tapestry weaving techniques were long lost. In 1781, the Spanish conquerors had outlawed Inca clothing and cultural traditions.

Nilda, 2 friends in Cusco, and 3 textile lovers from the United States co-founded The Center for Traditional Textiles of Cusco to recover the weaving traditions and reinstate the indigenous people's self-respect.

"I thought we should sell only good quality that we could be proud of, not synthetic or old, ugly pieces that were falling apart. And that the knowledge of the elders should be passed on to the younger generation.

"We could not hire teachers from outside. Only the grandmothers knew the vocabulary, the meanings of the patterns and technical information about dyes and looms. Thanks to them, we are where we are now."

Today, people all over the Sacred Valley of the Incas wear traditional clothing.

Weavers create on their looms, the patterns designed by their ancestors. The grandmothers and Nilda are achieving their dream.

Guadalupe Alvarez Valenzuela, 83
23 GRANDCHILDREN, 4 GREAT-GRANDCHILDREN

Guadalupe, Nilda's mother, learned to spin when she was "4 or 5. My mother taught me. I was making belts when I was 6 or 7. My oldest brother took my first spinning and weaving to the river."

Many weavers, like Guadalupe, believe that their first pieces must be thrown into a river as an offering to Pacha Mama, Mother Earth, so they will be assured of "weaving and spinning fast like the river, which never stops."

The ritual also helps weavers remember designs. "You put 3 coca leaves into the bundle, plus 1 Huayruru seed. If you want to remember more than 1 design, you add 3 coca leaves for each pattern. Then you pray and throw the packet into the water."

Guadalupe describes other beliefs that weavers hold about Mother Earth. "You must always, get Pacha Mama's permission. Before you do warping, put a little *chicha* (corn beer) and coca leaves in the hole in the ground before you put in the stake. Do that with respect and attention."

The first pattern Guadalupe learned was Tanka Churo, "The mother of all designs. It will bring you luck." She was taught by her mother, who was taught, in turn, by her mother. Guadalupe reports, "The same system is still going on. I taught my children, and sometimes teach my grandchildren. I hope they will go to the university and become professionals, but continue weaving, too."

In contrast, combining education and weaving was hardly Guadalupe's own mother's plan for her. Her mother, a Quechua woman who married a Spaniard, encouraged Guadalupe to go to school through the third grade, long enough that Guadalupe, "an educated Mestizo," would have a better life.

Her mother urged her to give up indigenous weaving and specifically, stop wearing traditional clothing, both of which were associated with uneducated lower classes. ("The elders," Nilda tells me later, "were discouraged; they had experienced years of painful discrimination and didn't want to pass on what they knew.")

Wouldn't Guadalupe's mother be astonished to hear that she has travelled to the United States to demonstrate traditional weaving! She and Nilda went to Vermont, Washington D.C., Colorado and New Mexico.

I try to imagine this handsome woman wearing her beautiful, hand-woven clothes in the United States. "Didn't people think you looked fantastic and exotic?" I ask. "We were the only ones dressed like this," she smiles. "Some people took pictures."

"What did you think of the U.S.?" I ask. "The trees impressed me; we don't have many trees here. And the cars; people don't walk there. I saw alpacas in Colorado. And chickens, cows, and sheep in Vermont. I like to travel—but I was born here and I like to come back to my home."

Her husband has joined us and a bevy of grandchildren nestle close to her. "We are happy here," Guadalupe smiles. Happy and proud. "We have worked hard. We have recovered our traditional clothes and weaving. Now everyone, even the children, knows spinning, dying, and weaving—and will have opportunity."

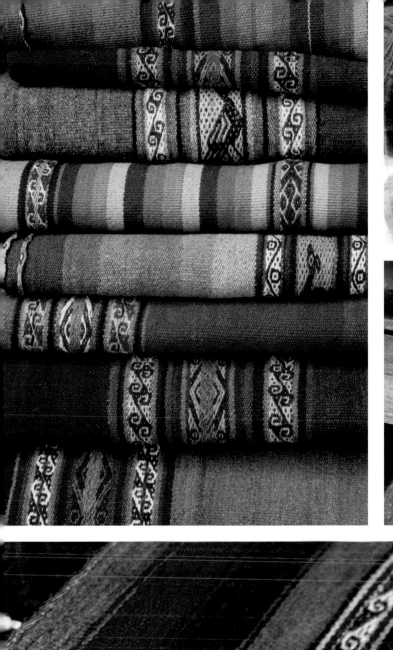

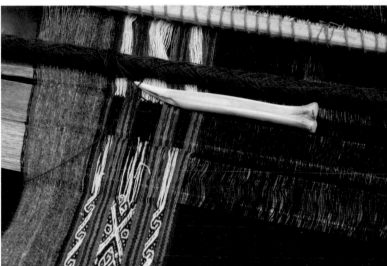
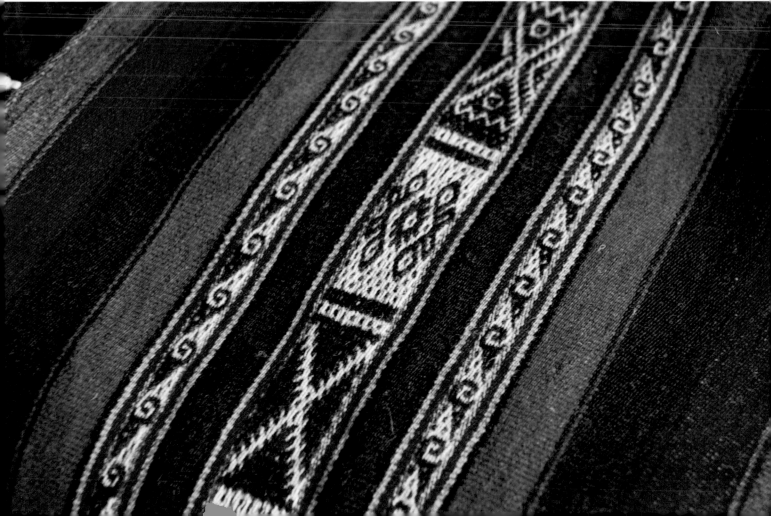

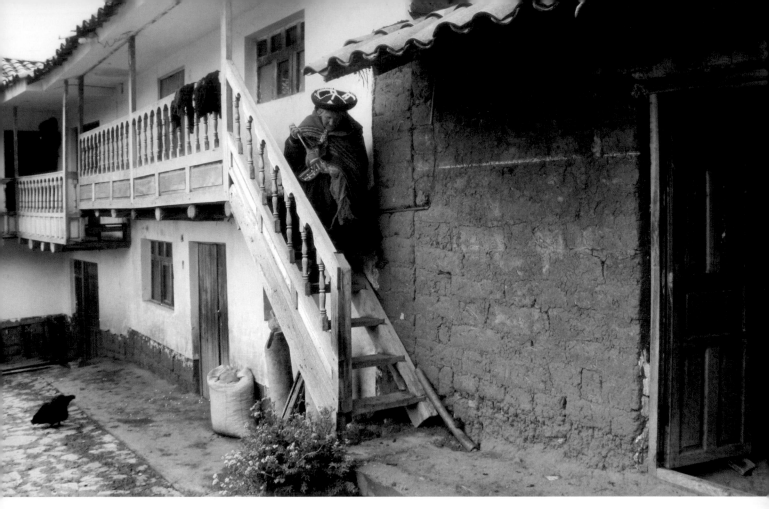

Rosa Quispe Quispe De Pumayalli, 67

17 GRANDCHILDREN

To avoid the mud, Nilda and I teeter across boards from the street to the gate. Rosa welcomes us to her 2-story, white house where wood is stacked inside to stoke the stove where stew is cooking for lunch.

People envy Rosa because she has a nice house surrounded by planted fields—but mostly because she had a husband who helped her.

"Whatever we did, we did together. He used to braid my hair very nicely. He worked in the fields doing men's work but he also knew how to cook. Sometimes if I came home late from the weaving center, he'd say, 'I will do the cooking so you can rest.' It will be 2 years this June since he died. Now when I come home, the house is dark and sometimes I go to bed without cooking."

Rosa learned weaving from her father's mother and still creates some of the patterns she learned then. In turn, Rosa taught her daughters and daughters-in-law. She also taught her sons, which is unusual; Rosa's husband used to spin and weave so it seemed natural for her to teach the boys.

"I used to take whatever weaving we produced to sell in Cusco and return to Chinchero the same day. I came back with fruit and vegetables—potatoes, barley, whatever we needed. I put everything on a donkey. There was no road. I used to walk fast; it took about 3 hours to get there."

I marvel at the idea of a "3 hour" walk to Cusco. By car, it took an hour and a half, circumnavigating the landslide, driving perilously over switchbacks and steep mountains. Then I remember Inca couriers tag-teamed and carried messages 250 miles in 1 day. Their descendants' lungs must be twice as big, and their legs 5 times as strong, as mine.

Rosa, her sister-in-law, and a daughter are all members of CTTC in Chinchero where children are learning to weave. Rosa is teaching all her grandchildren. One of them, her namesake, has become so involved with weaving that she now works at CTTC's gallery in Cusco. Young Rosa has been listening to our conversation, understanding every English word I say.

Rosa Bernadeth Pumayalli Quispe, 22
GRANDDAUGHTER OF ROSA

After lunch, the 2 Rosas show me the fields full of beans just outside their courtyard's back gate. Both carry drop spindles and work as we walk.

As a child, Rosa watched her grandmother weave. "I was so grateful and excited when she taught me! I was 7." The little girl shepherded the family's sheep until she was 10 and helped her grandfather do the shearing between December and April. "You separate the wool, dry it in the sun, remove the bad parts, wash it, and start spinning." She mastered the processes from start to finish.

Today, Rosa's responsibilities at CTTC in Cusco include purchasing textiles, teaching classes, and selling.

Having just earned her degree in tourism, for which she studied languages, history, and archaeology, Rosa has big dreams. In 5 years, she would like to launch a cultural travel agency so people can visit weavers' homes, share what they do, and stay overnight. "Already, people come stay with our family: researchers, students, whoever wants to learn," she reports.

Nilda's dream was that young people in the Sacred Valley would perpetuate traditional weaving traditions; young people like Rosa must make Nilda very proud.

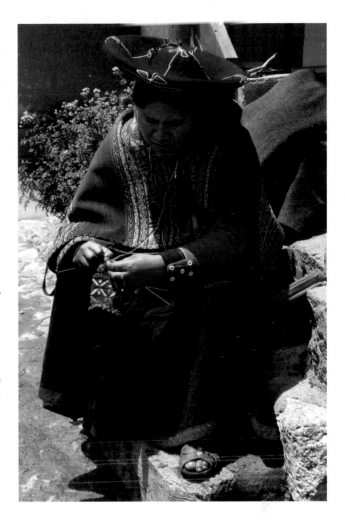

Santusa Huaman Auccacusi, 71
12 GRANDCHILDREN

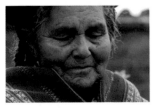

Santusa was one of the first weavers to join CTTC in Chinchero. I had looked forward to visiting her house, but the road is so muddy we can't get through. Instead, we have a cup of tea in Nilda's garden.

Santusa married a farmer from the jungle area when she was 16, and taught him to weave. They supported their 7 children by making belts, which Santusa sold in Cusco's Plaza de Armas. A narrow belt might take a half-day to make and bring $2; a wider, more complex belt might take 5 days and bring $15. "I never got any education," Santusa confides, "So I added with my fingers and asked passersby to help make change."

Twenty years ago, her husband became ill and 9 years ago, he died. Santusa kept the family going by farming and doing housework during the day, weaving at night, and raising their younger children.

She is proud of those children. In 1985, one son was among the students who interviewed grandmothers for Nilda's research. A daughter is now Treasurer of the CTTC Weaving Center in Chinchero. Two sons are university students in Lima; "one will be an archeologist; one will be a mathematician."

"I like to work," Santusa confesses, "but I must slow down now." Nilda explains, "She has arthritis, but she is still running like a little girl."

Chahuatire

We follow a flock of sheep down the main street in Pisaq, then exit town on a dirt road that narrows to a single lane and hugs the cliff. Again, a landslide has made the road impassable. We wait while local men muscle the boulders aside. The Rio Vilcanota rushes along hundreds of feet below.

Our route veers through tree-less, almost-vertical mountains. No wonder the Incas farmed on terraces. Maize flourishes. Streams, waterfalls and white water rivers tumble downhill. Wild flowers are everywhere: fields of chrome-yellow mustard; marguerites; pink trumpet vines; scarlet flowers the locals call *Cantuta*; purple potato flowers; white pea blossoms; blue lupine that people eat for protein.

A man passes us on a bicycle, almost buried in a heap of twigs that he carries on his back. In one small village, adobe houses are decorated with bas-reliefs: a sheep, a llama, a hummingbird. We are getting close.

Chahuatire, 13,156 ft. above sea level, looks over a vast green valley ringed with mountains. Driving into town, we can see the full length of the only flat street. A stream runs next to the pavement and groups of women in traditional clothes are washing laundry. About 800 people live in houses scattered on the steep slope below us; verdant crops occupy the steep slope above us. The main attribute of Chahuatire is: steep.

Rafaela Illia Mamani, 67

10 GRANDCHILDREN

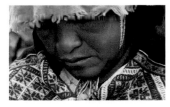

We sit on the earth at the corner of Rafaela's yard, which is fenced in stone. Her twin 6-year-old granddaughters climb over the rock wall and run down the incline to play, yelling and giggling, both wearing yellow veils on their hats.

The cloth that drops from their hat brims provides protection from the sun and rain. Single women and girls wear yellow; married women wear orange, and widows like Rafaela, whose husband died 20 years ago, wear green. Everyone ties their hat on with *watanas*, woven ribbons, which they create on small backstrap looms as Rafaela is doing now.

She explains, "Men make the hats, do embroidery, and create large woven pieces. There are more men than women in the CTTC weaving group, which works together at the Center here 3 times a week. My brothers belong. Even the President is a man. I taught one of my sons to weave; my daughters were more interested in going to school and watching television."

Rafaela was the first member of Chahuatire's CTTC group. Her grandmothers, both weavers, "pushed and pushed and said I must learn, but I wasn't interested. I taught myself to weave when I was 19."

One of the twins plops down next to her. Rafaela glances at me, "Here, grandmothers teach weaving—and history."

Rafaela tells the little girl about the *haciendados*, the feudal landlords who, for more than a hundred years, owned ranches so extensive that by 1961, 80% of the land in Peru was owned by 1% of these landowners. Indigenous *campesinos* were slaves to the haciendados, who allowed them to own plots just large enough to feed their families. They could not move away and the owner could appropriate their gardens at any time.

Between 1968 and 1980, the government of Peru seized 15,000 properties from the haciendados—45% of all the agricultural land in the country—and gave it to the laborers. This was akin to the abolition of slavery in the United States. Before that, Rafaela says, "The haciendados made life impossible."

"Everyone, including my family and I belonged to haciendados. They lived in Chahuatire and the rest of us lived outside or in the high places. There was little food, little time to rest. They fought a lot. Many times, I received beatings with roots or wooden stakes. I suffered very much. Sometimes, I was locked inside.

"They forced the women to take care of the cows, horses, alpacas, and thousands of sheep. Much of our life was spent working in the high places with the animals. If a puma or a fox ate a lamb at night, the haciendados took our animals to punish us."

When land reform came, the haciendados left. "Everybody divided the land and animals, celebrated and built houses in the village. We were free. We could see the people we wanted to see, weave together, spin together in the fields, and talk together. It was a happy time."

Rafaela married so soon after freedom came that she didn't have time to weave the elaborate clothes that brides traditionally wear here for weddings. Her jacket and shawl were, appropriately, bright red, but they didn't have button trim or lace.

Courtship is different today, Rafaela tells her granddaughter. Their family will attend the annual Women's Day festival later in February in Chiuchillani, where eligible men and women meet. Families are already weaving new, colorful clothing for the event.

Rafaela describes the day: "All the villagers around come to the top of the mountains to a special ceremonial place where there are no houses, no animals, only a very nice view. You can see the villagers coming from all sides. We will all wear our best clothes and dance."

Pedro, the CTTC President in Chahuatire, invites us to have lunch at his house. Two women, the group's Vice-President and the Treasurer, are cooking potatoes when we arrive, both wearing beautifully embroidered skirts. They set out white cheese, and I relax: the news that I am a vegetarian has preceded me. The family's guinea pigs, often served to guests, are alive and squeaking, running free on the floor.

The cheese is freshly made and the small, boiled potatoes are sweet and steaming. As we eat, I learn that some potatoes from each year's first harvest are buried, covered with hot rocks, to thank Pacha Mama for the abundant crop. The International Potato Centre in Lima claims 2,800 varieties of potatoes grow in this country. I'm delighted to share this bounty.

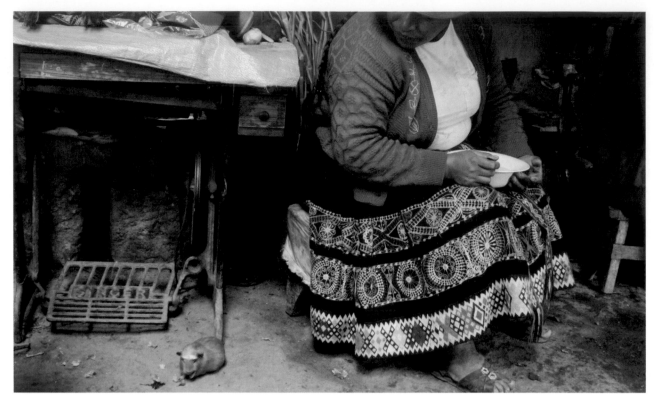

Apolinaria Illa Puclla, 71
22 GRANDCHILDREN, 8 GREAT-GRANDCHILDREN

Apolinaria's is one of the few houses located above Chahuatire. I climb the muddy fields that are blooming with fava bean blossoms and stop often to take pictures (a good excuse to catch my breath).

At last, we sit on the grass near Apolinaria's home. The ground slants so precipitously that I keep slipping downhill. She and her little black dog sit solidly on the slope, looking out at the valley. We can see twenty or thirty miles. February 6 was her birthday, she confides, but her family forgot all about it; I sing "Happy Birthday," which makes her laugh, and ask why she lives alone.

"This is my children's farm, they are right here. But I want to live alone. I am strong and active. I like doing my things myself. I wake up at 3 AM and work in the fields. Or I walk an hour-and-a-half to get wood for my kitchen. I have no donkey, so I carry the wood myself, which usually takes until 8 AM. I eat soup and weave until mid-afternoon, then take a nap, have dinner, and go to sleep for the night."

I ask Apolinaria about the haciendados. "They were always forcing us to do more and more. I was sick and my father was sick but we worked from morning to night. If you needed to wash clothes, you waited for dark. We didn't have enough food."

When her husband died 31 years ago, she became a single mother of 5: a mother bear. When the haciendados beat her, she fought back. "They were very awful. They raped women. Every time someone came to my house, I fought. I taught my children that if someone forced you, you needed to fight for yourself and get respect. If a haciendado picked up a stake to beat somebody, I would pick up a stake, too. I fought very hard and I was very, very strong. I was recognized for that."

Her approach paid off. "Only haciendado children were supposed to attend school here. They didn't want anyone knowing more than they knew. But I got my children into that school because I earned respect. Classes ended after the third grade but 3 of my children finished."

Since she has so many grandchildren, I ask what advice she has for grandmothers around the world. "Give all your grandchildren the same love. Talk with them. Treat them like your children. They will be happy knowing they are the best part of your life."

Pitumarca

Nilda suggested bringing gifts to the grandmothers and their families, so every day on the way to the villages, we buy bread and coca leaves. This morning we stop in Urcos and park in front of a folklife mural that could be an ad for Cirque du Soleil.

Women are setting up stalls in the market, unpacking produce from *mantas* (carrying cloths) woven of the acidic colors that Nilda's groups no longer use. Prodigious varieties of potatoes are on display plus at least as many types of beans. Red, green, orange, and yellow peppers are tumbled in heaps. Cow and goat cheeses are stacked on the tiled counters. Women vendors sit on the floor chatting over cups of coffee.

Coca leaves are jammed into garbage bags and repackaged like potato chips, 2 *soles* (dollars) per bag. "Coca is considered a digestive here," Nilda's sister, Flora, explains as we walk toward the baked goods. *Chuta,* wheels of bread 18 in. in diameter, are sold 5 to a bag and we buy as many as we can carry.

Pitumarca, north of the road to Lake Titicaca, 2-and-a-half hours from Cusco, perches at 12,400 ft. above sea level. The CTTC weaving center, like the one in Chinchero, is a grassy courtyard bustling with women weavers all wearing traditional clothes except that here, the *monteras* (hats) are black, their brims decorated with pleated satin ribbons.

Youngsters work diligently among the weavers (CTTC runs programs in every village for children and young people ages 6 to 25). The boys and girls learn spinning and weaving, and—as important—they learn how to organize and lead their groups, elect officers, handle budgets, and set prices. The older members in the Pitumarca youth group are proficient to the point of professional.

Working alongside the grandmothers, mothers, and girls, are men and boys wearing regalia every bit as colorful and be-ribboned. Altogether, there are 57 adults and 26 children in this CTTC group. Suddenly, I understand why wearing their native garb has had the same effect here as the mantra, "Black is Beautiful," did for African Americans in the United States during the 1960s. Everyone in this courtyard looks spectacular.

My husband, who flew in for Valentine's Day, offers to boost me to the roof to photograph the entire scene. That would put me at an even higher altitude so I decline—but later regret it.

Francisca Cjunu, 42
13 GRANDCHILDREN

Francisca is a "sandwich generation" grandmother and weaver.

Two of her 6 children weave with CTTC: Lisette, 14, and Marta, 25, whose 5-year-old daughter, too young for traditional garb, darts around the Center wearing a red t-shirt. Francisca taught Lisette to weave when she was small and taught Marta when she was a teenager.

Francisca's mother, Fermina Cjunu Huaman, a widow who says she is "75 or 80," is not only a weaver, but also caretaker of the CTTC Weaving Center here. She lives in a small apartment at the back of the courtyard; Francisca, Lisette, or Marta stay with Fermina at night.

It's not hard to imagine what life has been like for Francisca, who grew up "a day's walk away." Her mother "did weaving in order to buy coca leaves and something to eat," and taught Francisco to weave when she was 15.

Later on, "robbers from the South of Peru" stole all the family's sheep and Francisca's father fell ill. The family fled to Pitumarca to find a doctor for him and to give Francisca an opportunity to enroll her children in school.

Francisca's father died 16 years ago and the family lived in a rented house until the manager of the CTTC weaving center invited Fermina to care for the building.

My husband, noticing that Lisette is tracking every word of our conversation, asks if she enjoys caring for her grandmother. "Yes, she is very nice. We can cook together. We make soup of potatoes and vegetables." Lisette, a modern teenager, also likes Coca-Cola, ice cream, soccer, and, of course, weaving.

Her sister, Marta, weaves for money, competes in soccer matches against other villages, and takes part in traditional dance competitions. "Do you wear lots of skirts to dance?" I ask. "4!"

Francisca trains her bright eyes on the generation behind and the generations ahead.

Hilaria Copara De Huaman, 61
3 GRANDCHILDREN

Hilaria asks her 3-year-old granddaughter, Fannie Solidad, to lie down in the middle of her manta, then swings her precious cargo onto her back in one swoop. The piggyback ride is apparently old hat for Fannie; what's new is my camera, and she doesn't take her eyes off it for a minute.

I follow Hilaria to her house and enter through a gate in the adobe wall. Inside, a stream burbles between 3 small houses. A puppy runs to greet Fannie. Birds sing from the trees; sheep bleat in the fields nearby. Hilaria gives Fannie a lollipop, and the little girl leans stickily against her grandmother's back as we sit in the yard and talk.

"Sixteen years ago, when I had 7 children, my husband left me." Hilaria's eyes fill with tears. "He is now living with another woman. That was very hard." Hilaria and her brood lived in a rented house, which she paid for by weaving. After saving for 6 years, she finally had enough money to buy this land, and she built this house herself. "Alone," she says for emphasis.

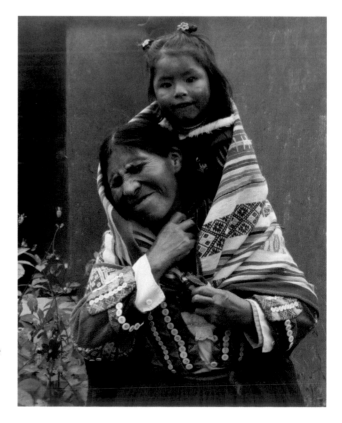

"When I was a child, my mother taught me, 'You don't know about the future. Learn dying and spinning and weaving so you can take care of your children no matter what happens."

Her mother and grandmother were weavers in Osefina, the "high village" (altitude, 15,201 ft.) where Hilaria was born. As a child, Hilaria accompanied them on the mountains, sometimes walking for 2 days to find leaves, stems, and roots to dye wool. Their weaving was fine, tight, and intricately patterned, "Like the Incas'," Hilaria remembers.

At carnival time Osefina is the site of a festival attended by people from all over the Andean highlands who come to celebrate fertility of the flocks and the production of alpaca wool.

Women's festival clothes have elaborate skirts that indicate both weaving ability and beauty. Women from distant communities pack their skirts in on horses since the many layers make them too heavy to wear. They pull the skirts on only as they approach the festival site.

Hilaria says, "I began weaving with my mother and grandmother when I was very young." Her grandparents took her first weaving to the *apus* (mountain gods) and asked Pacha Mama to give Hilaria "fingers as fast as moths." Obviously, the prayer worked.

"The first thing I sold was an alpaca poncho. I brought it here to the market and sold it for 200 soles. That was very good for me." She reflects on Pitumarca in the old days: "Not many houses. Straw roofs, not tile like this. The only big building was the church. No cars. The streets were only wide enough for walking. There were just 3 people selling fleece, weaving, and clothing on market day once a week."

Then as now, Hilaria admits, "I always weave and sell a lot. I make bags for coca leaves, *mantas,* ponchos, blankets for the bed, weavings for rituals. I used to spend a lot of time weaving, but my income was low.

"Thanks to CTTC, I learned to do better quality, brighter weavings that sell for more. I do demonstration weaving at the gallery in Cusco. I feel more secure now. I can earn more to help my children and eat real food. I am very proud to participate in this project."

Hilaria completed 2 years of school before her father "decided, 'girls don't need studies.' That made me very sad. Even with only 2 grades, I learned a lot and I liked it. I learned reading and the name of the capital of Peru. I remember everything." She vowed to

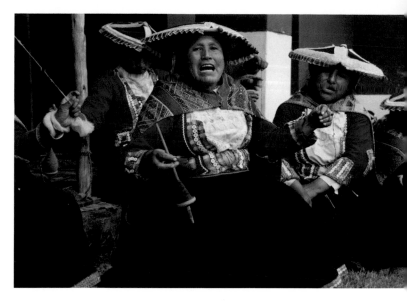

give her children the schooling she missed.

After her husband left, Hilaria paid for her childrens' educations. "Alone," as she would say. Now, one is in Lima studying printing at a technical institute and 3 are in university, one studying nutrition; one, technical agriculture; one, computer systems.

She has high aspirations for her grandchildren, "I pray to God that their parents will give them a better education than I had, so they can be professionals." But she wants them to know weaving, too. "Two already know everything about weaving."

Even Fannie, age 3, is learning to spin and weave. "I want to teach her everything I know," Hilaria says. "I want to keep the blood of my grandparents and parents alive. I want my grandchildren to have that blood."

Back at the Weaving Center, the singers have gathered in response to my questions about weavers' songs. Twenty women nest in their voluminous skirts, spinning and harmonizing.

A trio of teenagers has been waiting to show us the Inca ruins. We drive through dirt roads past adobe houses and across planted fields. At the top of the mountain, we park and navigate a path toward the stone ruins that have kept watch for centuries over the valley. Behind us, a ridge drops precipitously into another verdant valley.

Our teenaged escorts navigate that ridge, their clothes—red, green, yellow, black—contrast against the blue sky. They are spinning as they walk, creating the future that Nilda and the grandmothers dreamed of.

Cultural Preservation:
United Arab Emirates

"Draw a superhero from your culture," the animation teacher directed. The American students at Northeastern University in Boston scribbled pictures of Batman, Superman, and Spiderman.

But Mohammed Saeed Harib, the only art student from the United Arab Emirates, thought, "Grandmothers are the heart and soul of our culture," and began doodling.

The 6-pages he sketched in 1998 turned into *Freej*, a 3-D animated television show starring 4 grandmothers. It is the most popular television program in Dubai.

Freej means "neighborhood" in Emirati Arabic. The series takes place in an imagined, traditional area of Dubai much like Bastakiya—a quiet, creek-side cluster of labyrinthine, narrow streets and ancient wind towers. Looming over the roofs are the signature skyscrapers of the modern metropolis.

Sandwiched between old and new lifestyles, the grandmothers face all sorts of dilemmas: what to do about everything from wedding ceremonies to cosmetic surgery. No issue is too complicated to be resolved when the grandmothers gather for conversation and Arabian coffee.

The 4 grandmothers wear colorful *salwar kameezes*, long black veils that drop down their backs, bright scuff-style slippers, henna on their 4-fingered hands, and masks (*burqas*). One grandmother's origins are Persian. Another, African. One of the grandmothers has even had 4 husbands.

The grandmothers' strong personalities range from forgetful to feisty. *The Los Angeles Times* described the *Freej* grandmothers as, "Equal part Golden Girls and Fantastic Four." But these 4 are Muslim and *Freej* is about the Emirati culture: "What we cook, what we eat, what we wear," Harib explains.

Primetime for family television shows occurs during the month of fasting, Ramadan, when *Freej* airs at 6 PM Sunday through Thursday. It was an instant hit with viewers aged 3 to 70, all over the Arabian Peninsula when it launched in 2006.

Gulf News reported, "Four grandmothers and their veils have dominated conversations around *iftar* tables." (*Iftar* is the evening meal when Muslims break fast during Ramadan). When *Freej*'s second season began in 2007, fully half the population of Dubai tuned in.

Freej has so many "firsts" and "bests" that they're hard to count. First 3-D Arabic animated television series; first UAE television show to be broadcast nationally on an English channel (with subtitles); most-viewed television show in the UAE; first Arabic show on airlines across the region; best Arabic show on Sama TV Channel, 2006, 2007, and 2008; Hamburg Animation Award, 2007.

The *Freej* grandmother phenomenon is like Dubai itself, which is bigger than, taller than, faster than, flashier than anyplace else I've been. Advertising promises that virtually everything is vast, renowned, perfect, opulent, mesmerizing, fantastical. Billboards say, "More Status, Less Quo," and "Shop. Don't Drop."

Dubai Mall, encompasses 12 million square feet, has 1,100 stores, 30 mosques, a 2.6-million-gallon aquarium, and a lake with so many dancing fountains that Las Vegas' Bellagio Hotel version seems puny by comparison. The Mall of the Emirates offers an indoor ski run that's half a mile long. The new Burj Khalifa, the world's tallest building, is over a half-mile high (the Petronas Towers in Kuala Lumpur are about half that).

The U.A.E.'s most popular television series stars Dubai grandmothers who are sandwiched between a simpler past and modern metropolitan life.

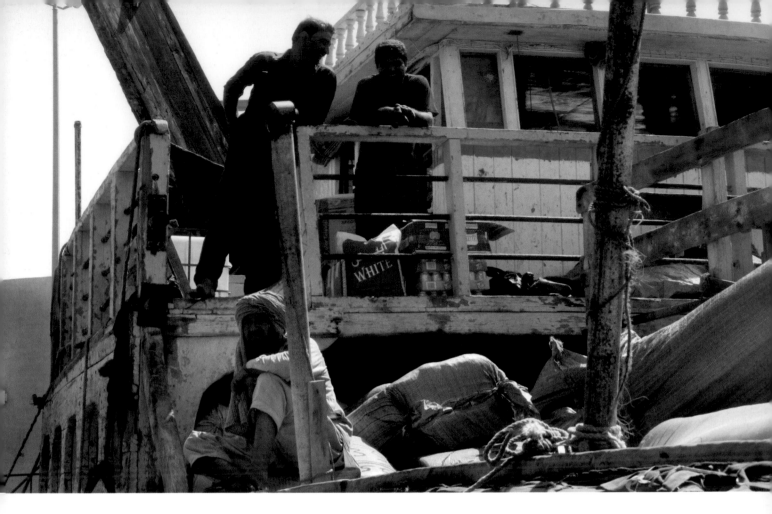

Dubai went from old to new with a speed that would make any grandmother's head spin. In 2009 Jim Krane wrote in *City of Gold*, "Those who eked out a living were, until about fifty years ago, among the planet's most underdeveloped societies. No one envied their existence of perpetual hunger and thirst, nor their diet of dates and camel's milk. The ragged folk spent nights around the campfire, reciting poetry and recounting intricate tribal genealogies that stretch back thousands of years."

Then, under the aegis of the Maktoum dynasty, the boom began. Dubai airport opened in 1959 with a single runway. In 2010, it was the world's fifth largest hub and served 47 million travelers. Electricity, running water, and telephones arrived in the 1960s. By 1985 almost everyone lived in an air-conditioned home.

In the 6 years between 2003 and 2009 alone, Dubai doubled its population and quadrupled its geography. By 2010, the city had almost 2 million residents and spread along the gulf for 40 miles.

Traces of traditional life still exist. The Dhow Wharf is jammed with wooden vessels like those that have carried cargo along international trade routes for a hundred years. The Deira gold souq is still the source for necklaces that girls wear when they graduate from Quran class. The spice souq is as busy as it was in 1908.

One can still find Bedouin musical instruments like goat hoof rattles, goatskin bagpipes, drums topped with goatskin. In Bastakiya, where wealthy Iranian merchants lived 100 years ago, old houses contain courtyards where camels were tethered at night. Camel racing, always a Bedouin pastime, is now the sport of Sheikhs and at least one restaurant serves camel burgers.

Dubai's grandmothers must feel as if they woke up one morning on the moon! Imagine that you were a grandmother who lived in old Dubai...and suddenly you are confronted with such burgeoning modernity. That dislocation was one inspiration for *Freej*.

Another inspiration: Emirati cultural traditions were endangered. By 2006, 80% of Dubai's population was foreign nationals from 100 countries. There were Christians, Buddhists, Bahá'i, Jews, and Hindus. Indians outnumbered Emiratis 7 to 1.

Mohammed Saeed Harib thought, "We Emiratis are a minority in our own country. We are losing our identity. Sooner or later, we'll forget where we came from." His idea was to build a *Freej* brand strong enough "to represent our culture." The television show was a beginning.

Through an ambitious licensing program, the 4 grandmothers' images now appear on Croc shoes, children's clothes, candies, crystal, stationery, schoolbags, facial tissues, toys, games, watches, and fragrances. Dubai residents can invite a *Freej* grandmother character to bring a *Freej* cake to a birthday party, corporate, opening or charity event.

Freej Folklore, a 2009 theatrical production, combined the animated grandmothers, live performance, orchestral music, and dance, plus double high definition animation. The spectacle was described by CNN as "a blend of Cirque du Soleil and DreamWorks' *Arabian Nights*."

Plans were on the drawing boards for a *Freej* theme park, the first Arabic theme park in the world. The grandmothers would act as ambassadors (think Disneyland Princesses) for 4 Freej lands where 2 million visitors a day could visit the Wild Wind Tower, the Celestial Forces Coaster, the Silk Traders Ride, and the Djinn King's Ring.

But it was not to be. At least not yet. The Dubai economy plunged into freefall in 2009. Half of Dubai's construction projects, $500 billion worth, shut down. Construction cranes were abandoned atop partially finished high rises. Four hundred thousand foreign laborers whose visas were linked to jobs, went home.

Nakheel, the company that sponsored *Freej Folklore* and planned to build the Freej Theme Park, laid off much of its workforce.

For a while, even the prospects for producing more *Freej* television shows looked bleak and the possibility of finding advertisers seemed low. But somehow, the fourth *Freej* season ran during Ramadan 2011.

Then Turner Broadcasting System launched Cartoon Network Arabia and contracted with Lammtara Pictures, Harib's production studio, to broadcast *Freej* episodes throughout the Middle East and North Africa. In 2011, Cartoon Network Arabia even cast the 4 superstar grandmothers in *Skatoony*, a British game show in which real kids compete against animated characters.

And so the *Freej* grandmothers added another achievement to their long list of firsts: *Freej* became the first Arabic television show to air internationally.

Interview

Wanting to experience old Dubai as the Freej grandmothers might have, I am staying at a bed and breakfast in a 100-year-old house in the Bastakiya section, a 40-mile taxi ride away from Mohammed Saeed Harib's Lammtara Pictures. The cab driver, a Freej fan, has a theory about why grandmothers are popular here: "Since men can marry 4 wives, anyone could have 5 grandmothers."

We leave the narrow lanes that wind through the adobe-walled compounds of Bastakiya and speed through mirrored skyscrapers of all colors. Some are sloped, bent, split, pyramidal; others are shaped like barrels, plates, trapezoids; some have slanted roofs and heliports. Burj Al Arab, the signature, sail-shaped hotel, is in good company. I am reminded of San Gimignano in Tuscany where nobles competed to build the tallest tower during the middle ages. Dubai looks like the 22nd century.

We pass 2 53-story copies of New York's Chrysler Building. Inland from Palm Jumeirah Island, the buildings of Dubai Media City bear logos of CNN, CNBC, Dow Jones, AP, BBC, Bloomberg, Reuters, Rolling Stone, Financial Times, Forbes, The Economist *and* Esquire.

Mohammed's assistant, Cherryl Landayan, escorts us through Media City's construction chaos to Lammtara's offices. Mohammed Saeed Harib originally planned to be an architect and his offices show it. The dark grey, 2-story space has white, egg-shaped swing chairs. The conference area is an island of white gravel where Lucite seats surround the table.

A 2007 photo on the wall shows Mohammed accepting the Young Business Leaders award from His Highness Sheikh Mohammed Bin Rashid al Maktoum, Vice President and Prime Minister of UAE, and monarch of the Emirate, Dubai. It was he who provided seed capital for Freej.

Smiling down from the largest wall is a reproduction of The Mona Lisa sporting the Freej grandmothers' signature burqa. I can't help laughing out loud.

Mohammed Saeed Harib, 32

Mohammed, a buff 32-year-old, wears black jeans and a t-shirt. He speaks perfect English. "I was born in 1978 and grew up in Dubai. I've seen its transformation from a village by the sea to a metropolis. We fast-tracked through evolution. For me, it was mind-boggling.

"If that journey was interesting for me, how was it for a grandmother who had been here when we were just nomadic settlers? I wanted to know how these grandmothers with simple ideologies and pure morals, react. How do they look at the world?

"We are a male-run society. When I was growing up, the media used to tell stories about how heroic the grandfathers were, going out to sea for 6 months, diving for pearls to sell to traders from Japan.

"The media totally ignored the mothers and grandmothers who used to raise the kids, work for a living, make sure ends would meet, educate 6 or 7 children, all in a very harsh environment at 50 degrees (122 F). Try living that kind of life! It is very, very hard. Unfortunately, as the country progressed, less and less attention was focused on the grandmothers.

"I thought, grandmothers are wise. Grandmothers have a beautiful sense of humor. They are amazing storytellers. But we are losing that. We are moving toward a globalized figure of a grandmother that comes from a factory.

"We are losing what makes us special. I wanted to archive that for the next generation. I wanted children to grow up watching grandmothers wearing the mask, putting henna on their hands—contemporary grandmothers who came from the old time. I wanted children to know: this is how they are reacting; this is their story.

"We all have grandmothers and were educated by their advice and insight. Always, you yearn for the days when you went to see your grandmother. It's a kind of dreamy patch. Dubai is like a first world nation now. I wanted to bring that hominess back.

"Fortunately for me, *Freej* was a runaway success. But grandmothers always were superheroes. And always will be."

I ask about Mohammed's own grandmothers. His father's mother was his "official" grandmother, and his maternal grand-aunt was his other "grandmother." Mohammed says, "I lost one and the second is suffering from Alzheimer's. *Freej* is homage to honor them. They were both very intriguing characters. Very

caring, funny, and wise. Their priorities and morals were alike."

As we talk, it becomes clear how Mohammed's grandmothers shaped the *Freej* grandmothers' characters. "Both women were amazing storytellers: 'Your grandfather had this old boat and he drowned.' All the stories were about heroics. About how they slept at night with no food, were cold, were poor. You have to imagine, all this fanciness was not here—this was a desert with no natural resources, no businesses, no nothing. They had to go to sea for food.

"The thing I loved most about my grandmothers was when they got super angry. They burst and yapped and cursed. It was like watching fireworks go off. Who knows what triggered them. Their temperament was different."

"In general, grandmothers in Arabia love poetry and love reciting it. My grandmothers, too. Grandmothers teach life lessons through poetry. I put that in each of my characters. People loved it!

"You saw in Bastakiya, how intimate [it is]. Many houses next to each other. If somebody cried in one house, they would know next door. They had a worry and it worried the whole neighborhood. Or there was one happiness for the whole neighborhood. That shines out of my *Freej* grandmothers. We miss that; now we are more aware of our individual issues."

Mohammed suggests 4 reasons the show caused a sensation immediately. First, its unique 3-D technology. "The show was over and beyond anything in terms of technical content. We wanted to do something that could be put on any international station and look good. That shocked people.

"Number 2, nationals are a 20% minority in our own country. TV here is always, *Who Wants to Be a Millionaire*. There used to be only Japanese cartoons. Nothing from the environment they grew up in. People wanted to be reminded of who we are.

"Third, grandmothers are portrayed in media as somebody about to die or who's ultra sick; that's the storyline of our dramas and soap operas. I get many calls from grandmothers who appreciate that we are showcasing women reciting poetry, solving problems, talking…not showing them as people in wheelchairs about to die.

"Last, *Freej* has 4 characters, as energetic as ever, solving their own problems. They see Dubai and they don't like it. People thought, 'I know this lady. She is my grandmother.'"

The breadth of the Freej audience surprised even Mohammed since the show was originally created for 18-to-35 year old women. Instead, "Kids love it that their parents are watching cartoons, a very weird concept. 'Grandmother is watching a cartoon; my mother thinks it's cool; my father thinks its cool. Who am I to object?' And they see the grandmothers on TV doing weird things they don't usually see them doing. Freej brought 3 generations together to watch. This is new for Arabic programming.

"Fathers and mothers love it because it's educating children about the importance and meaning of family unity, morals, friendship, generosity, watch my back—those simple lessons in an Arabic context.

"You might think, looking at me, 'He doesn't look connected to the past.' I think it began with going to the states for 5 years. It's 2 different worlds. Here, grandmothers are the central pillars of society. Every Friday, all the families—7 children and their wives and the grandchildren—gravitate toward grandmother's house. Once a week, not just on Thanksgiving or other holidays. Every single week. Our connection with that bigger family is very strong.

"In the States, that was nonexistent. It's a bigger country; they don't see each other very much. The mentality of a big family is not there. I missed my grandmother, I started doodling these characters with the mask, and my friends from here looked at them and said, 'Oh, she reminds me of my grandmother. I feel homesick.'"

Freej's 15-minute episodes are on YouTube in Arabic, which makes it hard for me to understand the characters, their patter, and the plots. I ask Mohammed to describe his 4 famous grandmothers. He starts with their names, which all begin with the honorific, 'um,' meaning 'mother of,' followed by each one's first son's name.

Um Saeed

Mohammed says, "My father's name is Saeed, so Um Saeed is named after my grandmother. She is the alpha grandmother, the leader of the pack who insults and advises you. She wears red, a dominant, hot color. She loves poetry and Arabian coffee. Everybody gathers at her house."

Um Saloom

"In animation, you need sidekicks—think Tom and Jerry. Um Saeed is thin, so Um Saloom is fat. Um Saeed loves poetry so Um Saloom is drowsy and doesn't remember what she said. Um Saeed is red; Um Saloom is blue.

Um Allawi

Mohammed continues, "Then I said, 'OK, lets step it up a notch.' I wanted an educated grandmother. Um Allawi is Persian. She speaks 3 languages, has a laptop and a Blackberry. Your twentieth century grandmother. She wears yellow." (Ashjan, the actress whose voice is Um Allawi, was asked in an interview, "What would you like to see your character do?" She responded, "She is Mona Lisa. Everything she does is perfect.")

Um Khammas

Mohammed says, "Um Khammas, the most successful character, is black, of African origin. I wanted a character who worked for a living, believes in women's empowerment and speaks her mind. She has a catering business. She sings for the weddings she cooks for. She is kind of rough around the edges, a 3-time widow. She wears green.

"These grandmothers can make you laugh, make you cry, break your heart," Mohammed summarizes.

He imagined, correctly, that the grandmother's masks would become the iconic costumes of his superheroes. He laughs at online comments about a *Los Angeles Times* article that say, "'Oh, look at those oppressed women, blah blah blah.' It's nothing like that. These masks are made of reflective paper because there was a lot of heat back in the day. Sand was blowing. It was a way to protect the face.

"Also, masks accentuate the beauty of the eyes. As a poetic society, we are in love with eyes. 'Your eyes are like the moon.' We're thinking of the days when, in this part of the world, they didn't have makeup. Ask any grandmother. They love the mask. It hides many things; it makes you beautiful."

I ask why men provide voices for 3 of the grandmothers. He explains, "Women's range of vocal chords create a young voice; often, they voice children. Men's vocal chords are more basic; they can sound older."

Mohammed asks Cherryl to delay his next appointment, and grabs the remote control. The large video screen in the conference area springs to life with *Freej Folklore*, "The largest-ever Arabic theatrical project. All the theatrical shows we had here were crappy, comedies. Cheap laughs. Here, you don't see *Les Miserables* or *Phantom of the Opera*.

"What we did was unique even on the global stage—for the first time, combined 3-D animation and live performance. We'd never seen ourselves this beautiful. We had all the sheikhs, the ministers, and grandmothers (grandmothers don't go to shows here). Everyone was blown away."

What does the future hold for Mohammed and his *Freej* grandmothers? "I want to cement these characters as icons. The United States managed to celebrate a mouse—and people are not that receptive to a mouse if you think about it.

"Tourists come to this beautiful, polished, evolved, city and they leave with—a souvenir camel! Why not a Freej grandmother toy to open dialogue? 'What is this on her face? What is she wearing?' As the years go by, the grandmothers won't grow older, they will always be the welcoming face of Dubai. That's my goal."

After working 5 years 24/7 to write and record Freej in Dubai, then direct the animation in Bombay and Singapore, Mohammed's trim beard is threaded with white despite his youth. "I am graying but the Freej grandmothers are not aging." He laughs, "At some point, I will pass them! 'See you, my children!'"

Environment: Thailand

When Tongbai Pongtawong, 73, looks through the warp threads on her loom, she sees a mountain range blanketed in verdant forest, including the kokkabok trees that inspired the name of her peaceful, rural village in Loei Province, Northeastern Thailand.

She tosses her flying shuttle with its bobbin of indigo thread, and worries about the other grandmothers who weave organic cotton 6 miles away on the other side of Phu Tab Fa peak where an open-pit gold mine has operated for the past 5 years.

Her friends in the village of Na Nhong Bong tell her that cyanide is leaching downhill and poisoning the water, which they can no longer use to cook or drink. Fish are dying in the Huay River. Rice and vegetables won't grow. Tongbai is nervous. Could the dust that gives people lung diseases there, blow to Kokkabok? Worse, will the company get the permit they have applied for, to mine closer to Kokkabok?

She has good reason to worry. Tungkum Limited, the Thai subsidiary of Australia's TongKah Harbour PLC, began mining in Loei Province in 2006. Tests 2 years later showed surface water was contaminated with dangerous levels of arsenic, manganese, cadmium, and lead. By 2010, more than 500 people in 6 villages were given blood tests by the Provincial Health Office. Cyanide was found in 63% of the samples. Lead and mercury were found in every single one.

Tongbai frowns, "I am not happy. I don't like them at all. But what can I do? I am small. If I speak out, they wouldn't listen."

True perhaps, but there is power in numbers. Tongbai and the other 43 members of the Kokkabok Group of Housewives Spinning Local Cotton (all are grandmothers between the ages of 45 and 75) asked their general manager, Mr. Odd Tongwarn, to write the government a letter of protest on their behalf.

He then accompanied several of them to meet with officials in Bangkok and express their distress. They cited the constitution and employed a uniquely Buddhist argument based on morality, compassion, and the interconnectedness of government officials and their constituents.

The grandmothers knew weavers in Na Nhong Bong who were selling organic cotton scarves to fund demonstrations against the mining company and others who were commuting to jobs in Loei City so they could afford to purchase food and water, which they'd never had to buy before.

In solidarity, the Kokkabok group voted unanimously to allocate 5 percent of their monthly income to support the fight and help the Na Nhong Bong families.

What irony! Brinks trucks drive off with gold bricks whose manufacture creates so many contaminants that the environment is devastated...while farmers a few miles away carefully grow and dye organic cotton without chemicals to protect the same environment.

Kokkabok's cotton group was launched after the US ambassador to Thailand, Richard Hecklinger, came to the village in 1999. Local women presented him with a set of cotton dinner napkins because cotton had long been the hallmark of the province. He was impressed. The Kokkabok Group of Housewives Spinning Local Cotton formed in 2001.

Local, regional and national governments worked with the Loei Foundation to provide equipment for the new group, which did not yet do weaving, only growing and spinning. Farming is considered the work of both men and women, so couples replanted their cotton fields with heritage cotton, which is resistant to worms and insects. They decided to use organic fertilizer and never to use insecticides.

Threatened by gold mining's poisoning of the environment, Thai grandmothers safeguard their communities' organic cotton tradition.

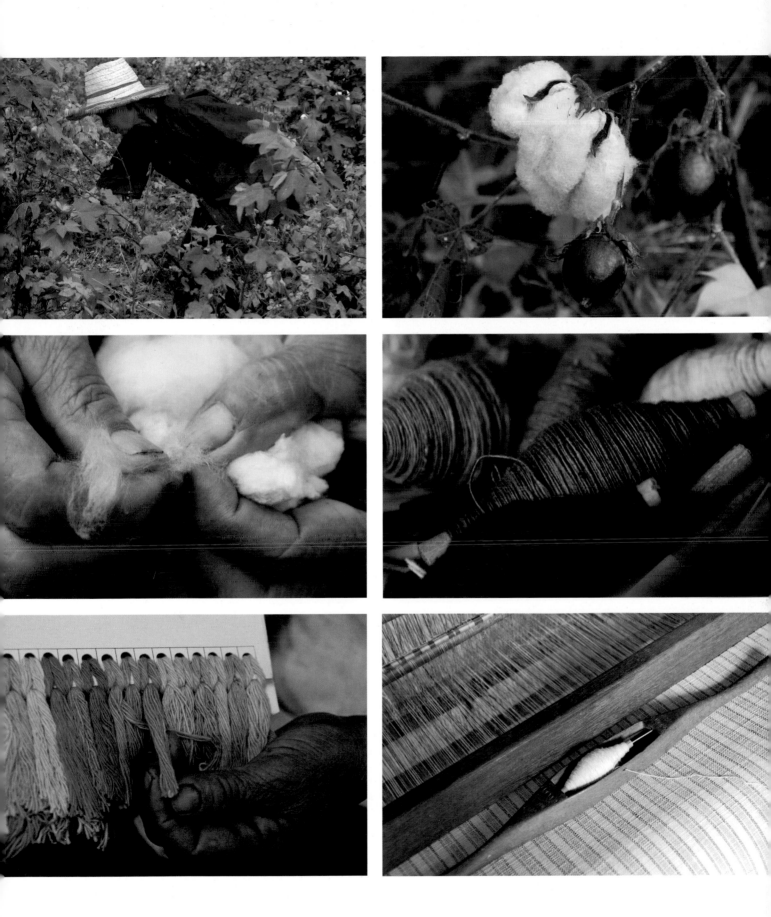

Kokkabok growers sell the cotton to the group for $3.50 per pound. Kokkabok weavers buy from the group for $3.90 per pound, then sell their cloth wholesale and keep the profit.

At the beginning, Green Net, a fair trade producer/cooperative, arranged for Kokkabok cotton to be cut and sewn into clothing, and marketed the products in Bangkok and abroad. Today, you can purchase Kokkabok organic cotton at the Lemon Farm in Bangkok and buy yardage online at www.tammachat.com.

The cotton tradition in Kokkabok goes back generations. Most of the grandmothers in the group learned to grow, spin, and weave cotton from their mothers and grandmothers. They have, in turn, taught their children and grandchildren.

On Fridays, youngsters can wear traditional outfits instead of their school uniforms. Kids from Kokkabok sport white organic cotton jackets made by their grandmothers. The day I visit the school, Waraporn Buabanburt, age 9, draws a picture of her village, including her grandmother spinning and smiling on the front porch of their home. Cotton is part of these children's past, present, and future.

Each November, the Kokkabok cotton group members contribute 32 yards of cloth to a local *wat* (Buddhist monastery) where it will be dyed golden brown and sewn into alms covers, sarongs, shirts, and shoulder wraps for the monks. Each gift of a weaver's time and talent earns merit.

The day before the grandmothers present this year's cloth, I accompany the women to the *wat*. The temple grounds are informally landscaped with kokkabok trees. Peacocks strut free. The temple itself, currently under construction, is a platform with pillars that the grandmothers festoon with ephemeral art:

ribbons, cotton bolls, bananas, pomelos, and *toongs* (a graduated series of hanging square flags, each a web of colorful cotton threads, believed to lead the soul to heaven).

About half the boys in the village become novices at this *wat*. At the moment, 3 novices are grandsons of cotton group members. One, who has a *yant* (sacred tattoo), tells me he likes to wear hand woven cotton better than factory cotton: "It's softer and lasts 3 times longer."

Cotton is celebrated annually one hour away in Loei City during *Dok Fai Ban*, the Cotton Blossom Festival, which features music, dancing, food and floats decorated with cotton. Since 2004, the grandmothers have demonstrated spinning and weaving there, and sold cotton napkins, placemats, scarves, skirts, and shirts.

The Kokkabok women were the only producer group to participate in the 2004 *Dok Fai Ban* event, which inspired Loei's governor to buy cottonseeds for 40 other villages. The following year, Kokkabok members taught growing and spinning skills to women in 8 of those villages, all of which now send their cotton to be woven in Kokkabok.

It is said that weaving skills first came to northern Thailand when people migrated from Southern China in the thirteenth century. Eight hundred years later, the Kokkabok grandmothers are working hard to sustain Loei Province's organic cotton heritage in the face of environmental challenges plus price competition from cheap, factory cotton imported from Vietnam and China.

The grandmothers' efforts are hampered further by the next generation's migration to the cities to make money selling lottery tickets, which earns more money faster than growing, spinning, and weaving. One grandmother confides, "We hope our daughters will return to the village one day and continue the weaving tradition."

Interviews

Thirty Kokkabok cotton women greet me in the 1-room village hall, which is cool despite 86-degree heat. The roof shades us and half-walls allow a cross breeze.

Ellen Agger and Alleson Kase at Tammachat Natural Textiles e-introduced me to "Tui" (Varunee Poolsin), the group's young, energetic marketing consultant who runs this morning's session as if it were an IBM board meeting.

My interpreter, Yo (Yosita) Nathi, whispers translations while the village headman, the local politicians, and the head of the cotton group welcome and brief me. The grandmothers all wear their business attire: natural cotton jackets. Tui records my schedule on a white board as the grandmothers agree to interview appointments.

Despite similarities, we are far from corporate America. Kokkabok's timber houses are lofted on stilts. Underneath, women work in the shade at wooden looms near the platforms where their families eat lunch and take afternoon naps. Huge earthenware jars contain rainwater to drink.

Five hundred residents live in Kokkabok's one hundred houses. Neighbors walk between the houses on paths as I do now. Chickens, butterflies, puppies, and birds flit around me. Bougainvillea, palms, protea, rubber, and banana trees grow wild. This morning I offered to photograph cotton group members and their grandchildren, so am intercepted frequently by proud grandmothers and posing youngsters.

Boon Reun Chantaw, 47
1 GRANDCHILD

Her grandson and her grandmother sit with us on the red-patterned mats that cover the platform under Boon Reun's family home.

The 2-year-old boy babbles, sings and giggles as he collects the seeds that fall from the cotton gin Boon Reun is cranking. The boy lives with Boon Reun while his parents sell lottery tickets in the city. "Once, his parents wanted him to live with them," she says, "After a month, I couldn't bear it. I asked them to send him back!"

She has dreams for this boy. "He should be healthy and a good person—should not be obstinate, drink alcohol, fight, or be violent." Although she finished only the fourth grade herself, she says, "I would like him to have the highest education we can pay for." Her cotton income and his parents' earnings buy the boy milk, clothes, and food now, and will fund his schooling in the future.

Cotton provides more than money, "It connects me to my family. I lost my mom when I was young. My auntie and grandma took care of me and taught me to do cotton. If I abandoned cotton, I would feel I was abandoning my family."

I ask her grandmother whether she learned cotton from her mother, "Yes, generation after generation. Now we plant corn, rice, and other crops. But in the past, there was only cotton."

The cotton gin (*eew fai*) reminds me of the clothes wringer my grandmother used when I was growing up in Illinois. The gin is fine for small batches but, "If we have more than 100 pounds, we dry it on a plastic blanket and send it to the factory about 19 miles away, which can handle it in an hour or 2."

I ask, "Will machines replace grandmothers some day?" But she assures me, "As long as customers want handmade cloth, we will continue."

Boon Reun is wearing a handsome blue jacket and ikat skirt, both made of her own cloth. "Every time I weave, I keep some for myself to make a sheets, a blanket, a scarf, a skirt, or jacket," she confesses. "I feel a strong bond with the earth when I wear cotton. I even sleep on cotton."

The scarf she's wearing includes silk, which she traded for cotton in a nearby village. She explains, "Silk is for special occasions and important people. We wear it to go to the temple, to attend a ceremony if someone becomes a monk, or to host a wedding (if you are a wedding guest, you wear cotton).

"Color," she continues, "is not so important. For funerals you must wear black, but for cheerful, fun occasions, you can wear whatever color you like. I like white best."

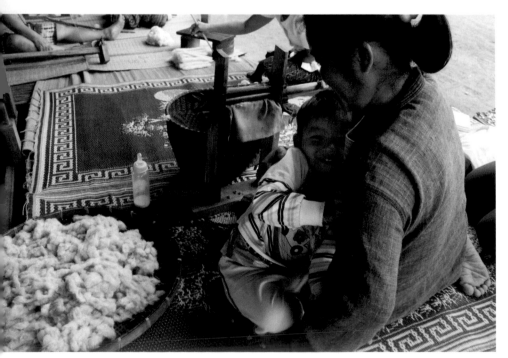

Boon Reun joined the cotton group when it started and served as its Chairman 3 years ago. I ask whether she can perform all the steps in the cotton process: planting, harvesting, removing seeds, spinning, dying, weaving. All the women in Kokkabok can. Their skills are not the only thing they are proud of.

It gives the grandmothers great satisfaction, Boon Reun says, that the group "shares 20% of the money we make. Five percent goes to the village that is damaged by the gold mine. Another 10% is given to the temple for ceremonies. When a member of the group dies, we help support their family. We love to help. We believe that if you are good, good will return to you."

Plain Tongwarn, 57
3 GRANDCHILDREN

Plain's parents arranged her marriage and for 40 years, she has been happily married to Odd, General Manager of the cotton group. "We had a small ceremony at home, performed by a man who was loved and respected by everyone in the village; his good spirits blessed us." She still teases Odd, who was 22 when they married. He brought a gift for her of only $9 instead of the customary $32. She laughs, "I can't believe I got married for $9!"

Plain is 1 of 19 weavers in the 44-member cotton group. She and Odd wear clothes made from cloth she created and they look cooler, literally and figuratively, than anyone else in the village. A friend designed her jacket, which has a chic, asymmetric closing. I crumple in this heat but the Tongwarns don't even wrinkle.

In their garden, they are cultivating cotton that grows naturally green and tan. Plain is experimenting with weaving colored-cotton patterns into white cotton cloth.

Every day this week, Yo and I have come here to eat lunch on the shady platform under the Tongwarn's house. Plain is polite about it, but my vegetarian tastes confound her: why would I eat a hardboiled egg and a banana when I could enjoy the shared dishes she prepares: fish, vegetables, and sticky rice?

Although she used to do bookkeeping for the cotton group (both she and Odd finished the fourth grade, the highest grade at the village school), now she spends all her time at her loom. She weaves 60 yards a month, which she sells for $270.

Plain contrasts her income with her daughter's: "The younger generation gets $700 a month selling lottery tickets. My daughter can weave, but instead, she collects 20 people in her truck, drives them places to sell, and gets a percentage of their sales. In 15 days, she covers her daughter's university expenses, $350 a

month.

Her 18-year-old granddaughter is the first one in the family to attend college. "She is a good girl, doesn't flirt with boys, wear makeup or sexy clothes. She is studying agriculture at Maejo University in Chiang Mai and "loves to make organic fertilizer for me to use in the fields. She really wants to learn weaving; even though she is bigger than I am, she sits on my lap and asks me to teach her.

"Every morning I go to the monks and wish that all my grandchildren will be happy and safe. Three years ago, my granddaughter was in a car accident. The other students were seriously injured and the driver was killed. But she was safe. She always wears the Buddha I gave her for protection. She was thrown from the car; it was a miracle."

One grandson is 8. The other, 13 "always comes and asks, 'Did you eat? What did you eat?' because I eat like a little cat. He is smart and likes to save money, which he gets from his parents and me. Collect, collect, collect. Sometimes I put my own money into his account. Sometimes I make temple donations in his name."

As she clears the lunch dishes, Plain smiles, "I feel fortunate to see the future in my grandchildren."

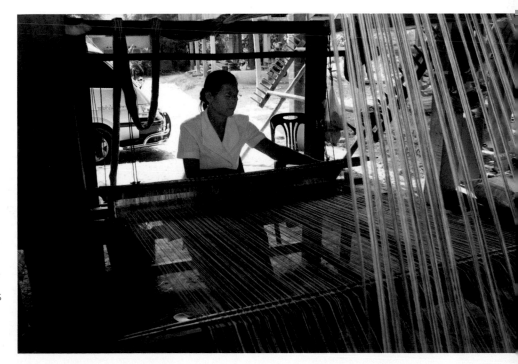

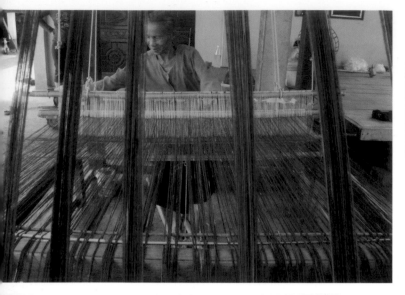

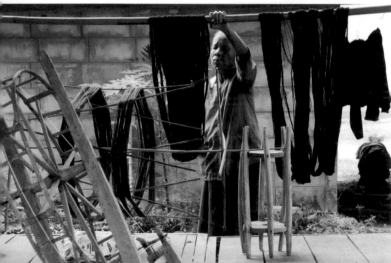

Tongbai Pongtawong, 73
11 GRANDCHILDREN

Tongbai lives across the road from a woman who specializes in yellow dyes.

Tongbai herself specializes in blue. She comes from "an indigo family." Her mother taught her 4 daughters to farm and dye with indigo, and the girls inherited their mother's land, which is still planted with the shrub.

These days even Levi Strauss uses synthetic dye to make "blue jean blue," but Tongbai uses indigo leaves from her own field, which she ferments in her back yard. She brewed a batch of dye last July and she's still using it now, in November.

She pulls on rubber gloves to demonstrate her dying method, and inserts both hands inside a thick circle of cotton thread. She dips the cotton into a bucket of indigo 4 times, then hangs the yarn on the clothesline to dry.

"Would you like to see my indigo field?" We follow her down the road across a little bridge. Her land is fertile and all her crops are thriving: cotton, sesame, tamarind, chilies, eggplant, black sticky rice, and papaya. Her grandchildren, 5 of whom live with her, cultivate a small garden patch.

At last, we see the plant that caught the imagination of people who considered it so valuable that they called it "blue gold." It seems cruelly ironic that "gold gold" is on Tongbai's mind every moment she sits at her loom and sees the mountain where mining is causing devastating environmental damage to nearby villages. Fear and frustration about the mine overwhelm her; her ebullient mood fades.

Boon Prommaharat, 73

12 GRANDCHILDREN • 8 GREAT GRANDCHILDREN

Like Tongbai, Boon's mother taught her to collect indigo, ferment it, and make "blue mud." As she savors the betel nut that stains her lips scarlet, Boon describes the blue dye recipe she's been using for 40 years.

"When the plant is 3 years old, I select leaf by leaf. I put many leaves in a vat with pure water; mix in a little fine, smooth ash and leave it in the sun for a week. Strain the blue sludge at the bottom with a sieve, dry it into flakes, grind them into powder." Voila, indigo blue dye.

Her family has specialized for generations in *mudmee* (weft ikat), which is a regional specialty. Cotton threads are tied at strategic points before they are dyed, which prevents the indigo from penetrating, and results in bright white patterns.

Her Majesty Queen Sirikit visited this region early in her husband's reign and saw mudmee, which so impressed her that she began wearing clothes made from this beautiful cloth—an important endorsement.

As Boon's husband weaves a large basket on the platform behind her, she shares her photo albums and regales me with grandchildren stories: this grandson, 28, is finishing his PhD in physics; this granddaughter, 8, triumphantly holds up her team's trophy in *takraw* (a sport that's part soccer, part volleyball).

Boon even has snapshots of the Cotton Blossom Festival. "We grandmothers are proud to show off our cotton skills," Boon says. She has participated in 7 of the festivals. "If there are lots of cotton bolls by February, everyone knows the crop will be abundant."

The festival began in 1970 before there were roads or cars, so Boon couldn't participate during the early years. "Now, between 1,000 and 10,000 people attend—almost everyone in Loei Province—because there are television commercials to promote it. I demonstrate weaving and spinning."

Then she laughs, "It is funny when foreigners try to spin!" Squinting at her traditional Laotian spinning wheel, which looks complicated, I sympathize with my fellow foreigners. At least they find the gumption to try.

Feint Chitta, 68
10 GRANDCHILDREN

The blossoms in Feint's yard are unlike any I've ever seen: exotic pink, red and white flowers used to make dyes. Yo, my interpreter, who is earning a masters degree in botany, helps explain how Feint creates her alchemy.

Feint mixes cassia flowers and jackfruit, bignonia and eucalyptus tree bark to make chrome yellow. She rinses the cotton once so it turns paler, and matches the result to quality control samples, which the grandmothers use to confirm that their colors perfectly match their orders.

The most popular color, Feint says, is rusty brown. The colors she'd most like to make are bright red, green, and purple.

Feint polished her color expertise 3 years ago when the Thai government sent specialists to her house for a week to train her in new dying techniques that she, in turn, taught her colleagues.

Feint's granddaughter, 17, arrives home from aerobic dancing wearing a lavender gym suit. With one foot in tradition and the other in contemporary life, she works as her grandmother's assistant. Already, she can weave and spin.

Twice a year, girls in the fourth, fifth, and sixth grades spend several days with Feint who teaches spinning as part of a course titled "Traditional Knowledge and Culture" (boys learn how to make organic fertilizer during equivalent sessions).

Feint influences many generations. She teaches grandmothers, mentors teenagers, and now she is weaving wraps for babies, combining silk with cotton to create "something that is soft, light, and delicate."

Paeng Tongpum, 64
6 GRANDCHILDREN

We peer past the elaborate antique birdcage and see Paeng and her husband napping on the platform under their house. Their pet bird chirps, trills, and sings. Paeng hops up. Her husband, 1 of 2 men in Kokkabok who spin, gets to work.

"My mother taught me how to spin when I was 9," Paeng says as she sits down at the loom, "but I had to wait until I was 12 to weave; before then, my legs didn't reach the treadles. I was a 'professional' (could do fine patterns) by the time I was 14."

"Could your husband spin when you married him?" I ask. "He saw me spinning and taught himself. He wanted to help me, and now he takes care of the spinning. That means I can do more weaving." Their bird shrieks and squawks.

All 4 of Paeng's children are selling lottery tickets in the city, saving for cars and school tuition. Paeng's weaving income allows her to contribute to those households. "They need bus money, food money. When one asks for $10, I give them $10. I love them all." "Nice grandmother," I say. "Nice grandchildren," she responds.

Paeng served on the Kokkabok Cotton Committee (elected by the group members for a 1-year term) and is now an advisor to the group. "I tell members how to make patterns and which colors will impress buyers. I work with women's groups from other villages who want to start groups like ours."

I jump, surprised when the bird screams again, but Paeng continues calmly, "Also, I give tours to visitors. Most come from the south of Thailand, Germany, and America. I take them to the cotton fields and demonstrate the whole process: picking, de-seeding, fluffing, spinning, dying, and weaving."

I am astonished that visitors can even find this village, which is 90 minutes from the nearest city, accessible via narrow dirt roads. "They see a brochure or find out about us on the Internet. Loei Province has a website that lists interesting things for tourists, and mentions Kokkabok."

If visitors want to buy cotton products in the village, that's possible, although the grandmothers don't push it because organic cotton is relatively expensive. On the other hand, "Our visitors have more income and tend to be concerned about the environment," Paeng observes.

"How do you convince people who don't know the benefits?" I ask. "I say, 'Organic cotton is handmade, which is difficult to do and time consuming. It's nice to wear: cotton absorbs water, so you'll be cool even if the temperature is hot. Organic cotton is grown without insecticides, so it's better for the planet...'"

Odd, the group's general manager, joins us and chimes in, "Only one other village in Northeastern Thailand makes organic cotton exclusively, so if you want organic cotton, come to us!"

As if cued by the last 3 words of that invitation, Paeng's daughter and granddaughter emerge from the house for pictures. The bird settles down to tweet.

Kampun Buarapa, 60

5 GRANDCHILDREN

We sit in the cool shade under Kampun's house. She weaves while her 4-year-old granddaughter lurks shyly in the neighbor's yard playing with a puppy but peeking at us. "It would be fine for her to join us," I suggest, but as soon as Kampun calls, the little girl whoops and runs away. "Naughty," sighs Kampun lovingly. "All my grandchildren are a little bit naughty."

Kampun is wearing a bracelet of cotton thread, as is her granddaughter. "This protects us from bad spirits and ghosts. We bring white thread to a monk who blesses it, then give it to our grandchildren. Monks...or magicians...can bless the thread. Every village has a magician to do the traditional rituals that monks can't do. We believe there are many bad spirits around. Magicians can scare ghosts away."

Suddenly my mind flies to Sawarng Kammanit, the 72-year-old man Odd introduced to me as a "traditional herbalist." Could he be the local "magician?" He said he holds ancient knowledge learned from his grandfather, who taught him to "raise herbs and collect medicine from the forest." He showed me leaves of purple ghost (which looked like maple) and said, "Ghost leaf makes bad spirits go away." He talked about herbs that scare snakes and juices that cure scorpion bites.

Sawarng's wife makes cotton for him. He uses cotton squares dyed with indigo to wrap packets of herbs, which he soaks in steam to ease pain, prevent headaches and provide aroma therapy for colds. He mixes "cotton root and cotton seed with water to make you urinate" and uses cotton for tourniquets.

Strong evidence that Sawarng is the village "magician" is his statement, "I use white threads, 7 of them, as holy cotton bracelets for protection. The numbers 3, 5, 7, and 9 are the numbers of life; 7 is the lucky number."

I ask Kampun what additional "magic" cotton can do. "It used to be that when people moved into a new house, they invited a monk for a meal and hung cotton thread around the house for protection, but today that is no longer done."

"What other cotton rituals are important here?" I ask. "Last month we celebrated an important Buddhist holiday," Kampun says. "Buddha told monks that they must stay in the temple for 3 months after planting so they wouldn't walk on seedlings. Monks still observe that advice. On the day the monks come out, Buddhists take food to the temple. Grandmothers and grandfathers stay for breakfast, ceremonies and mediation. The older generation keeps the tradition alive."

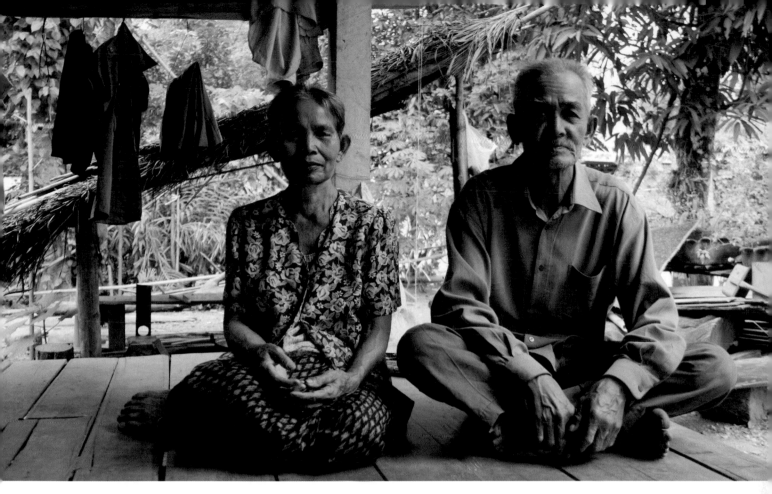

Boon Reun Tongwarn, 66

7 GRANDCHILDREN

Boon Reun and her husband of 46 years showed me the cotton fields when I arrived. Now, I end my stay at their compound, the largest of any I've visited. We sit on their platform, which is under the trees, not under their house. Her husband is the second man in the village who spins.

The place is bustling this evening since the family raises multiple crops. Boon Reun's husband is in charge of the tobacco and she is in charge of the cotton and rice, heavy white sacks of which men are loading, right now, onto a truck in the road. She keeps a sharp eye on the rice until the truck pulls away. Then she relaxes, ready to think about cotton.

And fashion. "When I was a teenager," Boon Reun says, "I had to sew my own cotton shirt. Even if it didn't look good, I had to wear it," she laughs. Right now, she is wearing 2 cotton skirts. She created the purple moiré one, which is protected by a factory-bought skirt that acts as an apron. "Factory cotton looks nice and neat, but for me, it doesn't look beautiful. Chemical dyes? There is no soul in that stuff."

Her double skirts seem to be a metaphor for old and new. "What has changed here since you were young?" I ask.

"Big changes. I had to walk a long way to get water and carry it home on my tiny shoulders. Today, we have plumbing and I just have to turn on the faucet: very convenient! Now, we use a car and trucks to transport things. We have electricity. There is no need to collect wood in the forest to make a fire because we use charcoal and cook with gas.

"Everything is a new experience for me. I sometimes forget to use the new things. The pace of change is like a rocket!

"However, the way we do cotton is exactly the same. And I still love to eat my own vegetables, even if they don't look as good as the vegetables from the supermarket."

This grandmother is so energetic at age 66 that Yo wonders, "Do you ever get bored or tired?" Boon Reun answers, "When I feel bored, I rest. When I'm tired, I stop."

Hoping she won't stop permanently anytime soon, I wish her a long, healthy life; if she were American, she might say, "Thank you." But she smiles, "When it is time, it will be time."

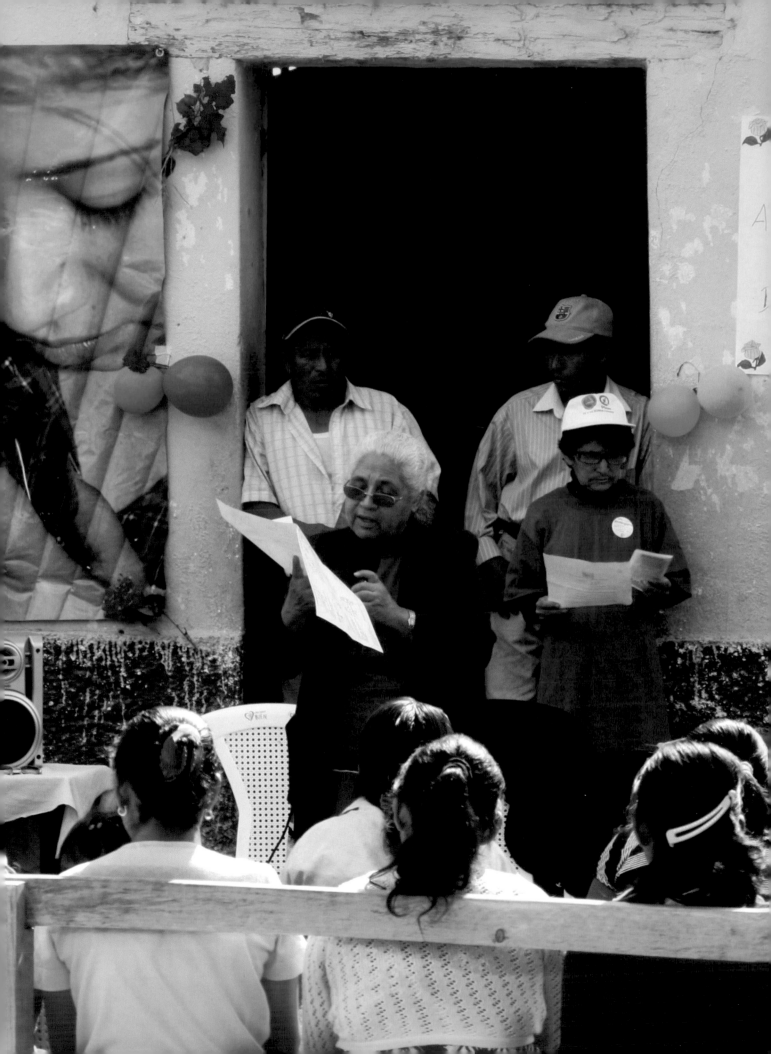

Human Rights: Guatemala

Village women tape clusters of balloons on the turquoise walls of the village community center: red, green, yellow, blue, orange, pink, aqua, white. Others balance sunflower and poinsettia blossoms on the balloons. Still others sprinkle bougainvillea petals and pine needles on the ground. There's going to be a meeting, but it looks like a fiesta.

We have driven over steep, cobbled roads in the volcanic mountain range outside of Jalapa, Guatemala. Now, we stop to let a man cross with his donkey that is loaded with wood. Anachronistically, a cell phone tower straddles a yard where corncobs dry on the ground. As we approach the village, people applaud.

This is Guisiltepeque. The grandmothers arrived earlier to help decorate for the meeting. A huge vinyl poster promotes their child protection hotline, The Tenderness Line, 79-22-77-31.

Some village women have graduated from Plan Guatemala's 12-session training course that aims to prevent child abuse by promoting good parenting. After receiving diplomas, the women organize community networks to put what they learned into practice. The grandmothers have come to help them teach parents to raise their children with love.

Already, men, women, infants, toddlers and teenagers are vying for the few chairs and benches, among them a woman who claims to have 40 grandchildren.

The grandmothers distribute Loving Parent Lotto cards plus handfuls of beans to use as markers. People whoop as they find graphics that match the words the grandmothers call, all describing behaviors that mark good parenting: "Hugs!" "Smiles!" "Talking!" Prizes are plastic bins, storage containers, and serving dishes. Everyone wants the game to continue until they have won.

As the sun rises higher, people pull the benches forward into the shade of the community center. Pretty soon, the people are virtually sitting on top of each other but nobody seems to mind. Mothers nurse. Women put folded towels on their heads for relief from the heat.

Maria Salome Campos, who wears a white lab coat, steps forward to explain that the grandmothers are administering vaccines today. She teases the crowd: "The vaccine is delivered with a syringe needle so big that it reaches into your heart." Nobody wants one. But when the grandmothers distribute "the vaccine," honey candy, *dulce de miel,* everybody wants some. Maria Salome says, "Put it in your mouths and savor it. That is what raising a child can be like: sweet and loving."

Ten Jalapa grandmothers volunteer with Plan Guatemala. For 6 years, they have run the child protection hotline and taught good parenting. Their first task was to "stop the silence." Sexual abuse of children was a taboo subject and beating was considered normal: parents disciplined children by hitting them; alcoholism and machismo escalated the violence.

In a few villages, local culture made the problems even worse. Some fathers in Hierba Buena and San Pedro Pinula believe it is their right to be first to have sex with their daughters. The grandmothers are working to halt this practice. Some girls who are pregnant with their father's babies have been placed in shelters, and the fathers, jailed. One, who raped repeatedly, was sentenced to 50 years in prison.

These problems are not limited to the Jalapa region. Asociación Casa Alianza Guatemala estimates that 7 out of 10 Guatemalan children suffer abuse of some kind. A 2010 Gallup survey found that most physical, sexual, verbal, and emotional abuse in Guatemala is not reported because people don't believe the authorities can help. Besides, mistreatment usually occurs at home where corporal punishment is legal.

One of the grandmothers told me, "Traditionally, women here were expected to do housework, have babies, and live with machismo and mistreatment. Our training gives them options."

Grandmothers operate a child abuse hotline and teach good parenting
practices in a region where family violence occurs often.

"Children, parents, grandmothers and neighbors often prefer to talk about child abuse with an understanding, warm, friendly, nice grandmother, rather than file a report with the police who are perceived to be repressive," a social worker tells me. A grandmother agrees: "We are soft," she says, "like avocados."

The grandmothers always carry around literature about good parenting. People often intercept them in the market or on the street to tell them about problems. One grandmother tells me, "Most conversations and calls take about five minutes. The people who talk to us are very stressed."

The grandmothers file police reports anonymously so abusers cannot trace them ("You never know who has a machete," one says). They sometimes refer cases to the Human Rights Ministry or to the Jalapa Departmental Hospital's Child Abuse team of social workers, doctors, nurses, and therapists.

The grandmothers' hotline is part of Plan Guatemala's Child Protection program, which serves 95 communities. In 2007, Plan worked with 6,000 families and handled 116 children's cases, divided about equally between sexual abuse, emotional/physical mistreatment, and abandonment/negligence. The Jalapa Hotline, the first in the region, is a model for newer programs in the cities of Escuintla and Salama.

When I visit the Hotline office, it seems as if the whole operation is running on fumes. The project, operated by grandmother volunteers, has had no funding since Plan Guatemala's grant from Japan ran out. The Tenderness Line can receive calls, but grandmothers cannot dial out, even to file a police report.

It costs callers 50 cents a minute to use the eight-digit hotline number, an unaffordable amount for people who live on $1 a day. A four-digit number could be called free and would be easier to remember, but the department's governor (who already loans the grandmothers an office, supplies, and staff to answer the hotline on lunch hours) has no budget to pay the monthly fee for that type service.

The hotline may get only four or five calls a month, yet each grandmother sits by the phone in rotation for a week of mornings (or afternoons) ready to say, "At your service. How can I help you? Calm yourself. Tell me what happened."

These grandmothers have heard the proverbial "everything": 13-year-olds pregnant with their fathers' babies; a toddler sedated by her mother and sent out to beg; a father who beat his "lazy" daughter with a chair; a newborn abandoned in a plastic bag; a neglected child dying of malnutrition.

Some of the grandmothers are determined to stop molestation because their own husbands or fathers used to beat them. One says she is serving humanity and God. Others say the work gives their lives purpose and meaning.

What they all agree about is this: despite lack of funds and death threats from abusers and molesters, they will protect children. Gloria Marina Lopez de Palma says, "Even if someone kills me for reporting child abuse, I will do it."

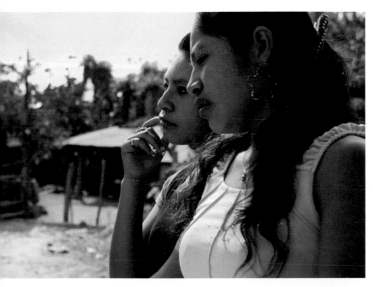
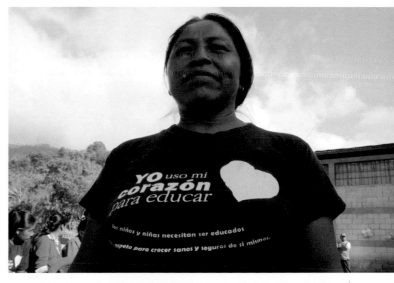
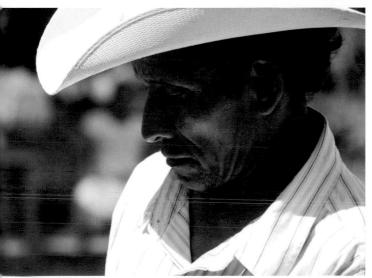

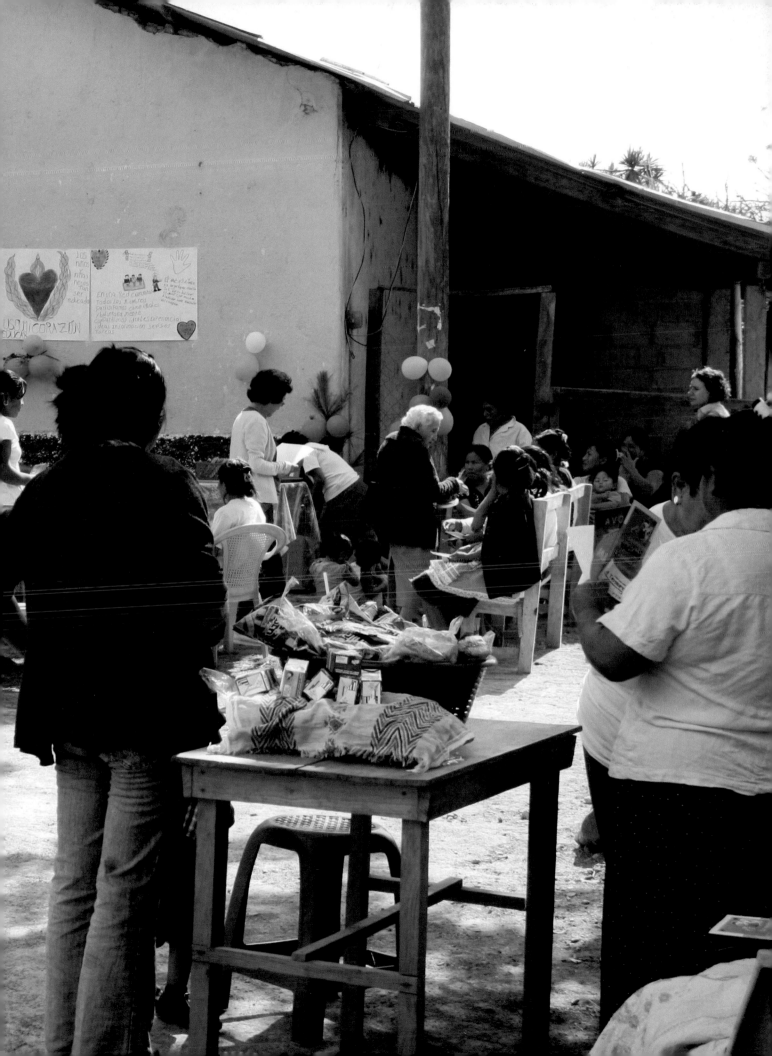

Gloria Marina Lopez De Palma, 66

3 GRANDCHILDREN

Pine needles carpet the sidewalk outside Gloria's house. She has recruited her neighbors to toss firecrackers into the street to greet us. Inside, hand painted welcome posters and palm fronds decorate the walls and more pine needles make every step fragrant. She has transformed our interview into a celebration.

A successful businesswoman, Gloria operates a small store, a *tienda,* in her house. Shelves hold shampoo, eggs, snacks, whiskey, pastries, and food-to-go, which she prepares.

Her namesake granddaughter Gloria, 10, loves to cook with her and today's lunch results from their collaboration: vegetable, chicken, and noodle soup with fresh tortilla chips, salsa, and guacamole, all served on a table with a cloth and bouquet of orange clivia. Gloria's two grandsons and her mother drop by. After lunch, the cat, Coco, and dog, Boomer, keep us company.

Gloria's daughter-in-law, who lives next door, watches the tienda while Gloria shops at the market for ingredients to cook, teaches classes at the

Catholic Church and works at the grandmothers' hotline. "I am busy," Gloria concedes, "but God doesn't chose lazy people." She is such a stalwart Christian that the church plans to give her an award on Saturday.

When I ask her to tell me more about her life, she bursts into tears. She has scars on her hands because her mother punished her, cutting her with the plate she broke accidentally while washing dishes as a child. Today, her mother, 85, "has nothing," Gloria says, "so I am her refuge."

Gloria's alcoholic husband ordered her to leave their wedding but when she started "to get on a bus in my white dress," he threatened to kill her. He beat her often over the next 30 years, and once tried to cut off her hand with a machete.

A priest recommended a separation 10 years ago. Of necessity, her husband now lives upstairs because their adult son is epileptic and Gloria cannot handle the seizures alone. On cue, the husband opens the door and walks silently through the room. She says he never speaks to her, and indeed, he doesn't even glance our way.

After counseling, Gloria forged her own path. "The grandmother workshops also helped me a lot. Now when I see women being mistreated, I tell them, 'Don't stay there; start working; free yourself!'"

Gloria is determined to stop abuse: "I was abused. My children were abused. I will not allow it. Children are our present and our future." Like the other grandmothers, Gloria argues that parents must talk with their sons and daughters, never insult them or use violence to harm them.

Her own grandchildren are polite and friendly. But she confides, laughing, that when she corrects one grandson, he teases her by pointing at the hotline poster on her wall and promising, "I will call this telephone number!"

When I leave, Gloria presents me with a small hand-woven cloth folded into a pumpkin shell, the oldest container in Meso-America. I am moved by her generous spirit, which thrives despite her difficulties.

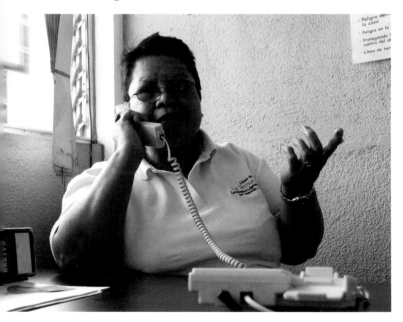

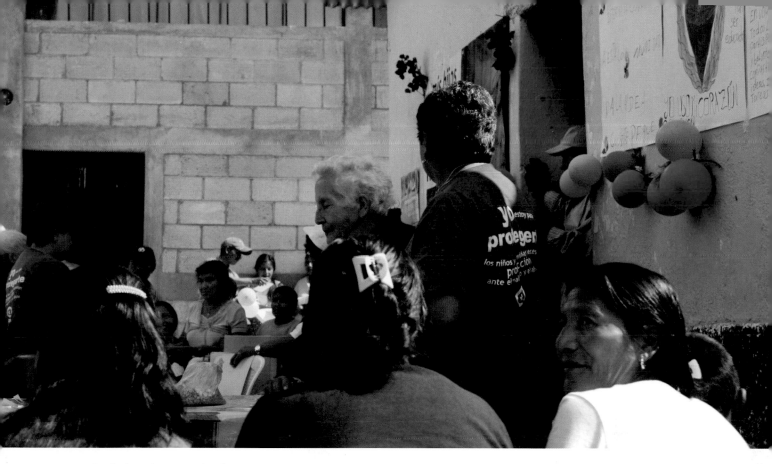

Natividad Agripina Berganza De Berganza, 80

6 GRANDCHILDREN, 3 GREAT-GRANDCHILDREN

One late afternoon, we have a Coke with Natividad. If you don't think grandmothers are courageous, read on:

"I was visiting a young family. I knew the father had killed people in the past. He became very aggressive. His daughter hid behind me for protection. I told him, 'Stop! I will report you.' He grabbed a machete, so I said, 'I will call the police to take you to jail.' Because I always carry fliers, I handed one to him and urged him, 'Read this. You don't have to act like this.' I had been trained. I wasn't afraid."

Born in the department of Jalapa on a *finca* (farm), Natividad describes growing up on "a river where I used to swim at 2 AM. We had horses and I rode sidesaddle wearing a long skirt."

She "always wanted to do something for humanity. When I was young, I visited hospitals to give patients company and a doctor taught me how to give shots, which I loved. When I was 8, I gave everyone shots.

"Long ago," she remembers, "police did not respect human rights; people learned from their bad example. Domestic violence has improved since I was small. People now know there are laws. But sometimes, a man abuses both his wife and children. The wife gets so angry and frustrated that she also abuses the children. It's a cycle.

"One of the problems in doing our work is racism," Natividad reflects. "I notice that people from town are not welcome in indigenous communities in general and in one, I am not liked because I teach that women have the same rights as men. One day, someone threw a stone at me. A policewoman accompanies me now."

Angelita Leticia Orozco De Navas, 65

8 GRANDCHILDREN

We head into a suburb of Jalapa that is under development. Dirt roads cut across dusty, flat earth. We stop by a high, concrete-block fence and enter a security code. The metal gate rolls open.

Inside: a yard full of grass and flowers; a sunny-yellow stucco ranch house; a backyard pond for ducks and a paddock for a pregnant horse. There is a white pavilion where marimba music broadcasts from a boom box and an ornate cage with a talking parrot. This is Angelita's daughter's house. She, her daughter, and 4 grandchildren greet us.

We talk in a quiet room in the immaculate home. A fountain tinkles as Angelita shows her family snapshots. She has a sister in Ecuador, another in Los Angeles, and has visited her son in Boston several times.

In one photo, she is riding an elephant ("Scary! He was so big," she laughs, "and the owner told me that if I touched his ears, it would tickle him so I did nothing!") There are also pictures of her wearing a crown. "We participate in an annual Evangelical retreat. In 2010, they made me Queen of the Year."

Angelita finished only the sixth grade because her mother wouldn't let her continue. She encouraged her own children to study and she proudly shows pictures of her grandchildren winning academic awards. "Sharon, who is 9, just came in second (by two points) in a competition to defend children's human rights. She says that when she is old, she wants to work on the Hotline."

Angelita enjoys sewing and, because she is "incapable of doing nothing," sews during her shift on the Hotline. I ask what kind of calls she has fielded recently.

"A man stood outside the school offering candies and money to little girls, then drove them to his house. We called the police and he is now in jail. We

got a call that a father raped his 7-year-old-daughter. We reported that to the authorities who rescued the girl and put her father in jail."

We move to the dining room table where Angelita serves Orangina, cheese melted on Fritos, and honey graham crackers. "We teach parents to listen to their children, to receive and accept ideas from them. Guatemala has signed the UN's Convention for the Rights of the Child. If parents don't listen, they violate children's rights.

"I am old," Angelita admits, "but I feel young when I do this work."

Maria Salome, 65
3 "GRANDCHILDREN"

Maria Salome always wears white. This afternoon, I ask why. "Because I respect the church. We believe Jesus is there. I like to go to the chapel near the hospital and talk to Him a little and pray."

Her white wardrobe causes her to look so convincingly like a doctor at the grandmothers' good parenting events that I ask her whether people are always afraid of her candy "vaccinations." "I like to get them a little scared," she chuckles.

"When we speak at schools, the first thing I do is advise the teacher about the vaccination. Some of them say 'Ohhhh!' and start to leave because they don't like vaccinations. I tell them, 'Teachers who avoid the vaccination must be mistreating students.'

"When I talk to the students, I ask them, 'Do you want me to vaccinate your teacher and your parents?' Some say 'Yes!' but some say "No," because they are afraid we will harm them. When they see the candies, they say, 'OK! Let's do it! Vaccinate me, me, me!'"

Maria Salome has no grandchildren, but she is considered a grandmother anyway. She raised two nieces. One, a pharmacist, has a 14-year-old daughter; the other, studying forensic medicine, has a son, 11, and a daughter, 17. "Those three children love me as if I were their real grandmother," Maria Salome smiles.

When she was young, Maria worked as a laundress to earn money while she studied to be a teacher. She taught until a spinal illness forced her to retire. Her teaching experience is indispensible when she and the grandmothers educate people to be good parents.

Since her mother lived to be 96, I ask whether Maria Salome ever considers what she might do if she lives 30 more years. She doesn't miss a beat: "I would like to continue working with the Hotline."

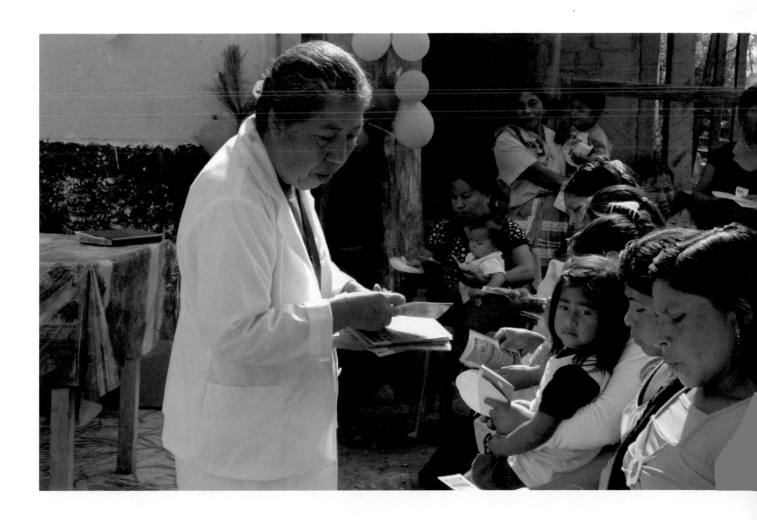

Raquel Gomez Ortiz De Ortiz, 68
VOLUNTEER

Raquel invites Natividad and me to her house in Jalapa one afternoon. We walk through a leafy atrium to a foyer with a vase of yellow roses that are so perfect I touch them to see if they are silk.

She and her husband tore down the original house on this property and built this one 5 years ago. Surrounded by dark wood bookcases that are filled with treasured bric-a-brac, we enjoy Coke and cakes. Raquel's favorite music CD is playing.

Her life was not always so pleasant. "I was 1 of 7 children. My parents used the belt on my brothers and sisters, although I was so quiet that they never belted me. Once my father hit my son; that was the only time that happened. Once, my husband hit our two children; I stopped him."

If these things could happen in her life, Raquel realized they could happen to anyone so she responded to the Hotline flier asking for volunteers 6 years ago and has been part of the grandmother group ever since.

"Recently, I took a call about a woman who locked her children, ages five and six, into the house so she could go to work," Raquel remembers. This kind of behavior, as unacceptable as the beltings she once witnessed, inspires her to donate one week of every month to stop it.

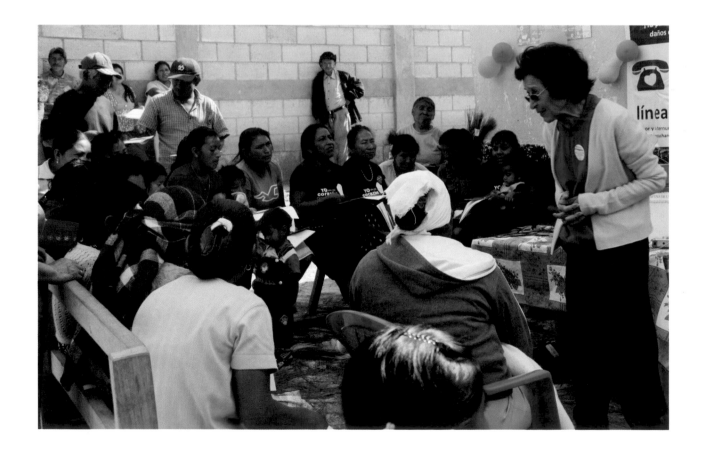

Elvia Marina Aquino Reyes, 75
3 "GRANDCHILDREN"

We sit at Elvia's dining room table drinking coffee. The flowered fabric on the chairs matches the covers on the kitchen microwave, water dispenser, and toaster. Elvia inherited this airy, urban apartment from her mother, and is very proud of it.

She was teaching a class of 115 first graders when the Supervisor of the Ministry of Education asked her to teach English, a language she didn't know. "I studied all night. I would say, 'My mother is Rosa,' and forget it. Then I'd say, 'My mother is Rosa.' Finally I bought a book. Six months later, I was a very good English teacher," she laughs. Her parents died one after the other, so Elvia raised her 4 brothers and sisters and spent her salary to send them all to school.

When they graduated, Elvia went to Los Angeles to work and study more English. For 6 years, she worked as a companion for an elderly couple, and took English classes every afternoon. Then she returned to Jalapa.

After her brother's wife left him, he brought his 6-month-old daughter to Elvia. "He said, 'I want you to be her mother.'" Her niece became the apple of her eye. "That girl now has 4 academic degrees and teaches at the university," Elvia says. "Everything I have belongs to her. She is my legal daughter. I gave her my mother's house. All 3 of her children call me Grandma."

One "grandchild," Fernando Jose, stayed home from school today to meet us. He's 11, and sits at a console in the dining room working on his computer with one hand and hugging his puppy with the other. "The next 'grandchild' is 13," Elvia smiles, "in the second year of high school. The oldest is studying chemical biology at university in Guatemala City. This is my family."

Elvia stays in touch with her teacher friends, which benefits the Hotline. "One told me about a man who raped his 2 teenaged daughters because he wanted to father their children. The girls and their mother were afraid to talk about it. We reported the case to the police."

As she always has, Elvia continues to take care of Jalapa's children.

Fluvia Amarilis Reyes Recinos, 64

5 GRANDCHILDREN

The grandmother volunteers are eating lunch together at the Hotel Casa Real in downtown Jalapa, the restaurant where they first met 6 years ago to hear Plan Guatemala's intention to start the Hotline.

After lunch, Fluvia and Elvia, will attend the prestigious Municipal Child Protection Board, whose members are carefully-chosen, responsible citizens nominated by the Human Rights Office to serve 2-year terms.

Fluvia is dressed for the meeting in a bright yellow t-shirt with a Human Rights insignia, with matching yellow purse and shoes. The color calls out: energy!

Quick-witted Fluvia is always the first in the group to make jokes and to dance. She and Elvia cut the rug after lunch on the first day I was here. She and Gloria launched the dancing after the meeting in Guisiltepeque.

"People see me as the clown," Fluvia told me yesterday. "But inside, I am crying." Fluvia was in a long, abusive marriage but told no one. She honored me yesterday by sharing her story for the first time. "I believe you were sent by God to hear my truth," she told me as she wept. Like Gloria, she is determined that other women and girls will not experience abuse.

At the moment, of course, they do. Fluvia describes a Hotline call about an angry mother who punished her two daughters for ruining some papers by holding the girls' hands in a pot of boiling water. The children were treated for burns and removed from their home. After the mother and daughters had worked with a psychologist "for a long time," the family was reunited. A social worker continues to monitor the household.

I accompany Fluvia and Elvia to the Municipal Board meeting where they discuss strategies to advise and sensitize parents and school children. Their current campaign aims to discourage child pornography videos on cell phones. The committee's work on problems as diverse as teen pregnancy and alcoholism is so effective that other Guatemala departments have copied it.

As we leave the meeting, Fluvia tells me something wonderful about the Grandmothers' Hotline. "Our symbol is the butterfly," she says. "We solve problems so children can fly."

Human Rights: Israel

I arrive in Jerusalem on April 10, 2010, the last day of Passover. Two days ago, a 62-year-old man was forced to wait many hours at the Al-Hamra checkpoint east of Nablus. He became so agitated at the delay that he had a heart attack and died. That's the kind of incident Machsomwatch exists to prevent.

Four hundred grandmothers monitor Israel Defense Forces' behavior at West Bank checkpoints to prevent human rights abuse of Palestinians. Two by two, they observe for five hours every day.

Thousands of Palestinians begin to line up at 4 AM, hoping to get to work on time. They progress through the checkpoints' 7-foot-tall corridors of steel bars that are barely wide enough to accommodate one person.

When Palestinians finally reach the booths where Israel Defense Forces check identity cards and permits, they may find that the soldiers, without notice, have closed their windows. Or that soldiers arbitrarily send them to another line to start over. Or that soldiers detain them for hours without explanation. Some soldiers are verbally abusive. Some simply refuse them entry without explanation.

On Muslim holy days, Palestinians are often denied passage even if they hold prayer permits. In 2006, a soldier at the Qalandiya checkpoint announced over the loudspeaker, "Everyone under 50 should go home. Have a blessed Ramadan."

Israel, which has occupied the West Bank and East Jerusalem since 1967, imposed the checkpoint system 24 years later. Checkpoints proliferated to prevent terrorists from entering Israel and to control movement within the Palestine West Bank. Today there are 39 end terminals, 60 permanent army checkpoints, 500 unmanned street barricades and hundreds of "flying" (truck-mounted, randomly positioned) checkpoints.

Everyday, between 70,000 and 100,000 Palestinians pass through checkpoints to get to school, doctors, and jobs. The largest number, 24,000, go through Qalandiya checkpoint between Ramallah and Jerusalem.

Driving prohibitions, curfews, and the security barrier also curb Palestinians' freedom of movement. They cannot drive on the paved, well-lit bypass roads in the West Bank. If they leave home during curfews, they can be shot on sight. The security barrier, a 470-mile-long, 26-foot-tall concrete wall, cuts off farmers from their fields, villagers from their neighbors, children from their schools, and the dead from burial grounds.

Restrictions on movement have a paralyzing effect on Palestinians' personal and professional lives. The unpredictable closing and opening of the checkpoints, the worry about whether authorities will issue permits, the fear of being turned away at checkpoints despite having a permit all induce feelings of anger, humiliation, and resignation, and feed the rage that leads to terrorism.

The grandmothers stand at the checkpoints and document the experience of sick patients denied passage to hospitals, farmers' products rotting in the heat en route to market, students missing their final exams, bridegrooms unable to attend their own weddings, and babies stillborn while their mothers are trapped in line.

The grandmothers' organization, Machsomwatch, publishes daily reports of abuse on machsomwatch.org, and sends summaries to journalists and Knesset (parliament) members. These reports forecast the long-term statistics. Between 2000 and 2006, 68 Palestinian women gave birth at checkpoints, 35 of whom miscarried and 5 of whom died. Between 2001 and 2004, 991 Palestinians were denied medical access, of whom 83 died.

Soldiers may be too young to make wise, humane judgments, the grandmothers say, since Israeli men and women begin mandatory military duty at age 18. Machsomwatch grandmothers are deeply concerned for the safety and future of Israel's youth. They are also determined to protect Palestinians' human rights.

The word *machsom* means "checkpoint" in Hebrew. The group's members are all Israeli Jewish women who oppose both the occupation and human rights abuse.

Most members are well-educated, retired professionals. Beyond that, they are diverse. Some are in their 50s, some are in their 80s. The 3 Machsomwatch founders were radical members of the Israeli peace camp. One founder was orthodox although some current members are secular. Some are Zionists. Some lost family members in the Holocaust.

Many, like Dana Olmert, daughter of former Prime Minister Ehud Olmert, come from highly respected families. Some served in the military. Hanna Barag was secretary to Moshe Dayan when he was Chief of Staff of the Israel Defense Forces.

The grandmothers, like observant Jews everywhere, teach their grandchildren to "repair the world," fight prejudice and injustice, and treat others as they would want to be treated. Those moral values inspire the grandmothers' behavior. "Ethnic persecution and genocide must never be allowed to happen again, not just to us, but to anyone," writes Yehudit Kesher, a Machsomwatch founder.

Some Machsomwatch members' names are on a right-wing groups' Internet lists of Jews who are Self-Hating, Israel-Threatening (the acronym tells you what these critics really think). Members of the right-wing organization, Women in Green, call Machsomwatch grandmothers "Judeonazis."

Impervious to such insults, Machsomwatch holds the Israeli military accountable to the citizens who pay their salaries and has won grudging acknowledgement from Israel Defense Forces' top brass. Shlomo Dror, spokesman for the Israeli Defense Ministry, said, "We found there are things we can change and make better."

Thanks to Machsomwatch, IDF soldiers are now trained to use respectful behavior when dealing with Palestinians. In some checkpoints, an emergency hotline now provides humanitarian assistance and there are drinking water taps, bathrooms, shade, and areas where Muslims can spread prayer rugs when the muezzin calls.

But making the checkpoints nicer is not Machsomwatch's goal. The grandmothers will only be satisfied when the occupation ends. A brave minority, they hope that by showing Palestinians there are other types of Jews besides the soldiers and settlers whom Palestinians see most often, they will have contributed to peace.

In 2004, Machsomwatch was awarded the Emil Grunzweig Human Rights Award by the Association for Civil Rights in Israel, for "their remarkable activities at a time of general indifference and waning sensitivity to the human rights of Palestinians."

They also received the 2010 Hermann Maas Medal. A senior member of Germany's Bundestag (parliament), Ruprecht Polenz, presented the award and lauded Machsomwatch women for resisting injustice even in the face of death threats.

Israel's oldest newspaper, *Haaretz,* published an editorial on International Women's Day 2006, naming Machsomwatch "the state's pride."

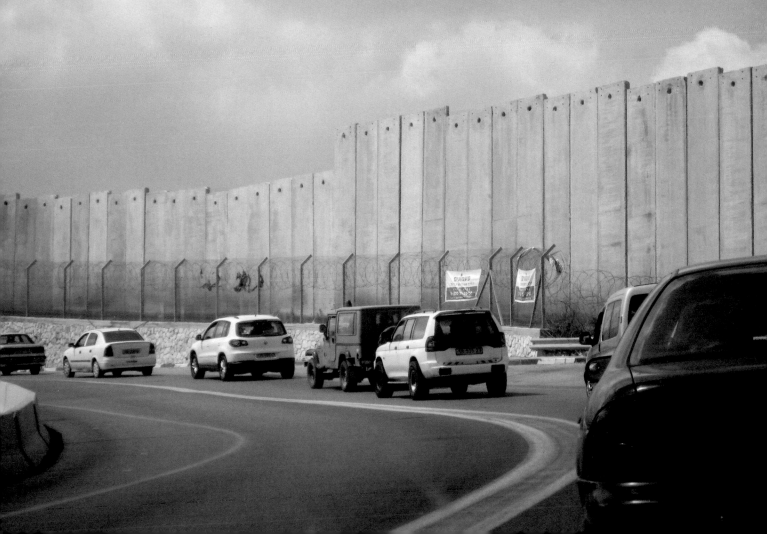

Hanna Barag, 75
5 GRANDCHILDREN

Hanna welcomes me to her German Colony apartment in a 3-story building where white geraniums cascade from the roof. Her grandchildren's playhouse sits in the garden. She stashes a baby seat in the trunk and we drive off to the checkpoints. I invite Hanna to tell me about her life and work with Machsomwatch.

She was born in Haifa to parents who emigrated from Germany. "I am the daughter of a working mother and working grandmother. I had my own conference-planning firm. I was divorced after 45 years of marriage to a professor and the second Intifada ruined my business, so I had time and could do what I liked.

"I worked part time for a feminist organization. A woman there said, 'I went to the Qalandiya checkpoint.' I came to Machsomwatch in December 2001. We were 40 women and there were 2 checkpoints, Qalandiya and Checkpoint 300 near Bethlehem. This was at the start of the second Intifada. People got killed right at my corner. We said, 'Violence brings violence. People should consider something else: less violence.'"

Hanna remembers, "A famous journalist wrote about us: 'These women go to all these dangerous places and are not frightened.' Who knew about the checkpoints? Everyone thought they gave us security. Elderly women, grandmothers, who go out and don't feel frightened? That was very sexy. So the journalist wrote about these crazy women. The next day 200 women wanted to join us.

"I was a shift organizer. 'I can go Tuesday.' 'I can go Wednesday.' 'Next week I'm going abroad.' We went in pairs to 40 checkpoints twice a day all over the West Bank. With 400, I couldn't organize it any longer. So we divided the checkpoints geographically. The group from Tel Aviv covers the center all the way to Nablus. The Jerusalem group covers this area. We have a southern group that covers Hebron and the South Hebron Hills. A northern group covers the Jordan Valley.

"We started talking to the people who are giving the orders. This is my special thing, the connection to the army in particular. It gave an opening for interventions we could not do on the spot with soldiers. In July, 95 degrees, standing there with no water, we could call the commander and say, 'Why is the checkpoint closed? Open the checkpoint.' We would complain, 'Why are there no toilets? Why is there no roof? Why don't women have a special queue?'

"The real ruler of the West Bank is not the army. It is the secret service, which has blacklists. All Palestinian men between 6 and 66 are, have been, or will be, on the list. Nine out of 10 are on the list just because their name came up. This is a big project of ours. Fifteen women work all day long to help people appeal to get off blacklists.

"We also have daily dealings with the civil authority, which gives out permits. The permit system is crazy. People who need to come through checkpoints every day carry a revocable permit for 3 months. They can come in at 5 AM and they have to be out at 7 PM. Your Israeli employer gets the permit, not you. Can you imagine how much corruption there is around these permits?

"Another thing we do: go to the military courts and observe. Have they done enough translation? Have the Palestinians seen a lawyer before they come to court? We write down everything that happens. It is not easy but to my mind, it is not a small thing. The process is not hidden any longer.

"We still work at the checkpoints. We are a tiny, hated minority doing something that in Israeli society is very difficult: talking about the soldiers. Everyone says, 'My child would never do such a thing,' but somebody's child does it! We don't publish or talk about anything we haven't seen.

"I believe 100% that we are making a contribution. When I get home, I have sleepless nights. I walk the corridor and tear my hair. I say, 'Nine years of my life!' In a way, I am being a social worker of the occupation, helping it become more humane. I didn't come here for that. Then I think of one person we've helped, and think, hallelujah, one less to suffer!"

As we drive past the dry, stony fields of the West Bank, Hanna tells me about a turning point in her life. She "met a 24-year-old Palestinian man whose son

was born with cancer in his eyes. When the boy was a year and a half, his grandmother took him to Jordan and one of his eyes was removed."

Hanna continues, "The father was working illegally in Hebron when a friend asked him to take a car to a Palestinian garage. Palestinians are not allowed to drive a car with Israeli license plates, so the father was blacklisted.

"Where was the mother? She was a Palestinian evacuated to Jordan. The Israeli embassy in Jordan gave her a limited visa to come home for a few weeks. But this woman didn't come for a visit; she came to marry this man. She became stateless because she overstayed her visa. She was a prisoner in her own house.

"The boy's cancer reappeared. The father turned to me, 'There is only one eye hospital. It's St. John in East Jerusalem. I am restricted and my wife is not allowed to leave the house.'"

Hanna pulled every string she could to get the boy to St. John Eye Hospital. Finally, with the help of a supportive right-wing member of Parliament, she got permission for the boy's grandmother to take him on a one-day permit that lasted from 5 AM to 5 PM.

The grandmother and child had to enter from an area in Bethlehem where Machsomwatch couldn't go, so Hanna arranged for some Christian human rights activists to escort them.

"We gave them money from our own pockets to take a taxi to the hospital. The doctor looked and said, "This is not a case for us. Take him immediately to Hadassah Medical Center.'

"While they took a taxi, I called a Machsomwatch member who works at Hadassah and asked her to translate since she speaks fluent Arabic. The doctor there said, 'This is going to take a few days.' The grandmother's permit ran out at 5 PM so she was hysterical. I phoned, got her 4 more days, and faxed her the new permit.

"The drama never ends. The grandmother was there 3 days. No hospital is obliged to feed a grandmother, so we fed her with money from our own pockets.

"The doctor said, 'I need to see the parents." I could not get the father from Hebron to the hospital so the doctor said, 'The best thing I can do is write a letter to the hospital in Hebron.'

"Now the Christian volunteers, the grandmother, and the child go by taxi to Hebron. No! The grandmother has a faxed permit. Not acceptable. No taxi driver will take her. Luckily, at home I have the

mobile number of the head of the border police. He gets them across. They see a doctor in Hebron and a few days later, the child dies. It was all too late.

"I made the mistake of my life. I went to pay condolences. The father, in very good Hebrew, said to me, 'Tell me, Hanna, what have I done that I couldn't take my child to see the doctor in Jerusalem? Maybe the child would have died, but at least I would have seen the doctor and heard it from his mouth. He would tell me the chances for future children. I would have felt I had done for my son what every parent would have done. Why did I deserve this? I did a favor for a friend, drove 300 yards, and I couldn't take my child!'"

Hanna says, "I came home and got a psychosomatic illness: recurrent herpes in my eye." Indeed, one of her eyes is visibly impaired.

Ironically, she and I are about to meet someone else with a severe eye problem.

We have reached the Qalandiya checkpoint. Hanna puts on a nametag that identifies her as a member of Machsomwatch in Hebrew, Arabic, and English. We enter the littered hangar.

As soon as we approach the steel bars of the checkpoint, a Palestinian woman named Manar notices Hanna's nametag. She and Hanna speak in English through the bars. Manar has been denied access and cannot get to St. John Eye Hospital in East Jerusalem for the annual check-up of her glass eye, which she got four years ago after an Israeli soldier shot her.

Hanna explains to me quickly, "Being injured by the IDF has two consequences: it qualifies you to see an

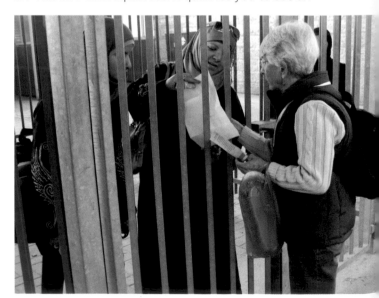

Israeli physician and it gets you (and everyone in your family) blacklisted to prevent potential retaliation." Catch 22.

Patients are allowed medical escorts, so Manar is accompanied by her 14-year-old daughter, Non, who has no permit (none are required until age 16). A few minutes ago Manar showed Non's birth certificate to an IDF soldier who said that a child's name must appear on a mother's permit.

"I never heard of that!" frowns a skeptical Hanna, swinging into action. She calls the IDF Health Coordinator of the West Bank and speaks in rapid Hebrew. When Hanna hangs up, Manar and Non have permission to pass through the checkpoint. We watch them walk past the exit sign that reads, "We wish you a safe and pleasant transit."

A man requests Hanna's help. He is a Palestinian laborer who has a permit to work at a settlement. (The Palestinian Authority estimates that 12,000 Palestinians do construction work at settlements). He found a better job but has been denied access through the checkpoint. Hannah says, "I will ask, but I am not optimistic." She's right: the man must apply for a different permit.

We drive north on Highway 60 past checkpoints and settlements. Hanna pulls off near Ramallah to show me a map. Across the field is a VIP Checkpoint used by Palestinian officials. I can see soldiers inside the observation tower. As soon as we stop, a jeep pulls up. An armed soldier jumps out and asks for Hanna's ID. "Move on," he commands, "It is not safe here. You might be shot."

We drive through Beit El, a Jewish settlement off Route 466. Like all settlements, Biet El exists in violation of international law. But housing Israeli Jews on land occupied since the War of 1967 has been the practice of Israel's government, which considers settlements legal. As of 2010, more than 500,000 people lived in 121 official settlements in the West Bank, East Jerusalem, and the Golan Heights. There were also 102 unauthorized settlements. Large settlements may have populations of 45,000, but Biet El has about 5,000.

The Beit El settlement began in 1977 when settler families moved into an IDF military base; it is still

guarded. Red-tile-roofed, white stucco houses and well-watered lawns sit on the top of a hill. Settlers' homes look expensive but owners get reduced rates as an incentive to move here. Residents are orthodox so women wear long skirts and headscarves; the men wear *peyos,* sideburn curls.

Hanna's cell phone rings repeatedly as we drive. It's clear that she is the go-to grandmother when other Machsomwatch members need her to exercise the military connections that she has maintained since she worked with Moshe Dayan.

Hanna explains, as we pass a fancy village, "Palestinians who live in the United States and want a foothold in Israel come here in the summer." Most other Palestinian houses that we see from the road are decrepit.

Near Shiloh, the religious capital of Israel for 300 years before Jerusalem, a synagogue tops a hill full of settlements. Hanna reports, "Settlers burned Palestinian's olive trees here."

As if on cue, her phone rings and she is asked to negotiate approval for a farmer to cross the Green Line to harvest his olive crop. "Very difficult. I will try," she promises. "What can they say but no."

Hanna points to a white house near the road. "The army took over that house. We got the soldiers out and made them clean it. We helped white wash the balcony. Then we had a party to welcome the Palestinian owners with baklava and coffee."

Tapuah is "violent settlers land," Hanna explains when we get to the junction of Route 505. "How did we survive seeing terrible things week after week,

Dana Golan, 27

Dana is Executive Director of Breaking the Silence, which is conducting a tour of Hebron for a busload of 17-year-old students from three military academies in Jerusalem.

Breaking the Silence is an organization of veteran combatants that stimulates public debate about young soldiers' controlling the Palestinian civilian population's daily life in the name of Israel's security. Testimonies from 700 soldiers and officers document that abuse of Palestinians, plus looting and destruction of their property, are standard IDF operating procedure.

We cross the Green Line into East Jerusalem, then enter a tunnel that only Israelis are allowed to use even though the mountain above it belongs to the Occupied Palestine Territories. Near Hebron, goats and donkeys roam the fields that are no longer accessible to Palestinians. Soon, I glimpse the Tomb of the Patriarchs.

Jewish settlements started in Hebron in 1968 when some Israeli Jews were given permission to celebrate Passover in the city, then refused to leave. Today, downtown Hebron (Section H2), has 30,000 Palestinian residents plus 800 Jewish settlers with 500 IDF soldiers to guard them.

Dana reports, "Our bus now has an Israeli police escort front and back for protection." How ironic: Israeli police shielding a bus-full of IDF officers and Israeli military students visiting territory occupied by Israel, threatened by Israeli settlers.

As we step off the bus, we are surrounded by a ring of Israeli police in blue uniforms who are, in turn, surrounded by a circle of Israeli soldiers in green, all of whom accompany us.

No Palestinians are allowed on Al-Shuhuda Street, even though their houses front on it. The IDF sealed all front doors shut with sheets of steel. Although some of the houses have been abandoned, residents who still live here must exit via their back doors or over their rooftops.

The street, which used to be a vital marketplace, is now bullet-pocked and abandoned, its awnings in shreds, its windows broken. Eighteen hundred shops have closed. Yesterday I visited Machaneh Yehuda market in Jerusalem, which was brimming with fresh fruit and vegetables, pickles and cheese, fish and poultry, bread and cookies. But here, shop doors are nailed closed.

day and night?" she says. "People handcuffed, beaten. Soldiers wear bulletproof vests. No one but soldiers, settlers, and us here. How did we manage not to get cold feet? Twice in 8 years, we saw explosives but the papers said there were terrorists every day."

Hanna parks and we watch Palestinians, forced to empty everything from their car, stack their belongings on the pavement.

We pass a flying checkpoint and proceed to Hawara, two minutes south of Nablus. Two weeks ago, Israel Defense Forces here killed two Palestinians, aged 16 and 19, who were defending their families and property from settler gangs' attacks.

"For seven years, I came here every Saturday," Hanna reflects. "We crazy women. We must be out of our minds. This was the most violent place we watched. Now the violence here is from settlers: they burn things, cut tires, throw stones, even attack the IDF."

Hanna warns me, "Hebron is Hell. You don't want to live in Hebron, believe me." I don't plan to live there, but I have arranged to visit that city with Dana Golan, an ex-Israel Defense Forces officer who served there for seven months. I want to hear a soldier's side of the story.

A Palestinian woman peeps at us from an upper window that's covered with camouflage netting. A child in a side doorway darts inside when he sees us.

I consider my own country's role here. Almost certainly, the soldiers' uniforms and M16's are supplied by the United States. And many settlers are from the U.S. Dana says, "In radio comedy shows, actors speak with American accents so listeners will understand that they are settlers."

Is that screaming settler who is brandishing a Nikon D7000, an American? Four other angry settlers with cameras join him. Breaking the Silence's videographer hauls a TV-size camera on his shoulder.

Dana explains, "Breaking the Silence has been the target of so much settler violence—stone throwing, egg throwing, and harassment—that we filed a case against them, which is now in the Supreme Court." Both sides will have photographic evidence if there is an incident today.

Dana notices a settler wearing a button, "Kill 'em all. Let God sort it out." She was stationed in Hebron during the Second Intifada, the Palestinian uprising that began in 2000 after Ariel Sharon, then a candidate for Prime Minister, entered Jerusalem's Temple Mount, the site of the Al-Aqsa mosque.

Dana remembers, "In November 2002 some of my soldiers were killed. Nine months of curfew followed. I remember it like yesterday."

We are to visit a Palestinian, Issa Amyro, founder of HEB2 TV, which documents daily life in this neighborhood. Suddenly, the police stop us and demand a permit. Dana and Yahuda Shaul, founder and co-director of Breaking the Silence, negotiate with the officers. After 15 minutes, Yahuda elects to use a shortcut. We follow a path, accompanied by the very police who stopped us but who now cannot let us wander alone. We traipse through an orange orchard, a rose garden, an olive grove.

Dana remembers other visits to Palestinian homes in Hebron. "We used to conduct midnight raids on Palestinian's homes searching for weapons. We would wake the family and while they watched, empty every drawer onto the floor."

I wonder what life is like for soldiers at the checkpoints. "Female soldiers at checkpoints sometimes do internal searches of Palestinian women's bodies and have gloves for that."

I ask Dana, "How do people respond when you describe these situations?" Dana leans forward, "Some shrug and say, 'war is Hell' but I remind them, 'This is not war. It is occupation.'"

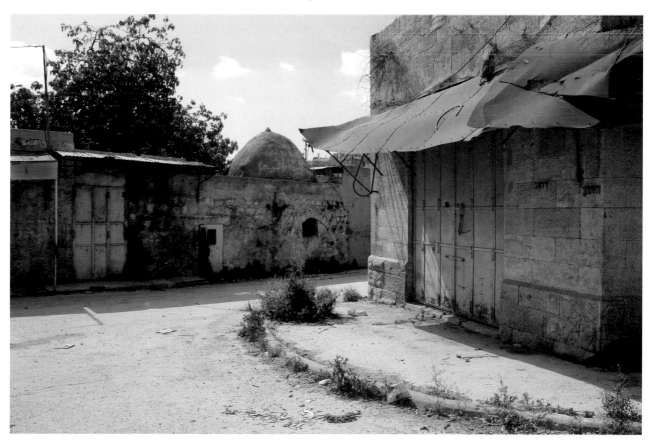

Daniela Gordon, 67
2 GRANDCHILDREN

Back in Jerusalem, I meet another Machsomwatch grandmother, Daniela, in a coffee shop. As she stirs her latte, she reports, "My car was stoned by settlers in Ramallah because I was driving on Shabbat" (the day of rest). Not seeing any police who could help her, she says, "I drove on."

Daniela's grandparents came to Israel in 1936; her other grandparents died during World War II. "There is a Hebrew saying on graves of those who couldn't escape the holocaust: 'They perished.' My mother said, 'They didn't perish. They were murdered.'

"We also have a saying in Hebrew, 'Certain things happen because a friend joins a friend.' A friend I went to school with, also a psychologist, was in Machsomwatch and said, 'Give it a try.'

"Suddenly I was on the outskirts of Jerusalem. I hadn't had much contact with Israeli or Palestinian Arabs and I said, 'Good Lord, I hope these women know what they are doing; I am in the middle of Arab land.' It was the one time I felt a little apprehensive. But the Palestinians smiled at us, greeted us. It didn't take long.

"I found you can help people just 20 minutes from where you live. Checkpoints are the symbol of the occupation and what it does to people's education, health, and livelihood.

"Between 2005 and 2007, I was the Machsomwatch district coordinator for Jerusalem. Even though the Israel Defense Forces claim that conditions are better now, they're not. Some West Bank checkpoints have been eliminated. Some places, checkpoints have been abandoned but in two hours, they can be operative again. Thousands of people still come at 3 or 4 AM. There are still lots of stone barriers so you have to make huge detours."

I ask Daniela if she has her family's support for her work. "My daughter identifies with me completely and in about 4 years when my granddaughter is 10, I think she will understand. Women use intuition based on experience more often than men do; I think that's why women understand and have compassion. My sons and husband are not as radical as we are. My in-laws are a rightwing family. I like them a lot but we don't talk politics.

"Machsomwatch ranges from very radical, post-Zionist attitudes to those who are for one state, which I dread. My friends and I are Zionists and want a state for the Israeli people. Two states. There are mornings I wake up and say, 'All our attempts are futile, there is no hope. For the future of my grandchildren, I should send them away.'

"On the other hand, I love this country. I was born here. I think we have a right to be here. It means nothing to me that we were here in biblical times though. It would be fine with me if Israel were in Uganda...move the whole country somewhere else (with this weather, by the way).

"But there has to be a place that's safe for Jews to be together, the sons and daughters, grandsons and granddaughters of the people who were murdered—not perished—during the holocaust."

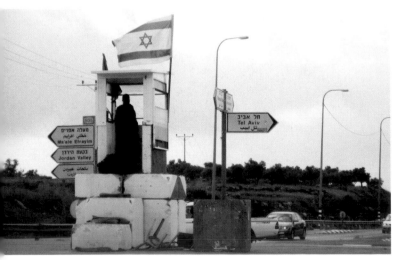

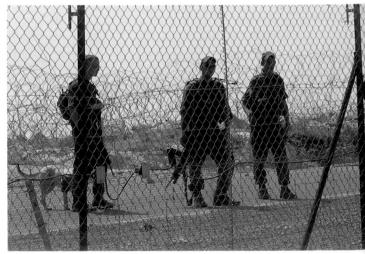

Photo by Rob Sangster

Ronny Pearlman, 66
3 GRANDCHILDREN

Ronny takes me to the Friday afternoon demonstration in East Jerusalem where protestors are objecting to the creeping expropriation of Palestinians' property in Sheikh Jarrah. There, 120 houses are scheduled for demolition, to be replaced by a settlement that will house 200 Jewish families.

Evicted Palestinian women embroider while standing on the sidewalks in front of their old homes. Their families sleep in tents pitched in what used to be their backyards. Local activists, progressive Israelis, soldiers, and police are out in force.

After the demonstration, Ronny chides a policeman, "Don't you think it's ironic that three hours ago you wouldn't let me walk here but now it's OK?" The man is nonplussed.

We have coffee and cookies in a hotel garden where a fountain splashes and birds sing. "All the things I will tell you helped me develop into a person who is very sensitive to the issues of freedom and justice," Ronny promises.

Ronny's father, a lawyer from Czechoslovakia and her mother, the daughter of a wealthy Viennese family, came to Israel as refugees from the Holocaust. Ronny was born in Jerusalem. Her family returned to Europe in 1947 and she grew up in Moravia "in the house of my grandmother and grandfather, who perished in Auschwitz.

"I always had a distinct and high Jewish consciousness. With Einstein, Franz Kafka, Marx, Rosa Luxemburg, musicians and painters, I was very proud of being Jewish. At age 12, I won a poetry competition for reciting a poem about Teresinstadt; the poem moved me deeply.

"I came back to Jerusalem after I graduated from university. I said to two Czech girls I met in the airport, 'Girls. We have to learn Hebrew—and in a kibbutz, they would give us food.' So we went to Golda Meier's kibbutz.

"I was starry-eyed walking around Jerusalem and Hebron. I thought 'Isn't it wonderful; there are Jewish and Christian and Muslim people here. That's the way it should be.'

"Later, I married a South African and spent 1970 in Cape Town. I was totally against apartheid. When we came back to Israel, we went by car from Bathsheba to Jerusalem. There was a checkpoint at the entrance to Hebron and the white people drove past, but the black people were checked. It didn't sit well with me." I interrupt her, "You saw the Jews as white and the Arabs as black?" She nods yes.

Ronny worked as an academic advisor to Palestinian students at Hebrew University. "I learned a lot. In its fervor to get the old city, the Western Wall and Temple Mount, Israel made all the villages around Jerusalem—into Jerusalem. Today, 270,000 Palestinians have the same ID card I do. They are called Permanent Residents and enjoy all the rights except an essential one: they can't vote in Parliamentary elections."

Today, Ronny is a practicing psychotherapist and still runs the women's clinic she founded— a background that helped when she joined Machsomwatch and later became Coordinator for Jerusalem.

"I am politically aware, which makes my life very difficult," she admits. "I have paid a price in intimacy with my sons who don't discuss Machsomwatch, which I care about so much. They are officers in the Israeli army. One is 38 and one is 35; they will be in the reserves until they are 45. Because they are psychologically well adjusted, they think it's important to be in the army. That is what 'psychologically well adjusted' means in Israel: you want to protect your country against the enemies you see on television every day. I am full of sadness watching this in Israeli society and my children."

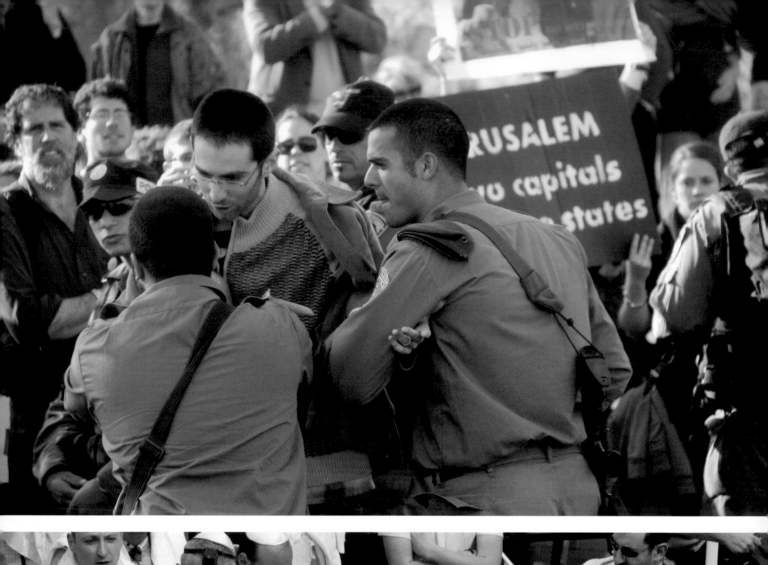

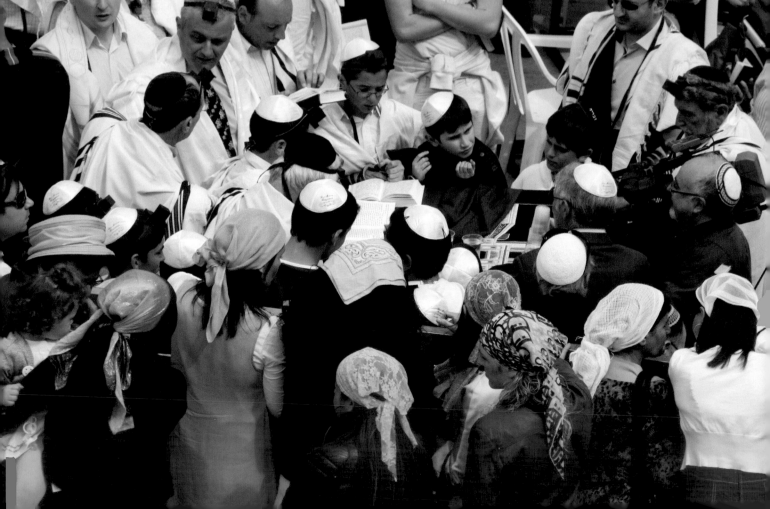

I ask Ronny how she deals with detractors' criticisms. "I am not an Israel hater. My Jewish values make me politically active. I am not saying everything is fine on the Palestinian side. All I am doing is trying to fix what's happening here that is wrong.

"I go to Qalandiya for a whole morning once a week. I will not stop. I am expressing active opposition to the occupation. It satisfies me that I am not a passive bystander. I try to send a message that there are many of us who oppose occupation. If and when we live in peace with the Palestinians, I will definitely be able to say that I contributed. And if that doesn't happen, I will have done my best."

I inquire, "Will your grandchildren live in peace?" She smiles, "No political scientist can predict jumps in history. I was convinced that Czechoslovakia would never be free. In South Africa, apartheid wouldn't have ended without constant opposition and without Mandela."

On International Holocaust Day last January Ronny went to Germany to accept the Hermann Maas Medal for Machsomwatch. "They played Joan Baez's song, *Jerusalem*," she remembers.

I reflect on that song's lyrics: "I believe there'll come a day when the lion and the lamb will lie down in peace together in Jerusalem. There'll be no barricades then, and there'll be no wire or walls. We can wash all this blood from our hands and all this hatred from our souls on that day all the children of Abraham will lay down their swords forever."

Ronny carries snapshots of her grandchildren in her purse, among them, a picture of her four-year-old grandson, Shahar. "We just celebrated Passover, the celebration of freedom, the exodus from Egypt. Shahar told me, 'I don't want to hear this story. I hate all the blood and violence.'

"I told him, 'Shahar, there is good news. You don't have to worry, this is an old story. The Egyptians and the Jews sat down and wrote a letter to each other that said we will never hit each other. We wrote a letter and we signed it. Since we wrote that letter, we go to the beach and look at the fish in Egypt. That's what we have to do with people who fight with us. Sit down, talk about it, say you won't do it anymore. Write a letter, sign it, and say never again.'"

It's Thursday morning. Near the Dung Gate to the Western Wall musicians are playing shofars and there is joyous dancing. Crowds of Jewish families prepare for their sons' Bar Mitzvahs, their picnic baskets full of food to share afterwards in celebration.

Immediately above the Western Wall on Temple Mount, hundreds of Palestinian children on school trips sit in the shade drawing pictures of the Dome of the Rock.

So near to each other, these children. And so far.

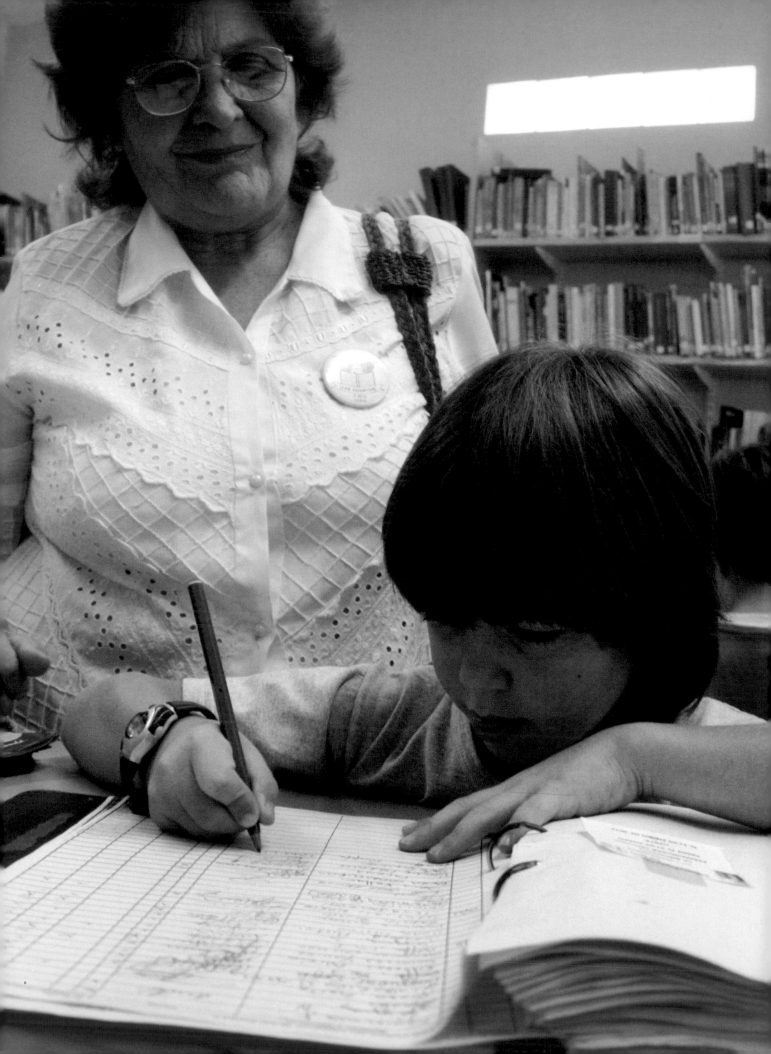

Education: Argentina

It was a great day when UNESCO named Buenos Aires "World Book Capital 2011" to acknowledge the city's efforts to promote reading. To celebrate, artist Marta Minjuin stacked 30,000 books to make a tower. The volumes, contributed by 56 foreign embassies, were donated to the city's new multi-lingual library when the display was dismantled.

Minjuin created her first tower of 30,000 books in 1984. Democracy had just returned after seven years of a military dictatorship that banned books, even St. Exupery's *The Little Prince*. When that display was dismantled, the books were distributed free to a public that was starving for literature and ideas.

General Jorge Rafael Videla, head of the military junta, believed, "A terrorist is not just someone with a bomb or a gun, but also someone who spreads ideas that are contrary to Western and Christian civilization." In his view, many writers, especially Argentine authors, did exactly that. The government burned their books.

In 1976, Biblioteca Popular Juan Juares, the library in Lujan, was boarded up by its founders who paid an armed guard to protect its books.

Offices of daily newspapers were bombed. Journalists were imprisoned. Authors were kidnapped, held in detention camps, tortured, then murdered.

Haroldo Conti disappeared on May 5, 1976 and was never seen again. He is honored on The Day of the Buenos Aires Writer.

In 1977, Rodolfo Jorge Walsh was murdered in the street. Considered the founder of investigative journalism, his Clandestine News Agency had chronicled what would become 30,000 disappearances.

Writer Mempo Giardinelli was 29 that year. His new first novel described the exploitation of poor laborers in his home province, Chaco, in Northeastern Argentina. His book was one of millions that were incinerated.

Despite the country's 97% literacy rate, the highest in Latin America, people stopped reading. Giardinelli, now 64, recalls, "The dictators changed totally, the role of books in society. If you read, you were suspicious. Perhaps the worst long-term effect of the dictatorship was its impact on reading."

Little did Giardinelli realize that he—and several thousand grandmothers—would reverse that impact.

After living in exile in Mexico for nine years, Giardinelli returned to Argentina in 1984. Over time, he wrote 40 books. His novels, stories, and essays were translated into 20 languages.

He received Spain's prestigious Grandes Viajeros Prize; was the first foreigner to win Mexico's National Book Award; and was given Venezuela's Romulo Gallegos International Novel Prize, the most important literary award in the Spanish-speaking world (Mario Vargas Llosa and Gabriel Garcia Marquez won previously.)

Ultimately, Giardinelli returned to his birthplace, Resistencia, and launched the Mempo Giardinelli Foundation, whose mission was to improve conditions for poor, primarily indigenous, people who were plagued by illiteracy.

Giardinelli gave his personal collection of 10,000 books to the Foundation and set an ambitious goal: "to stimulate reading, create new readers and improve literacy."

The idea for this program began to percolate when Giardinelli visited Germany and saw hospital volunteers reading to terminally ill patients. "I thought they might be reading the Bible," he remembers, but to his delight, he discovered they were reading literature to provide diversion and solace.

He decided, "Instead of helping adults die peacefully, I will help children live well." He and his sister, Lerida, invited educated older women to read to children whose families were so poor they had no books.

Children learn to love books and reading, thanks to Storytelling Grandmothers who visit classrooms all over the country.

"Success was immediate," Mempo remembers. Children were not only inspired to read but to go to school.

In the late 1990s, he married journalist Natalia Porta Lopez, whom he had hired as Program Coordinator for the Foundation's groundbreaking program, the Storytelling Grandmothers.

"The Storytelling Grandmother is symbolic," Natalia explains. "Anyone interested can take on this role, women or men of any age." In reality, most Storytellers are educated grandmothers in their 50s, 60s, and 70s.

By evaluating every reading session, the Foundation learned that the Storytelling Grandmothers bring to classrooms what some teachers don't: unconditional affection for children, books, and reading. Natalia Porta Lopez says, "This is our secret formula: affection plus high-quality literature equals children who read."

Slowly, the Foundation rolled out the Storytelling Grandmothers program to cities across Argentina. They provide grandmothers with a list of age-appropriate books: classics and contemporary works, myths and legends, with an emphasis on Argentine and Latin American authors.

Each grandmother is assigned a preschool, primary, or secondary school, where, over time, she builds a strong relationship with the children. The grandmothers also visit orphanages, libraries, book stores, and children's hospitals. Sometimes, they read to illiterate adults at soup kitchens, nursing homes, geriatric wards, prisons, and institutes for the blind, but 90% of their work is with children.

The Storytelling Grandmothers are revitalized by their gratifying, meaningful work. School children anticipate their visits eagerly and greet the grandmothers with joy both in classrooms and out. The Storytelling Grandmothers program in Argentina currently includes about 70 volunteer groups, a total of 2,000 grandmothers.

In 2009, Argentina's Ministry of Education incorporated the idea into the national education system. A Mempo Giardinelli Foundation staff member works with the Ministry and coordinates the national Grandparents' Story Reading program.

Natalia Porta Lopez reports, "We won an international prize from the Ibero-American States and another from UNESCO, which realized the program could be replicated in other countries. I wrote a complete guide about how to organize groups and carry out activities."

By 2011, Storytelling Grandmothers programs were underway in Colombia, Ecuador, Guatemala,

Mexico, Peru, Venezuela, and Spain. Even Richmond, Virginia has a group.

The Foundation monitors the results of the Grandmothers' work and reviews their reports. Every six months, the Foundation interviews the local person who has the most daily contact with the children. One librarian reported that since the Storytelling Grandmothers started working in her school, the number of books students checked out had quadrupled.

Not only is the program effective, Natalia says, "These women become local celebrities. They're called for press interviews, asked by school directors to sit by them at important presentations, called to judge competitions. And they all tell me the same thing: 'I am always seeing children who call out: Grandmother! Grandmother! Grandmother!'"

Natalia laughs, "I feel like the Queen of the Grandmothers!" But, she turns serious, "There are lessons to be learned. First, how much can be contributed by retirees. And second, how much affection affects learning."

It's hard to tell how much of Argentina's re-engagement with reading results from the work of the Storytelling Grandmothers because other reading initiatives have built on their work. The Mempo Giardinelli Foundation put children's books in pediatricians' offices. Then the government gave each schoolchild three books to seed a home library. Now, The Argentine Free Book Movement encourages readers to leave used books on park benches and buses with notes saying "Read this and pass it on."

There is no doubt that reading is popular again. In 2011, a million and a half people attended the annual International Book Fair in Buenos Aires. The number of books published in Argentina, which had dropped to half the 1950 level, is increasing again. In the nation's capital alone, there are 200 bookstores, 70 private and public libraries, plus numerous literary magazines, journals, and book publishers.

But best of all, school children are learning to love books again. The Storytelling Grandmothers continue to contribute more than anyone could have imagined.

Interviews

Storytelling Grandmothers are waiting for me in Lujan, 35 miles northwest of Buenos Aires. But the driver has no idea where to pick up my interpreter, who lives 15 minutes from my hotel.

Without GPS, map, or cell phone, the driver yells "Consulto!" at a man doing his morning constitutional, at a woman walking her dogs, at taxi drivers stopped by a traffic light. He dutifully follows everyone's

conflicting directions. Powerless without Spanish, I decide to count the "consultos." Fifteen. So far.

Finally we find Jane and head out of town past green fields with cows and weeping willows. The twin steeples of the Lujan cathedral come into view, the site of the annual pilgrimage that draws a million people to honor Argentina's patron saint.

Even though we are late for our appointment, the driver stops for consultos with several street sweepers, plus the drivers of an earthmover and an electrician's truck. At last we arrive at the designated coffee shop, which is overflowing with grandmothers and local journalists who have been alerted that the grandmothers will be in a book. The Storytelling Grandmothers are rock stars!

Over the next week, I follow these grandmothers everywhere. Because I have arrived during school vacation, they mobilize their own grandchildren so I can take pictures. We walk to the Lujan Biblioteca Popular, the library, where they do a reading; to the local bookstore, the Libraria de Mayo; to the park, where one little girl volunteers to read to the grandmothers instead of vice versa. The boys and girls follow the Storytelling Grandmothers as if they were Pied Pipers. And so do I.

Maria Esther Allende, 71
5 GRANDCHILDREN

Among the first volunteers when the Storytelling Grandmothers group started in Lujan in 2004, Maria Esther has been their Coordinator for the past four years.

Leadership is in her blood; she is the great-granddaughter of Ramon Palomeque, the last *cacique* (chief) of the Comechingones of Cordoba. A retired school inspector, psychologist, and teacher, she will be succeeded by two coordinators when her term is over next month. Given her responsibilities, it's clear why two are needed.

"I maintain relationships with—and send reports to—Foundation headquarters in Chaco. I give new volunteers two or three training sessions so they use the big voices, generous gestures, and dramatic inflections that children enjoy. I evaluate our work every 3 months, meet every 15 days to schedule volunteers, maintain contact with bookstores here in Lujan, and with publishers in Buenos Aires.

"I am the contact for government and educational officials. I do our radio show every week and our television show every 2 weeks. I am liaison for 34 primary schools, 28 daycare centers, universities, public and private hospitals and residential care facilities. My phone rings off the hook all day long. It is terrible. I need a break!"

It's hard to imagine how this vital woman will down shift. "I am going to rest!" she promises. "I will go to schools to read once a week, but that's it." But then she remembers, "I study Italian, go to the gym, sing in the choir, do yoga, go for walks." I marvel, "Do you have ads here for the Energizer Bunny?" She laughs but admits, "I am a widow. I live alone, and my family lives in Buenos Aires. I have to stay active."

Oh, she forgot to mention that she studies theater. "All kinds. Musical comedy. *Sleeping Beauty*. Chekov." And yes, when she reads on the radio or to children in schools, she performs. Maria Esther is unapologetic about loving applause ("It makes me cry sometimes") and performing ("When I have the mike, I run the world").

In fact, she relishes life in general: "For me, this is the secret, I enjoy every single thing. There will be problems but they aren't so bad if you enjoy what you do." She is a force. No wonder she has been named a Distinguished Person of Lujan and a Distinguished Person of the province of Buenos Aires.

Teresa Derna Soto, 64

2 GRANDCHILDREN

One of Teresa's first memories is about school: where she grew up, children raced to see who could get to school first so they could sit near the fire and stay warm.

As an adult, Teresa taught at all levels including university. Then she retired and began volunteering with the Storyteller Grandmothers, "hoping to reach far into the communities that don't have access to culture and education.

Teresa chose to read in a school near La Quema, Lujan's garbage dump. "The families in the nearby San Pedro and Santa Marta neighborhoods live by collecting trash. The youngsters don't have books—or the experience of reading—at home. We give a prize to the child who has read the most each week. Sometimes we award books, sometimes candy."

"Many educated people could read to kids. Why grandmothers?" I ask. "First, we are used to working," Teresa responds. "And our sense of personal usefulness comes from transmitting knowledge, the love of books and dreams."

Teresa smiles, "I used to read for information. Now I read to feed my soul and the souls of the children."

Cora Cecilia Sanchez, 70

2 GRANDCHILDREN

"Eight years ago, Lujan began acting groups for older adults. It gives me so much pleasure to act in front of children! I always bring props and sometimes hand-held animal puppets.

"I visit 3 classrooms, ages 3/4, 5/6, and 6/7. The younger ones love books about animals; if my 4-year-old grandson likes a book, I read it to others his age. Although I have to be careful; he gets jealous of the students! The 6-year-old girls want fairies and princesses, and the boys want heroes and superheroes. Children in primary school want scary stories, monsters.

"The first time I enter a new classroom, I ask if they have grandparents. A discussion follows, 'I do, I don't.' I say, 'From now on, I will be the grandmother for each and every one of you. Call me Grandma Cora.' Many times, when I go to the city center, children call, 'Grandma Cora! Hi, Granda Cora!' 'Bye, Grandma Cora!'

"One teacher told me that when her students look out the classroom windows and see an older woman with blondish hair, they call out, 'Grandma Cora!' It won't be me, but they hope it is. This is a wonderful

feeling. It really touches me.

Gently, she pulls out a sheaf of paper. "The youngest group made this book for me when they said goodbye this year. Each child drew a picture from one of the stories I had read, and dedicated it to me. The teacher wrote my name on the cover and stapled it together, but that was all she did. The book filled my soul and made me cry. So beautiful! It is a treasure for me."

"I am not a teacher. For me, this experience is about transmitting the joy of reading."

Noemi Grassetti, 71

5 GRANDCHILDREN

Noemi grew up on a farm in the province of Entre Rios that had no lights or running water. While their parents worked, the children stayed with their Italian grandfather, who had studied in seminary.

"He was cultured and knew about music and literature," Noemi says. "He communicated his love of reading and learning to us. Life in the country meant that books were the source of information, entertainment, everything.

"Even though he had already taught us to read and write, we rode on horseback 8 miles to school every day," Noemi continues. "For me, it was a beautiful experience. We loved being in nature."

Noemi married a Swedish-Argentine man and lived in Chaco among the indigenous people. "He was an autodidact who spoke French, German, Spanish, and Swedish. He mastered math and physics

to such a level that university-educated engineers consulted him. Our shared love of books created magic between us. We instilled that love of books in our children and I am reading their books today, to my grandchildren."

When they moved to Lujan, Noemi's friend Maria Esther, the Storytelling Grandmother's Coordinator, encouraged her to attend the Mempo Giardinelli Foundation's International Forum to Foster Books and Reading.

Today, as a Storytelling Grandmother, she spends a half day every week in a daycare center and 2 primary schools (one of which, she tells me proudly, is attended by a granddaughter).

Noemi, who grew up to love the great outdoors by riding to school on a horse, loves reading children books about nature. "The daughter of a friend of mine, Silvana Goldenberg, is an Argentine author living in Canada who writes stories about environmental protection. Reading books about nature to the children gives me great pleasure."

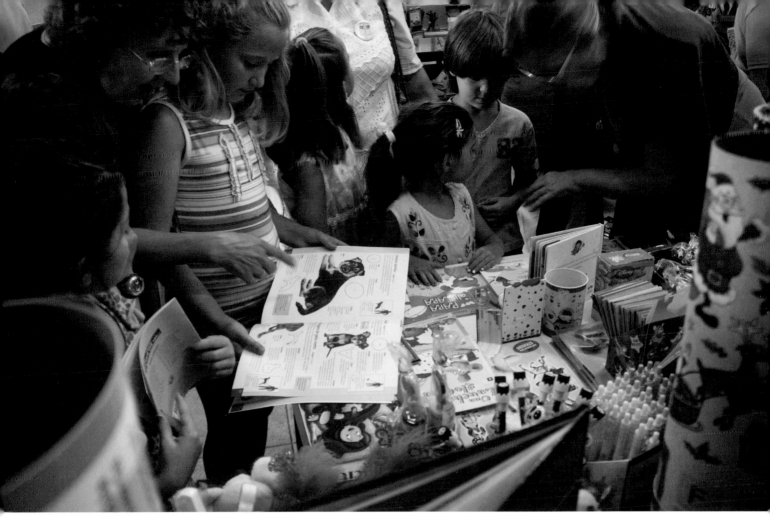

Silvia Nelida Devichi, 61

5 GRANDCHILDREN

Silvia is an in-coming Coordinator for the group, elected via secret ballot by 25 grandmothers and 2 grandfathers. (Yes, grandfathers. *Abuelas y Abuelos Lee Cuentros,* Story Reading Grandparents, became their official name in 2008.)

Silvia attended elementary, high school, and university at the same school in Lujan where she spent her entire career teaching preschool.

"When I retired I asked myself, 'What will I do with my life now? I can take care of my grandchildren, but what about all my diplomas and training and experience? Where will they go? Into a box?'

"I discovered the Storytelling Grandmothers in 2007 and now, I have a whole new life. A new start. I don't just give, I receive."

She knew, of course, that "when kids are in preschool, they have a computer with a clean, crisp, blank page. What they learn remains with them forever," but she was about to learn "a new joy:

reading with children up to sixth grade and seeing their enthusiasm as they learn new things."

"The children receive us with so much affection and love!" Sylvia says. "They leave us little notes that say, 'We love you,' or, 'Thanks for reading that book,' or, 'We really liked that story.' They might stuff a note like that into my pocket. Or into one of the books so I find it when I get home."

Silvia is excited about becoming a Coordinator: "I'd like to integrate the group more. I'd like to expand our group's small library—that's crucial."

"Now," she admits, "I feel useful. I'm from a generation that thinks if you're not working, you're not anything. When I retired, I felt desperate that my mission had ended.

"But this work has opened new worlds. I have new friends, am reading new books, and learning new ways to teach. I had been in a bubble: people loved and protected me. But this experience has opened my eyes. I am learning new realities."

Marta Susana Gigli, 62

10 GRANDCHILDREN

Marta's last name, Gigli, suggests a lot about her. "I taught every age from 3 to 5, and from 14 to 90—but not grade school. I laugh a lot, and sometimes kids in grade school interpret laughter as permission to do whatever they like."

"Now, as a Storytelling Grandmother, I am with primary school kids and I'm enjoying it. They anticipate my arrival and wait for the jokes: tongue twisters, guessing games, jokes about elephants. I tell a story and the kids have such a good time!

"I end all our sessions with happiness and joy. For example, I invented some new types of kisses.

"One is the balloon kiss. We collect a bunch of kisses in our hands, then the balloon expands and expands and expands...and bursts! We collect all the kisses and put them in our pockets.

"Then, there's the dough kiss. We put kisses in bread that rises and rises until it pops and we gather all those kisses. Or we might do that with hugs instead of kisses.

"If I am not going to a place happy, I am not going. This program is all about reciprocity. It's about giving and getting. I am in love with my work."

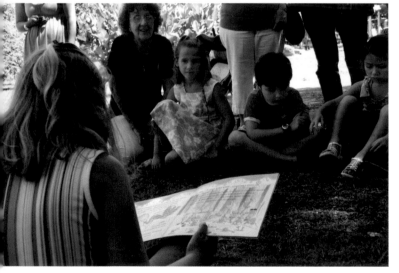

Irma Primavera, 80

3 GRANDCHILDREN

Irma has joined us in the park where the grandmothers are surprised by a role reversal: a little girl volunteers to read to the Storytelling Grandmothers!

Standing is not easy for Irma who uses a cane, so we sit on a bench to talk. It's apparent from the moment I ask her to spell her name that she has a mind of her own. "My husband's family name was Rinaldi, and the tradition in Argentina is to be "de Rinaldi." But I was always a feminist. With lots of pride, I use my name, Primavera. Nobody ever forgets it.

Stories have long been part of this woman's life: "I write poetry and stories for pleasure," she tells me. "I write about what I see. One day, boys in the neighborhood got a bird's nest down from a tree. I wrote about that."

I ask if any of her work has been published and she laughs, "I have a neice who says, 'Do something with these!' But I think she means, 'Organize them!' I always have several rough drafts of stories and poems scattered around."

As a Storytelling Grandmother, Irma usually reads to children aged 6 to 11. But once, "we read stories to students working on degrees in social work at the University here in Lujan. The dean and professors congratulated us. It was a very gratifying moment."

She would love to travel around Argentina, but "I can't do it in my current state. I am thankful I still have my mental abilities; that is the most important thing. This is just how life is right now. Maybe I'm an example for the children; they need to understand disabilities." I believe that Irma is a good example for many reasons.

Mabel Alicia Ramos, 63
11 GRANDCHILDREN

Mabel was an only child until she was 13. Bored, she read the almanac and her father's magazines. When she was older, reading became "an obsession." She competed in reading contests. She worked as a teacher until she had children.

She remembers too well, the effect of the dictatorship on books. "Books were destroyed if even the title seemed suspicious. My husband presented a play at a school, which was titled *The Rebellion of the Farm Animals*. 'Rebellion?' The play was prohibited.

"Schools were required to get rid of black listed books however possible. Soldiers came to our houses and if they found books deemed subversive, they burned them. My childrens' school believed children would be branded as subversive just because they used the informal form of the noun 'you.'

After the dictatorship, "In 1987, two friends and I started a television show for children. It was called *Tennis Shoes* and we invited average kids from town to talk, tell stories, and report the news. It was pretty progressive for Lujan at the time. There is nothing like it now; nothing comes close. But we couldn't get sponsors; it became a very expensive hobby.

"Then we started a radio program. During 1988 and '89 we read stories to children in the evening. Now, the Storytelling Grandmothers broadcast recorded stories every week night from 7 to 8 PM.

"When one of my granddaughters turned three, I read *The Little Lost Grasshopper* at her birthday party. That is where my idea came from, to use birthday parties for reading and storytelling instead of just for running around. Storytelling at birthday parties is still part of what I do.

"One granddaughter's teacher asked my daughter to read stories to the children at school. My granddaughter said, "My Mom? No! My Grandma!" From that time on, it was a family project. My daughter and I would go read stories. I brought books to school in a briefcase."

Mabel has plunked a kelly-green, patent-leather, box-shaped briefcase with shiny silver trim on the table in front of us. Irresistible! It might as well have a sign on it saying, "Magic in here!" Like a child, I can't wait to see the books by Latin American authors that the Storytelling Grandmothers read.

"This one is *Hugo is Hungry*. The illustrations show everything around Hugo turning into food. He finds a dauchshund, which he imagines as a hot dog. But the dog, too, imagines everything as food. With so much in common, they become fast friends.

"This writer, who lives near Lujan, writes about the Rat. In Argentina, the Rat is the equivalent of the Tooth Fairy. The first home the Rat visits is the wrong address and the dad kicks him out. In the second place, curiously, he finds 20 teeth, and leaves all the money but (as you can see) the child is awake and it is a trap! In the third house, he finds an old man's dentures and again, he leaves all the money. When he goes back to headquarters, they say, 'That's enough!' and fire him. He discovers a group of rats and joins them, moving and eating cheese: the perfect job for him.

"This author is from Spain and writes about a town where ogres are discriminated against in school, in stores. Ogres are sad. Then there is a story writing contest. Without anyone realizing it, an ogre decides to enter the contest. The children vote on the winner. The mayor says, 'An ogre can't win! Ogres can't even read and write!' The ogre father says, 'You know

nothing about ogres!' Every night, he goes to the plaza and tells stories to the children."

Mabel pinches something between her fingers, "When I show this bean, I say, 'What is this?' The children say, 'It's a bean!' I say, 'Well, it's the cousin of a bean but I keep it in this container because it's a dangerous garbanzo!' Laura Devetach wrote *El Garbanzo Peligroso*. Her books were banned by executive order during the dictatorship for 'excessive use of imagination.' Her sons and daughters are also writers. The family has its own publishing company.

"I do a radio show for adolescents through university level, and read *The Saga of the Ends of the Earth*. It's a fictional history of Argentina, something like the Tolkein trilogy. *The Days of Fire. The Days of the Deer. The Days of the Shadows*."

Mabel has been part of the Storytelling Grandmothers since 2007 when she read an article about the Foundation's work and thought, "This is for me!" Since she has so much experience, I ask how the grandmothers know they are inspiring children to love reading.

"Teachers look for vocabulary and comprehension.

We want children to ask questions and participate, of course, and we like to tell about the authors...but the most important result we look for is a moment of pleasure. Exclusively pleasure.

"Reading," Mabel says, "is a right." Reflecting on Argentina's experience, she leans forward to remind me, "The right to read must be protected."

The last three grandmothers I interview are part of Storytelling Grandmother groups in other parts of Argentina. Frankly, I wondered whether anyone could be as energetic and engaging as the Grandmothers in Lujan. But they are.

Isabel Elena Barbosa Menapace, 70
2 GRANDCHILDREN

Isabel ran a catering business for 10 years and taught cooking to children and adults. After 30 years, she cooked her final dinner, making 3,000 pizzas for party guests. "Goodbye!" she said, and retired.

After taking 10 years of workshops to learn how to be a storyteller, she volunteered for the National Library storytelling program. And she performed at International Storytelling Festivals in Mexico, Cuba, Venezuela, and Guatemala.

"I have presented stories to 300 children...without a mike! I say, 'How about a scary story about frogs?' 'No! We want a horror story!' I do noises that make them scream. But the star of the show is always the story."

BAMI (the government department that coordinates retirement benefits) and the Giardinelli Foundation co-sponsor the Storytelling Grandmother group in Isabel's northern Buenos Aires suburb, which she has coordinated for three years.

She and six grandmothers each go to four schools once a month and enchant the children by performing stories. After training for a decade herself, Isabel now trains her own group of Storytelling Grandmothers.

Marta Mensa, 63
5 ADULT CHILDREN

Marta coordinates the Storytelling Grandmothers program at Buenos Aires' Castelli Library. The Grandmothers who read to children there use the approach that the Mempo Giardinelli Foundation perfected.

But in 1998, Marta developed a different approach for a program she runs in the village of Don Torcuatro, called Grandparents, the Enchanters of Children.

Her inspiration was her uncle who, when she was a child, told her the stories of his life. Marta taught grandparents to narrate traditional literature from Spain and Italy (many Argentines emigrated from those two countries) and the grandparents began to sound as if they were telling their own families' stories.

"The Library of Mario Moreno funded our program called Traveling Boxes in the Hands of the Narrating Grandparents. Basically, we fill boxes with books that are appropriate for each grade level and take them to schools in high-need areas that don't have libraries.

We hold the books while we narrate, but we don't open them. We talk the stories; we don't read them.

"Often, we create dramas. For example, we might select a book by an Argentine author, Ana Maria Shua, titled *Invented Pets*. We make gigantic images of pets from the illustrations in the book. Each grandmother represents a pet and we narrate in sequence. Afterwards, we give the children nametags and they search for each pet.

"A high level of commitment is required to be part of this program," Marta admits. "Grandparents attend workshops three hours a week to learn new techniques and literature. In addition, they narrate twice a week. Typically, there are six or eight grandparents in the group, but the number fluctuates.

"Our work benefits children, but it also recovers grandparents' value. Some come looking for encouragement, then leave. For us, that's OK. One woman lost her husband, but the group's work coaxed her out of depression. Now she is the soul of parties, happy and enjoying life again. Another grandmother always wanted to be a teacher but never got the chance. Now, she is fulfilling her dream."

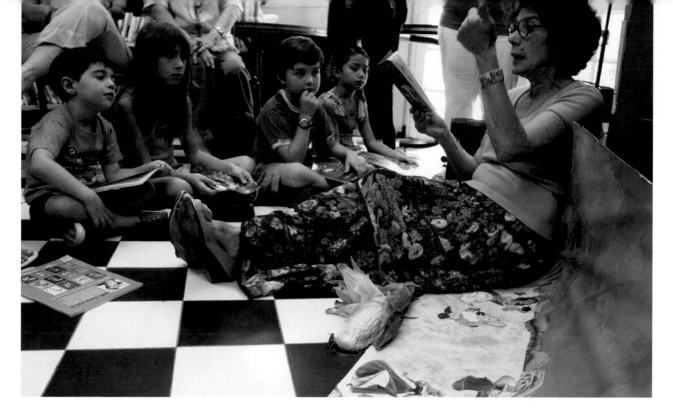

MARIA ALICIA ESAIN-ALIBRUJI, 61

5 GRANDCHILDREN

Maria grew up in a family of avid readers in Navarro, about 62 miles northeast of Buenos Aries. The town library, now over 100 years old, was her "refuge from a difficult childhood."

She taught her first students when she was 15, then worked as a teacher and librarian for 30 years. She is proud of collecting oral histories from the town's residents for the Board of Historical Studies, and of being the "Godmother" of the San Lorenzo Institute Children's Library, which she helped establish.

When she retired in 2002, she began visiting schools, reading and narrating. "With a colleague, I composed songs to use when I visited the schools. I like visiting preschools, kindergartens, and primary schools best, but I also do literature workshops for adolescents and read for older adults."

In 2006, "A great Argentine author, Graciela Repun, encouraged me to show my work to some editors." At the age of 56, Maria became a professional writer and has had more than 30 books published (see Amazon.com and YouTube).

"As a Mempo Giardinelli Storytelling Grandmother, I value books by other authors as much as my own," Maria says. With her Grandmother group, Maria conducts seminars, reads on local radio and television programs, and at schools and public libraries.

They also operate the Bookmobile in the Lakes Region, working with the Office of Culture. "We were awarded the honor of Distinguished Women by the Municipality of Navarro, which is a priceless honor," she says.

"But even more gratifying are the greetings by the children when they see us. 'Hello, Grandma Cuenta Cuentos!' 'Bye Grandma Cuenta Cuentos!' Daily expressions of affection. The shine of their eyes. Their smiles. Those things fill my soul with joy."

Maria's pen name is Maria Alicia Esain, but the children call her, "Little witch, Alibruji" because they love her 2008 poem *The Travelling Witch*, which rhymes and scans perfectly in Spanish:

This witch from Navarro came to visit and brought stories.
Many things come from her travel bag: all types of strange things!
She uses a feather duster to whistle, a stick to sing, a crazy bracelet
And a machine to grumble! What a daring witch, telling us stories like this!
She goes back to her city on the bus. We don't want her here!
She will never again bother these cute little kids!

"I give my poems as gifts," Maria says. "Reading is an act of love. Reading is a party."

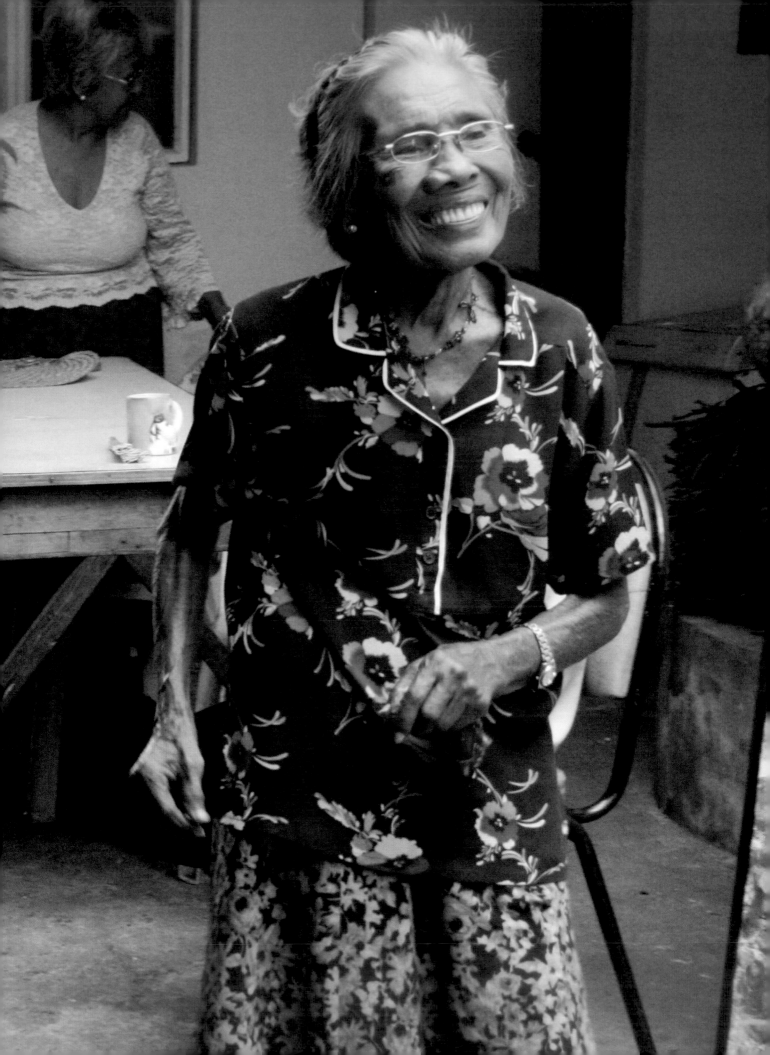

Justice: Philippines

"The Internet blog said this was a haunted house," says a disappointed woman tourist poking her point and shoot camera through the decorative iron gate. The Red House in San Ildefonso, Philippines, is newly painted but it still stands empty. The caretaker, whose goats graze in the side yard, has no key.

My opinion? The house is haunted. Its ghosts are 200 women and girls from Mapaniqui who, 66 years ago, were force-marched to this mansion, locked in, and raped repeatedly by soldiers of the Japanese Imperial Army. Mass rape was only one expression of the Army's violence against women.

Thirty garrisons in the Philippine Islands doubled as "Comfort Stations" where "comfort women" were imprisoned and forced to provide sex to the Japanese soldiers who occupied the country between 1942 and 1945.

Mass rapes and sexual slavery occurred everywhere the Japanese fought. There were comfort women in China, Korea, Southeast Asia, the Southwestern Pacific, even in Japan itself. No one has counted the number of women and girls who were raped but ultimately, some 250,000 were forced to be sex slaves.

In most countries, comfort women were as young as 11; few were older than 20. They were imprisoned for up to 8 months. Typically 10 comfort women served an Army company and each was raped daily by between 5 and 10 soldiers. One third of the comfort women died before the war ended.

The Filipinas went home, got married, had children, found jobs, grew old, became grandmothers, and told no one that they had experienced wartime atrocities which, in their Catholic country, were considered profoundly shameful.

Fifty years later, in 1991, a Korean woman, Kim Hak-Soon, shocked everyone by breaking down at the Asian Conference on Traffic in Women held in Seoul and revealing that she had been forced to be a sex slave of the Japanese Army during World War II.

She and two other Korean comfort women filed a lawsuit against Japan demanding an apology, reparations, and mention of the sex slavery system in Japanese history books, which they hoped would help prevent the practice in the future.

Nelia Sancho, a well-known human rights activist and leader of a Philippine NGO that participated in the Seoul conference, discovered that comfort women also existed, invisibly, in her own country.

In 1992, Nelia was interviewed twice about Japan's sex slaves on Daqui Paredes' popular radio program, "This Is Our Age," which ran on Manila's station DZXL. At the end of each broadcast, an announcer asked Philippine comfort women to contact the station. "Don't be ashamed. Being a sex slave was not your fault. Stand up and fight for your rights."

Sixty-five-year-old Maria Rosa Luna Henson was listening dumfounded that the subject was being discussed publicly. Later, she wrote, "I suddenly felt weak. I lay down on the floor, tears blurring my eyes. My heart was beating very fast. I asked myself whether I should expose my ordeal. What if my children and relatives found me dirty and repulsive?" It was weeks before she took her oldest daughter into her confidence and asked her to request Nelia's telephone number.

Rosa described her experience on Manila's Channel 2 TV. Listeners were horrified. Rosa's other two children wept, hearing their mother's story at the same time as everyone else.

Former comfort women all over the country resonated to Rosa's truth and responded to the request to tell their stories. A group of them presented their experiences on television and inspired more former comfort women to come out.

World War II sex slaves fight for reparations, an apology, and a place in the history books so their experiences will never be repeated.

The Task Force on Filipino Comfort Women, co-founded in 1992 by 7 women's organizations, recorded and authenticated the women's histories. In April 1993, the comfort women, assisted by a panel of Japanese lawyers, filed a class action lawsuit against Japan for violating The Hague Convention of 1907, which protected citizens of occupied territories. Like Kim Hak-Soon in Korea, the women demanded an apology, compensation, and inclusion in Japan's history books.

Forty-six Filipinas' testimonies, including Rosa's, were the foundation of the class action suit. I have read many of the 174 testimonies that were ultimately documented: some typed, some handwritten, some in English, some in Tagalog, all authenticated. They are stories of shock, rage, shame, desperation, and strength.

At first the former comfort women did not know each other but they began meeting and in 1994, formed an organization, Lila Pilipina, with six regional chapters. The members called themselves Lolas, the Tagalog word for "grandmothers."

Nelia Sancho was elected Chairperson and her NGO, the Asian Women's Human Rights Council, handled Lila Pilipina's administration, arranged much-needed psychological counseling for the members, and coordinated legal affairs.

Transforming shame and depression into political action, the Lolas began demonstrating in front of the Japanese embassy in Manila. By then in their 60s and 70s, some used walkers. They told their stories to the media, researchers, visitors, and students. The public was outraged.

The Lolas worked indefatigably to pursue their demands, collaborating with feminists internationally and with comfort women in other Asian countries who also filed lawsuits. Despite their ages, Lolas attended strategy meetings in Korea (where 80% of all comfort women lived) and gave testimony in Japanese courts.

At first, Japan denied that a system of comfort stations existed, but a scholar delved into the country's

military archives and proved they did. Then Japan argued that, having signed the San Francisco Peace Treaty of 1951 and having fulfilled the 1956 Reparations Agreement between Japan and the Philippines, they had no further obligations.

For 10 years, the Lolas' case progressed through Japan's courts. It was rejected and appealed in the Tokyo District Court. It was rejected and appealed in Japan's Appellate Court. Litigation dragged on.

Japanese politicians were divided on the comfort women issue. Some thought the country should admit, others thought it should deny, guilt. As different parties won elections, different policies resulted in what seemed, fleetingly, like progress.

Textbooks would include mention of the comfort women in one edition—but the references would be excised in the next printing.

Yohei Kono, Chief Cabinet Secretary and spokesman for the Japanese government, issued an apology in 1993, expressing "sincere apologies and remorse to all those, irrespective of place of origin, who suffered immeasurable pain and incurable psychological wounds as comfort women." Over time, that apology was edited, rescinded, disregarded, and reissued.

In 1995, Tomiichi Murayama, Prime Minister of Japan, led his government to establish the Asian Women's Fund, which offered "atonement" money to comfort women who applied and qualified. Each Lola could receive a letter of apology from the Prime Minister plus $42,000. Japanese citizens donated $26,000 of that amount; $16,000 was Japanese government money to be administered through the Philippine Department of Social Welfare and Development.

Some Lolas, including Rosa Henson, wanted to accept the offer: they were poor and anticipated needing financial help and medical attention as they grew older. Others felt they should not accept while their lawsuit against Japan was still underway; "charity" from citizens was no substitute for government

reparations; money dispersed by the Philippine government might never reach them.

Ultimately, 88 members of Lila Pilipina, including Rosa Henson, accepted atonement money, as did some members of Malaya Lolas and Lola Kampanyeras, groups that were born from Lila Pilipina.

In 2000, the Women's International War Crimes Tribunal took place in Tokyo. This unofficial trial included eight countries' former comfort women plus two retired Japanese soldiers who testified before an audience of 2,000. The final judgment was rendered in the Hague: international judges found Japan accountable for "state sponsored rape and enslavement," both crimes against humanity. Posthumously, World War II Emperor Hirohito was found criminally responsible. The mock trial supported the Lola's position.

Japan's legal decision did not. In 2003, the Lola's lawsuit finally reached the Supreme Court of Japan. It was rejected once and for all. The case was closed.

In vain, Lolas petitioned their own leaders for support. As a Presidential candidate, Gloria Macapagal-Arroyo promised to champion their cause, but when elected she didn't. When Benigno Aquino III became President, he suggested that if Japan would not pay reparations, his government might. But it hasn't. The City of Manila erected an historical marker to honor the Lolas. Today, I finally found it off a path through Bonafacio Park in a grass-less patch near a freeway ramp.

During the war, sex slaves were imprisoned in Fort Santiago (pages 132 and 133), and Saint Agustin Church (above). **Opposite:** *a small monument that honors the Lolas.*

The Lolas resolutely sought international support to force Japan to accede to their demands. They convinced Amnesty International to support their efforts. The United Nations issued a report that found Japan liable for crimes against humanity. Resolutions passed in Canada, The Netherlands, South Korea, Taiwan, the United States, and European Parliament, all urging the Japanese government to accede to the Lolas' demands.

Thirty-seven Japanese municipalities passed similar resolutions. About 200,000 Filipinos work in Japan: a natural constituency. Japanese comfort women became passionate allies. Japanese feminists, scholars, historians, teachers, and journalists remain among the Lolas' many champions.

In 2005, on the 60th anniversary of Japan's World War II defeat, the Women's Active Museum on War and Peace opened in Tokyo. It houses evidence presented at the Women's International War Crimes Tribunal and sponsors exhibits, seminars, lectures, and classes. The Lolas sometimes teach there, telling their stories to kindle public awareness among Japanese young people who can prevent their country's military sex slavery from reoccurring.

In 2008, almost eight hundred Japanese citizens sent funds to Lila Pilipina to buy the bungalow that is now The Lolas' House: a shelter, counseling center, and meeting place for Lila Pilipina. I will spend this week there. It is an interesting time to visit.

The Lila Pilipinas have collected more than 10,000 signatures on a petition that will be presented this week to the Japanese Prime Minister's office, urging the Japanese government to seek a comprehensive resolution to the comfort women issue. In total, the petition carries 620,000 signatures from supporters in Korea, Japan, and the Philippines.

President Benigno Aquino III has appointed a new ambassador to Japan who may be authorized to seek an official apology for the Lolas.

Four times in the past month, the Lolas have been at Mendiola, the Macapagal Palace gate, chanting and brandishing fists to urge the President, who was about to leave for Japan, to represent their cause. "Time is short. We are old," one placard read.

Indeed, the Lolas' cause is urgent. Most of the active Lolas are now in their 80s. Some observers suspect the Japanese government plans to delay until they all die, hoping the issue will go away with them.

The Lolas are too smart for that. They are educating the next generation and building international support that will survive them. And while they are alive, they are not about to give up.

Interviews

It's 87 degrees and the sky is leaden with humidity. Quezon City reminds me of old urban Chicago but with Hollywood billboards and Starbucks.

A gate between 2 buildings opens into an airy corridor, one wall painted vermillion, both sides lined with lush potted plants. The sign over the doorway says Lila Pilipina. The Christmas tree in the main room is decorated with shining ornaments. A large oil painting by one of the women shows the Lolas' House on a knoll covered with flowers. I didn't expect such a pleasant sanctuary.

My interpreter is Kat Palasi, a photographer friend who lives a few blocks away. We meet 7 Lila Pilipina Lolas and their Executive Director, Rechilda (Rechie) Extremadura, who was elected in 2000.

We meet in the room that triples as office, conference space, and research center. The Lola's testimonies and publicity scrapbooks are stored on shelves. We are surrounded by pictures that the grandmothers have drawn during art therapy sessions, photographs of the many members who have died, and hand-printed placards for protests.

The Lolas are media savvy and they have told their World War II stories often. "I will read your testimonies," I assure them. "But please tell me what your lives have been like since the war, and about the brave fight you have been conducting for the past 17 years."

Lola Narcisa Claveria, 80
21 GRANDCHILDREN, 12 GREAT-GRANDCHILDREN

Narcisa joined the group in 1993. "I saw Lola Rosa on TV. I didn't want my children and grandchildren to go through the things I did. What gave me the courage to tell my story on television was knowing that my entire family had been victims."

Narcisa's legal testimony tells that her father was headman in the village of Balintog. When the Japanese soldiers came in 1942, they tied her father and two brothers to posts. Narcisa, 12, was forced to watch as soldiers skinned her father. Her youngest brother cried, so a soldier stabbed him with a bayonet; he screamed once and died. Her mother and sisters were told to undress, then raped. When one sister resisted, she was whipped.

The soldiers took Narcisa and all the women to the municipal building where there was a battalion of soldiers. They were raped in front of each other, and raped every night for three months.

Narcisa reported in her testimony, "After one woman escaped, the soldiers took us everywhere with them. We walked barefoot over the fields on cracked, blistered feet. When the Americans started bombing the garrison, we escaped. We ran two miles but after that it was too painful. We walked on our knees."

Now, Narcisa admits that appearing on television in 1993 worried her. "I was afraid of what my 6 children would say. I had not told them. They said, 'What will my classmates say? That you were a whore!' They didn't talk to me for almost a year," Narcisa remembers, wiping her tears.

"Then, before Christmas, my husband called a family meeting. He had two sisters who were raped, so he was supportive. He said, 'What happened to your mother was not something she wanted; she almost lost her mind.' Once they understood, my children embraced me, apologized, and asked forgiveness.

"The most important Lola activities for me have been the rallies. Sometimes the police grab our banners and push us. But it's my right to protest: I was victimized.

"I believe we have made progress in the past 17 years. More people are supporting us now. If the Japanese and Philippine governments both wake up to the issues and if we get support from all the NGOs, we will get what we have always aspired for.

"But what if we die and nobody is here to tell the stories? Then I hope the whole world will fight for the next generation. It's crucial to *sulong*, fight on."

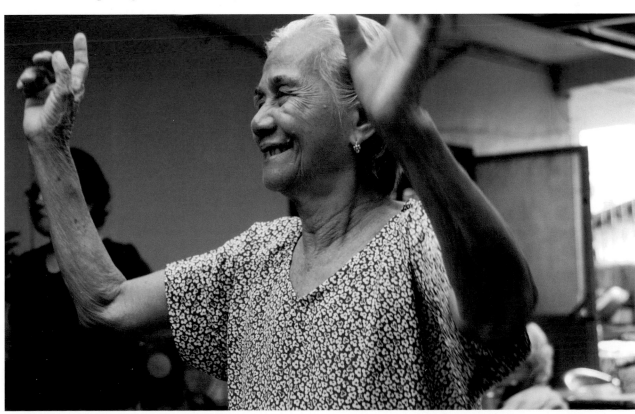

Lola Estela Adriatico, 83
9 GRANDCHILDREN

When she was 17, Estela and her cousin moved from Abra Province to Manila. She worked as a maid for a Japanese government official whose domestic servants slept on the third floor of his house.

According to her legal testimony, "One day, Japanese soldiers came. The other maids and I, a virgin, were all raped many times that night. The next night, the same. That went on for 3 weeks. We were locked in, guarded by soldiers." Her employer freed Estela in 1945 when the United States began bombing Manila.

Estela kept silent for 48 years. Like Narcisa, she came to Lila Pilipina after seeing Rosa Henson on television. In 1993, she dictated her testimony.

A widow now, she lives with her daughter and two grandchildren in an apartment in Balintawak. "I stay in touch with my oldest granddaughter, who is working in Saudi Arabia, via the Internet. I see my Manila grandchildren often.

"My grandchildren ask, 'Why do you join these grannies? You are old.' And I answer, 'I want to show the world that this happened and prevent it happening again. I want revenge. The Japanese have to pay for what they did.' I feel strongly about it.

"Innocents became victims," Estela says. "We have been fighting for a long time. The Japanese and Philippine governments have always ignored us. We Lolas do more than 10 rallies a year. There is lots of newspaper and television coverage. Our behavior inspires others to support our cause."

Estela's birthday is a month away. I ask what she will do to celebrate. She smiles, "I will go to church and ask the Lord for more years, so I can fight on."

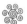

I spend several hours reading the Lolas testimonies. Suddenly, rain crashes on the corrugated roof so loudly that I can no longer hear the television the Lolas have been watching in the next room. In this part of the world, monsoons and typhoons happen. Lightning flashes, thunder roars, the lights go out, a pipe breaks.

I pull out my emergency flashlight and peer into the main room of The Lolas' House. There is competent Rechie on a ladder fixing the pipe, which is dumping water all over her. The Lolas are mopping and bailing. Never let it be said that grandmothers are not strong and skilled. The situation is under control in minutes.

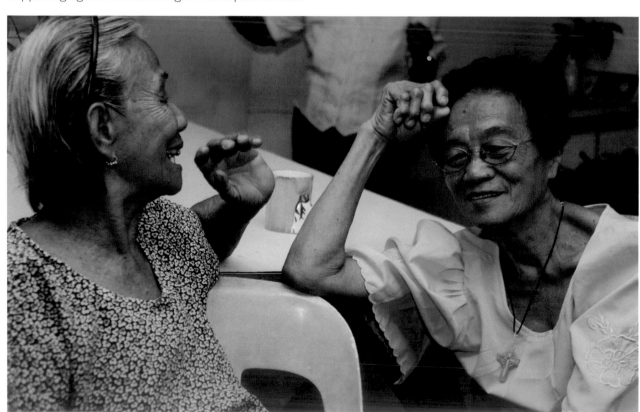

Lola Estelita Dy, 80
13 GRANDCHILDREN

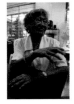

"Before Lola Rosa came out, people didn't talk about comfort women," Estelita remembers. Rosa Henson struck a cord when she said, "You feel small because you've been raped."

Estelita says, "I got up the courage to join Lila Pilipina before I told my children about my life. When I did, I said, 'What could I do? The Japanese had the power.'" Many women struggled with this conversation. "One Lola's children disowned their mother when they found out," Estelita remembers.

In 1993, Lila Pilipina had "about 170 members. Now there are only 15 or 20 active members. Some died. Some are senile. Back then, we were all in our 60s. We started without funds. To sustain us at a low cost, I remember cooking small fish in vinegar to take to our rallies. Also, salted red eggs mixed with tomatoes, eaten with rice.

"We would have lunch in the jeepney and rush through the traffic to be at the rally site at 1 PM. We would parade in the sun 4 miles to the Church of the Black Nazarene in Plaza Miranda. That could take until 5 PM.

"Today, some people who see us at rallies pity us. On the other hand, a woman with a walker inspires some to think, 'They are so old, they deserve justice.'

"I don't know about the current President of our country. Recently, we delivered a petition with more than 10,000 signatures to Congress. It took a month to collect the signatures. I suspect the document was ignored.

"But," she says, "we have more Japanese supporters now. I feel hopeful."

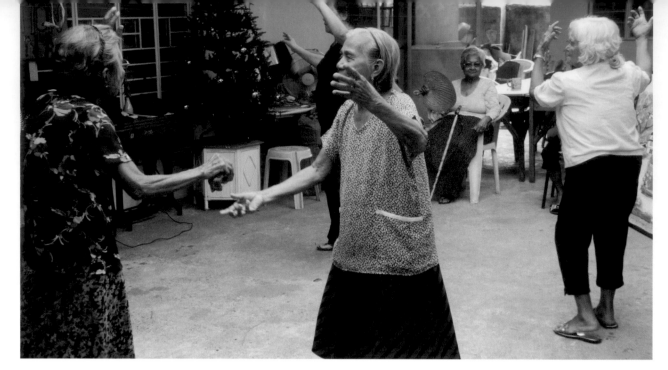

Lola Hilaria Bustamante, 84

10 GRANDCHILDREN

At age 15, Hilaria worked at a sewing factory in Manila that "was owned by the Japanese. I worked 6 days a week sewing army uniforms and camouflage nets used by snipers."

When Manila was evacuated the following year, her family sent her to live with her father's cousin in Hermosa to help pick rice. Hermosa was not as safe as her parents hoped.

"Walking home from the farm, three soldiers took me to their garrison an hour away. They raped me en route, and then locked me up with three other women. At 16, I was the youngest. The oldest was 20. Each night, three soldiers raped me. They came about 8 PM. During the day, we had to wash and cook for the soldiers.

"We got out when the Americans came. My mother wailed when she heard my story. In 1945, I sewed uniforms for the Americans."

Now 84, Hilaria's sewing skills are still good, despite cataracts. She may stay at the Lolas' House for a month to help sew dust cloths, colorful rounds of cotton that a Lola's daughter sells for them. One thousand dust cloths can bring $15 or $20, enough to buy food for the Lolas' lunches.

Hilaria joined Lila Pilipina in 1993 after seeing Lola Rosa on television. Members used to tease her about being "The Working Lola" because between 1980 and 1994 (when she was widowed), she worked as a laundry woman.

Hilaria doesn't want to be a burden to her children, so she lives alone in a small room. "When we do rallies, many Lolas stay here at Lolas' House. We get a text message on our phones, and we come.

"We don't bring big posters to most rallies because when the police come, they could be destroyed. We just bring small, handy placards. When it's only Lolas at rallies, the police are not that strict. But when other organizations join us, especially at the Palace gate, it sometimes becomes violent. Once I fell and almost broke my arm.

"Besides rallies, we sometimes do forums at the University of Santo Tomas, the University of the Philippines, or Ateneo de Manila University. The students need to hear about our experiences. Many don't know, and they cry when they hear. Even the Japanese cry.

"If we get the three things we want, it will be like having thorns taken from my breast. That will be our reward, " Hilaria says.

After lunch every day, Rechie turns on music and the Lolas dance. Separately and in groups, they invent their own steps, swept away by the rhythm. For women whose lives have been painful, ashamed, and silenced, dancing expresses a kind of happiness, freedom, and friendship that surprises me. They insist it's time for me to stop taking pictures and join them. I do, marveling at the healing power of dance.

Lola Felicidad Barberan De Los Reyes, 82

15 GRANDCHILDREN

Yesterday, November 22, was Felicidad's birthday. My interpreter, Kat, and I sing 'Happy Birthday to You.' When I ask Felicidad how she celebrated, she smiles, "I danced here."

Life after the war was not easy for women like Felicidad. She had 6 children, one of whom died at age 3. Her malicious mother-in-law coveted Felicidad's meager seamstress income, which was barely enough to buy bones and rice to feed her family. Her abusive husband died after years of heart problems.

Despite hardship, Felicidad sent all her children through the sixth grade. Her daily pay for sewing and tailoring was 5 pesos (12 cents at today's exchange rate), which was "good money for a working single mother," she says. "There were not many of us back then."

According to her legal testimony, Felicidad was one of 10 children whose parents owned a tailoring shop in Masbate. Japanese soldiers maintained a garrison inside her school compound. At age 14, Felicidad was among 40 students made to study the Japanese language, Nihongo. (The Japanese Army often installed civilian Japanese teachers in schools).

After 2 months, Felicidad's teacher organized the students to sing for the soldiers, then announced that the soldiers wanted to reward 5 who had sung particularly well. Two soldiers fetched Felicidad, saying she would receive her prize at the garrison.

There, Felicidad was put in a room with 10 women. All were tied and raped. Three soldiers raped Felicidad the first night, 5 the second, 3 the third. When she struggled, the soldiers laughed, punched, and kicked her. She wept and lost consciousness. She had such a high temperature that a Philippine interpreter working for the Japanese freed her.

When she told her parents what had happened, they cried. They urged her to flee with her pregnant sister to Tigbao where, "One day in 1944, I was washing clothes and 5 soldiers raped me."

Felicidad says that after the war, "I felt dirty and dared not tell anyone. Before I married my husband in 1956, I told him, but other than that, I told no one for 37 years."

Even though Felicidad's husband had been a prisoner of war and her sister was also a comfort woman, Felicidad's son was mortified in 1992 when he learned about her history. "It is so embarrassing that you are one of the comfort women," he said. She responded, "Yes, it is embarrassing, but it was not our fault."

When young neighborhood girls heard, they jeered at Felicidad on the street. She advised one of the girls' brothers, 'Tell your mom that the next time your sister does that, I will slap her.'"

Felicidad and Nelia Sancho visited Australia in 1995 on a national speaking tour. Like the other Lolas, Felicidad is committed to speaking out, which she believes is the first step toward ending violence against women worldwide.

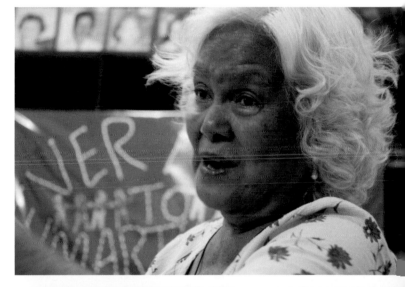

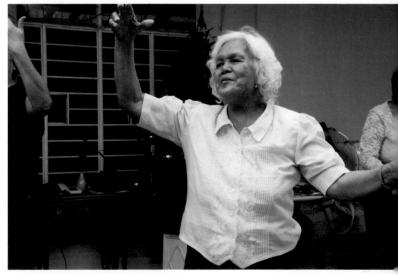

Lola Pilar Frias, 84
15 GRANDCHILDREN

 Each afternoon, Pilar is the most vital dancer among the Lolas. She is so invigorated by the music that even the Energizer Bunny wouldn't be able to keep up with her. "I learned to dance when I was 15 at the festival for my town's patron saint, San Pasqual, in Camarinas Sur."

As Pilar dances she seems to leave behind her sadness and difficulties. She says, "I am very happy here, dancing. I feel strong. Also, it's good exercise."

"But," she says, "at my house in Antipolo, I feel as if I am going to fall if I stand up. I sit all afternoon sewing in the street so the fresh air will revive me. I am weak and cannot travel now. But 7 times, I went to Japan and Korea with Narcisa. I have been to Kyoto and Osaka to speak."

Pilar was one of the plaintiffs in the Lolas' lawsuit against Japan. I ask what it was like to visit the country whose government caused her so much pain. "The first time, in 1998, I went to the Tokyo District Court. Three Japanese judges came in, saw us, turned back, and left. There was no testimony that time. They treated us like garbage.

"I heard the Japanese sing during the war and learned their songs," Pilar mentions. I ask if she will sing one, and am surprised by her sweet, melancholy alto voice. She tells me, "I sang that once in Japan and 2 men came up and sang it back to me, first in Tagalog, then in Japanese.

"Normally on these trips, we speak to students. It is very rare that we have old men in the audiences, but in 2007 in Kobe, there were some. I saw them and thought, 'They could be ones who raped us.' I was so angry." She puts her hand on her chest, frowns and looks away as her voice thickens. "If I had had a machete, I would have hacked them. I showed how angry I was. The audience was very quiet." Pilar rubs tears from her eyes.

"I am still angry after 68 years. The Japanese destroyed my dreams. I was in the fifth grade but the Japanese came and that was the end of my education. They burned our house. We had nothing to eat except tree bark. I hate war."

Pilar's testimony says that when she was 16, 5 Japanese soldiers came to her house in the island village, Anib, while she and her aunt were washing clothes. They accused Pilar of being a guerilla's wife,

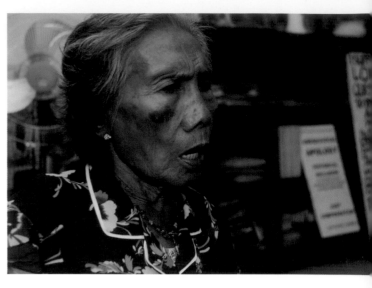

which she denied.

A soldier slapped her, burned her cheek with his cigarette (she still has the dark scar), cut the right side of her nose with a knife, and repeatedly dunked her head into a drum of water.

Next, one tied her hands, pinned her to a tree and 2 soldiers raped her. Three others raped her aunt. Pilar and her aunt fled to mainland Camarinas Sur. When they returned to their island in 1944, all the houses in their village had been burned down.

The women took refuge in a school. A week later, several hundred Japanese soldiers seized control of the building. For 2 months, not a day passed without her being raped. When the Japanese surrendered, she was released. Her parents had assumed she was dead.

"I was pregnant with my third child when my husband discovered that I had been a comfort woman. He separated from me. A log fell and killed him at the sawmill where he worked, so I became a widow at age 25. I married again and had 4 children. Two survived."

She returns to the present: "When I was young, the Japanese raped me every night. When it is time for them to listen, they do not. For 17 years we have tried. Our trips to Japan are trash. They get us nothing."

I am not surprised that a Lola gets discouraged. "What could the Japanese government do or say that would make a difference?" I ask. "In Japan, they always ask, 'How much money do you want?' I say, 'It is not just for us. The families of those who are dead also need to be compensated.'"

Pilar has reminded herself of the reasons she fights. She vows, "I am 84. My mother lived to be 96. I will use my years to fight on."

Lola Simeona Ramil, 82
12 GRANDCHILDREN

Simeona recently fell and hurt her hip, so she's using a cane. Her malady reminds her of the way Lolas leave rallies when the police hassle them. "When communication bogs down and there is a clash, police push and people start running. But we Lolas cannot run. We walk. Slowly!"

She elaborates, "The police respect us. They are usually young. They talk to us the way they would talk to their own Lolas who will get a broom and whack you if you don't behave," she laughs.

"My grandchildren sometimes give me jeepney fare to go to rallies. They support my work. I don't know if my daughter has told them, but she knows what happened to me during the war."

One day when Simeona was 14, her grandfather sent her to gather firewood. "I noticed 3 Japanese soldiers near the forest. They followed me. They raped me. My grandmother and older sister, the only family members who were home, came to look for me. I heard their calls but I was afraid the soldiers might still be nearby with rifles and I didn't want them to kill my family. After a while, I stood up. My grandmother saw me, pitied me, embraced me, and took me home."

As I collect my cameras, I remember all the places around the world where women have suffered much as the Japanese Army's sex slaves did during World War II. Germany, Rwanda, Democratic Republic of Congo, Bosnia, Sri Lanka. The list goes on. The rapes go on.

Rechie is playing the Videoke and it's Simeona's turn. She pulls up a chair, takes the microphone, and sings the 1972 hit, *The Impossible Dream*. The lyrics could have been written about the Lolas who have converted anguish into determination to vanquish violence against women everywhere.

"To dream the impossible dream, to fight the unbeatable foe
To bear with unbearable sorrow...
To right the unrightable wrong...
This is my quest: to follow that star
No matter how hopeless, no matter how far.
And the world will be better for this..."

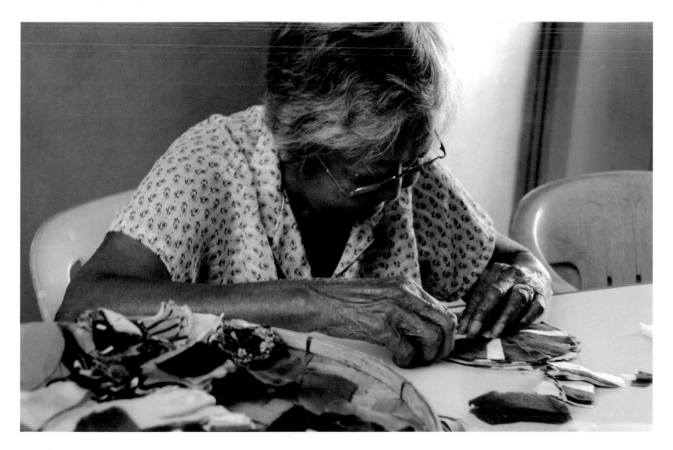

Justice: Argentina

Argentine grandmothers began searching for their grandchildren as soon as they learned the youngsters had been stolen by the military, an event that set the agenda for the rest of their lives.

At the beginning, their investigations were greeted with silence. The public was too afraid to acknowledge that between 1976 and 1983 the *junta* "disappeared" 30,000 people, forcing them into secret detention camps where they were tortured for information, then murdered.

Explaining the government's strategy to eliminate leftist dissent, General Iberico Saint-Jean promised, "First we will kill all the subversives, then we will kill their collaborators, then their sympathizers, then those who remain indifferent and finally, we will kill the weak."

The "Disappeared," as they are called, ranged from innocents to intellectuals to guerillas; many were blue-collar workers and students.

Adults were not the only ones who were abducted. Children who had not yet learned to talk were considered educable. They were stolen from the detention centers by military and police officers and raised to be "patriotic."

Pregnant prisoners were tortured but kept alive long enough to give birth. An obstetrician or midwife would be kidnapped from the street, blindfolded, taken to the room where the prisoner was in labor, and ordered to deliver the baby alive. After the mothers were killed, their babies were appropriated, sold, or abandoned.

"Later, military personnel said they regretted not having killed the children; they didn't anticipate the magnitude of response from the mothers and grandmothers. They thought we would stay in our houses and cry," recalls grandmother Elsa Pavon de Aguilar.

The grandmothers began to search. They received almost no help. Police, military, judges, and church officials supported the dictatorship. Lawyers were disappeared for writing habeas corpus documents so the grandmothers could demand the children's return. The state-controlled press reported no disappearances.

Each grandmother searched alone at first, unaware of the others. The women didn't yet know that stealing children was part of the junta's systematic plan to maintain power, eradicate political opposition, and induce fear. "I was never afraid; I had such a level of desperation that I didn't register other feelings," grandmother Mirta Sinista Acunya de Baravalle admits.

As they visited jails, orphanages, daycare centers, churches, courts, parliament, and ministries, the women began to recognize each other and talk.

The Madres (Mothers) of the Plaza de Mayo formed in 1977. That same year, twelve Madres who were looking for grandchildren as well as children, decided to work together; over time, they called themselves Abuelas (Grandmothers) of the Plaza de Mayo.

The Abuelas pretended their meetings were card games and birthday parties. They spoke in code on the phone. They posed as maids, nannies, teachers, and renters just to get into houses where their grandchildren might be living. They posted pictures and ran ads featuring photos of the disappeared children in 24 countries. They traded intelligence with grandmothers in other parts of Latin America. They wrote the United Nations. They asked the Pope "to end this calvary that we are living."

In 1978 the Madres and Abuelas of the Plaza de Mayo marched together during a religious pilgrimage to the city of Lujan. To identify themselves, they wore cloth diapers as headscarves. White kerchiefs became their signature.

The fearless grandmothers of infants and toddlers who were abducted during Argentina's military dictatorship have located 105 grandchildren.

The Plaza de Mayo is the backyard of the Casa Rosada (Pink House) where the President's offices are: a perfect place for political demonstrations. The Abuelas joined the Madres, walking silently in circles at the Plaza to protest their grandchildren's disappearances.

Mirta de Baravalle says, "At first, people approached us in the Plaza with notes. Over time, we had thousands of tips from different sources. We knew our children were someplace there in the bits of paper."

The Abuelas began talking with foreign journalists and earned support from international organizations and governments.

When the grandmothers began finding missing youngsters, they engaged social workers, psychologists, and physicians to help their grandchildren who were whiplashed by the revelations that they were not who they thought they were, and that the people they knew as their parents might have murdered their real mothers and fathers.

The Falklands War diverted the attention of the military and depleted the dictatorship's resources. Democracy returned to Argentina in 1983 and the grandmothers filed law suits immediately, even though they had no way to prove that they were related to their grandchildren and they had never even seen the babies who were born in captivity.

Determined to develop legal evidence, the grandmothers commissioned North American scientists to devise a procedure like paternity testing to prove kinship between grandmothers and grandchildren. Mary-Claire King, a California geneticist, developed essential tests whose results were statistically accurate at the 99.9% level.

When necessary, the Abuelas got court permission to exhume the mothers' bodies so forensic anthropologists could confirm that the women had given birth while interned. Eric Stover, Director of the Human Rights Center at the University of California, Berkeley, believes these investigations were the first use of science to further human rights.

By 2011, the grandmothers had identified 105 grandchildren. "Four hundred to go," estimated Abuelas' President, Estela de Carlotto.

Thanks to the grandmother's initiatives, a National Bank of Genetic Data for Relatives of Disappeared Children exists. National laws have been enacted to give adopted children the right to their records when they become adults. Children's rights to identity and life with their families are part of the United Nation's Convention on the Rights of the Child. A United Nations commission repatriates grandchildren taken to other countries. The U.N. added "appropriation of children" to its definition of genocidal behavior.

In February 2011, former dictators Jorge Videla and Reynaldo Bignone finally went on trial "for overseeing a systematic plan to steal babies born to political prisoners." The grandmothers had initiated the case in 1985. The *London Daily Mail* reported, "The defendants dismissed the process as an act of revenge by the leftist ideologues they defeated decades ago," and said Videla nodded off as the court clerk read the indictments.

As usual, the generals had underestimated the Abuelas who had 370 witnesses ready to testify that the junta leaders falsified paperwork and arranged illegal adoptions for people sympathetic to the military regime.

The long-delayed trial is only one of the grandmothers' current activities. "At first we knocked on doors looking for little children," the Abuelas' President Estela de Carlotto remembers. "Now most are in their 30s so we use a different strategy: we seed doubt about identity so they will request blood tests."

The Theater of Identity is crucial to that mission. Playwrights, producers, directors, choreographers, technicians, and actors volunteer their time and talents to present free plays about the Disappeared. Their performances end with the question, "And do you know who you are?" Thespians throughout Argentina, Spain, Switzerland, and Venezuela "act to remember; to find truth, and most important, to find grandchildren," the theater's founders explain.

Today, Music for Identity, Rock for Identity, Sports for Identity, and Tango for Identity all end performances by inviting audiences to wonder who they really are.

A global network of old and young supports the grandmothers' work. Student staffers at the Abuelas' office use Facebook and Twitter to support the Abuelas' searches. H.I.J.O.S., teen activists, say they work "for identity and justice against silence and oblivion." Citizens throughout Argentina relay rumors. Abuela chapters in other countries tip the grandmothers off.

The Abuelas recently launched an international communications campaign. Estela de Carlotto says, "We want to tell people all over the world that if this could happen in Argentina, it could happen any place. Identity is a human right. Our message is 'Never Again.'"

In March 2011, UNESCO awarded its Peace Prize to the Abuelas de Plaza de Mayo.

Interviews

A hot February wind blows tonight in Buenos Aires. I lean on the balcony and look into shadowy streets. Today at the San Telmo antique fair, I found traces of what nightlife was like here 33 years ago: brass bullets; black-and-white portraits of men in uniforms; 1970s telephones like the ones people used to call grandmothers with the news that their families had been disappeared. That's how they say it, "had been disappeared." Ironically, the passive voice implies unspeakable aggression.

Tomorrow, I will begin interviewing Abuelas of the Plaza de Mayo and some of their found grandchildren, now in their 30s, who spent years with "appropriators." That's the term the Abuelas use strategically to emphasize that their grandchildren were stolen. Not legally adopted or placed with foster families. Stolen.

Elsa Pavon De Aguilar, 74, 6 GRANDCHILDREN, 2 GREAT-GRANDCHILDREN
Paula Eva Logares, 34, GRANDDAUGHTER OF ELSA PAVON DE AGUILAR

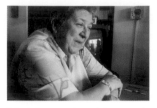

My interpreter rides up, her bicycle basket full of pastries for Elsa. We are too early, so we sit on the steps of the modern apartment building, which, we discover later, gives the security guard time to get nervous about what's in my camera bag.

Outside, leafy trees line the street; inside Elsa's apartment, plants thrive in the light. "People think these stuffed animals are for my great-grandchildren," she says patting a fuzzy bear on the couch, "but the truth is, I like them myself."

In 1977, Elsa's daughter and her husband, both members of the activist Monteneros, moved across the Rio de la Plata to Uruguay to seek sanctuary. "Nothing to worry about," her daughter Monica was nonchalant, "some comrades were detained and questioned but they were released." Elsa's only granddaughter, Paula, then two years old, accompanied her parents.

Paula doesn't remember being kidnapped from the Uruguay street with her parents in 1978, "but I have the memory of that violence in my body, in my being." Her fingers fidget with her silver rings.

Elsa's first reaction to the news of the family's disappearance was, "We lost the little girl!" Then she became very ill. After 2 weeks in bed with a fever, she realized, "My God. If I die, I will never find them."

She resigned her job as a laboratory technician. "I became so obsessed with the search that my husband said, 'I am afraid I will lose you.' I went to Uruguay and walked, asking questions at the police stations, military posts, schools, daycare centers, everywhere. I could have been detained myself. I was alone."

A priest put her in touch with other grandmothers who were also looking for their missing grandchildren. One, nicknamed "Chicha" Mariani, went to search in Brazil. An archbishop gave Chicha three snapshots of a four-year-old girl. Elsa recalls, "Chicha recognized Paula immediately and let me know." On the back of the picture someone had written the name, Paula Lavellen, with an address in Buenos Aires.

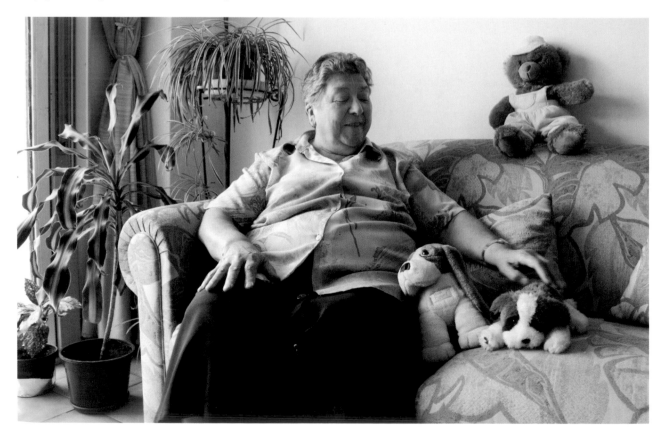

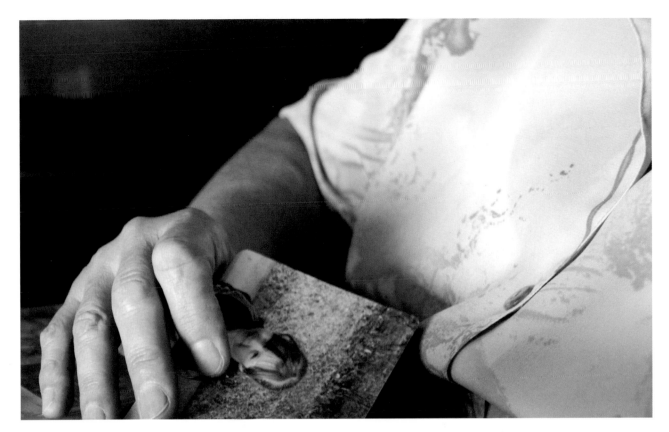

Paula takes up the story: "A subchief of police, Ruben Lavallen, had taken me from the detention center to his home. I passed many horrible moments. Ruben was a very violent person." At the detention center, Ruben was known as a brutal torturer; some prisoners saw him leave with a child in his arms in May, 1978. Paula was, indeed, living at the address someone had scrawled on the back of Chicha's picture.

Elsa began haunting the neighborhood. She went almost every day looking for clues. One day in 1980, she recognized Paula climbing off the school bus but there was no time to talk to her. Soon after that, the family moved away.

In 1983, when it became permissible to post pictures of The Disappeared, Paula's picture was displayed. The Abuelas received a call: Paula had been seen in the Chacarita neighborhood. Every day, Elsa rode for an hour on buses to buy groceries at the fruit and vegetable stand immediately in front of the house where Paula was supposed to be living.

"One day, my sister-in-law came with me. We saw Paula at the window and she shouted "Paula!" but the little girl ran to another room. Paula was seven then, but was wearing a preschool uniform." (Elsa learned later that the appropriators had registered her age as two years younger so her birth date would correspond with the date of her abduction.) "I was confused by the uniform, but I was 100% sure this was Paula."

The Abuelas contacted Ruben. Paula remembers, "He told me there was a crazy woman, a very bad woman, claiming to be my grandmother. She was trying to take me away."

Elsa and one of her daughters went to Paula's school. When her aunt joined the line for the school bus, Paula didn't look up, but she did confirm that her name was Paula Lavallen.

Elsa's husband went to the school. "Paula gave him such an intense look that he swore she was going to come right out and say 'Buelo!' which is what she called him when she was two."

Democracy started in Argentina at 7 AM, Monday, December 13, 1983. As soon as the court opened, Elsa filed a formal complaint against Paula's appropriator. "The only evidence we had was the few anecdotes I've described, plus our family pictures that showed Paula looking exactly like her mother did as a child. We knew we needed better proof. After months of prodding, we got the appropriators to take Paula to Hospital Duran for a blood test."

Happenstantially, that morning the American geneticist, Mary-Claire King, arrived from the United States. Doctors who worked with the Abuelas of the Plaza de Mayo met her plane and drove her to the hospital to analyze Paula's blood. It took months to

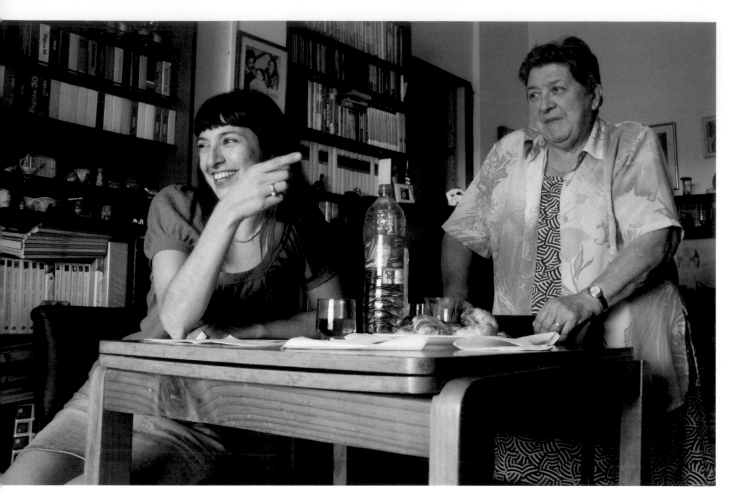

get the results but the scientific evidence proved with 99.9% certainty that she was related to Elsa, not the appropriators.

Paula had become the first grandchild ever identified with genetic testing, a procedure that would ultimately affect the destiny of all disappeared grandchildren.

But it didn't help her. The judge ruled that Paula should continue living with her appropriators.

While the outraged young volunteers who worked with the Abuelas engineered a radio campaign to tell the public what had happened, Elsa appealed.

"The judge sent me for psychological evaluation. Asked what I would do if the court decided not to give Paula to me, I said, 'I would go home. Cry until I couldn't cry more. Repair my shoes. Go back out to find my granddaughter.'

Paula remembers the morning her appropriators took her to court in 1984. She was 8. "I was told I could bring one doll. The judge told me I was going to meet my grandmother. The only story I knew was that she was a crazy old woman. I didn't want to go anywhere near her. I backed around the table

to get away."

Elsa had enlarged snapshots that showed Paula with her parents before they were disappeared. (For years, Paula didn't tell Elsa that she immediately recognized herself). "Paula threw them down saying, 'These are too new to be real.'

"I couldn't believe it!" Elsa continues. "There was no way I would give up. I asked her, 'Do you remember what you called your dad? His name was Claudio. He loved to put you on his shoulders and look at the moon. You used to say, 'C'audio!' Paula tested the word. The third time, she said, 'C'audio!' just like a little girl."

Full of joy, Elsa took Paula home that day. But the legal case wasn't resolved for many years. Paula chose never to see her appropriators again.

Today, Paula works at the National Bank of Argentina where her father worked long ago. The bank sets jobs aside for relatives of The Disappeared, and Paula serves on the bank's Commission for Memory and Justice, which evaluates applicants and arranges their employment.

Mother Of Ana Maria Baravalle, 86

5 GRANDCHILDREN

Her given name is Mirta Sinista Acunya de Baravalle but when I ask how she wants to be identified in the book, she is clear: "I want it known that I am honored to be Ana's mother."

Although she was one of the first Abuelas of the Plaza de Mayo, we meet in the office of the Madres, which she helped found and with whom she began her journey. "This is our house. These are our children," she greets me. Portraits of the Disappeared cover the wall behind her and reflect on the glass table in front of her. She is surrounded by their faces as she describes the night in 1976 when Ana vanished.

"Thirty soldiers came over the rooftops in military uniforms, their heads covered with masks. It was 2 AM. Our block was surrounded by military personnel and trucks. There was a Ford Falcon, the car that always took people away.

"The soldiers had a gunfight inside our house (our neighbors thought we were all dead). They took my son-in-law, Julio Caesar Galici, and Ana, who was five months pregnant. Her baby was due in January, 1977.

"I went to the police the next morning. They informed me that they had no jurisdiction in our zone. Then I asked our priest for a mass in the name of Ana and Julio. He said, 'Another one?'"

Outside the Interior Ministry, Mirta met other women who were searching for their children. The first time they talked, soldiers told them to disperse. "We ended up sitting in the Plaza de Mayo. Azucena Villaflor de Vincenti bent down, got her knitting, and announced, 'We're just taking some sun.' The second time we met there, she took out her knitting and soldiers with guns forced us to leave.

"Azucena organized a Madres demonstration at the Plaza de Mayo, not realizing that the date was a Saturday so nobody would see us. Soldiers came immediately. One put his gun in my back and said, 'Keep moving. You can't stay here.'

"In October 1977, the Madres mobilized 2,000 people to present a petition to congress. Soldiers threw tear gas and started to surround us. Many escaped—but 300, including me, were bussed to the police station and held until 3 AM.

"We gained access to some foreign journalists. My case interested them since I was looking for a grandchild as well as a daughter. As a precaution, I met journalists 'by coincidence' in cafes.

"We began to get threats. Chicha Mariani (who co-founded the Madres) was called The Mother of Terrorists. People were following me. After four of us Madres met with one of the repressors, the other three were disappeared. Later, their bodies washed up on the beach. The junta thought they could scare us into submission. It only made us fight harder."

Mirta was an early member of both the Madres and the Abuelas. In 1982, she and another Abuela convinced an Amnesty International conference in Europe to fund an office for the grandmothers. She grimaces, "Nobody wanted to rent to us when they discovered who we were, but finally we found a place. Often we worked there until 3 in the morning, then just slept there."

It's time for Mirta to go to the Plaza and march with other Madres and Abuelas, as she has done every Thursday for more than 3 decades.

As she stands, she pulls a clipping from her purse. "Every year on my daughter and my grandchild's birthdays, I write something in the newspaper," she says. "This one says, 'Thirty-three years without knowing your eyes, your smile, your voice. But I continue fighting and holding the hope of having you share your family with us. And between tears and smiles, you will pass through your true history, each day more present in our lives.'"

She is still searching for Ana, Julio, and the grandchild she has never met.

Nya Quesada, 90
1 GRANDCHILD, 1 GREAT-GRANDCHILD

Nya wears a stoplight red dress and lipstick to match. Married to an actor, she and two sisters were actresses and one, Menchu, was famous.

Nya tours me through the photos of her family members both in and out of costume. Her bookshelves are brimming with awards for her roles in everything from *Richard III* to *Hello Dolly;* she gave her final performance last year. She sets chic, black coffee cups on the cadet-blue tablecloth, and begins to talk.

"One day in 1978, I went to visit my only child, Adriana. She, her husband, and 2-year-old son, Nicolas, were not home. Their neighbors told me they had been taken by force.

My husband and I went door-to-door looking for them. We put an ad in the newspaper saying Nicolas had disappeared. For almost 3 weeks, we went everywhere that had to do with human rights, asking questions."

Although Nya didn't yet know it, Nicolas' appropriators had abandoned him with two suitcases of clothes on the doorstep of the San Martin juvenile court. A secretary who worked there took him home for a few days until the staff could figure out what to do next.

Nya puts down her coffee cup, imagining the afternoon when young Nicholas was allowed to watch TV. "By coincidence, Nicolas saw my sister, Menchu, playing a part in a comedy on television. He screamed, 'My aunt! My aunt!'"

"Menchu, my husband, and I went to the court to get him. Nicolas sprinted to hug us.

"Once someone called to say she'd seen Adriana. That filled me with hope but ended in nothing," Nya touches her necklace: a pendant shaped like a woman's profile drops from the long, silver chain. "Adriana and I got identical necklaces when we were together," Nya says softly. "I wear mine everyday."

Marcos Suarez, 35
GRANDSON OF MODESTO VERGARA DE VEDOYA

I meet Marcos at my hotel just one block from the park where he and his father were last seen before they were disappeared in 1976. As he settles into a chair, I try to imagine the little guy who went to play on the swings under the high, leafy trees where I walked this morning. How did his life unfold?

"Something wasn't right," Marcos remembers. "I was raised by two women: my mother, America, and her sister. I always asked, 'Where's my father?' but nobody would answer. I didn't have much in common with the family. There were no pictures of America when she was pregnant. My birth certificate said I was born in America's house but she was a nurse and nurses don't have babies at home. I lived my life as Gustavo Marcelo but I always suspected there was a ghost of Marcos inside me.

"About 1989, my history class studied the Disappeared. That was the first time I'd heard about them. I was the right age. It became a possibility." His doubts grew as he learned more about the Disappeared.

"When I was 15, I asked America, 'Why don't you have any pictures of me when I was young?' She said, 'I had them all in a bag and left them on the bus.' Left them on a bus? It seemed like a really big lie.

"In high school, H.I.J.O.S., a group of activist children of the Disappeared, told me the Abuelas could do a blood test and end my doubts."

He took the test after he emerged from a 10-year rough patch, taking drugs, getting into trouble, going to jail. "I didn't know it," Marcos says, "but the Abuelas had been trying to find me for years. They'd had a photo of me at age 8 months, on display all over the world.

"The DNA test immediately identified my grandmother, Modesta Vergara de Vedoya. Now, she's 83. I had lived with her in La Plata the first 4 months of my life. When I saw her again at the Abuelas' office, we hugged and both of us knew immediately —we felt it physically—that we had hugged before." Marcos smiles. "I knew her instinctively, I just didn't recognize her." Modesta had searched for 30 years to find Marquitos, Little Marcos.

By the time he discovered his true identity, Marcos had a son, 10, and daughter, 8, who found the revelation that they had a whole new family bewildering.

He began piecing his story together, talking with relatives; combing through insurance company, hospital, court, and government records; pouring over files in the Abuelas' library. America had died of cancer but her sister contributed details. By now, he says, he has accounted for all except 4 days of his life.

"I now know that my parents were medical students, both politically active. My mother was disappeared in October 1976. My father and I were disappeared that December. Within a week, my appropriator left me at the hospital where America worked, because I was sick with a respiratory infection. America, already 43 and wanting a baby, took me home. Her mother commanded, "Take him back!" but she didn't. At first, I was furious that America lied to me all those years.

"Ultimately, I felt relief. Now I use my own name. I know that the ghost of Marcos inside me was real: I wasn't crazy. And I know my parents wanted and loved me."

Today, Marcos works for CONADI, Argentina's National Commission on the Right to Identity, which helps the Abuelas locate disappeared children.

Rosa Tarlovsky De Roisinblit, 91
2 GRANDCHILDREN; 2 GREAT-GRANDCHILDREN

Rosa sits at her desk in her business suit and pearls. Patricia, her disappeared daughter, looks down from a portrait on the wall, as present in this office as she is in her mother's life.

Patricia was pregnant when she was disappeared with her husband in 1977. Their daughter, Mariana, was safely visiting her paternal grandmother.

"In 1983, a woman who had been in the concentration camp told me that my grandson was born on November 15, 1978." (Like others in Buenos Aires' large Jewish community, Rosa uses the word "concentration," instead of "detention," to describe the camps.)

Years later, Rosa's granddaughter Mariana, was volunteering at the Abuelas' office and answered an anonymous call from a woman who described a boy born on November 15, 1978." Certain she was about to find her brother, Mariana ran from the office and went to the place where the caller reported he worked.

"It was a complete surprise to him," Rosa continues. "That very afternoon, he was in our office

with his arm out saying, 'I want my blood tested to see if this girl is my sister.' The National Genetic Data Bank already had my blood. We sent his off.

"I was in Boston when I received the call saying, 'Rosa, he is your grandson.' Screams, tears, laughter, and joy! I went home, excited to get to know him.

"When his appropriators were sent to prison for their crime, it was very, very hard for him. He and I have a good relationship but he is still attached to the woman who raised him.

"He wanted to keep the name Guillermo, even after learning that my daughter named him Rodolfo Fernando. He is now Guillermo Rodolfo Fernando Roisinblit. His wife agreed to use the name Roisinblit. 'Our heirs will hold the family name for us, grandmother,' he promised."

His sister, Mariana, grew up to be a prize-winning playwright whose work has been performed at the Theater of Identity.

Rosa, Vice President and spokesperson for the Abuelas, has traveled "everywhere" to bring the grandmothers' voices to the world, promote the universal right to identity, and search for her daughter, Patricia.

Alejandro Pedro Sandoval, 33
GRANDSON OF CLELIA DE FONTANA

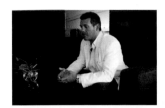

Alejandro's white linen jacket makes him look as if he just stepped from the pages of GQ. I have never before seen a man wearing a thumb ring. His appearance broadcasts privilege so I'm not surprised when he tells me, "I had a really good childhood. I lacked for nothing economically and emotionally. I never suspected I was an appropriated child."

His days were filled with rugby matches and cookouts in a suburb full of gardens and Tudor Houses. Unbeknown to him, "My appropriator was always part of the intelligence apparatus in Argentina. This was a man who knew how to move the pieces of a puzzle, to make a person love him."

"When I was 26, I was driving with my appropriator and he asked me to pull over because he had something to tell me. He began to cry. He is 6 feet tall; I had never seen him cry. He asked forgiveness. 'You were adopted. You are a child of the Disappeared.'

"A month later, I picked up the newspaper and read about a retired military officer who had been detained for stealing a child of the Disappeared. That retired military officer was my appropriator. Within a week, he had been arrested and sent to military prison.

"The court ordered DNA samples to see if I was his son. My appropriator telephoned me: 'In 48 hours, there will be a raid on my house to collect articles with your DNA and mine. Give them things with only my DNA: my toothbrush; your jacket with my hair on it.' It was as if he were giving an order. I did as he requested but the police guessed something was fishy. Since this was a farce anyway, I brushed my dog's teeth with a toothbrush and ran a comb through my dog's coat. Obviously, when they found animal DNA, they knew the samples were not mine.

"Six months later: another court order, another raid. This time they got articles with my DNA."

"By 2006, the Abuelas had a vast National Genetic Data Bank. My sample matched my maternal grandmother's. Her name is Clelia Deharbe de Fontana, and she was 78 then. I first met her at the judge's office. She came with my grandfather and uncle. For them, it was amazing. For me, it was strange."

The group stood looking at each other until Alejandro's uncle, Edgardo, said, "Well, here we are, so let's meet!" Alejandro's grandparents hugged him and cried. His grandmother was filled with joy after searching for Alejandro for 29 years. Uncle Edgardo was gratified to witness the end of this odyssey since he had introduced Clelia to the Abuelas long ago.

The Grandmothers had set their sights on Alejandro's appropriator decades before. Thanks to them, he was subpoenaed in 1985 and again 2002. Thanks to them, in 2004, he was arrested and put in military prison where he managed to delay his trial for five years.

Alejandro had a difficult time pivoting from one to another identity. "After I found out who I really am and who my appropriator really is, I went crazy for 2, 3, 4 years. You feel pain, guilt, sadness, rage. Everything. "

In 2009, the judge sentenced his appropriator to 16 years behind bars. Alejandro decided to break the tie with him.

"I visited him in prison. As he came in, he was yelling, 'This is all your fault! Your fault!' 'Why?' I asked, 'You're the one who committed the crime.' My appropriator's face hardened and he yelled, 'It's your fault' one more time. His wife had obtained documents saying she was mentally ill; she was set free. I have not seen either one again."

Like Marcos, Alejandro began to research his life narrative. "My parents were taken from my grandparents' house in 1977 when my mother was 20 years old and 2 months pregnant. She was an activist with Father Mujica, who helped the poor. My father co-founded MR 17 and brokered an agreement between Peron and Castro. I was born in Campo de Mayo, the military detention camp where my appropriator worked." Alejandro doesn't mention that right now, ironically, his appropriator is incarcerated at Campo de Mayo.

"Now I know who I am, who my family is, who my parents were. I am proud of them and what they did."

Thinking about the volcanic changes in the past 2 years, I ask how his life is now. "The last 2 years have been intense," he nods. "And to make things more complicated, I fell in love. I've been living with Julia but we couldn't get married because I didn't have documents in my real name."

Then he smiles, "Now I do."

Estela Barnes De Carlotto, 80

14 GRANDCHILDREN

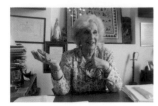

Last week when I got to the Abuelas' office for my appointment with Estela, who's led the Abuelas for 22 years, her assistant asked me to "come back next week." Estela was hosting the President of Brazil. Why hadn't anyone called me to cancel? Today, I wait again in their high-ceilinged reception room, still feeling annoyed.

Some people say the Abuelas should be apolitical and feel Estela is too close to President Cristina Kirchner. That relationship probably helped get the 2009 law passed that made DNA testing mandatory for everyone suspected of being an appropriated grandchild. A controversial case is now in the courts to determine whether that law is an invasion of personal privacy.

Estela arrives, a polished, elegant woman, a grandmother-version of Bill Clinton: intelligent, charismatic, and charming. She wins me.

Like many grandmothers, she is still searching for a grandchild. "In 1980, another grandmother and I traveled to Brazil. We met a refugee, a woman attorney, who knew my daughter, Laura, in the concentration camp. She told me that Laura had given birth to a boy in June 1978. She said the baby had been given to his grandparents and Laura had been released.

"I said, 'Our daughter was assassinated on August 25, 1978. Her body was returned to us. I couldn't look, she was so disfigured by bullets.' 'No!' the woman protested. 'They let her go! I loaned her a black bra. She said goodbye to us!'

"We were both too upset to continue: I had found out I have a grandchild, Guido; she had discovered that her friend was dead."

In 1985, the Abuelas initiated a lawsuit against the generals responsible for disappearing and appropriating children. In 2011, the trial finally started. One of the 34 cases involves Guido. Estela began preparing evidence long ago.

"We asked that Laura's body be exhumed to prove she had been pregnant and tortured. The judge authorized it. I went to the cemetery with an Argentine team of forensic anthropologists and a forensic scientist from Chicago, Clyde Snow. When we saw the remains, the first thing we discovered was that she was wearing her friend's black bra.

"Clyde Snow said, 'Estela, the process of giving birth leaves marks on the pelvic bones. You do have a grandchild.' I love all my grandchildren, but my most important obligation is to find Guido."

Estela was a school principal before she became President of the Abuelas. I ask how she made the transition. "I've always been a defender of human rights, life, and justice. When Laura was assassinated, something else came out: strength."

Her answer doesn't quite explain how she learned to manage a complex organization with staff, international chapters, volunteers, performances, and a presence on Facebook. "Facebook? Not me! I'm an old woman. I use pencil and paper!" she laughs.

I reflect on her life: "The Abuelas have recovered grandchildren, changed Argentine law, changed international law, developed a blood test that's accepted as legal evidence worldwide, created a DNA data bank. You have raised 3 children, loved 14 grandchildren, and searched for Guido. Of all the accomplishments, what makes you proudest?"

Estela reflects. "Meeting each grandchild. In the beginning we looked for a little baby. One day, we have in front of us, a grown person. Meeting again is a miracle. Almost like a resurrection."

Opposite: *The Tree of Subversion graphic was a teaching slide used in a counter-terrorism course for Argentina military officers during the dictatorship.*

Spiritual Life: Laos

The old city of Luang Prabang occupies a finger-shaped peninsula bordered on one side by the Mekong and on the other by the Nam Khan Rivers.

The monks set the city's rhythms. At 6 AM, they come clad in orange robes tied with chrome-yellow belts, walking barefoot, single file, silently, past believers who kneel and place handfuls of rice in their alms bowls to make merit and give the monks support and succor. At 5 PM, the monks slip off their sandals on the steps of the temples, then enter to chant together; deep, resonant sounds invade the darkness.

More than 30 gilded, sparkling, Buddhist temples qualified Luang Prabang as a UNESCO world heritage site in 1995. The ancient buildings speak eloquently of the time when the city was the capital of the Kingdom of a Million Elephants; a royal city led by a Buddhist monarch. Luang Prabang was named for the revered Buddha image brought for the King's coronation in 1353. Today, almost all Laotians follow Theravada Buddhism, "the way of the elders."

Tourist trappings are omnipresent: Internet cafes, bike rentals, money exchanges, souvenir shops, massage parlors, and travel agents hawking "Trips to the Waterfalls!" A French gloss, left from the time Laos was a colony, still shines: two-story buildings with balconies, tall louvered windows, dark wood floors, and antique European furniture. The streets are crowded with westerners from France, Italy, Germany, Australia, New Zealand, England, and America.

At dusk, Hmong grandmothers unfold red umbrellas, light their lanterns, and stock their stalls. Souvenir shoppers examine handmade coin purses, hats, hot pads, bookmarks, dolls, slippers, and scarves.

I have come to meet weaving grandmothers who create fine silks, who learned from the women before them and teach those who follow them; savvy businesswomen-grandmothers who started the Night Market; religious grandmothers, whose spiritual lives lead some to the temples as *Nang Khao* (celibate women who live as nuns and pursue contemplative practices) while others create offerings for weddings, funerals, and ceremonies.

Grandmothers in Luang Prabang become increasingly spiritual, turning from textiles and the tourist trade, to rituals, ceremonies, and temple life.

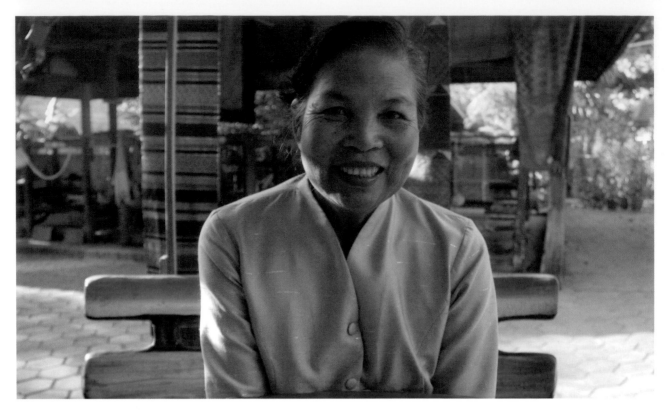

BangOn Douangdala, 58
4 GRANDCHILDREN

Silk cloth wafts in the breeze at the Lao Natural Textile Dyes boutique, the business BangOn launched in 1993. The rich colors and intricate patterns of the silks tell tales of *nagas* (water serpents, the most powerful creatures in the Buddhist canon), the strong elephant-lion, the magical horse, and many more. Silk making is the legacy of the Lao-Tai grandmothers.

As we sit at a little green table in her garden in Ban Xang Khong, a village not far from Luang Prabang, BangOn snuggles her youngest grandson, Alanva, who is 10 months old.

She learned to weave 51 years ago but now she focuses on dying silk and teaching. Her compound includes a pavilion with 10 looms where she leads workshops in response to a request "from the Governor of Luang Prabang province to increase the beauty and quality of local weaving."

In 2006, the Governor invited foreign VIPs to visit her shop. When they arrived, "I gave them a flower, some water, and a tour," BangOn remembers. "I saw many of them on television at an ASEAN meeting after they were here, and they were all wearing their purchases."

That visit resulted in a shelf-full of framed photographs: the Prince of Luxemburg; Singapore's Minister of Education; the Former Governor of Bangkok; the President of Mongolia; the Deputy President of Viet Nam. After that, luminaries kept coming. "Last month, the wife of the Crown Prince of Thailand visited," she says.

A master dyer, BangOn learned from her older sister while growing up in Xam Neua, a city in Laos' main silk-weaving province. She raised silk worms as a child, and learned to weave patterned silk when she was 12.

These days, her grown children run her shop. "That gives me free time to go to the temple, which makes me happy. "

She donates her weaving income to many temples. "I am now supporting the Had Siaw temple across the Mekong," she tells me. Wat Had Siaw is hidden in the forest near the riverbank. There are cracks in its sanctuary walls and its painted murals are damaged.

"I have happily given some temples $3,000 to build a stair or water tank, depending on what they need. When you have enough to eat and use, you must share. If you do good things, you will be born again."

Recently, BangOn donated a long, narrow strip of property to a temple. "My first idea was to run a resort on the land, but it was too close to the temple and that would have been inappropriate. I gave the property to the temple as a sacrifice."

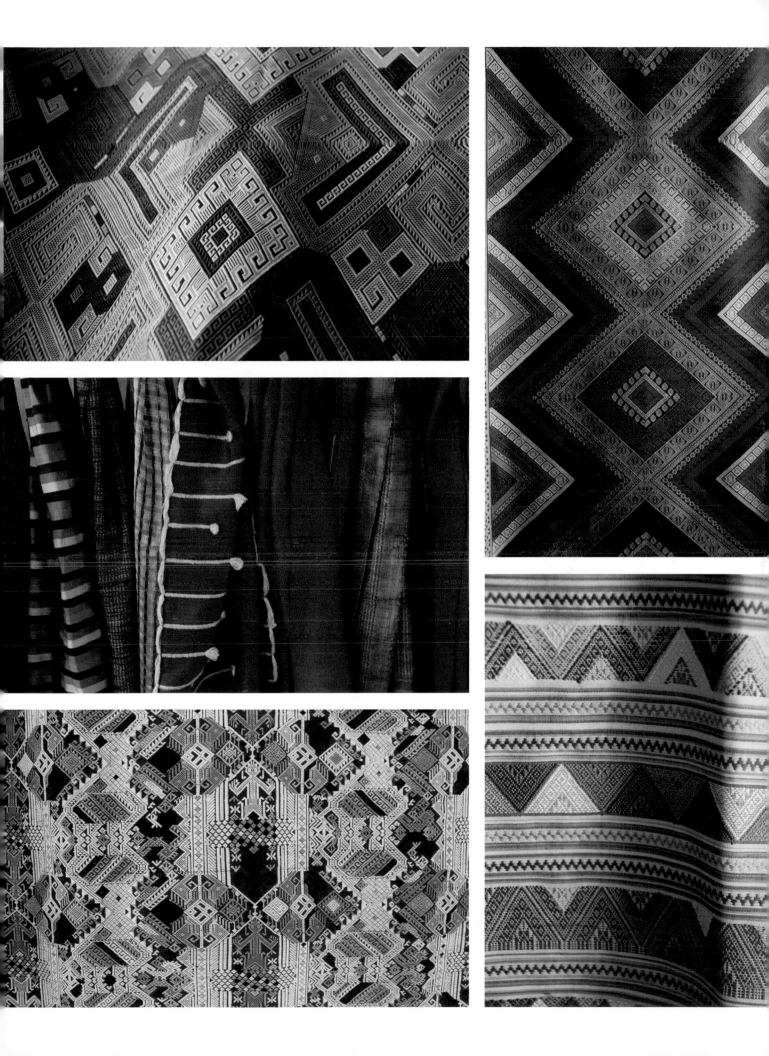

BangOn is "considering becoming a nun. I sleep at the temple every night now. During *Khao Pansa* (Buddhist Lent), there is a three month Rains Retreat. I will stay full time at the temple."

BangOn's plan is unusual. Although most men in Laos join a monastery for at least a short period, there are only about 400 women who become nuns, in part because full ordination of nuns has never been practiced here. Some Laotian women have been taught they cannot reach enlightenment unless they are reborn as men.

Several abbots in Luang Prabang believe the exclusion of women contradicts Buddha's teachings about equality. After all, he preached to men and women alike and recommended the renunciant path as the most effective way to achieve liberation. Many women were attracted to this path, including Buddha's stepmother and aunt.

Absent full ordination, only Vipratsana meditation is open to women. It aims to attain contentment and perceive all forms of reality. It requires exacting exercises plus living away from stimuli such as colors, sounds, smells, and community.

Anticipating her move to the monastery, BangOn has evaluated her assets, "I have enough money for the children," she says. She is in the process of transferring her business to her 38-year-old son.

Her legacy is assured. She has taught her 16-year-old granddaughter and her daughter, Veomanee, to weave. "My dream is that they will have money and will preserve the weaving tradition."

Women who retreat to Luang Prabang's monasteries observe eight precepts: refrain from killing, stealing, lying, intoxicants, wearing ornaments, singing and dancing, using luxurious beds or chairs, and sex.

"What does your husband think of this?" I ask. BangOn responds, "I told him that we are old enough. He said nothing." (I suddenly remember a cultural primer distributed by the Canadian Development Agency that says, "Acceptance is the Lao worldview: things are as they are and should be. I am responsible for myself and you are, for yourself. There is no need for discussion or confrontation.")

I reflect on the life expectancy of women in Laos: 66. And I appreciate how thoughtfully BangOn, now 58, vibrant and successful, is planning her next chapter. She says, "It is time for me to build a spiritual life. To live a holy life. When you die and separate, you will be holy if you do something good. I want to be a nun. This is my way."

At the monastery she will wear a simple white cotton robe, live on food donated by the lay community, eat nothing after mid-day, and meditate for an hour in the morning and evening. I ask if she is considering shaving her head but she smiles, "Buddha taught me that I can be a nun with or without hair."

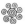

BangOn's friend's son is getting married this afternoon and she has arranged an invitation for me. We enter through the garden where hundred of tables are being set with cerise, pink, and white cloths for the reception this evening.

All the furniture in the large living room of the bride's parents' home has been removed to accommodate the family and close friends who sit on the floor around the couple. Each woman guest wears a beautiful, woven scarf over one shoulder.

The bride's embroidered blouse, intricately patterned forest green silk ceremonial sash and *sinh* (skirt) sparkle with golden thread. Her hair has been smoothed into a conical bun. She kneels next to the groom who wears a crème-colored silk gabardine jacket and forest green hip wrap.

Behind the couple are two elaborate *phakhuanes*, floral arrangements created by the grandmothers: spires of marigolds mixed with candles in a silver bowl surrounded by ritual foods including rice, egg, chicken meat, candies, and charms. Each item has a special meaning, which the grandmothers understand well. (Their understanding also equips them to prepare for birth ceremonies, festivals and New Year celebrations).

The Baci ("baa-see") ceremony, although Buddhist, is not conducted by a monk, but instead by a revered elder whose marital happiness is a model for the new couple. The ritual culminates when each guest ties a white blessing ribbon onto the wrists of the bride and groom. Crisp paper bills are tied in, too. Ultimately, their wrists flutter with ribbons and money.

The couple rises and walks to the stairs with the grandmothers close behind carrying the floral arrangements, which they set near the nuptial bed that is scattered with red rose petals. The couple kneels, and then climbs onto the bed together.

Wide eyed, I wonder what will happen next but it turns out this is only a photo op. Serially, family and friends join the bride and groom on the bed to pose for formal wedding portraits.

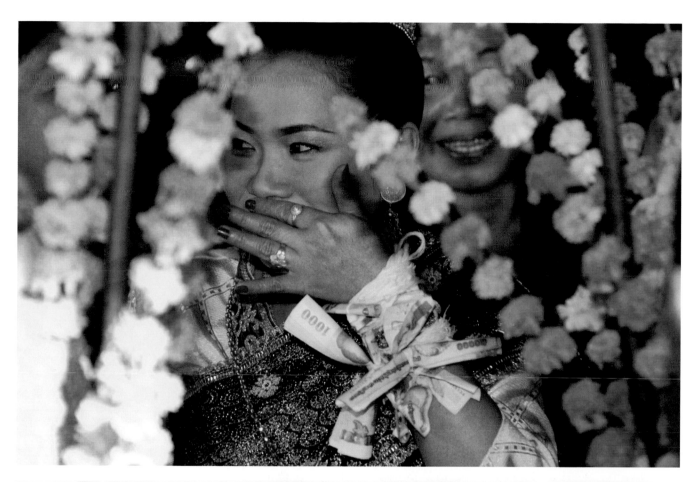

Veomanee Douangdala, 35
1 SON

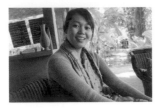

BangOn's daughter, Veo, co-founded Ock Pop Tok (East Meets West). The enterprise now operates three retail galleries, a demonstration center, a café, a guest house and a nonprofit foundation, Fibre2Fabric, which is dedicated to preserving Laos' weaving traditions.

Ock Pop Tok offers tours and classes for visitors in Luang Prabang, and sells its silk products in Singapore, Sebastopol, and Santa Fe. Laos' average per capita annual income is about $900 but Ock Pop Tok weavers earn that in 6 weeks.

The Living Crafts Centre is a mile from Luang Prabang, easily accessible via a noisy *tuktuk*. My driver darts through the motorbikes, then dives off the main street. We bounce down a dirt road through the woods toward the river, then through a gate, and there, in a Mekong garden, is the Centre.

Veo has invited me to lunch. We sit in rattan chairs under a ceiling swagged with silk. The menu includes her favorites: riverweed with buffalo chili sauce; fried silk worms; silkworm poo tea. Blinking, I order the Weaver's Lunch, noodle soup. It's delicious.

"I learned to weave from my mother when I was 8 years old, starting with the simplest patterns," Veo begins. "I would try to think of new designs and weave more and more difficult patterns. Learning the old ways is important because it shows respect for our parents and ancestors. But trying new things and pushing the boundaries is part of being an artist."

In 2000, Veo co-founded Ock Pop Tok with Joanna Smith, a British photographer and graphic designer. They fused western design and color with Laotian patterns and methods. Last week, they celebrated the organization's tenth anniversary by staging a weaver's parade and fashion show. The 10-foot-long *naga* (sea serpent) sculpture created for that party, still patrols the garden.

Ten years ago, Jo, who had just graduated from university in London, volunteered to teach English to children in Luang Prabang. On her motorbike, she visited Veo's village, Ban Xieng Leck, about 3 miles out of town. Veo spoke excellent English, having left high school to work in one, then another, hotel. Jo asked Veo to teach her to weave, then designed a traditional Laotian *sinh* (skirt) for each of them.

"It was a very different, interesting design," Veo remembers.

Veo suggested that they start a gallery shop below Jo's apartment, but Jo set the terms, "This is about fun and friendship." Jo's photographs of local temples inspired many of the new designs the shop stocked in addition to the traditional patterns that they commissioned Veo's mother, BangOn, to weave. Veo admits, "We paid her after we sold her work." Another, then another, weaver joined the team.

Today, there are 30 weavers working for Ock Pop Tok, compensated with salary, paid holidays, health plan, food stipends, and training. "For women, weaving means earning money, making more decisions, and ultimately becoming the leader of the family. Just ask my Mom," Veo smiles. But she admits, "Some Lao men are ashamed to make less than their wives." Like it or not, women's new economic power often offsets the socially sanctioned male domination.

The Lao Tourism Authority funds Ock Pop Tok's Village Weaving Project. Weavers from about 30 villages visit the Centre in rotation to learn color, technique and design. In turn, Ock Pop Tok learns dye recipes.

Visibility is growing. *O Magazine* featured Veo and a hand-woven scarf in July 2010. Now, five months later, "We are still getting orders," she says.

The Mekong's tide is so low that a lone fisherman climbs out of his boat and pulls it along with a rope. After lunch, I watch his progress through organza prayer flags in the Ock Pop Tok gallery. The natural hues of the beautiful weavings could only come from turmeric, olive, tamarind, indigo, teak, and ebony.

The next evening, the Fibre2Fabric gallery hosts the opening reception of its new exhibit, *Telling Stories: Legend and Meaning in Lao Textile Motifs*. The centerpiece is a great naga created from silk and cotton scraps saved by Ock Pop Tok's tailors and dressmakers. The serpent sways from the ceiling on invisible strands. As western tourists sip white wine, I marvel at the weavings, each completely different from the next.

There are patterns derived from house gables and stairs, ferns and flowers, lightning and clouds, fish bones and animal teeth. There are symbols for water and the sun. One skirt, woven in a southern province near Vietnam's Ho Chi Minh Trail during the 1970s, features an American military helicopter flying through a sky filled with birds and parachutes.

The silk textiles in all three Ock Pop Tok shops are works of art. The weaving is even and taut; the dye colors are elegant and subtle; the patterns are infinitely complex. I have admired weaving all over the world. This is some of the best I have ever seen.

Khampaeng Phonetilath, 50, 4 GRANDCHILDREN
Bualy Thilanthakoun, 54, 3 GRANDCHILDREN
Vanh Sipasert, 58, 7 GRANDCHILDREN

Three of the weavers working at the Living Craft Centre's pavilion are grandmothers, from the village of Ban Moo. They work at Lao-Tai looms made of wood and bamboo, which were built by their husbands.

They take a break to chat with me over tea in the café and as they lift their cups, I notice that each woman wears a bracelet of holy threads that have been blessed at the temple to bring health and good fortune.

All 3 learned their skills from their mothers when they were about 10 years old, and in turn, they have taught their own daughters. Bualy's daughter also weaves here.

"The weaving our mothers did was very different," one observes. "They farmed the silk worms, and did the spinning. We taught our daughters those skills—but today we buy finished silk and just dye and weave it."

Another explains how the trio got here. "The only male weaver at Ock Pop Tok came from our village. Two years ago, he recommended us. The patterns we do now are very different from what we did in Ban Moo. The wedding patterns stay in the village; we do them here only by order. Here, we make every design: old ones, modern ones. The manager gives us many new patterns to weave and they are beautiful!"

"What hopes and dreams do you have for your granddaughters?" I ask. They agree without hesitation: "That the girls will live 'The Weaving Life' and keep the silk tradition alive for the future."

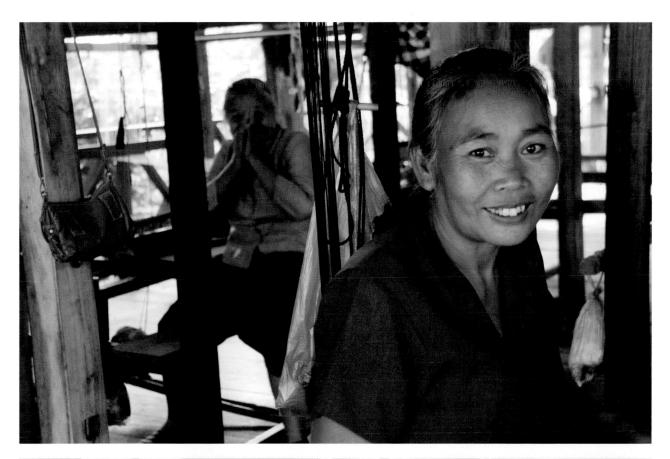

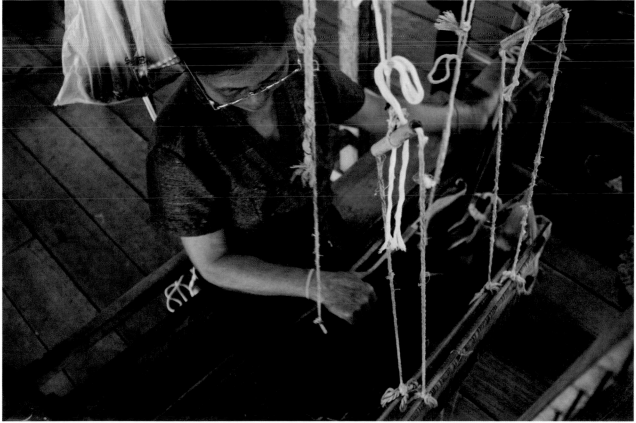

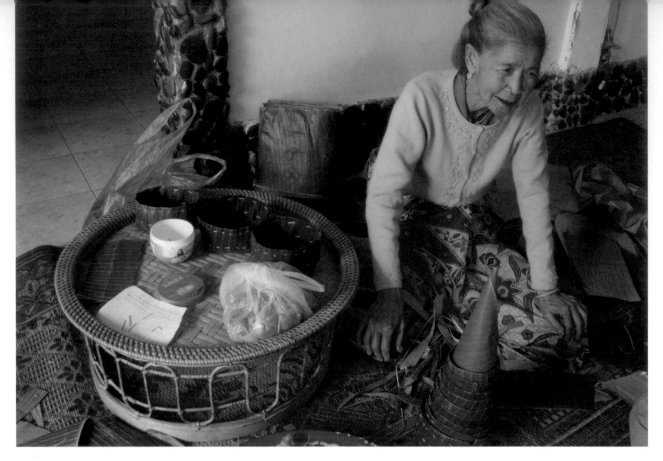

Chanpheng Chalewnphon, 81
4 GRANDCHILDREN, 5 GREAT-GRANDCHILDREN

Veo and BangOn have arranged for me to spend the morning with Chanpheng, a family friend.

Just as proud of her grandchildren as any of us, Chanpheng gives me a tour of the pictures on her walls and bookshelves: "She was Miss Luang Prabang 2008, and went on to become Miss Lao New Year," Chanpheng smiles. Another granddaughter was Miss Lao New Year in 2001 and still another, in 1999. "This grandson is studying law in China. This granddaughter is married to the Laotian Ambassador to Myanmar."

She settles on a mat on the floor near a low table that's brimming with banana leaves and marigolds. She is creating a temple offering to ensure that her nephew's surgery goes well. He now lives in the United States, and relatives there sent her $100 to buy supplies and make the *Mak Boeng* (offering) that she hopes to finish tomorrow afternoon and deliver to the temple so the monks can bless it. As she works, she talks about her life.

"I was number 8 in a family of 12 children, 6 boys and 6 girls, born in the village of Xieng Thong. I was shy and uneducated, not a flirt.

"My husband was a widower. My parents thought marriage was a good idea. Then, husbands were supposed to be at least 10 years older and my parents liked the fact that he was in government service. My father was District Governor and later, so was my husband.

"I was 21 and he was 40 when we were married. We loved each other. He took me to parties every time he was invited. We were very happy until he died 20 years ago.

"When I was about 30, we went to Bangkok for a month. We flew there and Laos' Ambassador to Thailand picked us up at the airport. My husband's niece was the ambassador's wife, so we stayed at the Embassy. We visited many places in the city and countryside. We took the train back home and saw even more."

As she begins to add rows of marigolds to the offering, I ask how most grandmothers in Luang Prabang spend their days. "They go to the temple morning and evening. Cook rice. Work in the house. And teach their grandchildren to do the right things. I was lucky," she admits. "My grandchildren listened to me. But it was lots of hard work when they were young.

"Because everyone is grown, I have time to make offerings to earn money. I am happy to do these things. If I give money to the temple, I will be reborn."

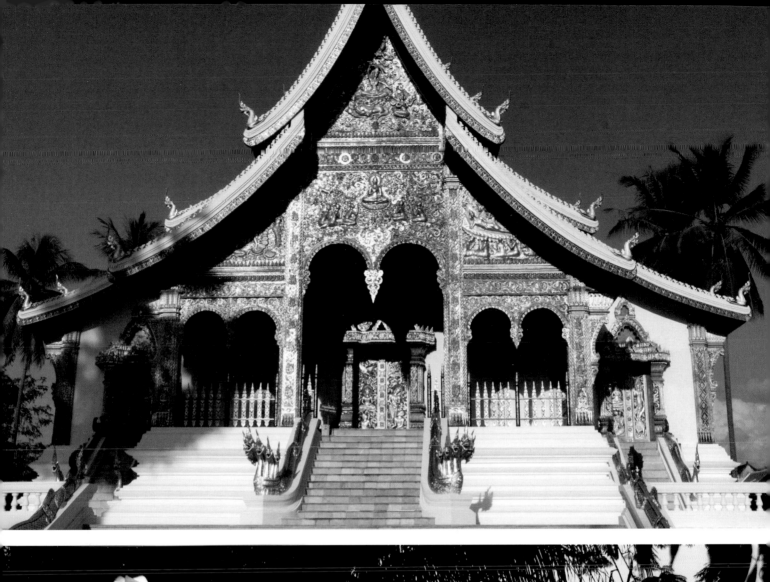
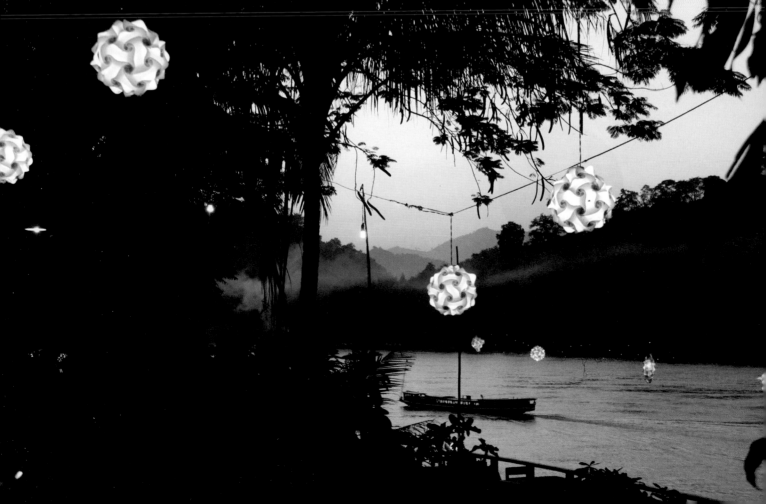

Sou Xiong, 65
7 GRANDCHILDREN, 1 GREAT-GRANDCHILD

There are many ethnic groups in Laos, including about 400,000 Hmong. Sou, a talented grandmother, demonstrates at the Ock Pop Tok Living Craft Centre where she also teaches.

When she was 6, Sou's mother began showing her how to make batik: weave the hemp fabric, draw on it with a wax resist, and dye it. "After I married at age 12, my husband's mother continued my lessons." Sou remembers. "And later, I taught my daughters and granddaughters."

"Did your grandmother do batik?" I ask. "Yes, my grandmother and my husband's grandmother knew batik well." I can't help counting: five generations of batik experts! Ultimately, Sou became the batik specialist in Phou Luang Tai, a village "surrounded by 3,000 rice fields."

Although Sou is not wearing batik at the moment (she sports a pink hoodie that has "New York City" written in script on the back), she creates batik to be worn everyday as well as for festivals, parties, celebrations, and funerals. (Every Hmong has a set of beautiful clothes to wear to their own funeral; women devote many hours to embellish the panels and collars of these outfits.)

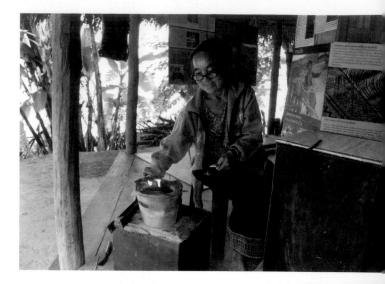

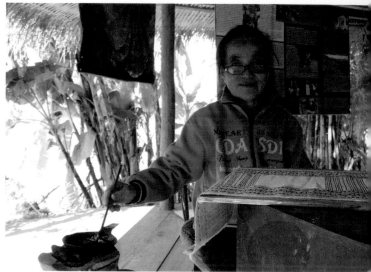

Hmong women wear an elaborate, brand-new outfit for New Year, *Nor Phe Chao,* which starts on the first new moon of the 12-month lunar cycle. This year, New Year falls on December 10, a month from now. Sou is finishing her costume, which she has been working on for 6 months. She does all the appliqué and batik work herself, but she saves enough time to finish skirts that other women order.

"On New Year's day, I wear my new outfit and watch the boys and girls sing and toss balls," Sou says. People from many villages will gather. The boys line up on one side, the girls on the other and toss cloth balls between them. If someone misses or drops the ball, she or he must give the person who tossed it an ornament, redeemable by singing a love song. Frivolity marks the games and if a boy likes a girl, he will ask her to marry him.

Sou met her own husband tossing balls on the first day of New Years 53 years ago. When his parents saw her in her costume, they marveled, "Such a lovely couple!" and agreed to the marriage. "That day was

very, very happy," Sou remembers. "For my husband and me, it was love at first sight."

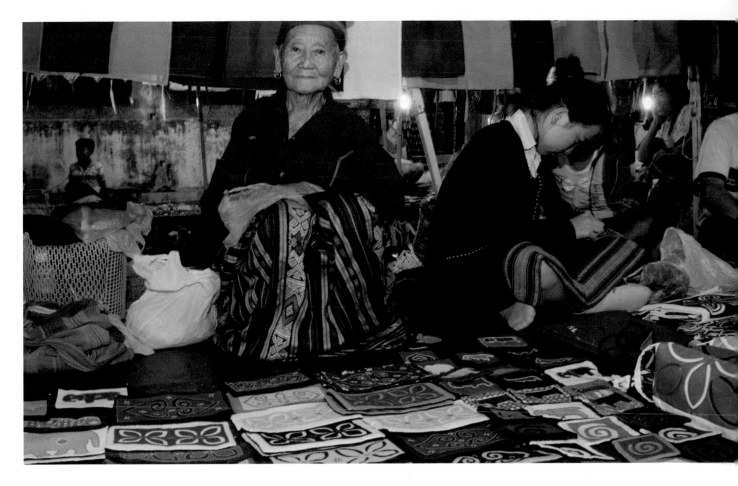

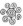

Hmong grandmothers were the founders of Luang Prabang's Night Market. *Sisavangvong Road,* the main street in old Luang Prabang, is closed to traffic daily between dusk and 10 PM. Hundreds of stalls materialize, full of souvenir handicrafts that tempt tourists to stroll and shop in the cool evening air.

The Hmong people migrated from China in the 18th century and lived at high altitudes where they practiced swidden (slash and burn) agriculture. When the fields were depleted, whole villages moved. When the Lao government outlawed opium, Hmong poppy farmers, at the bottom of the economic pyramid, were relocated to cities. The Hmong still live together in their village groups, even in Luang Prabang.

One vendor, Mrs. Song, 55, who has 23 grandchildren, began selling crafts in 2002. She remembers, "The market began with three Hmong women selling in the middle of the day. Foreigners said it was too hot and they were too sleepy to shop at noon; they wanted to shop at night. So here we are.

"In a good week, I can earn $75 but in a bad week, $25. There are many more sellers here now. Many of the vendors are not grandmothers and many are not Hmong," she says, glancing at the surrounding stalls.

Mrs. Ban, 73, is a Hmong grandmother of 19, all of whom, she tells me, "want money. Sometimes they cry to get it." During the days she works in the rice fields. During the evenings she sells at the Night Market and has since 2004. "It's a good business. I move my stall around to get better traffic. November/December, around Hmong New Year, is our best season. I met my husband on New Year when I was 15. We loved each other and that night we got married," she says.

When I ask whether she has her New Year outfit ready, she responds, "Yes, but we White Hmong do not wear hemp or batik like the Blue Hmong." (Hmong clan names derive from the dominant colors in their traditional costumes; in Laos there are White, Blue, and Striped Hmong.)

The next grandmother I talk to began selling in 2006 to help support her 17 grandchildren. By that time, she says, there were "10 or 20 vendors." I keep walking and chatting, buying a souvenir from each grandmother I talk to.

Instead of giving me coins as change, they wheedle me into selecting "just one more small item." Bewitched by the grandmothers and by the glowing light of the lanterns in the Night Market, this creative selling actually makes sense.

Spiritual Life:
Indigenous Grandmothers

Road signs on Arizona's N17 hint at the American west's past: a town named Bumble Bee; Big Bug Creek; Badger Springs and Bloody Basin Roads; Horse Thief Recreation Area; Dead Horse Ranch State Park; 1000 Trails Road.

North of Phoenix the earth is peach-colored, blanketed by sage and saguaro cactus, bordered by high mesas. Cottonwood, population 3,000, looks like a metropolis. Tall trees with yellow leaves dance in the strong December wind. The highway climbs past emergency off ramps for 18-wheelers.

Suddenly, the road curves into a valley where the afternoon sun strikes spires of red rock. I pull over, awed. Sedona is a glorious place to meet grandmothers who believe that human beings, the earth, and everything on (and off) it, are One.

For a thousand years, this area was home to the Sinagua Indian tribe. Today, it hosts the annual Hopi, Navajo, and Native American Culture festivals. This week, it is the site of the Seventh Council for the Next Seven Generations, a gathering of the International Council of the Thirteen Indigenous Grandmothers.

It takes more than an hour to navigate the dusty, rutted, 10-mile road that leads to the Mago Retreat Center, a 200-acre sanctuary where participants are already gathering at the Sacred Fire near 2 white tipis. People enter the ceremonial circle from the east where they are smudged with purifying sage; guests sweep the smoke 4 times across their bodies and breathe deeply.

Every 6 months, the Thirteen Indigenous Grandmothers meet in a different member's homeland. This is Grandmother Mona Polacca's. As our host, she opens the gathering, wearing a ceremonial white deerskin dress with fringed sleeves and a fine beaded yoke. Her mother's people are Havasupai, People of the Blue-Green Waters. Her father's people are Tewa and Hopi, the Sun Tribe.

About 400 participants have assembled from all over the country. Activists. Therapists. An attorney and his wife. A young woman writing a book about dance. Some are bundled against the cold but many wear accessories that reflect indigenous cultures: a porcupine-quill necklace, beaded bracelets, embroidered textiles from China, paisley scarves from India, knitted caps from Ecuador.

The Thirteen Indigenous Grandmothers were first convened in 2004 by Jyoti, a descendant of the Cherokee Nation. Jyoti remembers that people in the spiritual community that she co-founded, Kayumari, "started receiving promptings. Many of us started hearing the words, 'When the grandmothers speak...'

"Then people started telling us the prophecy of the Eagle and the Condor," which promised that one day elders would gather to share different traditions, medicines, and healing ways with all humanity.

"In 1998, during a ceremony," Jyoti remembers, "The Divine Mother came to me. She said, 'I am going to give you one of my most sacred baskets. In this basket, I am going to put some of my most cherished jewels. Those jewels represent lines of prayer that go back to the original times. Do not mix them. Do not change them. Protect them and keep them safe. Walk them through the doorway of the millennium and hand them back to me. I have something we are going to do.'"

Over the next few years Jyoti discussed her mandate with two indigenous grandmothers, both healers. She visited Bernadette Rebienot in Gabon and Maria Alice Campos Freire in Brazil's Amazon rainforest. Synchronistically, both women had just signed petitions urging indigenous people to unite and become guardians of the planet once again. They both urged Jyoti to act. "It is time."

Thirteen Indigenous Grandmothers conduct healing prayer ceremonies for peace.
Opposite, *Nepalese shaman Aama Bombo swallows fire to purify, bring light, and honor God.*

Through her worldwide spiritual network, Jyoti identified indigenous grandmothers, all legends in their own communities: shamans, healers, curanderas, mediums, medicine women, and spiritual leaders.

She invited 16 of them to gather October 11-17, 2004 in the Dalai Lama's Menla Mountain Retreat Center in Phoenicia, New York. The Center is on Iroquois land, an appropriate site because the Iroquois always consulted their own Council of Grandmothers before making any decision.

Of the 16 grandmothers whom Jyoti invited, 13 came. Only a few knew each other, but immediately they recognized that they had been called to answer an ancient prophecy: "When the Grandmothers from the four directions speak, a new time is coming. And they will come to shake the world awake." And indeed, the Indigenous Grandmothers had come from all 4 directions.

North:

Rita Pitka Blumenstein, Yup'ik, Alaska

South:

Bernadette Rebienot, Omyèné, Gabon

Clara Shinobu Iura, Amazon Rainforest, Brazil

Flordemayo, Mayan, Nicaragua/Honduras/New Mexico

Julieta Casimiro, Mazatec, Mexico

Maria Alice Campos Freire, Amazon Rainforest, Brazil

East:

Aama Bombo, Tamang, Nepal

Tsering Dolma Gyaltong, Tibet/Canada

West:

Agnes Baker Pilgrim, Takelma/Siletz, Oregon

Beatrice Long Visitor Holy Dance, Oglala/Lakota, South Dakota

Margaret Behan, Cheyenne/Arapahoe, Montana

Mona Polacca, Havasupai/Hopi/Tewa, Arizona

Rita Long Visitor Holy Dance, Oglala Lakota, South Dakota

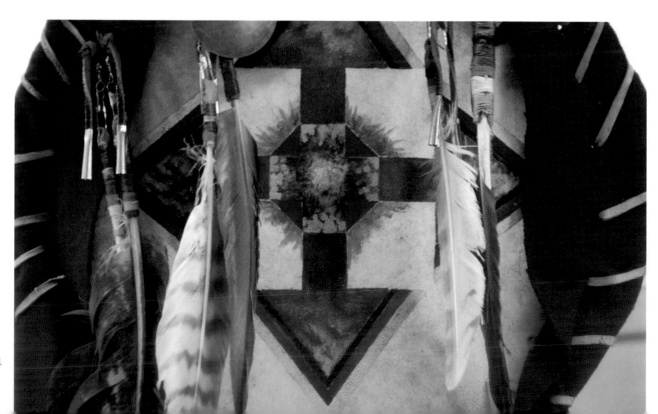

When the grandmothers met, Rita Pitka Blumenstein told them with tears in her eyes, that her own great-grandmother had foreseen that she would participate one day in a council of 13 grandmothers. When Rita was 9 years old, her grandmother gave her 13 eagle feathers and 13 stones to present to the grandmothers when they finally met.

Rita didn't need to explain the mystic significance of the number 13. In ancient times, a year had 13 months and 13 full moons. The grandmothers at the gathering felt that their own grandmothers in the Spirit World were calling them to action.

Despite their differences, the Thirteen Indigenous Grandmothers share a great deal. They are guardians of their families' physical and spiritual well-being and of their tribes' survival.

Second, they share beliefs. Indigenous people have traditionally lived as One with the environment. What happens to Earth happens to them. Some tribes attribute the most ancient memories to stones, the oldest beings on the planet. The Cheyenne and Lakota are taught that their first language came from the animals.

Third, the grandmothers do similarly powerful spiritual and healing work. Visions, dreams, prayer, ceremony, and ritual are conduits to reach the sacred Spirit World through nature. The grandmothers use plants as medicine, and honor the 4 directions and 5 basic elements: earth, water, air, fire, and light.

Finally, all the grandmothers are alarmed by the world's dire condition: violence, war, hunger, poverty, spiritual disconnection, corruption, pollution, loss of human rights, and materialism.

At that first meeting, the grandmothers acknowledged that these crises were urgent. Mona said, "We are in the eleventh hour." Agnes observed, "In Oregon, 200 species are gone." Flordemayo urged, "We must move as quickly as the light." Rita Pitka Blumenstein agreed, "We better hurry up."

The group vowed to form an alliance and share their secret prayers, rituals, and ceremonies in an effort to precipitate global healing. "If our voice is to take wings, we must do it," Julieta concurred.

This is part of the statement they crafted:

We, The International Council of Thirteen Indigenous Grandmothers believe that our ancestral ways of prayer, peacemaking, and healing are vitally needed today. We come together to nurture, educate, and train our children. To uphold the practices of our ceremonies and affirm the right to use our plant medicines free of legal restriction. To protect the lands where our people live and upon which our cultures depend. To safeguard the collective heritage of traditional medicines. To defend the Earth Herself. We believe that the teachings of our ancestors will light our way through an uncertain future.

Agnes Baker Pilgrim, who was chosen as the spokesperson of the Council, proposed that they meet every 6 months to understand each other, touch the ground where each grandmother lives, create a unity stronger than their differences, and catalyze peace.

Since that first meeting, the Thirteen Indigenous Grandmothers have prayed in Saint Peter's Square at the Vatican in Rome. They have had an audience with the Dalai Lama in Dharamsala, India. They have taken action to put water issues on the United Nations' agenda and to preserve sacred sites around the world.

They have been asked to represent the indigenous voice in numerous international summits, and have received resolutions of acknowledgement from the National Organization of Women, the California Legislature, and the Brazilian government.

And every 6 months they hold public gatherings like this one in Sedona, where each grandmother conducts a traditional ceremony and prays for peace. I will interview 6 of the Grandmothers, representatives of the Thirteen.

Grandmother Julieta Casimiro, 74
25 GRANDCHILDREN

Julieta will conduct the first prayer ceremony. She allows me to help her prepare by placing flowers in the red earth around the Sacred Fire, the universal spiritual symbol of energy and awakening. I plant stems of roses. carnations, ganzanias, baby's breath, calla, rubrum, and Peruvian and Madonna lilies. The bright blossoms are the colors of Mexico. On this cold December morning, they seem anomalous and magical.

Julieta stands 13 candles among the blossoms. The tapers are green, blue, yellow, lavender, red, and orange and they symbolize the Aztec's 13 realms of consciousness. She tells me that sometimes her 4-year-old granddaughter places the candles; "a smart girl," she smiles proudly. "God wants candles and flowers to send a message to the spirit in a clean way, to ask for hope, love, charity, and peace."

An image of the patron saint of Mexico, the Virgin of Guadalupe, decorates Julieta's dress. She teaches that the Virgin of Guadalupe is the human embodiment of the Aztec goddess, Coatlique, who gave birth to the moon and stars, as well as the sun god. Coatlique is also called Tocî, "our grandmother." The Virgin, along with the Lady of the Moon, the Lady of the Sun, and the Lady of the Stars, guide Julieta's devotions.

When everyone has gathered, Julieta prays, walking in a circle, tossing incense into the flames, lighting the candles. She says, "We are praying to heal the world. I ask with all my heart: bless my children and my adopted children here. To the sun: may we always have your light..."

She sings in Spanish about "happiness in the house of the Lord," and says the rosary for the world's children. "Santa Maria, Madre del Dio..." she prays, swinging a container of copal incense, "transport us to happiness in the country of the sky..."

Then she prays in Huautla Mazatec, her language. The other grandmothers enter the circle, first turning to face the 4 directions. They pray silently according to their own traditions.

Julieta enters the crowd sprinkling water from a juniper branch on people's heads. She is tiny, but determined to reach high enough. There is delighted laughter all around as she hops, waving the evergreen with its sparkling droplets. People welcome the water and thank her, "Gracias, Abulita."

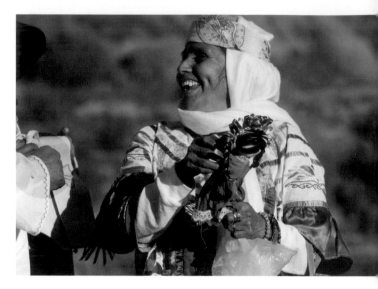

Born in Huautla de Jiménez, north of Oaxaca, Julieta began exploring her healing gifts as a 17-year-old newlywed. Her mother-in-law, a traditional Mazatec healer, taught her. She has, in turn, taught her own children and grandchildren.

"When I am not home, my daughters do my work," she tells me. "They all know how to work the medicine. At 5 years old, they begin to have insight. One of my grandchildren at 3 years old, asked me 'Why are these people coming?' I said 'They come to pray and be healed.' The child's response was, 'OK, I am going to pray with you for them.'"

Julieta's medicine is teonanácatl mushrooms, which she calls "ninos santos" (sacred children). "If it's urgent, people rush to my house. No problem, I can help them. I ask, 'Are you sick? What are your prayers?' If they have trouble with the heart, lungs, ovaries, teeth, or ears—the inside machinery—I put my hand on the pain while they are traveling with the medicine. It is God, through the holy mushrooms, who heals."

Thinking back, Julieta remembers being contacted for the first Grandmother's gathering. "Jyoti asked Guillermo who called my friend Francisca who said, 'Yes, we know a grandmother,' and telephoned me. The first gathering was 2 weeks later—the beginning of the Council, the beginning of the story.

"All the things we have to fix! To bless the children, the places, the world, to work for things that are not in place. We need to pray! I do my prayers. My sister grandmothers each have their own way. But we support each other. People see what we are doing and are happy for that."

Grandmother Agnes Baker Pilgrim, 84
10 GRANDCHILDREN, 34 GREAT-GRANDCHILDREN, 2 GREAT-GREAT-GRANDCHILDREN

Her dragonfly totem appears on her scarf and moccasins. Four years ago, Maori people marked three sacred lines on her chin.

Grandmother Agnes serves as spokesperson for the International Council of Thirteen Indigenous Grandmothers. She has gumption. When I watched the film about the grandmothers, *For the Next Seven Generations,* I applauded when Agnes asked the Dalai Lama, who had just returned from the Vatican, "Is it possible that our Thirteen Grandmothers could have an audience with the Pope?" (The Dalai Lama, who offered to send a letter, teased the Grandmothers, "When you have the audience, you should behave well!")

Agnes is the eldest member of the Rogue River Band of the Confederated tribes of Siletz in southern Oregon, the People of the River. She has been called "the voice of the voiceless," because she uses her simple eloquence to pray, among others, for Bengal tigers, African animals, wolves, salmon, condors, rivers, trees, and water.

She is Keeper of the Sacred Salmon Ceremony, which she reintroduced to the Applegate Valley area of the Rogue River after 150 years. She describes the female salmon. "After the journey upstream to lay her eggs for the last time, she turns back downstream and begins to die. Her flesh falls into the water and nurtures little fish. The remains of her body nourish 33 kinds of birds and 44 kinds of animals who drink from the water, representing unconditional giving and the truth of our interdependence."

Like the other grandmothers, Agnes believes healing the world begins with enhancing individual consciousness. This morning, she intersperses prayers with lessons.

"When I breathe, the trees breathe," Agnes says. My mind flies back to my fifth grade science class: humans exhale carbon dioxide; trees absorb it.

"We are all water babies," Agnes says. I imagine us all swimming in amniotic fluid.

"Our bodies are 75% water," she continues. I remember that newborns have exactly that amount (even though older bodies become desiccated.)

"Without water, we die. I've toured all over the world," she says. "The Ganges, the rivers in Kathmandu, New Zealand, the Mississippi. They are all polluted."

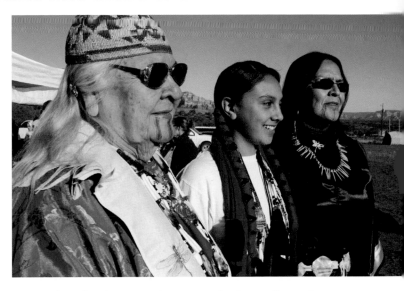

Her shiny bucket contains water she has collected in Oregon, India, Italy, New Zealand, Mexico, and many other countries. She prays, "Thank you for water, the blood of Mother Earth..." The words 'Amen' and 'Aho' reverberate through the crowd.

Agnes invites everyone to "Talk to the water. Come. Tell the water it is sacred." When it's my turn, I look into the pure water and think of girls I have seen carrying water in dirty jerry cans in Kenya; women balancing buckets of algae-green water from Lake Victoria; Indonesian grandmothers bathing in streams before carrying that water home to drink; sari-clad women with urns of water on their heads in Gujarat; my experience standing in buckets to bathe in China and Rajasthan. How fortunate we are to have pure water when we turn the tap.

Last August, Chantele Rilatos, Agnes' great-granddaughter, was chosen as the Thirteen Indigenous Grandmothers' second Youth Ambassador. An honor student and soccer player, she is also a Fancy dancer. When she performs a beautiful dance to honor our hostess Grandmother Mona, her shawl fringe flies as if she has wings.

Agnes closes with a reminder, "We must give support and encouragement to each other and to whomever we meet," she says. "We are all in this leaky canoe together."

Grandmother Rita Pitka Blumenstein, 76
10 GRANDCHILDREN, 7 GREAT-GRANDCHILDREN, 1 GREAT-GREAT-GRANDCHILD

Today, Rita, a Yup'ik Indian, lives on the Alaskan tundra but she was born on a fishing boat on Nelson Island in the Bering Sea. Her father, half Russian and half Aleut, died a month before she was born, but he left instructions for her to attend a Montessori school in Seattle, and a bond to pay her tuition.

Rita grew up to enjoy a 43-year marriage with a Jewish man; their daughter calls herself a "Jewskimo." Not surprisingly, Rita's ceremony is a creative, eclectic mix of cultural influences.

She has placed 13 stones around the Sacred Fire circle to represent the 13 planets and the 13 grandmothers. She prays for healing water, earth, fire, and air. Chanting in the Yup'ik language, she tosses cedar into the fire from the four directions.

She invites the Thirteen Grandmothers plus all the grandmothers in the audience to form a circle around the Sacred Fire, and then invites the children to stand in front of them. She greets each youngster, and invites the children to bless themselves by touching their hearts, then their heads. After the children scatter cedar in the fire, Rita asks everyone to howl like an Alaskan wolf, creating a deafening cacophony.

The Magic Penny is Rita's favorite song and she sings to the boys and girls:

> "Love is like a magic penny,
> If you hold on tight,
> You won't have any.
> Lend it. Spend it.
> Give it away.
> It comes right back to you.

She invents an additional chorus for Malvina Reynolds's song:

> "Laughter is something if you give it away,
> Give it away, give it away...
> Laughter is something if you give it away,
> It comes right back to you."

Rita cackles gleefully and, sure enough, everyone laughs right back.

Rita passes the crowd a large ball that is painted to look like the planet. It travels overhead from hand to hand. Each trip, the ball circles closer to the Sacred Fire until it is transferred from grandmother to grandmother, and finally, from child to child.

My eyes fill with tears watching this symbolic demonstration of how knowledge and responsibility are conveyed from generation to generation.

In the movie about the grandmothers, Rita admits, "When I was 4 years old, I played doctor. I really made them feel better!" Today, she is certified as a traditional medical doctor and is teaching her skills to her 17-year-old granddaughter. I ask whether Rita considers herself a doctor, healer, shaman, or medicine woman. "My name is Rita," she smiles. "I am special. There is no better than—and no less than— me. That's who I am."

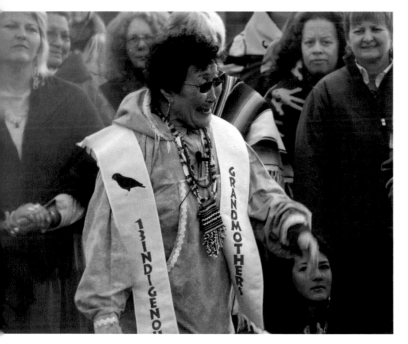

Grandmother Clara Shinobu Iura, 59

3 GRANDCHILDREN

Clara's adopted son fathered her 3 grandchildren, for whom she has great dreams: "A world of more freedom, peace, justice, friendship, sincerity—and truth.

"I have always tried to search for my truth," she reflects.

She grew up feeling, "You must always seem to be *something*; just to *be* seems impossible, especially in the Japanese culture where appearance is fundamental." Although Clara's immigrant family lived in Sao Paulo Brazil, her father's family founded the Catholic Church in Japan and her Japanese mother's family is Buddhist.

Clara's personal quest took many turns. She studied philosophy at Sao Paulo University. Feeling inhibited by the Japanese culture, she rebelled and lived on the streets, eating canned food and squatting in old houses.

The afternoon she decided life wasn't worth living, she was "invited into a museum that gave free art workshops. I decided to create a clay sculpture." For 8 hours, Clara shaped a great tree. Only when it was time to leave the museum did she realize that the tree's roots were severed, a metaphor for her life.

"I felt as if a new door had opened. A friend invited me to meditation classes. I felt such a great love for the sun, sky, and nature! Something was filling me up as never before.

"I read Bhagwan Shree Rajneesh's book (he wasn't yet called Osho) that said, 'Believe in the master inside you.' I started believing in that voice," Clara says, describing her passage into clairvoyance. "I could see the future. I could meet people and describe things in their lives. I could look at you and know your grandmother's name. It was all true.

"For three months, I talked with extra terrestrial beings who told me about the existence of God, asked me not to eat meat or deal with technology. I was a philosophy student but this seemed too distant from my reality. It was like a Flash Gordon story! Yet everything they told me has happened: the melting of the polar ice cap. The rising of the seawaters. Earthquakes. They said I would meet people working for spiritual awareness.

"At the same time, I was able to do powerful healings—like the shamans of Siberia and the Ainu people of Japan." (Ainus are animists who believe the most important spirit is Grandmother Earth).

Today Clara is a medium and healer who collaborates with another member of the Council of Thirteen Indigenous Grandmothers, Marie Alice Campos Freire, in the Santo Daime community of Céu do Mapiá, in Brazil's Amazon rainforest. This Christian shamanic community uses Ahyuasca as a sacrament and its members aim to live a spiritual life in tune with Mother Nature.

"After all this time," Clara says, "I have returned to Japan. Someone who was healed through me, gave me a trip as a gift. When I landed, I wanted to lie on the ground and hug the whole country.

"I felt very lucky to be the daughter of Japanese parents. I felt happy to respect my parents and myself. I visited the place my parents are from. I am very proud of this Eastern heritage, the Buddhist tradition, and the Ainu knowledge that is in my blood."

Grandmother Aama Bombo, 66
18 GRANDCHILDREN, 5 GREAT-GRANDCHILDREN

Aama Bombo means Mother Shaman. As a 5-year-old child then named Bhuddi Maya Lama, she longed to follow in the footsteps of her powerful father who could heal others. But only men were supposed to be shamans in Nepal's Tamang culture.

She was 16 when her 80-year-old father died. At age 25, Aama experienced uncontrollable shaking. "People thought I was sick or crazy."

She came to understand that her father's spirit, unable to find a man or boy with such a generous heart, had come to teach her. "I healed a sick woman next door. I didn't know what to do, but I did what he told me."

Today Aama may treat 100 people in one morning at her home in Boudhnath near Kathmandu. "Healing is an obligation," she says. Her patients range from the indigent to the royal. King Birendra was her patient; she warned him of the Nepalese massacre in 2001 when one of his sons shot him as well as many members of the royal family.

I ask Aama if there were a legend in her culture about the time of the grandmothers. "It's part of the prophecy. This is the time grandmothers, mothers, and sisters will teach," she responds."

Like all grandmothers, Aama holds great aspirations for her grandchildren. "I wish them to have a good education, understand who they are, walk in a good direction, learn about themselves." I wonder if she would like them to follow in her footsteps. "If that is written on their foreheads by fate," she nods. "But if

they want to be a shaman, they need to work.

"The main reasons the Thirteen Grandmothers have gathered: for peace, for Mother Earth, for the next Seven Generations. Those common principals unite us. We are trying to give the lessons of our ancestors. Despite the differences, everyone is equal. Loving. Good. Some talk better or do ritual better... but everyone has the same pure heart."

Her presence is commanding as she enters the circle around the Sacred Fire in Sedona to conduct her ceremony. Dressed in white, she wears a high crown of peacock feathers.

Aama is Buddhist and Hindu but her ceremony is more ecumenical than the categories suggest. She beats a penetratingly loud, insistent drum marked with a trident, Shiva's emblem, "to open the heart."

Then she invokes the spirits of the 4 directions, the underworld, the heavens. Primordial spirits. Native American deities. Spirits from the Sedona area ("They are all around us.") Spirits of the water, wind, fire, sky, stars, and planets. Spirits of flowers, soil, and leaves. Water and serpent spirits. Wandering spirits. The spirits of jungle and gold. "Mythical beings we've never seen but we feel their presence and they teach us." She calls the 33 million gods and goddesses of the Hindu pantheon: Kali, the warrior goddess; Hanuman, the monkey god; Shiva, Saraswati, Durga, Gauri, and many more.

She blows the conch shell to honor them, feeds them, offers them water and a red flower. Calls on them to educate people to bring about peace on earth. She prays "To make the spirits happy, salute them and, if you have done something wrong, to ask for pardon."

She swallows fire "to purify and bring light and honor God like the sun shining on the earth." She jiggles to animate the bells that encircle her. Seated, she turns all directions, falls backwards, prostrates herself. Some people in the crowd are transported. Aama tells me later, "The mantra becomes like medicine, clearing the body, spirit, and soul. People feel the presence of their ancestors and cry when they feel the energy."

Aama walks through the crowd flicking water from a whisk, causing laughs of joy, even ecstasy. "Hara Hara Ma. Holy Baba..." Then she dances from the circle, bells ringing, and presents each of the Thirteen Grandmothers with a white prayer scarf.

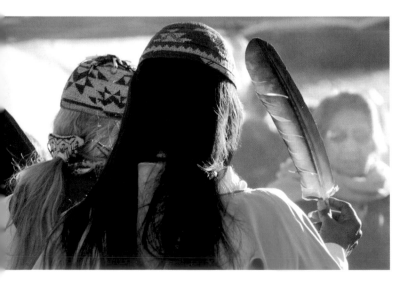

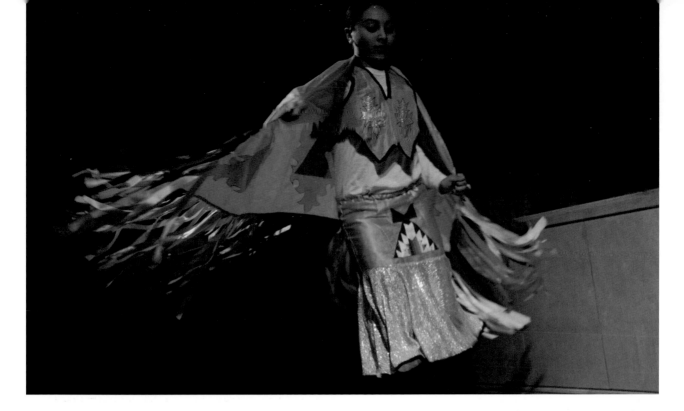

Grandmother Flordemayo, 60

3 GRANDCHILDREN

Flordemayo was born in a highland village where Nicaragua and Honduras meet. Her father, a shaman, and her mother, a midwife and healer, realized that the youngest of their 15 children had the gift of seeing visions. Flordemayo saw, surrounding everything, "a dance of color and light."

At age 4, Flordemayo accompanied her mother to births. "She would give me the baby after the umbilical was cut and the baby was clean and wrapped in a little blanket. I would innocently look, see how the light looked and see things in the past and future. Little bits of information, but enough to delight the mother and father."

Following her father's death, her mother moved the family to New York City, away from the political violence in Central America. Flordemayo was her mother's apprentice until she died of cancer when Flordemayo was 17.

After her own children were grown, Flordemayo continued her practice as a Curandera Espiritu (healer by divine spirit). She also trained with the Mayans.

In 2004, not only did Flordemayo receive Jyoti's letter of invitation to join the Thirteen Indigenous Grandmothers, she was personally prompted to join the new Council by the Grandmothers of the Four Directions who appeared to her. Thinking about the Thirteen Indigenous Grandmothers now, she says, "We are all children of light. We are all the same. That is the root of peace."

Deeply engaged with the reclamation of sacred objects throughout the Americas, Flordemayo profoundly regrets the loss of the Mayan's "52 crystal skulls that were carved by our ancestors. They represented the intelligence of humans, the keepers of knowledge, the way of the Maya, and guided us with everything: astronomy, farming, calendar keeping."

Today there are no crystal skulls in the Mayan region, which stretched from the Yucatan to Nicaragua, but some are in the Smithsonian, the British Museum, the Museum of Man in Paris. "I'd love to bring back crystal skulls that belonged to the Mayan people. It would be such an honor. We need them to survive, to teach. Keeping them behind glass does no one any good."

Flordemayo presents the final ceremony at the Sedona gathering. She carries a crystal skull of yellow jade wrapped in a golden shawl. In the ancient Mayan calendar, the skull represents Kemee, the androgynous Day Lord of the West, "who brings us the spirit of humanity as the sun goes down and comes up, the cycle from darkness into dawn."

She says, "The prophecy tells us that consciousness is preparing the spirit of the feminine, the spirit of the grandmothers. It is in the prophecy that we shall walk into the light, united, from the four directions."

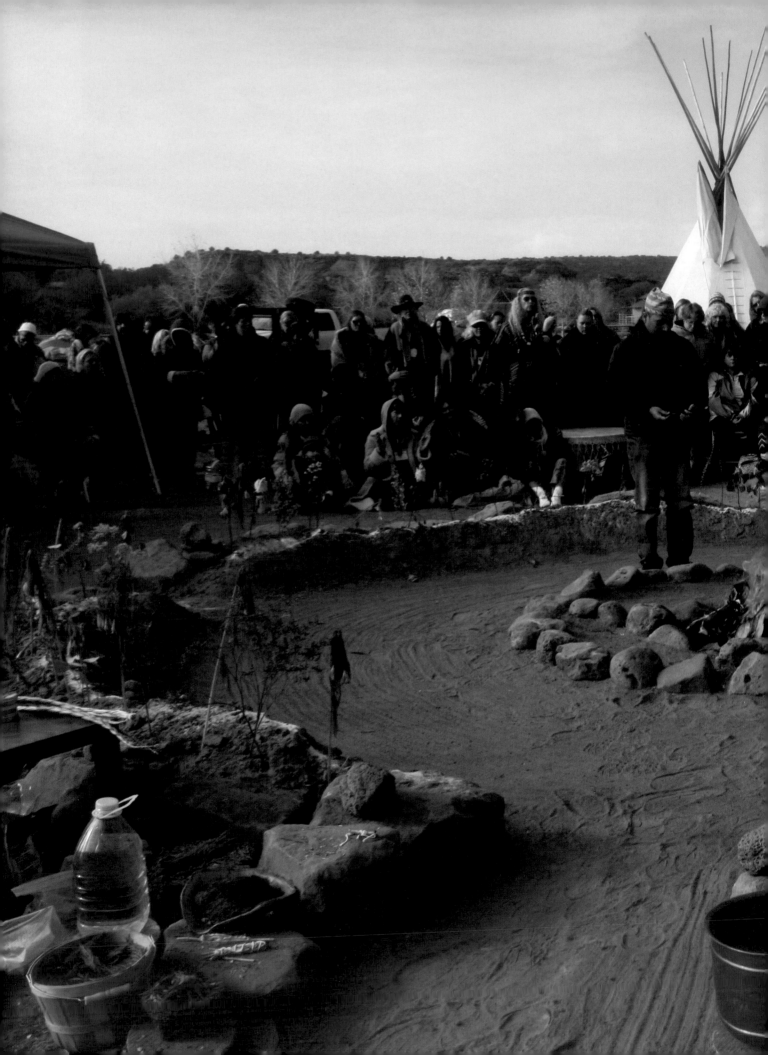

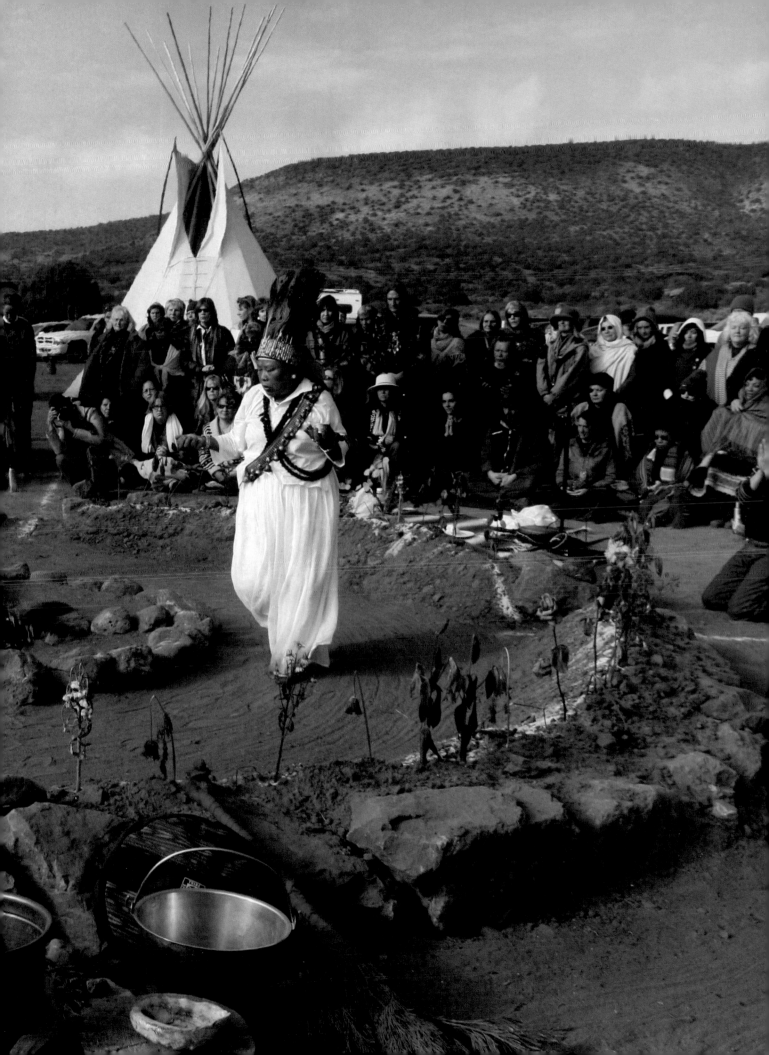

JYOTI, 62
2 GRANDCHILDREN

Jyoti, a grandmother, psychologist, spiritual midwife, and healer, helped convene the International Council of the Thirteen Indigenous Grandmothers in 2004. Today, she is their Traveling Ambassador Charged with the Mission.

After she serves me tea at her house in the California redwoods, her granddaughter climbs onto Jyoti's lap. "My grandchildren Aliya and Jessie were born 3 weeks apart. So one summer, 2 years into the formation of the Thirteen Grandmothers Council, I became a grandmother twice. I call myself 'a grandmother in training,'" she laughs. Her third grandchild is due this week. "I really want my grandchildren to walk on this beautiful earth, enjoy Her, sing with Her, pray with Her."

Jyoti grew up in Texas. She says, "I didn't ever get to meet my Cherokee great-great-grandmother on my father's German side. When the Cherokees came down the Trail of Tears, my great-great grandfather and she got together. She has come to me many, many times, as real as you sitting on this couch.

"My mother's and father's mothers died when I was a young adult. So the Thirteen Indigenous Grandmothers are my grandmas. Some have adopted me. I'm older than five of them—and younger than all of them.

Jyoti admits, "I didn't go seeking all these things that have come to pass with the grandmothers." On the contrary, Shri Dhyanyogi Madhusudandasji, the Indian sage, told her to be of service when he named her Jyoti ("light") long ago when she was known as Jeneane Prevatt. He told her to wear white always. "White will remind you that you will always be a woman of service. That is all you are to be."

Jyoti tells me how the Divine Mother appeared to her and offered her a basket of jewels; how she was urged by shaman grandmothers in Gabon and Brazil to call the Council. She equivocated, "Were we strong enough? Temperate enough? Finally, Mother said—in this *voice*—'My daughter, the time is now.'" She didn't know how to begin.

"Finally, my grandmother spoke to me. 'Remember, granddaughter, that you must start with the seed of it all, our relations. Begin there. Everything will unfold naturally. Don't worry.'

I spread the word throughout our spiritual community. I said, 'Go to the elders. Let's get their guidance about how these grandmothers will come to us.' We got 16 names." Thirteen of them came to the first gathering.

"It was profound when they sat down at the round table. The Divine Mother had told me that the grandmothers were Her representatives. Only a few of them recognized each other—yet they knew each other. There were grandmothers at the table whose people had not sat together for generations. There were taboos. One grandmother would honor the snake and another would find it fearsome.

"All of us knew this was not just another conference. Something was opening up. A fire in our hearts was kindled. The next time the grandmothers got together, they cried and hugged each other."

Joyti reflects on indigenous traditions: "It's a way of life that is not understood. Right here in the U.S., people are still shot, imprisoned, killed, for singing songs to Creator. Our blood, when you cut us, runs the same color. How can people go to someone's house and tell them what they should and should not be doing? What arrogance! Let us reclaim our humility. Remember our compassion. Sit down in non-judgment and listen to how they teach. Listen to how wise they are."

I ask Jyoti why the indigenous women whom she invited to the Council had to be grandmothers. She responds, "When your stone rolls along a certain length of time, you gather things with it. If you've been awake while travelling, even better. If you've put that into spiritual focus, how potent it becomes!

"These grandmothers have done that. Grandmother Agnes was almost beaten to death. As a girl, she was one of only 22 who were left in her tribe. She survived cancer. She is still here with generosity of spirit and warmth of being. She loves you. She says, 'Just keep walking. Pray, my darling. Creator will take care of everything. I prayed this morning, don't worry.' She is so sure of it, you can't not be. Some of our grandmothers have illnesses that could take them at any moment. But their dedication to prayer is a life-work."

The Thirteen Indigenous Grandmothers' gatherings have drawn crowds around the world and spawned circles of grandmothers. Jyoti explains, "Sitting in your grandmother's lap when you're hungry, tired, and scared changes something. People go home and connect with their own grandmothers and with the elder wisdom in their communities."

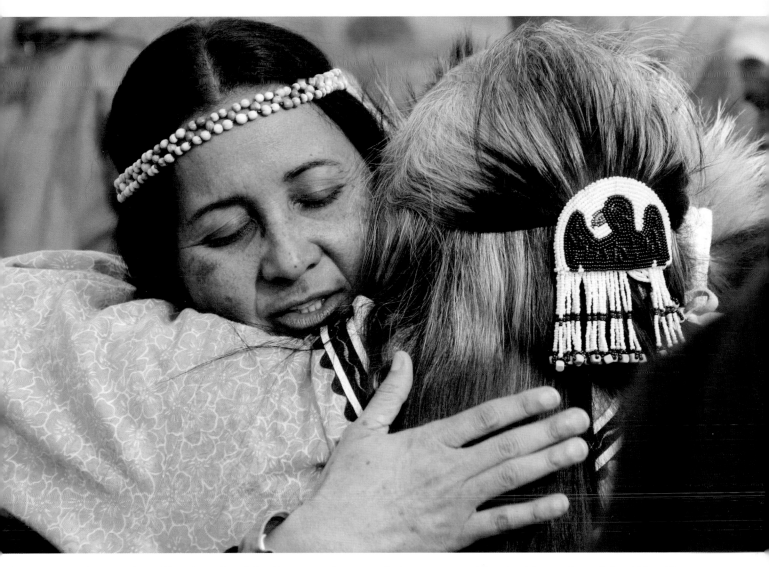

Why was this millennium the right time to gather the grandmothers? Jyoti believes, "The grandmother of us all is coming back into her house. These grandmothers are the first representation of Her embodiment. At the very least, that is salve for us. At the very best, it brings us salvation, a way of life that's about unity, harmony, and peace."

Years ago, Jyoti studied at the C.G. Jung Institute in Zürich. "Jung said that the most difficult time we'd have would be when the archetypes of an old paradigm left the stage. I believe we are in a moment like that. The First Grandmother is pulling us, bringing us home to ourselves. We have to go through purification, shake off false concepts, and embrace our impermanence. As the grandmothers reclaim

their seats as matriarchs, it's good medicine. We will realign ourselves."

"We are living in a time when the grandmothers are called to share. Sometimes when I sit in the tipi and watch my wonderful white friends walk in and sit down...and my native relatives serve them, love them, heal them. When I reflect upon our history between these peoples, such acts of kindness are the most active moments of compassion you can be present for."

Jyoti finishes her tea. "This is a moment on our planet when we are making a choice. I believe the Grandmothers are challenging us to do it while awake. To open our hearts with compassion and acceptance and love and hope and charity."

Health: Senegal

Cars, trucks, busses, and horsecars come to a halt but the cows lumber on. It's 7 AM in Dakar, rush hour, and the road out of town is under construction.

Vendors work their way through the vehicles selling candy, Kleenex, cookies, and newspapers. Young boys crowd around the cars using tin cans as begging bowls.

Somehow, Falilou Cissé finds us and climbs in just as the traffic opens up. The road becomes a freeway, flirts with the sea, then cuts inland through flat, brown scrub scattered with baobab trees. At the animal market, a man leads five horses past a fellow in the ditch lathering his goat, beautifying it for sale.

Falilou is Community Development Coordinator for The Grandmother Project. I have read his view of his country's grandmothers: "They are the guardians of educational wisdom through stories, song, proverbs, charades, riddles, incantations, pharmacopoeia, rites, and recitation. They are the health workers for children from birth (at which they assist) up to adolescence. Grandmothers are the best schools for young women."

His observations dovetail with the experience of The Grandmother Project's Founder/Director, Dr. Judi Aubel, whose training was in medical anthropology, public health, and adult education. Working 25 years in community health programs throughout the developing world, she discovered that involving grandmothers in health improves children's well-being dramatically and permanently.

In 1997 she first discovered that giving grandmothers contemporary medical information to add to their indigenous knowledge could improve children's health. Three examples:

In Laos, grandmothers believed that drinking liquids made diarrhea worse, which put their grandchildren at risk of dehydration. Now grandmothers know it is necessary to drink water and that breast-feeding should be continued, so children recover naturally.

In Mali, grandmothers traditionally told pregnant women to eat less than usual to have a smaller baby and easier delivery. Now grandmothers tell them to eat more than usual; they are stronger during delivery and have healthier babies.

In Senegal, grandmothers believed colostrum (the secretion that precedes breast milk) was bad for newborns. Now they advise their daughters to let their babies nurse immediately. Infants benefit from the high-protein and antibodies that colostrum provides.

The Grandmother Project, an American nonprofit that Dr. Aubel co-founded in 2005 trains NGOs to use grandmother-inclusive methods. The Grandmother Project has collaborated with The World Health Organization, The Red Cross, USAID, The World Bank, UNICEF, World Vision, and others in Albania, Benin, Burkina Faso, Djibouti, Laos, Mali, Mauritania, Nicaragua, Senegal, and Uzbekistan.

At the moment, we are driving past small, white mosques with blue doors. There are mountains of peanuts in the fields. We see compounds where reed fences enclose round, thatch-roofed huts; roadside abattoirs where skinned cows hang, exposed to the dust; a horse cart parking lot where all the horses' noses are buried in feed bags. Mamadou, the driver, steers us through an obstacle course of potholes.

Mamadou and Falilou chat in Wolof. The words sound carbonated; bubbling is punctuated by "Wow!" and "Shew!" plus clicks and the sound of air sucked through teeth. What a wonderful language.

We're en route to visit grandmothers near Vélingara, a town in the Kolda Region 10 hours from Dakar, southeast of Gambia. Twenty villages there are part of a 3-year program called "Girls' Holistic Development Project," which the Grandmother Project and World Vision are conducting to improve girls' health and well-being, plus end child marriage, teen pregnancy, and female cutting (which the United Nations terms female genital mutilation).

Grandmothers guide villagers to identify what is good and bad about cultural traditions, then teach what's considered good (dances, stories, values) and help eliminate what's bad (female genital mutilation, child marriage, teen pregnancy).

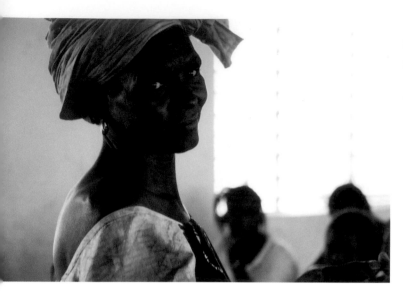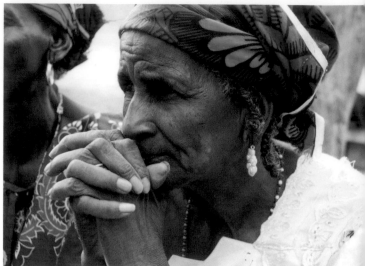

About 26% of all Senegalese women have been cut, but 90% of those in the Vélingara area have. Cutting of baby girls continues in secret even though Senegal passed a law against female genital mutilation in 1999—and even though many communities have made much-publicized declarations to the media promising that cutting will stop.

Cutting is a deeply entrenched tradition. Before it became illegal, it was part of a month-long rite of passage called *koyan* (which translates as "the endurance test"). Between 20 and 40 village girls aged 8 to 10 were educated about womanhood by their grandmothers after a traditional cutter, a grandmother herself, did her work.

In the Vélingara area, the type of cutting done most frequently is removal of part or the entire clitoris. Anesthesia is not used; instruments are not sterilized.

There are many reasons people support this practice. Parents think cutting will prevent their daughters from having sexual relations before marriage. Fathers think cutting will make their daughters more marriageable. Men believe cutting diminishes libido so their wives will not stray. Grandmothers want cutting in order to preserve tradition.

The health consequences of cutting are dire. Immediately after the procedure, there is pain and bleeding. Serious infections can follow. Recurrent bladder and urinary tract infections, even infertility may result. During childbirth, mothers and infants' lives can be at risk. According to the World Health Organization, 70% of infibulated women hemorrhage.

My thoughts about this damaging tradition are interrupted when large herds of cattle and goats cross the road, halting all the 18-wheelers, lorries, dump trucks, and tankers en route to Mali. Large tan bulls with sweeping horns can cost $850, Falilou says. Per capita income here is $1040, barely enough to buy one such animal.

I return to my reflections. The United Nations views female genital mutilation as a human rights violation. The African Union's Maputo Protocol, which 28 countries including Senegal have ratified, aims to end female cutting. Eight African countries including this one have laws against the practice. There has been a strong outcry from feminists internationally.

Many organizations have tried to stop cutting in countries from Egypt to Tanzania, and from Senegal to Ethiopia, the region where it is most prevalent. However, almost no efforts to stop female genital mutilation have explicitly involved grandmothers who are typically cast as "the enemy" because they perpetuate the practice.

Neither The Grandmother Project nor World Vision ever speaks out against female genital mutilation, early marriage, or teen pregnancy. In fact, they start by validating existing, positive practices.

With the grandmothers' guidance, communities decide on their own which practices are "bad" and agree to bring them to an end. Imams, school teachers, health workers, cutters, parents, girls and women, boys and men, grandmothers and grandfathers—everyone in a village—is involved in passionate discussions. Ultimately, they reach consensus. Decisions made this way, stick.

We stop for lunch in Kaffrine where I buy bananas and peanuts from a woman in a street stall. Falilou and Mamadou buy ribs that are cut on the top of a cart and wrapped in paper "to go." Both share their lunches with the swarming beggar boys.

Underway again, Falilou explains, "The Grandmother Project has three phases: reinforce and extend grandmothers' family-based authority into the community; inspire grandmother leaders to conduct community dialogues to identify good and bad cultural traditions; support the community's decisions to maximize good, and abandon bad, traditions."

That first phase seems to me to be tricky. Grandmothers lost influence when television and schools (taught in French) valorized western behaviors. Additionally, "Grandmothers abandoned their roles as advisors because they felt they were not relevant in these 'modern' times," according to Judi Aubel.

Even worse than being irrelevant, older women in this region are sometimes suspected of being "devils." In Ghana, Mauritania, Burkina Faso, Gambia, and Tanzania, elderly women are imprisoned as witches. Disapprobation is not so severe in Senegal. Falilou assures me, "Grandmothers have regained respect here by teaching traditional culture and values in village schools."

When community health workers tell the grandmothers that cutting is responsible for the hemorrhaging that women experience in childbirth, the grandmothers are surprised. As animists, they had believed evil spirits caused the complications. The discovery that as perpetuators of cutting, grandmothers are responsible for the problems, shocks and saddens them.

Typically, they immediately ask their Imam whether the Koran requires cutting. It does not. They ask the village chief to call an Intergenerational Forum to decide how to end the practice.

"The forum is a very old African tradition," Grandmother Project Facilitator Mamadou Coulibaly has written, "a big, shady tree under which young and old used to meet to talk. Intergenerational Forums are a means of reviving this ancient practice, a way of giving people space to talk and exchange ideas."

At Tambacounda we turn south and drive on a dirt road for 60 slow miles. I can't imagine how the pregnant women who need emergency care can survive long enough to get from Vélingara to Tambacounda's regional hospital.

I have come to meet grandmothers in 8 villages. I seem to be the only guest staying at La Pailotte, the little hotel where I eat dinner in the open-air dining room that has 3 tables covered in oilcloth. Birds fly over my head, fluttering between the bougainvillea and the lattice wall. The cook has prepared a platter of fresh shredded carrots, beets, asparagus spears, artichoke hearts, and potatoes with mustard sauce. I will order this dish every night; it is a feast!

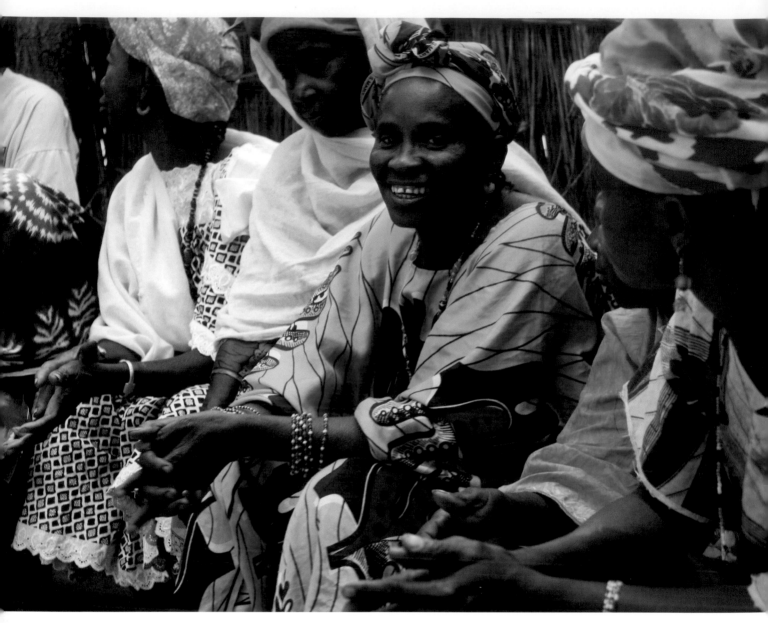

Interviews

Fofana Boubacar, World Vision's coordinator for the Girl's' Holistic Development Project, will be my interpreter this week. He, Falilou, and I walk through a gap in the reed fence that encircles the village of Saré Farambà. Cows and goats roam free and chickens peck the hard earth between the huts.

We arrive as prayers are ending. Men roll up their rugs, which look anomalously Middle Eastern in this African setting. Ancestors of the Fulani people in this area converted to Islam about a thousand years ago. Slowly, the culture morphed toward patriarchy. Today those with the highest status are male religious leaders and village chiefs.

The chief of Saré Farambà is waiting to welcome us, sitting on a low platform under a thatched, peaked roof in front of his hut. I ask permission to talk with some of the 25 village grandmothers in the Project. His wife reminds me to cover my head, as all married women must do. I struggle unsuccessfully to approximate the chic turbans that local women wrap. It is an elusive art.

Dado Balde, 47

4 GRANDCHILDREN

Dado is beading a calabash in her village's unique design, a rainbow of stripes. These decorated gourd bowls are used for everything from marriage ceremonies to carrying milk. She puts hers on the roof to protect it from animals.

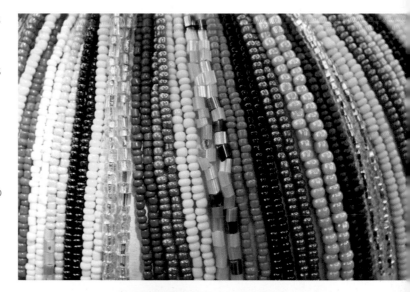

"You are welcome here. We are very happy to meet you." Her grandchildren run up. "Bonjour!" each says, shaking my hand, then bowing or curtseying deeply. I can't remember having been greeted in such a charming way. Dado looks proud. "They did not used to look face-to-face and talk. Now we grandmothers tell them the traditional way to respect visitors and elders.

"This is one of the changes," she explains. "Before, grandmothers had nothing to do, no activities. The Project is something great for us. We see a very big change in the community.

"This is how it began. A World Vision woman told us the Project would involve grandmothers to promote culture and traditional values and to fight against harmful practices. This interested us. We knew grandmothers could be important. If I wanted to tell you all the importance grandmothers have now—in the house, community, between people, in educating young people—it would take all morning!

"Grandmothers have knowledge to give young people. In our history, we have many stories. If children are old enough to talk, they listen just for fun. I tell them stories like the one about the rabbit and the hyena—not very complicated, very humorous, very funny, they like it.

"At 7 or 8, they can learn. If I tell a grandchild a story he enjoys, he tells his friends, 'Come see my grandmother. She has a nice big story. You should share it!' The same story can teach boys to be courageous and girls to help their mothers.

"By the time a girl is 12 or 13, stories are for education. There is more drama. They can spend the whole night listening because they want to know the ending before they go to bed. These stories develop knowledge and wisdom: how to be with their friends: solidarity, generosity, tolerance, what it will be like to live in society. Other stories open the mind to a larger view of the world. We give these stories to prepare children to be adults."

I eat dinner with some of the Grandmother Project advisors and facilitators. Siradio Diao, a teacher, tells me, "You gain from education but you lose your culture." Mamadou Coulibaly expands: "Losing our cultural values explains our children's loss of direction."

Siradio has written a series of stories-without-endings to provoke community discussion. The Project has also published a book, illustrated by schoolchildren, about grandmothers' roles and cultural values, which grandmothers use when they teach in local schools once a month.

Malang Sanga, Director of Kael Bessel's school, says, "I am very keen on this program. Today's grandmothers were once little girls, adolescent girls, young women, young wives and mothers. They

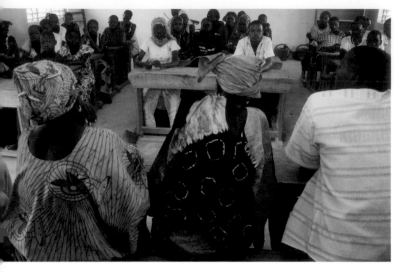

learned a lot through those stages."

His comment reminds me of the words of Mali philosopher, Hampâté Bâ: "In Africa, when an old person dies, it is like when a library burns down." A Senegalese proverb says, "The grandmother's heart is the school where one prepares oneself for life."

We walk through Malang's schoolyard, past huge kettles cooking over open fires under a tree where mothers are preparing maize-and-onion porridge for the students' lunch.

Two grandmothers are teaching a class of 13 to 15 year olds about early pregnancy, which is timely because one or two cases just occurred in a nearby village. They recommend abstinence: "If a girl becomes pregnant, school is finished for her." "Because she is young, there will be medical risks to mother and baby." "The boy will leave you. You will be left alone with your troubles." "You will have two years to breast feed and will have to stay home."

The question is, "Whose fault is early pregnancy?" The boys claim, "Girls provoke us with their clothing" and "Mothers do not supervise their daughters." Girls say, "Boys have the power, even if we are not interested." The boys' hands fly up, fingers snapping for attention. Snap, snap, snap, a rain of snaps.

An Imam smiles from the back of the room where he is observing (local adults will continue the discussion in the village later). Fofana whispers, "The grandmothers are so confident, so free!" (Judi Aubel will tell me later, "There have been no teen pregnancies in that school for the past two years. That is the work of the grandmothers.")

In the adjacent classroom, younger children are playing a game the Grandmother Project developed. They select cards from a deck and read questions like, "What is good and what is bad in our culture?"

One girl reads her card aloud, "Demonstrate a traditional dance." She jumps up to perform. The teacher, a tall man wearing a t-shirt that says "Marines," delights the kids with his own dance, which inspires the class to laugh and applaud.

Binta Sabaly, 53
10 GRANDCHILDREN

When we get to Binta's house in Kandia, she is dancing and singing with Fatoumata Baldé and all their grandchildren. The women are trained midwives and longtime friends.

Binta steps out to tell me about teaching children with *tindis* (stories), *tallis* (riddles), and *dippis* (songs). "After only 10 months in the Project, there are lots of changes in the attitudes of children. Youngsters get advice from the traditional games. They learn how to be tolerant, make peace, respect elders, how to be in society. If we are not united in the community," she says, "we cannot face the difficulties of life."

Health is among the difficulties of life. Binta explains, "We are in a poor area. It is very difficult for pregnant women (or malnourished children) to get medicine. If we want to transport a patient to Vélingara, we use a horse cart; there is no ambulance.

She reports, "A law against cutting was passed years ago but people didn't change." At a meeting, Binta explained the relationship between cutting and the childbirth complications that village women had all witnessed first hand. "The grandmothers decided to stop the practice because it was very harmful."

Binta's cell phone rings and she speaks quickly in French." Aware of her responsibilities as a midwife, I ask, "Does someone need you?" "No, no," she smiles and invites me to join the dancing.

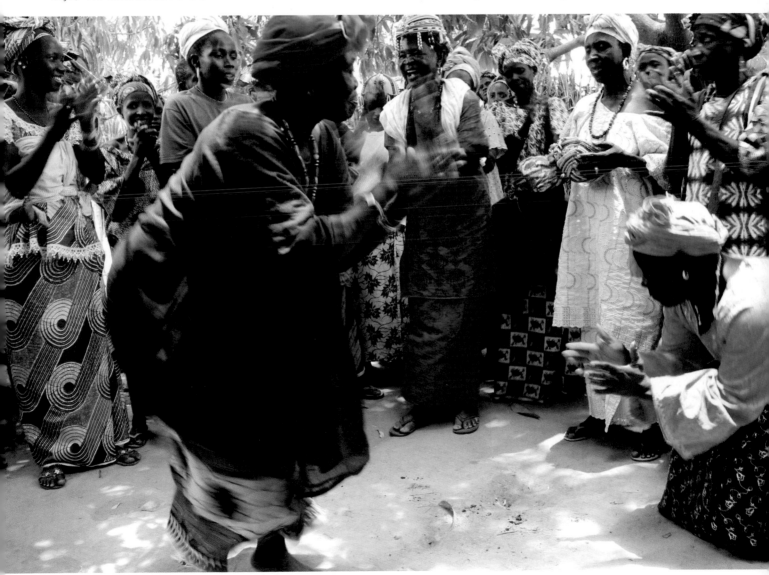

Aminata Diao, 130
"COUNTLESS" GRANDCHILDREN

As we walk through the village, Fatoumata Baldé asks if I would like to meet the oldest grandmother in Kandia. We duck into a hut where Aminata Diao sits on a cot wearing only a sarong skirt.

"She is 130 years old," her daughter says. I have never heard of anyone so old. Aminata has white eyebrows, cataracts, desiccated skin, flat pendulous breasts, and a thick deep voice. She is definitely old but is she really almost twice my age? At first, I am so awed that I can't think of a single question. Finally, I ask how many grandchildren she has. She has no idea, there are so many.

"You have seen many changes in Kandia," I say. "Yes, I remember when there were only 6 huts." (The population is now 1,000.)

"Why have you lived so long," I ask. "We used to eat from the trees. There used to be many in the forest. It's very different now. Everything I ate was natural. We put it in the sun to dry: no harmful preservatives, nothing from a refrigerator. Lots of milk."

"What advice do you have for elders?" I ask. She responds, "Have more confidence and stay healthy. Refuse to eat things if you don't know the source."

"What advice do you have for young people?"

"Respect your elders, take their advice. It's unfortunate that the young don't listen to their elders. They think we are old fashioned, that our time is over."

As if to disprove that allegation, after her daughter helps her put on a pink blouse and headscarf, Aminata grips her cane and slowly walks outside to pose for pictures.

Fatoumata Baldé, 60

18 GRANDCHILDREN

Fatouma was the first girl to attend Kandia's then-new elementary school. She went to high school in Kolda, then spent many years teaching Pular literacy classes. As we walk toward her hut at the river-end of Kandia, she tells me proudly that she has 2 grandchildren in university, one of whom is earning a Masters Degree.

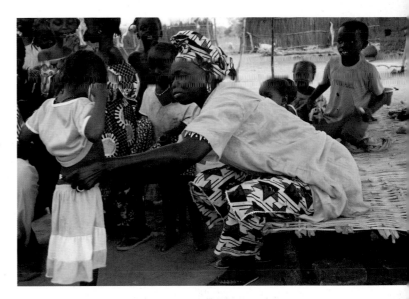

Despite her love of education, it was Fatoumata's dream to work in the Kandia clinic, which she joined in 2004. I ask her about the biggest health problems here. Early pregnancy is a great problem. The normal age for pregnancy is 18 but some girls are 13, 14, 15.

"We advise teenaged girls to abstain from sexual contact until they are married. We tell them pregnancy is natural, but if you are too young, your body will not be ready and it can be difficult to give birth without surgical interventions like a Cesarean Section, which can only be done in Kolda or Tambacounda, not in our village health office where most babies are born. We tell them that the baby and mother can die.

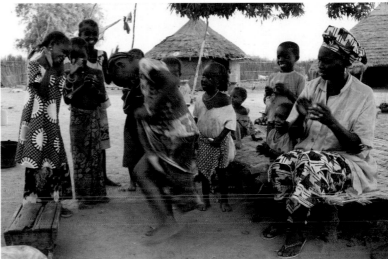

"Some marry and become pregnant before they are old enough. Early marriage is a tradition, but it is a bad one and we decided to fight against it. We grandmothers encourage the mother and fathers not to give their daughters in marriage before they are 17 or 18. Teen pregnancies used to happen very often but in the past 2 years, the cases of teen pregnancy have not been frequent," Fatouma says proudly.

"Malaria is also a great problem here," she continues. "We recommend sleeping in your clothes and using bed nets, but many people spend at least half the night outside because it is very hot. When it rains, there is water in the river and the mosquitoes come. Ten or 12 people a day may get Malaria."

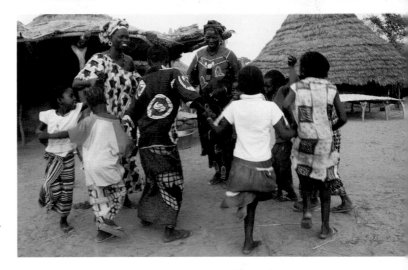

Her husband is lifting buckets of water from their young granddaughters' heads as the girls parade in single file. When her ten grandchildren, all those who live in Kandia, have gathered, Fatoumata, still wearing her pink health worker's uniform, sits with them under a tree teaching them a traditional dance.

The children begin clapping and singing, picking up the pace as they go. They take turns stomping and swirling faster and faster until, finally, nobody can dance fast enough and the children are laughing too hard to try.

Diabou Soto Baldé, 60
4 GRANDCHILDREN, 4 GREAT-GRANDCHILDREN

Diabou's grandchildren sit with us on her porch in Saré Farambà until our adult conversation bores them and they drift off to play. I ask Diabou to describe the *koyan* (initiation) rites that used to be practiced.

"The grandmothers came to tell the girls the date of the ceremony. The day before the ceremony, the initiates' mothers braided the girls' hair in front of their faces with beads. We called the praise singer, and made songs with clapping, that were especially for this kind of ceremony. We spent the whole day singing and clapping in the houses of the girls who were going to be cut. Then the grandmothers took the girls to the forest. Cutting required 2 or 3 days.

"The grandmothers returned, put the girls in a room in the village, and gave them their meals. In my day, there were no health workers to help. We used traditional medicine. To stop the blood and pain, we made powder from tree bark or we used roots like yam or potatoes. After 2 weeks the girls healed. The grandmothers spent the next 2 weeks educating them.

"The days that followed koyan were special occasions. Parents, relatives, and friends were invited from other villages for a big party with new clothes, food, and ceremonies.

"Cutting had been done for many, many years. Maybe we didn't take the time to analyze it; we were just doing it because it was part of the tradition. When we went to the community discussion with the midwife, we came to understand there can be bleeding, infections, complications in pregnancy. I, myself, felt very bad when I learned this. I felt that I had lived in a bad way.

"But I am very proud now, because people do understand and decided to stop the practice. Other villages are copying us. In the future, there will be no problems with pregnancies, and that is a big change."

"The Grandmother Project showed us that young girls must have good intellectual, health, and religious development: total well-being. Now we continue koyan education, but without the cutting."

The new, cutting-free, ceremony still begins with singing and clapping, as it always has. I invite Diabou to sing a traditional koyan song. She renders a rhythmic, repetitive chorus that is so infectious that I join in. Since I can't speak her language, my effort causes everyone to laugh, even me.

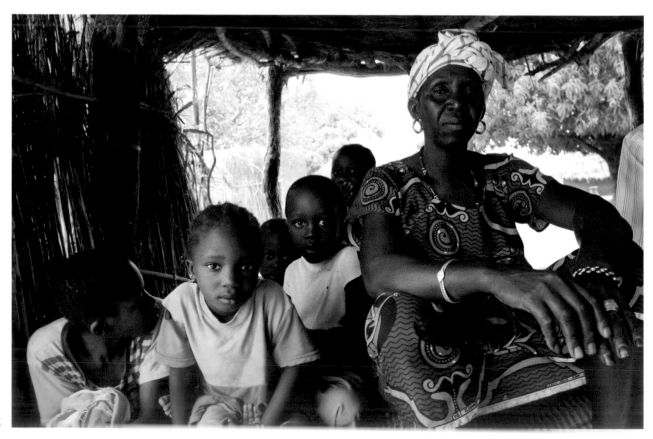

Hawa Baldé, 75
11 GRANDCHILDREN

Hawa, who has been involved in Grandmother Project activities for two years, is President of the Saré Kouna grandmothers' group, which has 15 members. "Before, men made the decisions here. Now they call on me to represent the women and grandmother's ideas."

I get the impression that things are changing fast in this village. Hawa says, "Before the Project, if we wanted to call our grandchildren and tell stories, their mothers said, 'Don't approach your grandparents, they will eat you.' If you sat with your grandchildren and two days later, they got sick, you were blamed.

"Even if I was angry about being called a witch, I didn't show it because my anger would indicate that the claim was true. We used to assure our grandchildren that we didn't eat children, but they were too young to understand.

"Before, there was zero communication between grandmothers and their daughters-in-law. Perhaps they were jealous. When The Grandmother Project discussions started, everyone said what was in her heart. We began to love each other and work together to educate the girls. It was a big change. Now, grandmothers' importance is validated. It gave us a new chance."

Hawa chairs the grandmothers' committee that's responsible for girls' learning to become women. "There are 3 parts," she says. "Games, stories, and dances to teach values. Lessons about how to live well as girls in the family and society (how to take care of younger brothers and sisters; how to respect your parents; how to greet elders). And lessons about becoming a woman (how to prepare for your first period; how to avoid contact with teenaged boys; how to be with your husband; what values to teach your children)."

The grandmothers call get-togethers twice a month for girls, women, and grandmothers. "We talk about religious education, how to care for pregnant women, how to deal with early pregnancy and teen marriage.

"Our village decided to abandon cutting 2 years ago. After the law against it was passed in 1999, in our hearts we were not convinced, but many grandmothers stopped out of fear. We let everyone discuss without influence from us, so decisions are made freely. Now we have stopped because in our hearts we know it is harmful."

Hawa is so obviously a natural leader that I ask about her vision for the future. "I want to build unity and solidarity by adding activities such as farming peanuts and planting mangos." As we leave, I see children poking a mango tree with a long stick, knocking down the ripe, delicious fruit. They might be tomorrow's mango growers.

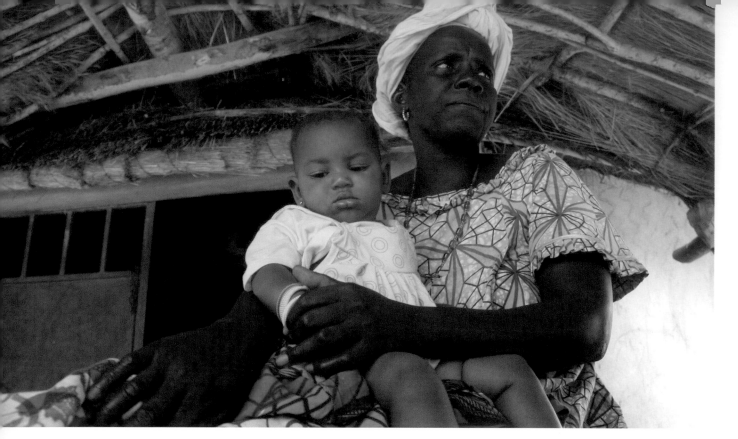

Maimouna Diamanka, 40
5 GRANDCHILDREN

Maimouna calms her fussy grandson on her lap. We are sitting on the porch of her house in Saré Farembà. Goats bleat loudly; a cock crows even more loudly. We chat about fashion and food until her toddler stops fretting.

I marvel at the beautiful turbans Senegalese women wear; mine is shapeless. Maimouna explains, "Girls watch their mothers tie their scarves. By the time they are married, it has become easy." I ask what she likes to cook. "Rice with peanut sauce; sometimes I do it with tomatoes."

I ask if she remembers her own grandmother. "I remember a lot. She used to tell me, 'Don't lie. Don't have bad behavior. Don't stay out late at night.' When I told her I wanted to go out, she said, 'I have just a short story to tell you' and I always got so interested I stayed home."

Maimouna uses the same strategy today. "We teach girls traditional games to play after dinner. We know where our granddaughters are, because we can see them. We might say, 'I am thinking of something with three legs...' and they have to guess what it is."

She worries that her granddaughters may suffer the consequences of having been cut before the village decided to stop female genital mutilation 10 months ago. "Complications could be the biggest problems that the girls will face in their lives."

Those consequences convinced villagers to stop cutting but it took 5 meetings to mount the case. "After discussing it among ourselves for a month, we grandmothers decided to ask the chief to call a meeting.

"The chief took the position that the law requires an end to cutting and he must report it to the police. But, he said, 'If the practice is to end, everyone here must agree to it.' In the first meeting, some people did not want to stop. Others said there was no relationship between the practice and pregnancy problems. We could not make a decision.

"We called a second meeting. We had a health worker come explain. Grandmothers and mothers, elders, and other respected members of the community who had seen the medical consequences, described them. Everyone knew that the grandmothers' opinion would be in the best interest of the community and we grandmothers opposed cutting.

"In the third meeting, people agreed to stop. We called a fourth meeting for people who couldn't come before. In the fifth meeting, we voted. Today, if cutters come, we tell them, 'Go away. It is totally stopped.' The grandmothers are responsible for that."

Sirayel Diao, 60
32 GRANDCHILDREN

Sirayel's grandchildren are dancing when I arrive. Her 15 children have so many children that the circle is very large. Sirayel taught the youngsters this dance, she says, "They like it and do it every day. Before the Project started in Kandia, they watched TV. Now they prefer to be with me to hear stories and play games."

I hadn't considered the possibility that an ex-cutter might have a family, much less one this big. While we talk, her daughters pound grain, shell peas, and fetch water from the well. Her sons get chairs for us and when she sits, waving her striped fan to create a breeze, her grandchildren cluster around her as if she were the queen.

Sirayel is an activist: "All of my children went to school. If boys have no education, they will be bad, bad, boys. If girls have early sexual contact with boys, they will be exposed to early pregnancy. The grandmothers are fighting against all of this.

"The solution? First, understand that the problem is economic. Parents are fighting for something to eat. Boys cannot have all the clothes they want. Girls look for boys because they want something their parents don't have: money.

"The Project allowed us to know that we grandmothers are not without importance. We have our place and must work and take care of our families. We learned it's important to teach grandchildren the work we do. I am teaching them to cook, wash, and make crafts."

I ask if cutting was a paid job. "I was given some food during the month or paid $1 per girl at the end of koyan."

"How did you become a cutter," I wonder. "My mother taught me how to take care of the young girls. I never saw anything wrong with cutting. Not one person ever had problems from my mother's work or mine.

"I told girls that if there were any problems, I would take revenge on those who caused the problems." (Fofana explains, "She means she would use *juju*,

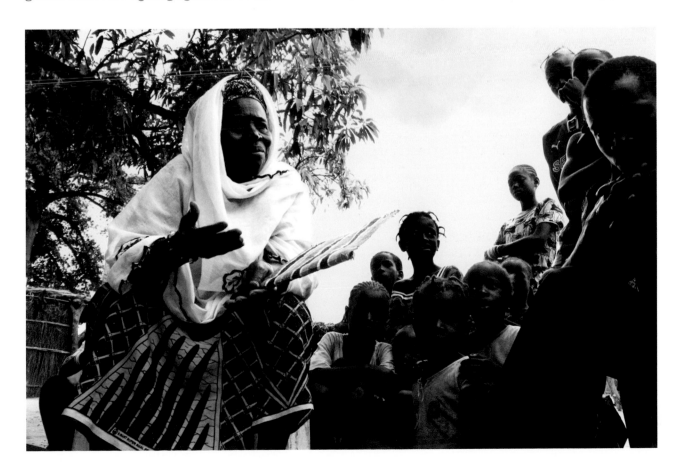

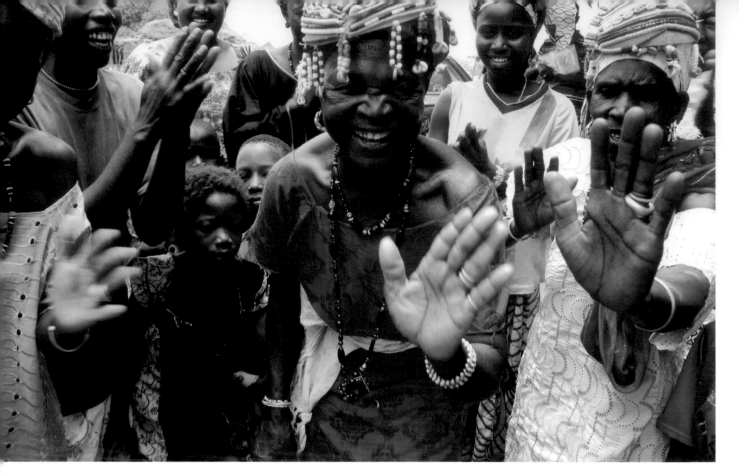

magic, to kill the vampires who like young girls' blood.")

Sirayel continues: "We spent every night of koyan teaching the girls how to behave when they got married: to cook, earn, do housework; it is the first identity of a woman to be a good wife.

"The best way to teach them was to beat them, to make them afraid of you," she says. "I still believe that." She reaches out, grabs a granddaughter's ear and twists hard. (Corporal punishment is next on the Project's list of traditions to address.)

I try to imagine what it must have been like for Sirayel to be one of only two cutters in the area— respected for traditional and spiritual knowledge, responsible for rites of passage, representative of generations of cutters—and to be fired summarily by popular demand.

"I agreed to what the community decided," she says. She believes girls will feel relieved not to be cut ("Nobody wants to be hurt") and men will adjust ("They thought they wanted to marry women who had been cut, but they are beginning to change their minds.")

"I am proud to do spinning," she says about the skill she was trained to do instead of cutting. "I also sell peanuts. I do a lot of jobs to take care of all these young children.

"Put this in your book," Sirayel urges me. "There are grandmothers, former cutters, who abandoned cutting. They have dedicated their lives to educating children in the community. We are not asking for money. Visit a village and support us in our efforts."

I am fascinated by the role that dancing plays in Senegal. The new group in Saré Samba Néty includes 18 grandmothers. They are meeting under a tree whose canopy provides relief from the searing sun. "We dream of our grandchildren having a good education and a good life," the group leader says. The grandmothers break into applause to express agreement.

I ask if they will show me a traditional dance. The leader, who is dressed in red, claps the calabash on her head as if it were a hat. The grandmothers join her; singing, clapping, and dancing up a storm. They decide when I have taken enough pictures and pull me into the fray. We all have so much fun that they dance me to the car.

It's dusk when we get to Saré Boulel where Yoba Baldé lives (we will visit her daughter, Hawa, tomorrow). Fifteen Project grandmothers have gathered. Yoba greets me saying, "This is your home." She takes my hand and leads me into the circle to dance. What a felicitous welcome!

Hawa Baldé, 47
7 GRANDCHILDREN

"Before, we were like animals in the forest: together, but not working together. We lived in the same place but didn't talk to decide our futures,"

Hawa says.

"After the first intergenerational meeting at the chief's house, someone said he couldn't remember having a meeting like that for a long, long time. Young people, men, teachers and grandmothers sat together to plan activities and ceremonies."

Hawa wasn't there when she was elected President of the grandmother committee in Saré Demba Maré. She was in Kandia, where she volunteers as a nurse's aid in the health clinic. "I was surprised, happy, and proud because they believed in me."

We are sitting under the thatched awning in front of Hawa's hut. Her granddaughter, who wears a t-shirt that says "Dublin," watches me curiously; her other grandchildren approach quietly and bow respectfully before they join us.

Hawa's husband greets me in perfect English. Having worked for 7 years in a guesthouse in Eilat, Israel, he now runs a shop in Dakar. "It is not easy to find such a husband," Hawa confides. "He had no problem with my involvement with the Grandmother Project. He told me, 'If I'm not here, don't wait to get permission. People need help. Go ahead.'

"This is the Project's second year here. Communications among us has improved. We spend more time discussing education and culture to save us from life's difficulties. Although The Grandmother Project doesn't push to end cutting, they educate people about its consequences and 20 villages have decided to abandon the practice.

"Last year, the grandmothers had two big cultural events. For one, we invited a storyteller to explain the history of our area. If we said our family names, he

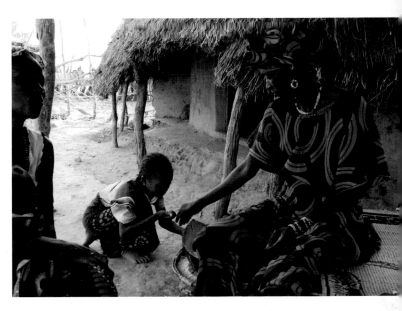

could tell everything about our families, things we'd never known. He even told us about the first house in our village. I have lived here 32 years, but I didn't know about that. Young people loved it. This little girl," she smiles at a granddaughter, "ran to ask lots of questions afterwards.

"Meetings bring unity and peace between us and this is a very good thing," Hawa says. "If the village is not unified, it cannot develop. If grandmothers do their best to educate children, it is more important than having money. To take care of childrens' health is most important of all."

As I ride back to Dakar, I reflect on the courageous grandmothers who have led their communities to abandon the damaging practices that had been part of their cultural tradition for so long. Much has been made by the press about the number of Senegal villages that have promised to abandon cutting. But in reality, only the grandmothers seem to be bringing the practice to a stop.

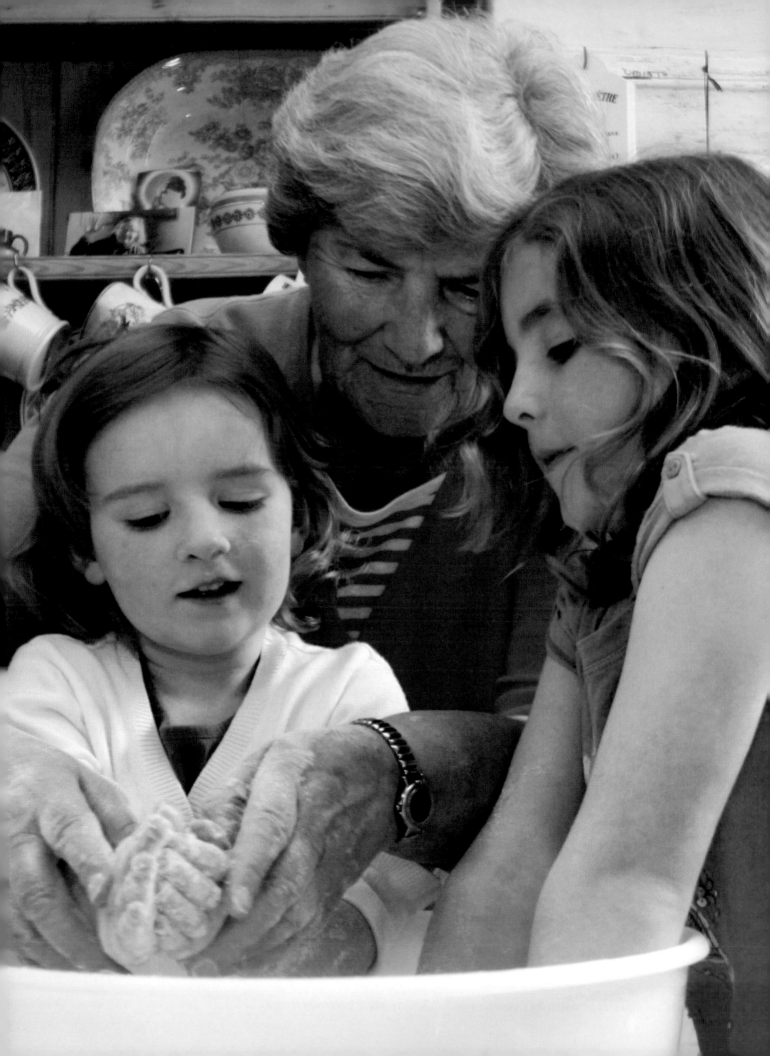

Health: Ireland

I make strawberry soup with my granddaughters. I don't have a clue how to forage for seaweed, skin a rabbit, or churn butter. Darina Allen, grandmother of 7 and Ireland's best-known chef, not only knows, she is teaching those skills to packed classes at Ballymaloe Cookery School in County Cork, Ireland.

Darina and her friend, equally famous California chef Alice Waters of Chez Panisse, both view grandmothers as the guardians of inherited wisdom. When they saw Carlo Petrini, founder of the Slow Food movement, in Turin they proposed sponsoring a "Grandmothers' Day" where grandmothers would teach grandchildren about growing and cooking.

The idea appealed to Petrini so much that he decided Grandmothers' Day was too good to limit to Ireland; he hoped all 100,000 Slow Food movement members in 153 countries would celebrate it.

The first celebration occurred in April 2009. Irish grandmothers ran a small farmers market with their grandchildren; made chocolate and butter; taught the children how to plant vegetable seeds. They baked scones and had tea parties, went fishing and cooked their catches. One newspaper published a supplement of grandmothers' recipes. Schools started edible gardens and Darina donated chicken coops and hens so the students could take fresh eggs home from school.

Now it's April 2010 and I am documenting the second Slow Food International Grandmothers' Day in Ireland, starting with photographing Darina's grandchildren cooking in her home at Ballymaloe, where the southeastern coastal hills are dotted with daffodils.

Ballymaloe ("Bally-ma-lou") translates to "land of milk and honey," which is a perfect description of the Allen family's idyllic 400-acre farm, 100 acres of which are cultivated as organic gardens. Fresh milk and newly collected honey are just the beginning.

Darina has invited me to stay here, so I have an elegant room in Ballymaloe House, the Georgian mansion where Darina's in-laws, Myrtle and Ivan Allen, raised their family. It's been remodeled into a 40-room luxury hotel, but its original 14th-century Norman castle tower is still intact.

Ballymaloe's restaurant, a destination for gourmets, was made famous by Myrtle Allen (who opened it in 1964), Darina (who started her career as Myrtle's sous-chef five years later) and Darina's brother Rory O'Connell (who succeeded Myrtle as executive chef when she retired).

Jim Allen gives me a ride to the Ballymaloe Cookery School, laughing when I ask how he is related, "We are all in-laws and out-laws." Sure enough, Darina's daughter-in-law, Rachel Allen, greets me at the School holding Scarlet Lily, who is not quite 1 year old and is wearing a toast-colored eyelet dress. Rachel, following in Darina's footsteps, has her own cooking show, writes cookbooks and teaches at the School.

This afternoon, Darina is in Dublin chairing a Slow Food Ireland board meeting and she's asked her aunt, Florence Bowe, 71, to show me around. Lunch is food the cookery students created this morning: pasta; sausage; greens with garlic flowers; walnut pie "with a tinge of chocolate and a big dollop of whipped cream." Every morsel is fresh from this farm and is, to borrow the title of Darina's TV cooking show, "simply delicious."

In 3 large, immaculate kitchens, 10 groups (6 students to a teacher) work at individual stations with equipment color-coded for each student. Buckets of tulips testify that it's springtime.

From the deck, Florence points out the "stony and not-so-stony beaches" of Ballycotton Bay, visible beyond a field of solar panels that run everything. There are fields of rhubarb and farther away, grazing cattle. We walk past herds of sheep. Seventy different herbs thrive in the herb garden. We duck into a

Irish grandmothers and grandchildren celebrate The Slow Food Movement's
International Grandmothers' Day together, planting, cooking and enjoying healthy food.

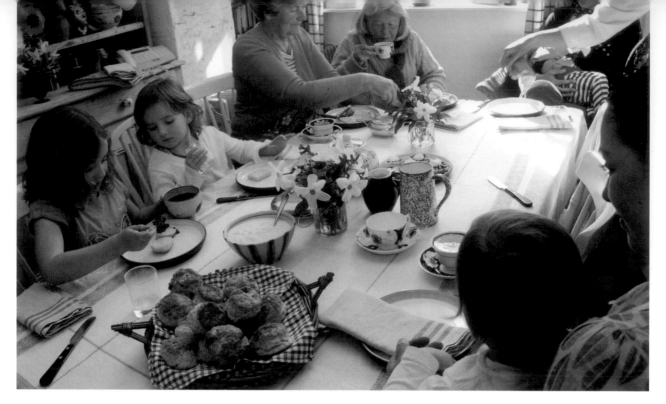

greenhouse that Florence says is "always full of 20 to 40 varieties of tomatoes," all planted in a blanket of recycled cardboard that inhibits weeds.

We pass a small coop of showy chickens, some with black spots and red heads, others with shiny teal and rust feathers. Florence leads me through the formal gardens where pink magnolias bloom.

In the ornamental fruit garden, there are budding almond, plum, and olive trees; later, there will be flowers on heirloom apple, peach, fig, and Asian pear trees, and on the gooseberry bushes whose blossoms are magnets for hummingbirds.

A pond is surrounded by bluebells and wild garlic. A meadow provides refuge for ducks and peacocks. I thread my way into a maze, a Celtic parterre that covers almost an acre.

Darina's 7 grandchildren all live "within 6 minutes" and some are waiting for me right now. Florence leads me into Darina's home, a 2-story farmhouse adjacent to the gardens. The kitchen is bustling. Lily, 5, Anna, 4, and their grandmother, Mary Dwayne, 71, are making scones.

They mix the ingredients in a bowl, knead the dough, roll it out, cut it into circles, put it in the oven, and sweep the floor while the scones bake. Lily does an Irish jig, then goes outside and returns cupping a pale blue Araucana egg that has just been laid: a treasure.

Florence pours fresh cows milk into glasses and Mary organizes everyone around the kitchen table. Darina's daughter, Lydia, carries in 3-month-old Jasper, and seats his 2-year-old sister Amelia at the head of the table.

Sinead, who is Lily and Anna's mother, arrives with Tess, age 1. The children slather homemade butter and fresh rhubarb jam on the warm scones. Tess, who now has a great deal of everything delicious on her cheeks, looks blissful.

Tonight Darina is giving a dinner party in the Ballymaloe Restaurant. We gather in the library with chintz-covered furniture and a fire crackling on the hearth. Guests include Florence Bowe, Myrtle Allen, and a writer for the *Irish Farmer's Journal.* In 1962, Myrtle Allen was a correspondent for this very publication.

Myrtle Allen, 86
22 GRANDCHILDREN, 18 GREAT-GRANDCHILDREN

Myrtle's husband, Ivan, came to Shanagarry at age 17 in 1932, the depth of the Depression, at the invitation of William Strangman, who owned the property that became the Cookery School many years later. The two men built green houses and grew tomatoes, mushrooms, cucumbers, and apples.

Myrtle remembers, "In 1943, wartime, most of our fruit and vegetables were exported to England and Wales. The surplus came to my kitchen along with cream, butter, and eggs. Slowly, I learned how to cook with them, guided by my gourmet husband."

"In 1964, I felt confident enough to open our dining room as a restaurant 5 nights a week," Myrtle recalls. She served the same homegrown food she cooked for her family: brown bread, smoked eel, beef with horseradish, turnips, apple cake. For a while, she didn't tell anyone who was doing the cooking.

The restaurant's first ad in the *Cork Examiner* in May 1964 was headlined "Dine in a Country House."

Darina remembers, "Myrtle had utter belief in the simplest, most perfect foods, everything dictated by the seasons. Thirty years ago this kind of thing was unheard of in restaurants." Ballymaloe House became such a success that today, people come from all over the world for "Country House" cooking.

A waiter comes into the library with dinner menus and everyone focuses on them immediately. "We write a new menu each afternoon when we see what we have got," Myrtle explains. Myrtle's personal notes, printed on the back of the menu, name the farmers, butchers, and fishermen with whom Ballymaloe chefs have worked for years. By now, Myrtle has retired as executive chef, but she is still an energetic, formidable presence in the restaurant.

The menu includes vegetarian dishes such as spiced aubergine soup with roast pepper and coriander cream...and black-eyed bean stew with mushroom and coriander served with basmati rice and poppadom. I don't even know what poppadom is, but my mouth is watering. Darina seats me next to her so we can talk.

Darina Allen, 61

7 GRANDCHILDREN

Darina has dedicated her newest book, *Forgotten Skills of Cooking*, to her grandchildren: Joshua, Lucca, Willow, India, Amelia, and Scarlet Lily.

"It's wonderful cooking with my grandchildren. They soak up everything. They absolutely love to cook, peel, mix, grate, chop—anything from pancakes to apple pies.

"We show them how to sow seeds. And they'll eat any vegetable as a result, absolutely everything they grow, even if they shivered at the thought before. Amelia [Lydia's 2-year-old] eats raspberries off the bushes in her bare feet and breaks bits of broccoli right off the plant."

Darina was born in Cullohill (current population, 200), in central Ireland. The first of 9 children, she was 14 when her father died. Her mother, Elizabeth O'Connell, took over the family's pub and raised the children.

Darina recounts, "I was 9 when electricity came to our village. There were no fridges or freezers. Mummy taught each of us how to bake and roast, braise and stew, and the joy of sharing food and sitting around the kitchen table with family and friends. She had a thriving kitchen garden, kept hens, even had a house cow. She baked brown soda bread virtually every day and would tie on my little apron and give me a piece of dough that I proudly baked beside her traditional loaf.

"On May Day, my friends and I built May altars and decorated them with primroses, bluebells and May bush. We gathered baskets of young stinging nettles and chased each other with glee. The nettles that survived were brought home and made into soup. Colcannon is mashed potatoes with cabbage beaten in; on Halloween, my friends and I would leave a dish of colcannon for the fairies and ghosts."

After Darina graduated from the Dublin Institute of Technology in hotel management, she wrote to Myrtle Allen "asking to be a lady cook. There were only about 6 good restaurants in Ireland then, and none would have a woman in the kitchen." Myrtle would. The 2 women began to evangelize for cooking gourmet meals with the freshest local ingredients.

Darina launched the Ballymaloe Cookery School in 1983; founded the first farmers' markets in Ireland;

starred for 9 seasons in her own weekly television cooking show and wrote 14 cookbooks. Today, she leads both Slow Food Ireland and its East Cork convivium (the word "convivium," Latin for "feast," identifies Slow Food movement local chapters). The list of awards Darina has won is long.

Our dinner table conversation turns to weddings. The *Farmers Journal* writer's wedding will be July 31, the same day as Darina's daughter Emily's. "We are going to serve roasts that guests can carve at their tables," the reporter says. Darina responds, "We will use tomato plants as centerpieces so guests can pick tomatoes and make their own salad with greens." Not just any greens will do; she identifies wedding-worthy greens leaf by leaf on her own salad plate.

Turning to me, Darina says, "The last few years, we've had a reality check." She's referring to the country's 2008 financial crisis. "Most people had focused on money-making work. It was better to be an architect than learn to cook. When people lost their jobs, they could barely make themselves a cup of coffee. Not anymore. It's *de rigueur* to be self sufficient in terms of food."

Darina worries about teen obesity. "It's not their fault. It's how food is produced now versus the 1950s: high yield, nutrient deficient. Plus, they live in food deserts: cooking skills have been lost. We have started education projects for 9-to-11-year-olds in local schools. They have gardens with herbs and vegetables, which the kids sell to their parents once a week. Half the students farm and half cook, then they trade. Food should be brought into every subject— geography, everything."

It's time for dessert and Darina insists we try carrageen pudding. Topped with a tart rhubarb sauce, its light, silky consistency comes from cooking milk, eggs, sugar, and seaweed, which, Darina says, "We take from the rocks when the tide is out, around the time of the spring equinox." I can't imagine how this dessert can contain that green, slimy seaweed I see sprawling on California beaches.

Darina asks the waiter to bring some carrageen to the table, then closes her hand over what looks like a small sponge, which she deems, "Not quite enough to make this dish." This woman is an expert on things I never realized people should know, but increasingly, I'm convinced everyone should learn.

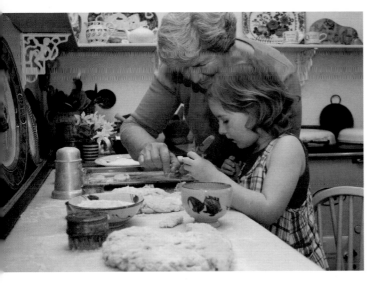

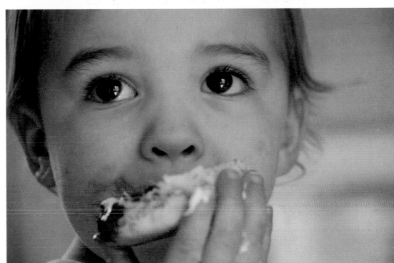

Waterford is the oldest city in Ireland. Vikings arrived here in 850 AD and the city charter was granted in 1205. In the shadow of Dunhill Castle, which was ravaged by Cromwell in the 17th century, is the Dunhill Ecopark, the futuristic venue of tomorrow's Grandmothers' Day celebration.

Donal Lehane greets me, a man whose life downshifted from fast to slow a few years ago. He was CEO of an international company that made cheese for McDonalds when a heart attack convinced him to proceed at a lower pace. Today he leads both the Slow Food Four Rivers convivium and the community organization that runs the Ecopark on the principals of social entrepreneurship.

The Ecopark has 9 acres planned for permaculture gardening. There is an apiary ("No bees, no food," Donal says), community garden, weather station, and a natural filtration system of plants and willows that purify local wastewater.

The Ecopark was built, and is sustained, by volunteers from local villages. Donal smiles, "To motivate volunteers, you must light a fire, ignite their passion. I'm a bit of an arsonist."

When we pull up, about a dozen grandmothers, grandfathers, and grandchildren are working at the raised beds in the Edible Garden. They remove the weeds, work compost into the soil, rake the earth smooth, and mark furrows. The youngsters cover seeds that will produce peas and cabbage come summer.

Helen Hutchinson, 63

16 GRANDCHILDREN

Helen and I watch 2 of her grandchildren, Sean Schley, 3, and his brother David, 1, plant. The boys' mother, Helen's daughter Tina, recently wrote an article about Helen in *Fenor 2010,* a local magazine. It was headlined, "Waterford's Granny of the Year 2009—Our Mam."

Helen describes how she earned the title. "Some of my grandkids just wrote me in. When they told me, the first thing I said was, 'What am I going to wear?!'"

As a child, Helen "grew up eating potatoes the size of marbles." When she got married, she raised her 8 children in a 150-year-old, 2-bedroom cottage in the country with no running water. Even in 2009, Helen had neither the means nor the need for a fancy wardrobe.

"So my daughter-in-law comes with a dress, it's lovely, off the shoulder, black. My sister-in-law's shoes. Another sister-in-law gives me a shawl. The jewelry came from a friend of mine. One of my daughters did my hair and makeup. Every single thing I had on—none of it was mine.

"A limousine came from the hotel with an escort. They gave us a glass of pink champagne. I don't drink, so it went straight to my head. I was laughin' and jokin' and talkin' to the judges, telling them how the grandchildren sleep in my little house. There could be 2 grandchildren in the top bunk bed and 2 in the bottom bunk and 2 on the floor and 2 beside me and 1 at the end of my bed.

"I talked about how the little kids think everything is magic at my house. 'Please' is a magic word. I tell them, 'The sugar you sprinkle on food is magic dust.' The kids were crawling under a tree 2 fields up and found tiny seedlings, mushrooms, toadstools, and bluebells. As far as they're concerned, those are fairy gardens. I told the judges about all that.

"There were 20 grannies in that contest and I won it outright. The vote was unanimous. All my grandchildren came up on the stage. The little fellows were dancing around me. I was standing there saying, 'That's marvelous!'"

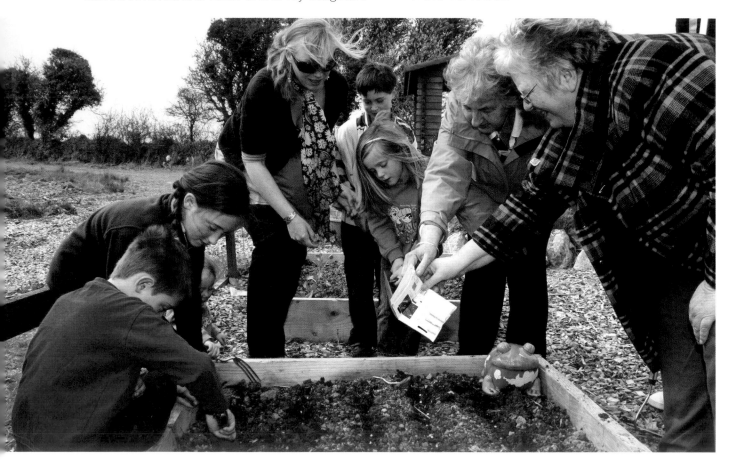

"Next day, a phone call came, 'You're to represent Waterford in the regional finals in Tullamore in three weeks.' I said to the boys, 'Oh God, what am I gonna do! I can't wear the same clothes!' So Shaws in Waterford dressed me. I think the suit itself was worth 300 Euros. I looked a million dollars!

"In Tullamore they had the weatherman interview us. I was not putting on airs and graces cause I don't have airs and graces. I told about how the kids come and they have ropes in the trees, a sandpit brought up from the beach, muck to dig in, flowerpots with compost if they feel like setting little seeds. They cook mud pies with daisies and buttercups on top. They can get as dirty as they like. We get 2 or 3 packages of paper and everyone draws; I have pictures all over my walls. Saturday nights, we have movies and popcorn."

Helen thinks back on the regional Grandmother of the Year competition: "All the other grannies had professionally-made banners and posters. All mine were done by the kids. There were 7 grannies to be picked and I was the second one. The little fellows went crazy. 'It must be the clothes,' I told them. I was like Cinderella."

For the next level of competition, "Shaws dressed me again, but the suit this time cost 650 Euros, lovely big pink flowers and pearls. Here I am up on stage and they're clappin' and cheerin' and didn't I win again! I was one of the 12 chosen to go on to the All Ireland Finals in Dublin.

"There, I told them how I love playing tricks and how the grandkids help me. My son got a new van on his fortieth birthday. At 3 o'clock in the morning, we wrapped the van in cling film [Saran Wrap] and we went round and round. The little fellows crawled under the van with it and we used up the whole roll. We put 30 or 40 balloons on the roof rack. My son came out to go to work and nearly died. I like doin' things like that. It's great!"

Helen also told the judges, "What I don't like is the grandkids' cell phones. 'Why, Nan?' the boys asked. 'You're not talking,' I said. Sitting at the dinner table their thumbs were still going. I said, 'Give me the phones.' Now, mine is called the Talking House. Even the littlest one comes in and says 'dadadadada.' I told the judges that.

"I won a piece of Waterford crystal and got beautiful flowers. I got my picture taken with David Beckham. Just because I'm a granny! Nothing like that ever happened in my entire life! I have a photograph album full to the brim. I still have the posters and banners the grandkids made, folded under the mattress so they won't get wrinkled. They'll stay there until I'm 90."

Rita Byrne, 70
3 GRANDCHILDREN

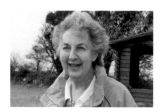

Tomorrow, Rita will open the Grandmothers' Day celebration by telling stories about how people lived in the past, a style so different from contemporary life that one of her grandchildren, looking at her old snapshots, asked, "What was it like when the world was black and white?"

Kinvara, in West Ireland, must indeed have seemed black and white when Rita was "pushed to the limit by strict nuns who ran the Sisters of Mercy National secondary school." Ultimately, she became a teacher.

"During World War II the English said, 'Nothing comes into Ireland.' I was 10 or 11 when we got the very first oranges. I'd never seen a banana. The west of Ireland is barren, poor land. But we had gooseberries, rhubarb, and a crab apple tree at the bottom of the garden, the only dessert we had.

"You killed your pig, made pork steaks, blood pudding, salt pork. Big fat bacon hung on iron hooks in the kitchen to dry. My mother always had chickens, geese and ducks and my father used to snare rabbits or shoot them with his .22 rifle. Two rabbits and a hen made a stew that was to die for.

"At Easter and Saint Patrick's, we roasted a kid goat; it was delicious. Living beside the sea, there would always be mackerel, oyster beds, and crabs.

Eggs and butter, which mother made, were the money that kept the house going.

"Everybody's granny was your granny. If you did anything wrong, your neighbor would give you a whack on the backside. I didn't have a granny, but there were grannies all around us. They wore black—and crossover aprons of navy blue with a little sprig of white. My mother, a widow, always wore black and had her hair in a bun. That is the granny my children remember.

"In my 20s and 30s I realized that Ireland was changing. We had electricity. The open fire was gone. We had flush toilets. In longhand, I began to write down little bits and pieces about the past."

One of the grandmothers Rita interviewed in the 1980s told her, "We worked threshing, milking cows, feeding calves and pigs, looking after fowl, children, and housework. We made currant cake and apple tarts and then a big dinner for 20 or more hungry men. We milked by hand, churned the cream, and sold butter and eggs. A jug on the dresser was our bank. We were poor but we didn't know; everybody was the same."

Another said, "The paraffin lamp had to be filled every night, a dirty, smelly job. With the coming of electricity in the 1950s, the heavy smoothing iron was replaced by the electric iron. Electricity was the beginning of emancipation for the women of Ireland."

Noeline Power, 65

7 GRANDCHILDREN

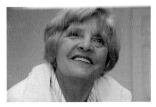

"We were the first to bring electricity to rural Ireland," Noeline says about the Irish Countrywomen Association. She is the new regional President of the organization that was founded 100 years ago. "We have 15,000 members, so our voice is heard! We've got a huge centenary celebration underway. There's even a postage stamp in our honor!

"Ireland's President, Mary McAleese, opened the celebration with a story about when electricity came. Her grandfather said, 'It will never take off.' His wife said, 'Now, when I turn on the microwave, he knows he's wrong.'

In 1960, rural women still pumped water outside. The ICA was instrumental in changing that situation by shifting responsibility from the central government to local authorities who moved quickly to create municipal water infrastructures.

The ICA also taught farm women to plant more than potatoes, cabbage, and onions; started school gardens, advised members on poultry and egg production, cheese making, and beekeeping. As diets and nutrition improved, families became healthier.

Noeline loves to cook. "Apple pie is my favorite and I'm forever making scones. I learned to make one cake when I was 3 or 4: put mixed fruit in a teapot overnight; the next morning add flour and eggs. It's lovely!"

Noeline proudly shows me her chain of office, a necklace of silver links, each engraved with the name of a past regional ICA president. "I wear it at meetings, otherwise, I keep it in a safe," she smiles. In 2 years when her term is over, her name will be etched on a link and she will relinquish the necklace to her successor.

"I was young when I joined ICA. I would never have thought 30 years ago that I'd be a President. I would go to the meetings and look at those women full of confidence. I might have to speak and I'd think, I can't even swallow out there. But now I'm wearing this!" she says, touching her silver necklace, "Isn't it lovely?"

May Ryan, 75

17 GRANDCHILDREN, 5 GREAT-GRANDCHILDREN

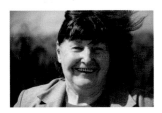

May and I watch the children planting. The sun is out but a strong spring breeze blows her hair as she reminisces about her life. She worked as a nanny, then became a cook and caterer. "My favorite was New Year's Eve; you'd load the car, leave at 6 in the morning and get back at 2 the following morning.

"My youngest son died when he was 2-and-a-half. I was very depressed. The world was closing in on me. I went to the Industrial Estate Training Center and, at the age of 40, I did a 2-year chef's course and graduated with distinction. I worked until I retired in 2000.

"The first 15 years of my married life, we had no electricity or water. On Saturday night, I got the children in front of the fire, washed them, washed their clothes, then washed the floor with the same water. There was nothing to spare.

"We bought a little farm and sent my daughter through college, but for 20 years, my wages went straight into the bank. Money from pigs went to pay back the loans. We sold the land and got good money. We're OK now.

"My husband and I took a tour of Ireland on bicycles the first year we were married. My children won't believe me, but we camped out and cooked out. We didn't have another holiday for 20 years.

"When my youngest girl was 20, my husband and I decided to go to the bicycle races. We've done that for 35 years. I have travelled with my friends to Puerto Rico, the Canary Islands, Turkey, and Greece—but my husband just goes to bicycle races," she laughs.

Sally Sweeney, 62
2 GRANDCHILDREN

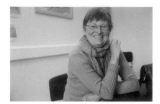

Sally's grandsons live in England but, "they come over 2 or 3 times a year and I go to them 4 or 5 times. I say to myself, it's not California, it's not Australia, it could be an awful lot worse.

"My daughter Catherine is getting the boys to bake, cook, and grow things. They just love to go down to the plot, as they call it. They weed and dig, steal the raspberries and eat peas straight out of the pods.

"I am a member of Grow It Yourself (GIY). It started in Waterford and has grown exponentially in the space of two years. People at last are realizing that they can't trust what they buy off the supermarket shelves, and are much more conscious of their health and of food miles.

"Michael Kelly had the idea. He floated it to my husband and myself and we said, 'That sounds great.' He called a meeting in the library in Waterford City thinking maybe 30 or 40 might turn up but almost 100 came.

"I went on the original steering committee in Waterford, then decided to start a group in Tramore. GIY took off. There are now 60 groups in Ireland. I got an email the other day from GIY Kalamunda outside Perth, Australia!

"My husband and I have got an acre and grow as much as we can. Potatoes, herbs, carrots, spinach, garlic, beans, peas, a bit of everything. We have three chickens (Faith, Hope, and Charity), so we have eggs. I'm a beekeeper; my husband helps although he's not so happy to be up close and confidential with the bees.

"Eoin and Rhian absolutely love granny's honey. When we go visit them, we bring honey and eggs on the car ferry. One time we flew and I put the eggs in my check-in luggage; it's a wonder with the pressure that they didn't all explode in my case!" she laughs.

"Something else I'm involved with is the Transition Town Movement, which deals with big concepts like climate change, global warming, and oil. If we look around, the things that sustain us are 100% dependent on oil.

"The Movement started with a man in Kinsale, Ireland, who began to look at ways that individual communities can build resilience so when the effect of Peak Oil (maximum extraction) actually hits, they will have the capacity to meet the challenge. Again, that organization expanded exponentially. There are Transition Towns throughout Britain, Ireland, America, worldwide.

"The trouble is, we needed solutions yesterday. When my children were born in the 70s, people said I was a total pessimist, focused on these problems. Now I'm becoming more mainstream. Even if it's only a small amount that I can do, I can't not do it.

"All this is about being a grandmother. You bring children into the world, they bring children into the world. You just want there to be a good environment for them to grow up in."

It's Grandmothers' Day. Kieran Cathcart and I are driving north from Waterford to Dublin. When I contacted Dublin Tours, I requested a driver who could get me to 2 or 3 cities the same day. Kieran has scouted all the shortcuts and, because he has a Masters Degree in Medieval History, tells me about the sights. The gorse in the fields flies past. I marvel that although my mother, Verna Daily, was Irish, I have never visited this country before.

Monica Murphy, 66
15 GRANDCHILDREN

At about 5 PM, I walk into Monica's daughter Carole's kitchen and stop short. The room and the little girls in it are beautiful.

The huge kitchen has white walls and is surrounded by high windows that open onto the garden. Its counters are lit with tea-lights that make it seem peaceful even though everyone is busily at work. There is an eating area with a commodious long table, and a sitting area with fireplace, generous couches, and an antique 2-story dollhouse.

Seven little girls are so polite and pretty that I wonder if they are models. Nope, 6 of them are Monica's granddaughters and 1 is her sister-in-law Meg Wood's granddaughter.

Monica, leader of the Dublin convivium, wears the signature Slow Food apron. She is the wine buyer for Febvre and Company Ltd., the importer/distributor based in Dublin that sponsored Ireland's Slow Food movement for years. Monica also sources wines for Febvre's sister company, Paul Sapin, selecting the best vintages from Slow Producers in Italy, France, the United States, South America, and Africa.

Although a dozen of Monica's grandchildren (including 2 sets of twins) live in Ireland, 3 grandchildren live in Italy, fortuitously close to some of that country's best wineries.

About 8 years ago, Monica, who spent 11 years in the cheese business before joining Febvre, was invited by a cheese maker friend to "come over on Sunday because Myrtle and Darina Allen and all these people are coming down and we are going to launch the Slow Food movement in Ireland.' So I've been part of it," Monica says, "since the beginning."

She leans on the counters and answers questions for the older girls who are preparing dinner. Aoife, 13, and Leah and Holly, both 11, weigh butter on a scale. Cut ham. Tear greens. Mix salad dressing. Blend fruit and juice. The menu tonight is salad, quiche with ham, a sausage dish, and coconut macaroon tarts. The children will drink smoothies. We adults will enjoy a Sauvignon Blanc, then a biodynamic Barbera del Monferrato, courtesy of Monica.

The impulse to cook runs through this family. Monica says, "Aoife wants cookery books for her birthday. She has done research and has all sorts of things she wants to cook. My daughter Sharon is our professional cook; she went to Ballymaloe for a professional course, then to America to work in a restaurant before a 12-year career cooking on super yachts."

Monica reflects, "Being a granny in Ireland has changed radically over the past 20 years. The previous generation would most certainly have stayed home. Now grandmothers who are not working like Meg and I still are, are coming back into the childcare role in a big way. When I retire, I hope to be here for the children after school. And I will start writing the books I have been promising myself for years."

Meg Wood, 63
4 GRANDCHILDREN

Meg supervises cupcake and sugar cookie production at the long table, surrounded by Monica's granddaughters Keara, 9, Beth, 8, and Ellie May, 5, plus her own granddaughter, Emily, 6.

Emily stayed with her grandmother last night and lost a front tooth. "The tooth fairy found me even if I wasn't at home!" she grins; Irish fairies are clever.

Meg is Food Buyer at Avoca, a store that opened almost 300 years ago as a woolen mill selling fine, hand-woven tweed. Avoca now operates 7 destination stores in Ireland, plus one in Maryland, USA. "Donald and Hillary Pratt bought Avoca in 1974 and thought, 'Wouldn't it be nice to give people a cup of coffee and a scone once they were there?'

"Today, food contributes 40% of sales," Meg reports. Avoca's flagship store is considered, per the Internet, "the only proper food hall in Dublin." Thanks to Meg, Avoca purveys jams, marmalades, relishes, chutneys, sauces, mustards, oils, coffees, and teas and artisanal foods from around the world. There are special rooms for cheeses, charcuteries, and wine from small, independent vineyards.

She elaborates, "Our bakers start at 4 AM to make breads, scones, tarts, cakes, and biscuits. Some days we make 1,000 cupcakes. We're fascinated with cupcakes. We call them 'Fairy Cakes with a bit of punch on top.'" She hands the girls a big box of food coloring bottles, pens with edible ink, gumdrops, and a zillion kinds of sprinkles.

The girls decide to make 2 frosting batches, pink and purple. There is much discussion about how thick frosting should be to squeeze through a pastry sleeve.

This afternoon is a busman's holiday for Meg, but she's used to that. "My grandchildren love to come to my house to cook. Their mothers much prefer they do it at my house. I have all the ingredients. We do lots of things. Fantasy birthday cakes...castles and trains and cars." She shakes her head, "A woman said, 'I hear you make birthday cakes. Will you do one for me?' I looked her straight in the eye and said, 'You couldn't pay me.'

"I was born in England. We came to Ireland on holidays and stayed at the Falls Hotel, which Monica's family owned in County Clare. That's where I met Monica's brother. We started going out when we were 14, and now we've been married 40 years. We had twins to start off and then a girl, with a 12-and-a-half year gap between them. That wasn't the plan, but there you go. 'It was a good party,' I said afterwards."

Before she married, Meg studied ballet at the Royal Academy of Dance, "but I smashed my Achilles tendon so that was the end of that. I did a hotel management degree and worked at the family hotel until we sold it in 1989. I've always been into catering of some sort.

"I am looking forward to retiring. You know, all those books you're going to read, and the garden is going to be really nice and you'll have time just to 'be'? The hotel was 365 days of work a year. Because Avoca is a family business and customer oriented, I do anything and everything, which drives me demented because I can't get my own work done. I've had my mother to look after and that's been hard for the last couple of years. You just end up always rushing, with no time."

Being with her grandchildren relaxes Meg. "I don't know that they're more precious than your own children, but you've got pampering time. You're not fretting about one needing a bath before she goes to school in the morning. You can take one child out. I took Emily to London to see the ballet and *Peter Pan*. It was absolutely glorious."

"Our extended family is too big to have Christmas or summer holidays in one house so we rent 5 houses in West Cork together. Life has been up and down, we've had lots of worries, but we don't bitch and moan. We've always had fun and we get on. People always think, 'Oh, if we had a little more money, we could do this or that,' but you know something? You have enough."

The girls, done decorating, array their cookies and cupcakes on plates. Smiling, Emily bites into one of her confections, proving conclusively that a missing front tooth can't keep her from a "Fairy Cake with a bit of punch on top."

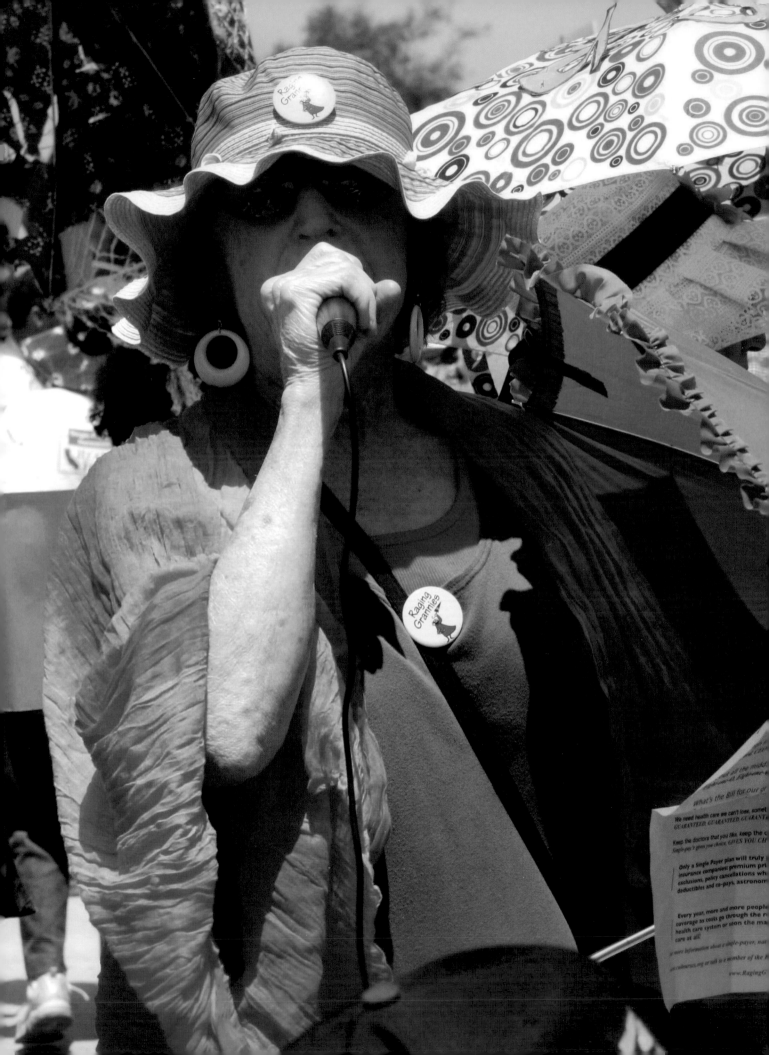

Politics: United States

She starts down the aisle. Another grandmother follows. Then another. Four hundred people stand up and cheer. The Raging Grannies are starring in the documentary that is about to be screened at the hundred-year old Victoria Theater in San Francisco, site of the Frameline33 Film Festival.

The oldest theater in the city is even older than the Grannies, who are in good company—celebrated people have performed here: Mae West, Whoopi Goldberg, Michael Moore, many others.

"That was the icing on the cake," Ruth Robertson admits later, but "The cake is getting our message out to the world."

The Raging Grannies get their message out with smiles, satirical songs, and skits. If there are Raging Grannies in your neck of the woods, you can recognize them by their ruffled aprons and flowery hats, and because they sing witty, pointed, political lyrics that skewer strategies (and strategists) that could make life difficult for their grandchildren.

The Raging Grannies started in Canada. There are now some 60 groups in that country, the United States, UK, Israel, Japan, and Australia.

Since they began, the women's attitude has been, "We're just a gaggle of Grannies, urging you off your fannies." But that ditty makes them sound tamer than they are.

They first appeared on February 14, 1987 in Victoria, British Columbia, a retirement haven. Calling themselves The Nuclear Emergency Response Team, they presented an "un-Valentine," a broken heart, to a local member of Parliament who was sanguine about nuclear issues. Railing against having a nuclear submarine in the harbor, the Grannies sang an updated version of *Yellow Submarine*:

> In the town where we reside,
> There are certain things we like to hide.
> Yes our harbor's very quaint
> But at times it seems like what it ain't.
> What about these atomic submarines,
> Atomic submarines, atomic submarines..

Kazoos screeching, bells ringing, cymbals crashing, they snared public attention for the issue—and shattered stereotypes of how older women act.

The group soon switched to the name Raging Grannies. "Raging" was a controversial word at first but members were convinced when a founder quoted Mary Daly: "Rage is not a stage or something to be gotten over. It is transformative. Like a horse who streaks across fields on a moonlit night, her mane flying."

Independent Raging Granny groups proliferated. None had membership fees, bureaucracies, or offices. They don't follow Roberts Rules of Order and don't take either minutes or attendance. They rally about myriad issues, most left of center politically.

What they share are wild hats, shawls and aprons, playful protests, and the idea embodied in their song, *Democracy Is Not a Spectator Sport*, which they sing to the tune of *John Brown's Body*:

A complacent American public means a flaccid democracy, so Raging Grannies belt out witty songs that enhance awareness of the issues they support.

Without the right to protest
Where would we all be?
Without the struggles of the past
There'd be no democracy...

The California Raging Grannies gaggle featured in the film held their first gig in 2000 and morphed, 6 years later, into the San Francisco Bay Area Raging Grannies' Action League.

Award-winning independent video producer Pam Walton filmed the group from 2006 to 2008 for her documentary, *Raging Grannies.* She remembers, "When I turned 60, I was really depressed. You can see the end from there. Aging is an issue that interests me.

"I met the Grannies when I was making a short film about the 2004 US Presidential election. The Grannies were holding a mock funeral for free elections, marching down the street with a cardboard coffin to Congresswoman Anna Eshoo's office, to demand that she check into the vote count in Ohio.

"This Granny gaggle has been written up in *Wired Magazine, Time Magazine,* the *San Francisco Chronicle,* the *San Jose Mercury News,* and *Rolling Stone.* They've appeared on Fox News' *The O'Reilly Factor* and Jon Stewart's *The Daily Show* on Comedy Central. They've been booed and cheered," Pam says.

"It would have been easy to make the Grannies into caricatures but that would be wrong. They are intellectually sharp, unapologetic about their opinions and willing to do just about anything to get their message of peace and social justice out into the world. I view them with admiration and affection."

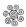

Unlike Pam Walton, the Tea Party does not view the Raging Grannies with admiration and affection. It's Fourth of July weekend 2009, and the Tea Partiers, new to major protests, have disembarked from limousines and Hummers.

Hundreds of people line the streets in either direction from the intersection of Winchester Boulevard and Stevens Creek in San José. The weather and the emotional temperature are equally hot; the national healthcare debate is underway.

The Raging Grannies, who are in full regalia plus parasols, sing out for single payer healthcare, which will, they believe, give all citizens, ages, races, and economic strata affordable medical services. The Tea Party, which is aligned with health insurance companies, argues for small government (and they do argue!) and thinks government-funded single payer healthcare is socialized medicine.

The Grannies belt out a song to the tune of *My Bonnie Lies Over the Ocean*:

My pharmacy's over the border, I can't afford medicine here.
They're talking reform now in Congress, the changes we need now are clear.
Healthcare, healthcare, we need single-payer healthcare right now!
Healthcare, healthcare, we need single-payer healthcare right now.

Since they always chat with the opposition, the Grannies start across the street toward the Tea Partiers. They are swept back to their corner by a screaming swarm of people wearing red, white, and blue; "patriots" who have appropriated the country's colors and who surround the little group of Grannies.

Tea Party advocates block the Grannies from view; drown them out; hold placards over their faces; swear and scream. The Grannies, a feisty bunch, respond, "Didn't your granny teach you better manners than that?"

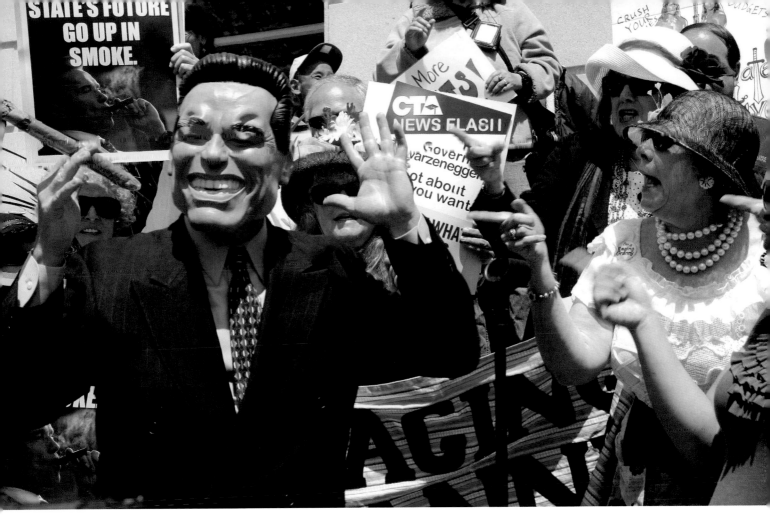

This summer, the State of California is in a financial tailspin that many fear will lead to bankruptcy. Government employees are being paid with IOUs, the two largest pension funds have been closed, and Governor Arnold Schwarzenegger, unable to negotiate a budget deal with the legislature, is in the process of cutting funds for education and human services.

The public is outraged by a recent *New York Times* interview in which the "Governator" admitted he relaxes in a Jacuzzi with a stogie and refuses to let his harsh budget cuts get him down.

The Grannies gather to protest in front of his office at the Federal Building in San Francisco, joining forces with activists who represent children, the elderly, and people with disabilities.

Granny Ruth Robertson has arranged for a Schwarzenegger look-alike to saunter among the protestors waving a cigar, a perfect foil for the Grannies' rage.

To the tune *Daisy, Daisy* the Grannies belt out:

Arnie, Arnie, what are you going to do?
Cutting budget for human needs won't do!
We know you love your Jacuzzi
But it's made your brain woozy.
Your cigar smokes, but real folks
Will suffer while you make jokes...

The TV cameras can't get enough of the Grannies, some of whom carry canes, one of whom rides in on her disability scooter clad in fiery orange. That one is named Gail.

Granny Gail Sredanovic, 70
1 GRAND DOG

Gail is the Raging Granny Action League's songwriter. We sit on the back porch of her environmentally green house in Menlo Park overlooking her garden and sip tea at a picnic table covered with a brightly patterned vinyl cloth. I want to know about the songs.

"They say, 'We need a song in 2 days' and I usually say, 'No, I can't do it.' Then I do it. Ruth gets me started but I do the bulk of it. If you study the issues we take up, you will be angry. The more you know, the worse it seems. Sometimes I get up in the middle of the night, or pull over when I'm driving and make a few notes, otherwise the idea will vanish."

"We are not entertainers, we are educators. We're there to tell you what you need to know about the issues in a form you will enjoy and, potentially, remember. We attack behavior but not people. We

don't use swear words. We go for sarcasm. Rhyming really helps. Repetition. Simplicity."

Gail is multiply talented: she was a Fulbright Fellow and speaks English, German, Spanish, Serbo-Croatian, and French, which she taught at high schools and at Stanford. I ask if she also had a musical background. "Piano and violin lessons as a kid; some experience with African drumming and," she laughs, "rhythm band in kindergarten."

Gail was one of the original 7 activists at the first Raging Granny gig. "I had been a member of a women's peace group. As older women, we didn't get a whole lot of people listening to us. I saw the Raging Grannies in Washington, D.C. and reporters were all zooming in on them. I thought, 'Maybe this is the ticket.'

"Our first appearance was in October 2000 in Palo Alto, protesting weapons in space. There was a certain amount of stress getting the songs ready and getting the people. I ended up having

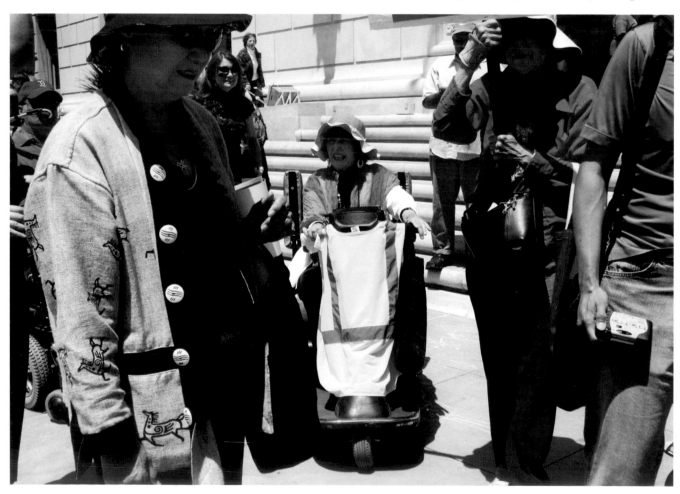

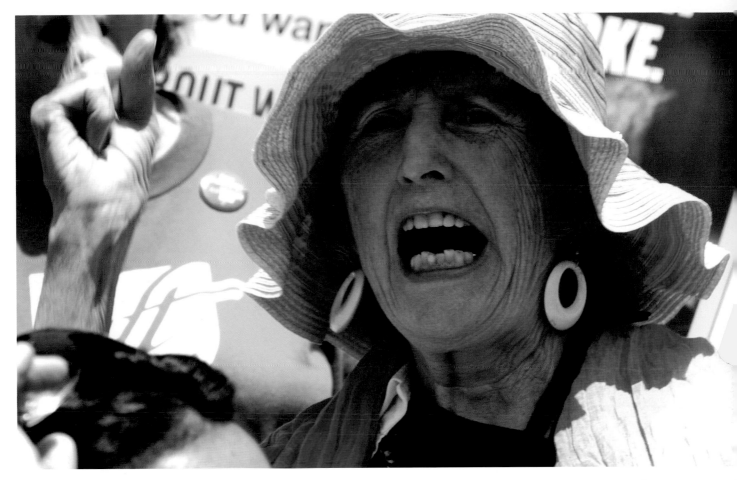

arterial fibulation, so I was in the hospital the night before. They released me the next day and I went to the protest, of course. That's what you do! I was medicated and pretty well zonked, I realized later."

"Is your Raging Granny persona different from your Gail persona?" I ask. "I have a lot more nerve when I am in costume with other Grannies. Also, I am not easily provoked, just always reasonable. Being a Raging Granny is extremely therapeutic.

Gail's 2 hip replacements haven't slowed her down. "I did a fair amount of agitating when I was on crutches and using my disability scooter, getting curb cuts for access. I have a big interest in the environment. Emotionally, I feel strongest about our terrible foreign policy; injustice and causing massive human suffering is overwhelming."

About a year after the US invaded Afghanistan, National Security Advisor "Condoleezza Rice spoke at the Stanford graduation. We were in the front with other protesters behind us. The sheriff kept telling us to move. In the end, they didn't have the nerve to haul us away. That was the first time we got media. We figured as long as there is a photographer around, we are pretty OK."

Gail's mother's family emigrated from West Ireland, and spoke Gaelic. "I was raised with stories about the terrible misdeeds of the British soldiers in Ireland. I took Catholic teaching about social justice seriously. I love to recite the Sermon on the Mount to people. In a way, being a Raging Granny is like belonging to a church social group. We are in agreement on our principles: we help each other, visit if someone is sick, send cards if something goes wrong.

"Lots of other people protest in costume, but the Raging Grannies are a press magnet," I observe, wondering why. Gail reflects, "It's key to get media attention for our issues, to get our point of view in front of the public. All the media have cut back. Reporters are overwhelmed and grateful for an informative press release, interesting interview, good photo op. We know when to schedule things to make their job easier.

"We're thrilled when our songs are on the news. And I feel really proud when I realize that other Granny groups are singing my lyrics." Gail, the mother of 2 grown sons, smiles proudly, "It's a lot like seeing your children go out into the world and do well."

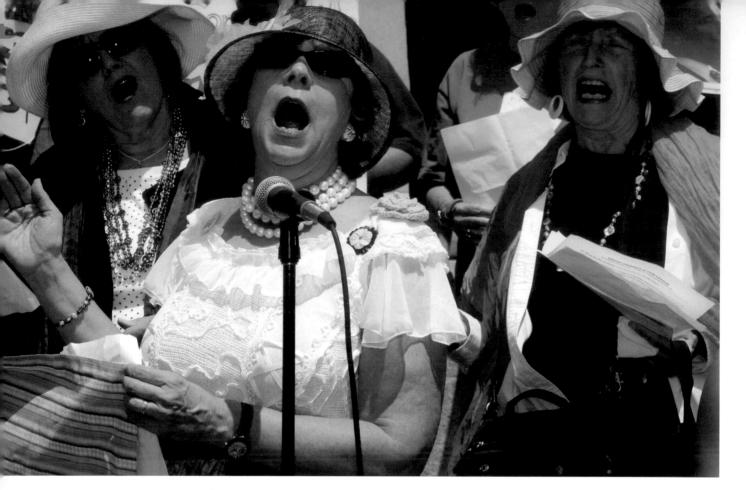

Granny Ruth Robertson, 56
GRANDMOTHER-IN-WAITING

Ruth Robertson's first grandchild isn't due until next January but she's been a Raging Granny since 2002. "Some people at the Unitarian Church in Palo Alto said, 'Ruth, you love to sing. You would love the Raging Grannies.' I said, 'I love the name. What is it?'

"The group had been working on environmental issues and was powerfully antiwar. I did Vietnam protesting in high school. It didn't take much to convince me. I went to a rehearsal at Granny Shirley Powers' house.

"The rehearsal was mayhem! People were rewriting lyrics and shushing each other. Every rehearsal was chaotic, but it was always fun. At meetings we discussed what kinds of places we wanted to rage. Originally most members of the group were content to stand on a street corner and sing quietly.

"Others of us wanted more action, like facing off with the Minutemen! From that desire to be more outrageous and to confront those with diametrically opposite positions, came the name Raging Grannies Action League.

"We are political wonks," Ruth says. "We identify issues just by being well read: *The New York Times*,

The Guardian, the Internet, mainstream, business, and left-wing media. We have monthly meetings just for yakking: 'Can you believe in San José they are doing racial profiling and arresting more Latinos for wrong left turns...' We've gone to City Council meetings and we do international issues—the full range, whatever grabs us.

"The healthcare situation worries me right now. If they do some little bitty reform, there will still be Big Pharma and big insurers gouging people. The issues change very fast. When Gail and I give the Grannies suggested talking points, we say, 'You're free to say what you want, but here's the latest in case you're not up on things.' Healthcare issues are very complicated.

"Our main goal is to get press attention," Ruth says. "Fifty people might see us standing for an hour on the street, but if a newspaper takes a picture, many more get the message."

When I ask Ruth which of their hundreds of rallies and demonstrations she considers most successful, she says, "When the National Guard invited us to Sacramento to prove they were not spying on us, we took them tea and cookies. The press was already saying how ludicrous it was that the Guard

was spending taxpayers' money to establish an 'information synchronization knowledge management intelligence fusion unit.'"

"A California senator was trying to get the Guard to cease and desist. As we set up tea, we noticed an anti-Muslim poster in a cubicle. One woman took a snapshot, evidence of discrimination. When the press exposed that, it was incredible. We have a saying, 'Grannies like to go where they are not wanted.'"

Ruth has been married for 30 years. She met her husband in Japan where they were both studying for graduate degrees in Japanese literature. When they returned to the U.S., times were not good for people seeking academic careers so they went into business in Massachusetts, then Texas. After their son and daughter were born, Ruth reduced her workload; "I really wanted to be with my kids," she says.

Her husband has voted Republican in the past, but he's so supportive of her, Ruth says, "He sometimes drives what we lovingly call our Grannymobile."

Organizing Granny gigs, researching issues, and managing press relations are the equivalent of a full time job for Ruth since the group does between 1 and 3 events a week. "We plan about 50% of the

gigs ourselves; we join other groups for the rest. I do a lot of Internet networking. Email is a tremendous invention!

"We have about 25 members. We're always recruiting. Sometimes people see us and ask how to audition. That makes me laugh! Others say, 'I'd love to join but I can't sing.' I answer, 'What makes you think we can? We just put someone on the mic who can sort of carry a tune. Everyone sings along, and you can mouth the words if you're tone deaf. You don't even have to be a grandmother. You just have to be a woman and be willing to wear a funny hat.'"

Ruth has 50 Granny-type hats displayed in the family room of her house where we are having tea, plus a collection of Granny aprons in the upstairs hall. I try on a few and can report that the styles are fashion-backward, frumpy, and wonderful fun.

Granny Barbara Baxter-Berman, 74

3 GRANDCHILDREN

"The mask of age is powerful," Barbara tells me over lunch in a Palo Alto shopping center café. We've been talking about the Raging Grannies' disguises. "We create the mask of age day by day as long as we live. I'm the only one who can't see my mask. I see myself as being younger, but to others, I look like an old woman.

"In some cultures, China for example, the mask of age is a garment of sagacity and people look up to you. In the West, especially the United States, you're seen as an ugly, useless crone."

I ask if the public ever discounts the Raging Grannies. Barbara nods, "It's easy to dismiss women dressed in a clown-like way singing meresidotes. But they don't throw rotten eggs at us. The granny mask enables me to say and do things I might be too shy or fragile to do. Octavio Paz, a Mexican poet and essayist, has written about masks; when you put a mask in front of your face, you are changed."

I'm interested in learning what's behind the Raging Grannies' disguises. Barbara was born in Lansing Michigan, in "a farm community that turned itself into a United Auto Workers town. My father belonged to a union.

"I managed to get all A's and a scholarship to the University of Michigan, where I settled into radical left-wing politics and graduated in psychology. I came here to go to graduate school at Stanford, but got married instead—maybe a wrong turn, but it produced three wonderful children.

"When my children were young, I did painting and ceramics, then Japanese and Chinese brush painting. I got an MFA at San Jose State in sculpture and 3-D installation art.

She and her husband joined the American Civil Liberties Union. "We both were on the Northern California ACLU board, and I was on the Executive Committee of the Northern California Citizens for Democratic Action," doing petitions, passing out pamphlets at Kepler's bookstore. "I'm a thinker and feeler, not a marcher," Barbara explains.

Her 10-year-old granddaughter, Anjali, "is the apple of my eye, a bright, shining, eager, wonderful girl. When she visits, we may climb on top of my cottage and prune the persimmon tree or rake leaves off the roof. She loves board games and we play Chinese Checkers.

"I live on social security and my clothes are from junk shops," Barbara says. She has no computer and keeps up with the news by listening to the radio and going to the library. I ask what issues are on her mind these days. The list is long.

"It bothers me a lot that people honestly think that American medicine, culture, blah blah blah, is better, and that everyone else is 'other.' The exploitation of the weak and helpless—in California, immigration issues—makes me despondent. I see immigrants as hardworking, decent people like my grandparents, my parents, and me.

"I've been a registered Democrat all my life. In my adulthood, I've watched my party march toward the right, a scandalous shame. In a democracy, you get the government you deserve. The Bush years were an example of the American people's inability to influence their government. The Supreme Court's decision about corporate campaign funding astounds me; how could that happen in our country!

"I am most passionate right now about the war in Iraq. I'm a bad singer, but we've sung about it until other people's ears are ready to fall off from hearing our sour notes. I love my country, but our wars bother me a lot.

"It's easy to see what's wrong, but if I could make things right? Educating girls is the single thing the world could do to equalize the hierarchy of the family structure, control of money, and gender relations. That's the world I dream of for Anjali."

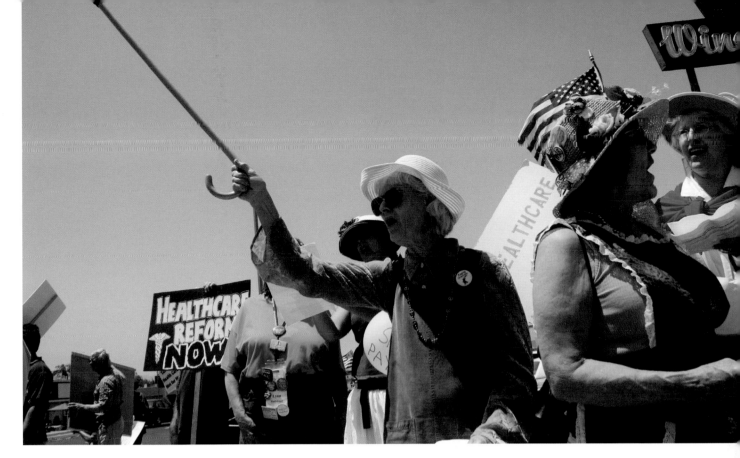

Shirley Lin Kinoshita, 67

2 GRANDCHILDREN

Seeking shelter from the rain, Shirley and I have lunch at the San Francisco Ferry Building after the Raging Grannies have finished singing in solidarity with homeless people who want affordable housing.

Shirley is Coordinator and Founder of the San Jose Raging Grannies gaggle, which often collaborates with the gaggle that Ruth and Gail lead. "Our group grew out of the Women's International League for Peace and Freedom, which started with the Suffragettes. They fought for the vote and in 1915, became antiwar activists. The San Jose Raging Grannies follow their lead and focus on feminism and peace."

Ruth Robertson has alerted me that "Shirley's Twitter name is PopoShirley (Popo means grandmother in Chinese). I am sure," Ruth said, "that she is the only Raging Granny who tweets!" Shirley's busy life gives her a lot to tweet about.

Having earned a Masters degree in Library Science in 1965, Shirley has been librarian in school, college, public, technical, and hospital libraries.

A talented artist, she makes *washi* (Japanese paper dolls), paints watercolors, and teaches traditional and contemporary Chinese brush painting as well as *Sumi-e* (Japanese ink painting).

In her "spare time," she studies hula and ukulele to reacquaint herself with Hawaii where she was born and grew up.

"A year and a half ago, I decided to apply for appointment as a Human Relations Commissioner in Santa Clara County. I wasn't even interviewed; the job was mine. The President of the Commission is Palestinian. There are two Jews, Filipino-Americans, Pakistani-Americans, Latinos, Gays, Lesbians, and I am Chinese-American. Diverse groups like this are more contentious, but also more creative."

Shirley's family is ethnically diverse. "The first week I got to UC Berkeley, I met my husband, a chemistry teaching assistant. He is Japanese Canadian. We were at Berkeley at the height of the free speech movement. That radicalized me.

"We have two children and...my grandchildren? When anyone asks, I dive for the pictures! Kira is 5 and Tedford will be 2. My daughter is a lawyer and her husband is Human Rights Director at Global Exchange. They are going to monitor elections in Columbia so I will be babysitting." Social justice work suffuses Shirley's family; it must be in the genes.

Shirley Powers, 73, 1 GRANDCHILD

Shirley is the musician in the Raging Granny Action League. "I came to California in 1966 after growing up in Wisconsin, getting a music degree from the University of Wisconsin, and teaching music in elementary schools there.

"I was a founder of the Palo Alto Raging Grannies. A few who started with us dropped out because they thought we were too wild. 'Feather boas, loud colors, plus 'someone swears,' they said. I laughed myself sick over that; I was the only woman on the U of W sailing team, and I've been swearing like a sailor ever since."

We are having tea in Shirley's Palo Alto bungalow. "I am still the only professional musician in the group so we meet here and use the piano. For gigs, I bring my ukulele. We choose a simple song like *Frère Jacques* and Gail usually writes the words. There are Grannies who have no idea where the tune is. Makes me crack up. They just can't find it. Sometimes we forget the words but we keep going.

"Our first classical number was *Beethoven's Ninth Symphony*. I thought we'd try it and it was a big hit." She sings:

> Sending more troops
> Will not stabilize
> Aaaafghanistan.
> Bombing villages,
> Killing children,
> Only helps the Taliban.

Shirley is surprised that the Raging Grannies are in the spotlight. "The documentary about us premiered at the Cinequest Film Festival in San José. There was an opening party in a penthouse. Press, television stations all wanted us to go outside on the roof and sing a song. So I clutched my ukulele and went.

"Problem was, it was February and it was freezing. Fortunately, I had on long johns under my Granny skirt! We sang to the tune of *When The Saints Go Marching In*." Shirley picks up her ukulele and sings:

> When we make peace instead of war,
> When we make peace instead of war,
> How I want to be in that number
> When we make peace instead of war.

"It was amazing! And later we got to see it on TV! My grandson, Ryan, who is 8, was quite thunderstruck. At the movie opening, they asked our family members to come up front. He and my daughter did and people applauded forever. We are still pretty much floored.

"At the Framelines33 Film Festival, we stood stock still after we sang on stage when the movie was over. Shocked. We can't believe it. I get all fired up when we're out there. Lose my voice. We dance around, throw our hats in the air, whatever. And suddenly we're the 'in thing.' That startles us. Half of us say, 'What the heck is happening?'"

Shirley has "always been an athlete. Tennis, sailing, swim laps, ice skating, downhill skiing—I've done every advanced downhill run in the Sierras except KT22 in Squaw Valley." These days, she and her life partner John, an ex-Benedictine Monk, do ocean kayaking and hike in the mountains.

She also writes poetry. "I was active in the 1960s Civil Rights Movement and taught kindergarteners music at the Nairobi Day School in East Palo Alto, which was then as segregated as the South. The 15-year-old cousin of one of our students was killed for stealing a bicycle. He climbed a fence and the police shot him in the back. I was shattered. I wrote about how, from the top of that fence, he might have seen cabbages and okra, growing things. *Stone Cloud*, a poetry journal published it.

As a poet, Shirley realized, "I wasn't connected to a university like Adrienne Rich. I wasn't famous like Anne Sexton or Sylvia Plath. But I kept writing and sending poems to small presses and literary magazines and had almost 100% success getting published. My work has been in 200 poetry journals."

Shirley wrote about the Raging Grannies' 2003 protest of the US invasion of Iraq. That demonstration in front of San Francisco's City Hall, was perhaps the largest of the Grannies' events. The city's Poet Laureate, Devorah Major, selected Shirley's poem, *Raging Grannies*, for the San Francisco Public Library's project, "City Reflections: War and Peace on Our Streets," which later became a book. Here's an excerpt:

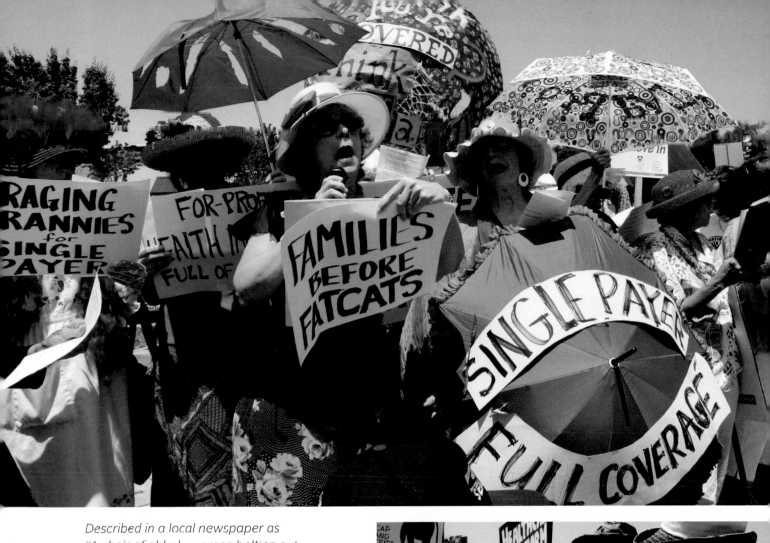

Described in a local newspaper as
"A choir of elderly women belting out
Make Peace Instead of War,"
We stand on stage facing
250,000 cheering anti-war protesters in
 San Francisco...
Waves of applause dance in the
Sunlight and though I have no
Illusions of being another Janis Joplin
I feel like some kind of aging rock star
So anonymous.
So personal.

Shirley smiles and sets the record straight. "That
newspaper said 250,000 people, but those of us who
were there said 500,000."

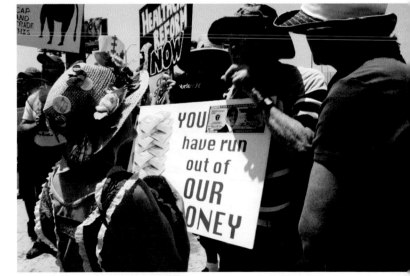

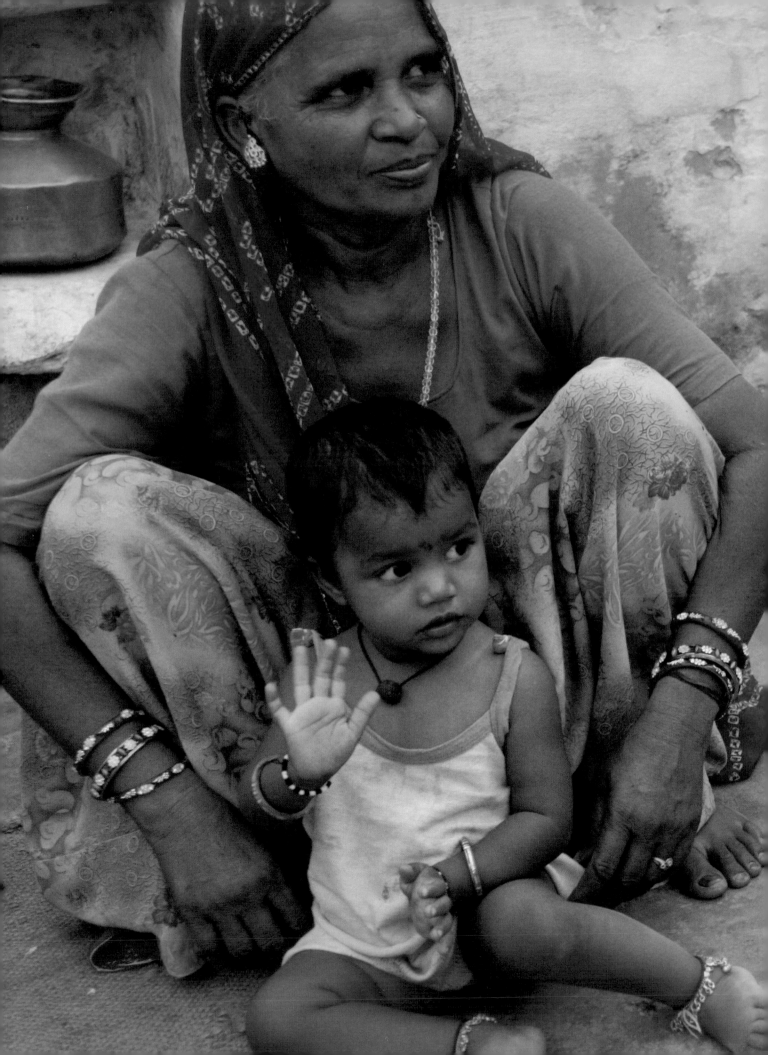

Energy: India

At 6:30 AM the September Indian sun pops up like an orange and the world goes from black to bright in an instant. If solar power had not been invented, surely the sunrise in Rajasthan would inspire it.

Since 1984, the Barefoot College in Tilonia has been teaching solar engineering, aiming to bring light to dark villages. Forty percent of rural Indian households have no access to electricity. They rely on kerosene for light and firewood for cooking.

The Barefoot College teaches the poor to be professionals without requiring them to read and write. Like Gandhi, the school believes that no one should be denied the right to use, manage, and own technology.

At first, the solar engineering faculty taught illiterate and semi-literate village men. Armed with their new technical knowledge, the men left their villages and went straight to Kishangarh, Jaipur, and Delhi to find jobs.

The college did a course correction and began training village grandmothers who also were illiterate or semi-literate, lived off the electrical grid, and existed on less than 50 cents a day. The women were mature and gutsy, cared about their grandchildren's futures, and wouldn't dream of moving away from their families.

Grandmother students came from all over India, which has 22 official languages and several hundred tribal tongues. They couldn't talk to each other or to the teacher.

So they sat together at a table in an electronics laboratory with soldering irons and voltmeters. Their teachers were illiterate local grandmothers who had already finished the training and who shared their knowledge generously via demonstrations, graphic manuals, color-coding and gestures.

After 6 months, the student grandmothers could build, install, repair, and maintain solar lighting systems. They could assemble solar lanterns, parabolic solar coolers, and solar water heaters.

They could also negotiate a "Memo of Understanding" with their communities. Each contracted to install solar panels on 100 houses, run a local repair/maintenance shop for 5 years, and teach solar engineering to their successors.

In turn, their villages agreed to create a Community Energy Development Committee to collect the fees to pay for both the panels and the Grandmother's salaries. Participating households committed to contribute between $3 and $10 per month, the equivalent of what they spent previously for kerosene, flashlight batteries, candles, and firewood.

When the Grandmother Solar Engineers returned home, they transformed their villages like a September sunrise in Rajasthan, from black to bright.

I visit one of those villages, Rebariyo Ki Dhani, which has almost as many camels (100) as people (125). Every hut has a photovoltaic panel on its corrugated roof. I am invited into a compound where a woman with 13 grandchildren asks how she can enroll at the Barefoot College.

Four women regale me with stories about how life changed when they got electricity. Youngsters could study without getting black lung disease from kerosene lamps. The chance of fire was reduced and toddlers no longer risked getting burned. Mothers no longer had to walk to town to buy fuel. Midwives could deliver babies at night. Mothers could work longer hours in the fields and earn more money since they didn't need to cook dinner before sundown.

By 2011, the Barefoot College had trained 146 grandmothers from 16 states all over India who brought light to 648 villages with 9,833 households.

Indian grandmothers learn solar engineering and bring light to their dark villages,
then teach other grandmothers from developing countries to do the same.

It seemed to Sanjit "Bunker" Roy, who co-founded the Barefoot College with two friends in 1972, that the Grandmother Solar Engineer program could be replicated outside of India.

He knew that 1 in every 5 people in the world (1.5 billion) live without electricity, yet the sun provides 6,000 times as much energy as the earth's population will need by 2020. Sunlight is universally available and free.

In Kenya, only 15 or 20% of the country's population lives on the electrical grid and in rural areas, only 5% have electricity. Economic and environmental considerations convinced Bunker Roy to move forward: a rural family in Africa burns about 60 liters of kerosene a year for light—and an average kerosene lamp spews a ton of carbon dioxide into the atmosphere in less than 10 years.

With support from the United Nations, Bunker and the Barefoot College's Village Energy and Environment Committee visited dark villages in the least developed African countries. Partnering with local NGOs and talking through an interpreter at community meetings, they explained solar lighting.

If villagers were interested, they set forth a scheme that would make the community independent of potentially corrupt and usurious "urban experts" who promised solutions. The community would form a local committee, contribute a building as a repair workshop, agree that participating households would pay a monthly fee, and chose 2 illiterate or semi-literate grandmothers between the ages of 40 and 60 to go to Tilonia (at the Indian government's expense) for 6 months of training.

Bunker developed a sixth sense about the grandmothers. "I would interview them and suddenly, I would know: 'This is it! She can do it, she can make it happen.'"

In 2008, African grandmothers first arrived. They slept in a small dormitory on campus. The Barefoot College provided everything from bedding to food; supplied each woman and her family with cell phones so they could talk for 10 or 15 minutes a week; provided each woman with a $100/month stipend to help with her family's expenses while she was gone; gave every grandmother an eye test and dental exam plus medical care if she got sick.

The African grandmothers' teachers were none other than the Indian grandmothers who, having brought light to their own villages, returned to share what they knew.

"We are all teachers; we are all learners. There is no 'us' and 'them,'" one told me.

Classes took place in the electronics lab, now renamed the International Training Center. After six months, the African Grandmother Solar Engineers returned to their villages. Because Indian solar panels cost one quarter as much as those manufactured in Africa, panels were transported by ship to African ports, then relayed to the remote villages, courtesy of the U.N.

Soon, the grandmothers' villages were solar electrified. Their neighbors were elated and local journalists were effusive. The grandmothers' solar lanterns not only provided light, but charged cell phones so farmers could check the price of eggs in the next village or make electronic bank deposits. Irrigation pumps and maize-grinding mills were equipped with solar power. Sierra Leone soon decided to partner with the Barefoot College to start a satellite campus.

By 2011, 283 Grandmother Solar Engineers had electrified 34,500 houses in 24 countries in Africa, South America, the Middle East, and Asia.

As important as the health and economic benefits that their villages experience, is the fact that Grandmother Solar Engineers themselves are transformed. With every reason, they feel competent and confident. Their villages view them as VIPs.

Bunker Roy smiles, "I meet them as grandmothers. But they return to their villages as tigers."

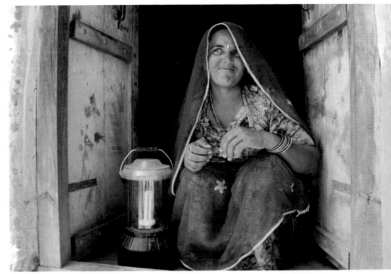

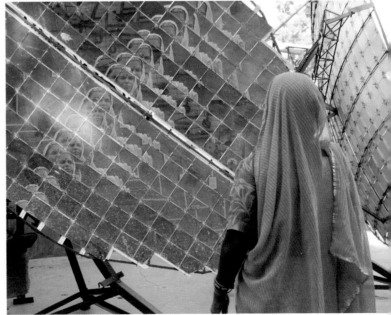

Interviews

The bougainvillea and morning glories that creep along the balcony of the guesthouse are brimming with bird life. I hear wings fluttering, chirps, and trills from the far trees. I turn off the ceiling fan and open the window and door. Cool air!

I slept fitfully last night, still in who-knows-what time zone after flying directly from California. My mosquito coil smoked and the air was an inferno; no wonder I jolted awake from a nightmare, believing my bed was in flames.

Yesterday, Bata Bhurji, the College's Barefoot videographer who will be my interpreter, met me at the Jaipur airport and we drove 60 miles southwest to Tilonia. Once we left the highway, unpaved desert roads were full of goats and buffaloes. It was over 100 degrees, the air so dry that my cheeks stuck to my teeth. Bata asked Jeevan, the driver who wore a splendid rainbow-striped turban, to stop and buy me a case of bottled water. That precious box sits in my room now.

At the Barefoot College one lives according to Gandhian principles. My room in the guesthouse is immaculate but spare: a cot, a rattan stool, four shelves, three hooks, a light, a ceiling fan, a window. That's all I need. The bathroom has a toilet and I will bathe in a bucket this week. Having danced to air-dry yesterday, I asked Bata whether they use towels here. She found me one.

Every building on campus has rainwater catchment on its roof. The school buildings run on solar electricity. I feel lucky to be in this utopian environment until I discover that my adapter won't fit into the proprietary outlet. I will be out of business if I can't charge my camera batteries, computer, Kindle, toothbrush, and cell phone. Feeling like an energy hog, I ask Bata for help. She brings an adapter.

A parabolic reflector on the kitchen roof tracks the sun, making solar cookery possible; Barefoot Chefs boil, broil, or grill enough food for 40 people. Outside the dining room everyone does a little skip to leave their shoes outside, selects a large aluminum plate, and sits on the floor to eat chapatti, rice, squash, and dahl, all with their fingers. I can't manage dhal with my fingers. Bata hunts out what may be the only spoon on the premises.

During dinner, I meet the faculty who teach many technical subjects including medicine and dentistry; a licensed dentist from Italy is here to teach tooth extraction. With that exception, faculty members are illiterate local people who have perfected their expertise here, and rotate between studying new skills and teaching them.

After dinner, each of us scrapes scraps off our plate for the dogs and birds, then scours it at an outside sink. When Prince Charles visited, even he did this.

The third class of African grandmothers will arrive this week to study solar engineering. Until then, I will interview the Indian grandmothers who learned and teach at the college.

GULAB DEVI, 50

6 GRANDCHILDREN

Gulab repairs a solar lantern and describes how she got to the Barefoot College. "When I was young, my parents didn't allow me to go out of the house to school. When I was married, my in-laws wanted me to stay in the house and cook. I kept thinking, 'What is this?' I wanted to do something.

"When I fetched drinking water from the hand pump in my village, I shared problems and gossip with other women. One day, people from the Barefoot College came and offered to train us to do hand pump repair.

"I asked my in-laws who said 'No, no, no, no! It's a man's job.' My mother-in-law was particularly against it, 'You must cover your face. How can you do repairing?'

"I asked my husband who said, 'Please go!' He told his mother, 'If she wants to go, please don't interfere.' He passed away 5 years ago but his blessing is always with me. When I came out, I was a little afraid but I thought, 'My mother-in-law will laugh at me, so I must do this with power and confidence.'"

Halfway through the 1 month course, Gulab showed her mother-in-law a diagram titled *How to Make a Hand Pump*. The older woman said, "I don't understand. Are you able to do this?' 'Yes,' Gulab smiled.

"Soon, a hand pump in Harmara broke and the village head said he knew who could fix it: me. I didn't show it but I had some hesitation. It just isn't possible to remember all the parts after only 15 days of class.

"I invited my class to help. The pump was in the center of the village so the men sat, had tea, and said, 'It is ridiculous that women are trying to do this.' Everyone was watching, laughing and making remarks like, 'It's impossible!'

"All 14 of us ignored the comments and finished the pump. Some men said, 'We salute you. We are proud of you.' They changed their minds. I am proud to have done hand pump repairs. It's still men who do that work but now they can't say they're the only ones!

"The Barefoot College concept is that if you want, you can learn other things. Solar is not as easy as hand pump repairing. But light is very important for our lives so I am teaching it," she says, soldering the final wire into the lantern.

We go outside to sit on the stairs hoping to find breeze. I ask what it's like to teach women from

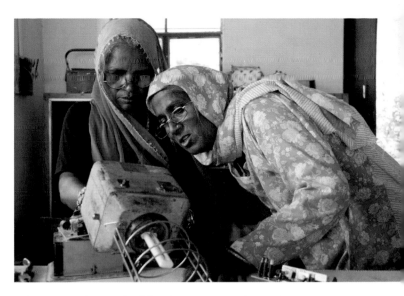

other countries. "It is difficult. We use color codes. At the beginning, we put the color names in different languages on charts by country. Pretend you are from Tanzania. I would show you red and ask, 'What is this color?' and you would say 'Nyekundu.' When I work with you, I look at the Tanzania chart and say, 'Use Nyekundu here." Obviously, Gulab has learned how to read and write, at least a little. And she is a multilingual expert on color names.

"The students call me the 'In Charge' and say, 'We are good! Give thanks to the teacher. Namaste teacher!' I am so happy to know they are doing well. I am proud to teach in the solar section. We are deleting dark and providing light for families."

Later, Bata and I give Gulab a ride to her house in Harmara, a couple of miles from Tilonia. She lives in a compound with her extended family. The whitewashed courtyard is a flurry of pre-dinner activity.

The minute Gulab sits on the ground, her youngest granddaughter, not quite 2, clamors into her lap. Gulab hugs her, "We have a saying: 'We deposit the main money in the bank, but we like the interest better.' In other words, I love my son, but I love my grandchildren even more. They are my life."

I ask what hopes and dreams she has for her grandchildren. "I want to educate them. If their parents are not interested, I will support them so they can study and stand on their own feet. I know what illiteracy is. My parents couldn't afford to send me to school and anyway, girl children were not allowed to go out. I want my grandchildren to study and be able to do their own work. I want them to be independent."

Kamla Devi, 45
3 GRANDCHILDREN

 When Kamla was married, her husband was 13 and she was 7 years old. "When we marry, we walk around the fire 7 times. My parents and I walked around the fire. I had no idea what was happening, but I liked it."

Kamla's first baby was born when she was 16. Her second was born 3 years later, the year her husband died. Three years after that, her mother-in-law and father-in-law died as well.

"I had to care for my children alone so I started to work in a factory for 5 rupees [about 10 cents] a day. Then I heard about the Barefoot College where I could teach weaving and make 150 rupees [about $3.50] a month. It was the first time I taught.

"After 6 months, I moved to hand pump repair. My children were alone. Sometimes they made their own food or went to bed without eating. They suffered a lot. When my oldest boy was 13, he understood my problems. He went to Bombay to find a job.

"After I finished with hand pumps, I moved to the recycling section for 2 years. For the past 8 years, I have been in the woodworking section, making toys." We are surrounded by shelves of whimsical, colorful wooden toys and games that Kamla has created: birds, biplanes with red propellers, puzzles; balancing toys, tigers, camels, and clowns.

She shows me a model hand pump that splashes real water, which she built for Barefoot College demonstrations. And a motor that runs with a rubber band, which is used for teaching. Her creativity and technical skill make an impressive combination.

"Today, both my sons are in their 20s. I arranged marriages for them. The older one lives in Kishangarh (an hour from Tilonia). My younger son works for the Barefoot College and his family lives with me." She smiles, "Sometimes, I make wooden toys for my grandchildren."

Bata and I visit Kamla's compound. Inside a stone fence, her house sits at the top of an incline. As dusk falls, her daughter-in-law cooks over an open fire and her grandchildren play tag.

Kamla reflects, "Because of my inner strength, I could fight my unhappy life. We shouldn't wait for someone else to help; we should do something about it. I had sadness and many difficulties that I don't want my grandchildren to repeat. I want to give my grandchildren a good education so their lives can be smooth."

I hope Kamla's grandchildren are as smart as she is, capable of learning skill after skill after skill, then teaching them all.

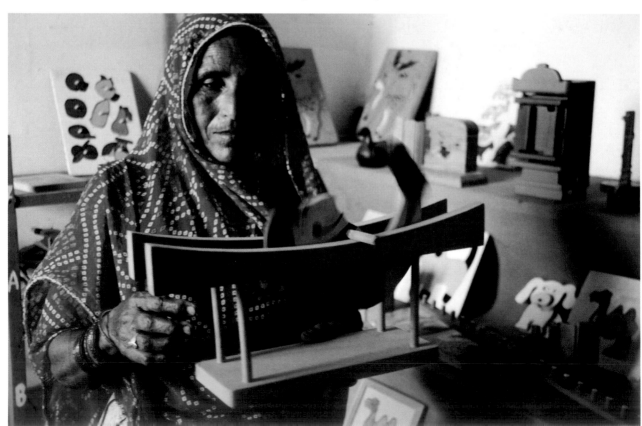

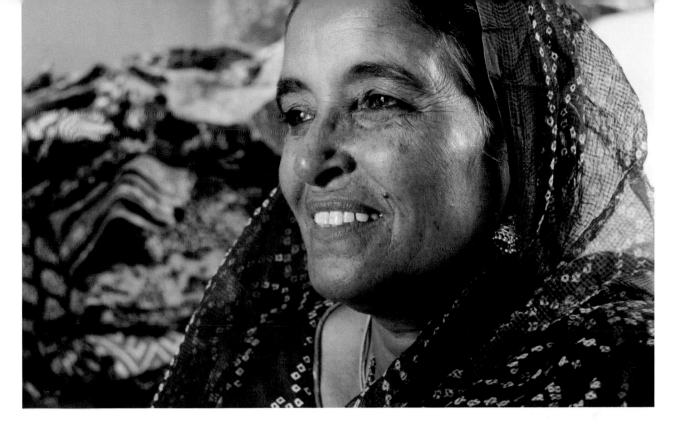

Sarju Devi, 55
3 GRANDCHILDREN

 Sarju, who is Bata's mother, heads the Barefoot College crafts section, which includes textiles. On my first day here, Bata invited me to select my favorite cotton fabrics from hundreds of bolts of cloth, all woven on campus. The college wanted to give me a custom *salwar kameez*. I settled on an apricot, slit-side tunic with pants printed in a sprig pattern of apricot, green, and blue.

Today my outfit is ready. As I slip into it, I feel magically transformed as if I, an outsider, have become part of this place by wearing clothes of fabric grown, picked, carded, spun, woven, dyed, designed, fitted, and sewn here. The feeling is so powerful that tears spring to my eyes.

Sarju inspects me and clucks. The pants are too wide at the ankles. She sends them away and gets tea so we can relax while the pants are reworked.

Born in Tilonia, Sarju was married at age 13. "Child marriage is still a big problem here," she reports. "I was excited because, although I didn't understand what it meant to get married, I knew it meant a red dress and gold and silver jewelry: new clothes." Clothes always interested her.

"In 1973 I started in the Barefoot College communications section, stitching little clothes for the string puppets [marionettes], which have a thousand-year history in Rajasthan. They were used for court entertainment to tell stories about kings, queens and emperors. Our communications department does street theater using string puppets, glove puppets and masks to tell stories about village problems. If people give speeches about the problems, villagers think, 'They are just taking up our time.' But if it's entertainment, they listen."

Sarju's husband joined the Barefoot College in 1981. He personally played the role of Kharbar Khan, the beloved, funny, strategically-wise announcer puppet. And he expanded the communications department to encompass photography, television, music, and video.

In 1992, Sarju transferred to the crafts section, which is now the largest department. "She is queen of crafts," Bata says proudly, "She designs everything." Sarju muses, "I will keep working until the end of my life. Playing with grandchildren is OK, but if we just sit in the house and gossip, our minds will jam."

As the seamstress brings my salwar, Sarju tells me proudly that her 2 grandsons "are studying; they are very nice and fabulous." Then she pulls out a snapshot of the youngest, "She is 2, so naughty. Her name is Bubbli. Every evening she calls and speaks very cutely, 'Hello, Nani!' I make puppets for her and little toys and necklaces, small tops and skirts." She strokes Bubbli's picture gently, "I can see the future in my grandchildren."

Gaulka-Ma Devi, 90
13 GRANDCHILDREN, 2 GREAT-GRANDCHILDREN

Before meeting Gaulkama, I discuss the role of grandmothers with "Vasu" (whose real name is S. Srinivasan). His official title is Barefoot College Facilitator. An educated man, he explains, "Bunker and I were elites who opted to live a non-elite life."

Vasu has lived here for 36 of his 60 years. Having smoked for so long that he has "only 5% of his lungs left," he now holds office hours every morning, sitting in the fresh air on a bench opposite the dining room. Virtually everyone stops after breakfast to report problems, issues, ideas, news, and gossip.

Vasu is enthusiastic about my grandmother project. "My own grandmother made me what I am. She told me the *Prince and the Pauper*." He smiles, "You remember: the Pauper helped the Prince who turned out to have nothing; a Barefoot Prince! My grandmother died when I was 8 but until then, because I didn't eat, she improvised stories to make me do so. Every day, another story!

"Grandmothers teach us values by telling stories that are like an appliqué of anecdotes, riddles, parables—a fantastic collection. Children who are raising goats (and not going to school) learn about drought and how to cope with crisis. They learn to be fearless, an important value. Grandmothers' stories teach about good and evil, about giving things without expecting something in return, about the meek and the powerful (a lamb and a tiger). Children learn tolerance: a stag and a tiger drink from the same watering hole. Despite the violence in India, grandmothers keep a lot of people from rioting.

"You must talk with Gaulka-Ma; she helped us understand what village women needed when we first started. She is very wise; a religious person. She picked up everything from the Ramayana. But she is the most liberal person. Afterwards, ask her to tell you a story."

Bata and I find Gaulka-Ma at a Hindu religious festival on a hill outside town. The red-and-orange patterned tent is overflowing with women wearing magenta, fuchsia, turquoise, and orange saris, all praying. Gaulka-Ma invites us to meet her later at her house in the village of Paner.

Bata, 30, worries that she is inappropriately young to translate for Gaulka-Ma. But Gaulka-Ma remembers Bata's family and prefers Bata to the older woman we have brought along. "May I record our conversation?" I ask, as always. "No problem," Gaulka-Ma agrees, "I want my voice to be heard around the world."

She describes the early years of the Barefoot College's satellite campus in Kotri. "They wanted to talk about women's lives and women's rights, to learn what kind of problems villages' women have. The worst problem was fetching water from far areas. There were no taps and no wells. There was no transport to go to town or the city market so we had to walk and walk and walk, carrying our children. The men didn't want the women to leave the house.

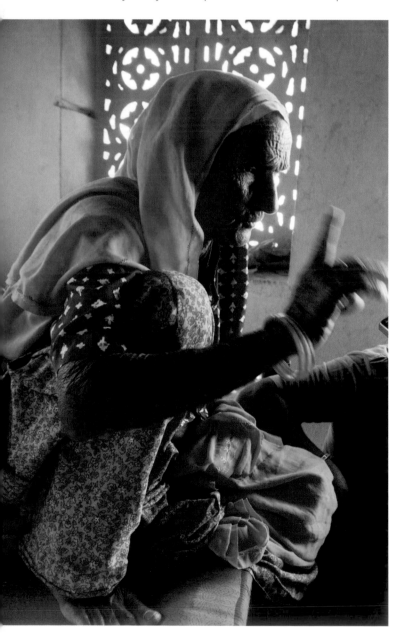

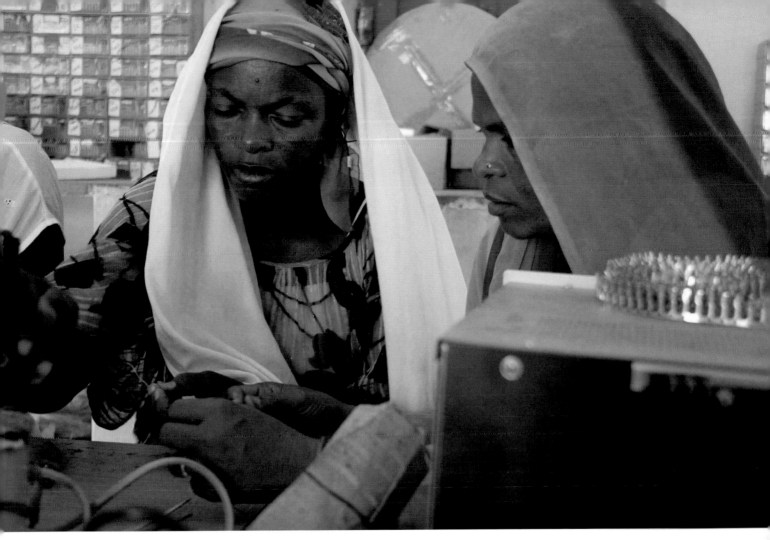

They said, 'No, you are not intelligent and cannot do anything.'

"Times have changed. Now women can go out. They are working like men. That was long ago," Gaulka-Ma says. "How long ago?" I ask. "When 1 rupee [worth about 2 cents today] was valuable enough that you could pay to dig a well with it."

"What do grandmothers do here?" I ask. She explains, "I am responsible for teaching my son's wife, transferring my responsibility to her. I tell her, 'Everyday we sweep our house with a broom. We use a clean spoon for serving dhal. If I go out, you must wash the spoon.'

"I love my grandchildren better than my son and daughter-in-law; they are my blood. I take care of them, play with them, give them baths, feed them. Their mother doesn't understand as much as I do about taking care of babies. If my daughter-in-law is harping on them, I tell her, 'No! You cannot do that to my grandchildren.' If I go out and someone gives me something to eat, I tie the food in my scarf and bring it home to my grandchildren."

As Vasu suggested, I ask Gaulka-Ma to tell a story. She sits tall on her bench, one knee up, and tells about 4 young goats who are tricked and eaten by a lion; ultimately their mother gets them out of the lion's stomach. It's a long, complicated story with enough animal characters to stock a zoo.

She gestures, her bangles rattling. Every time a new animal enters a scene, she coos, chirps, sings, squawks, roars, or brays. Twenty youngsters of all ages, including 4 of her grandchildren, gather around, mesmerized. At the end, the moral is clear: mothers of all species, cows, buffalos, birds, goats, and humans, stop at nothing for their children.

As her young audience disperses, Gaulka-Ma turns to me, "Women are doing everything these days. I am happy that woman are living freely."

I always end interviews by inviting the woman to question me. Usually they ask where I live, whether I am married, or what my family is like. Not Gaulka-Ma: "Tell me. Why do you dress so simply?"

I glance at my black t-shirt and floral-print skirt, then face this 90-year-old woman in her orange, red, and yellow outfit with her Kelly green fan and laugh, "There are no women in the world who are as glamorous as Rajasthani women!"

Bila Devi, 52
7 GRANDCHILDREN

Without even knowing Gaulka-Ma's evaluation of my wardrobe, Bila takes action against my sartorial dowdiness the minute I enter her courtyard. She escorts me inside, grabs her other skirt and scarf off the hook, and instructs me to change.

When I emerge in her box-pleated skirt that's printed with green, pink, blue, and yellow flowers and her pink-and-white chiffon scarf with a gold metallic border, her daughter puts silver bracelets on my arms and glues a self-adhesive *bindi* to my forehead.

Bata picks up her camera and two of Bila's grandchildren rush to be in the pictures. Her grandson says, in proud, perfect English, "My name is Mukesh. I am happy to meet you." He is about 10.

Ten. That was Bila's age when her older sister died. Bila was married to her sister's widower who was 30. After the wedding, she rode home in her new husband's horse cart, but she was so small that she slipped onto the road, and still has the scar. "I can't forget my wedding!"

She gave birth at age 16, had 4 children quickly, and by the time she was 21, her husband died, leaving the family "very poor. I started my life at the Barefoot College. Thanks to them, I built a house and helped my children study."

Bila studied and taught in almost all Barefoot College departments. She started "in the craft section, sewing little birds. Then the weaving section; in 6 months, I wove a carpet. Then I worked in the kitchen making chapatti.

"Then I learned to be a midwife and found out about plants and health. I can't count the babies I have given birth to; I know if the baby is down or up, moving or not, and (now that we have transportation), I take mothers to the hospitals for tetanus and TB injections.

"I went to Himachal Pradesh [northern India], learned to make smokeless stoves, and returned to teach villagers here to make them. I recruited women from the fields to learn, 2 per village. I am never shy. When we train, it's not like: 'Do this. Do that.' I work with the women. And I push them to work hard.

"I had never been to school but the Barefoot College gave me 6 months of education. I can read and write perfectly, so I became a Night School teacher. In the daytime, I go to villages and teach about homeopathic medicine and prenatal care."

Bila's "Jack of All Trades" approach impresses me, but she's not done. "I worked in the recycling section. And with the preschool children."

When I hear that Bila also makes puppets and

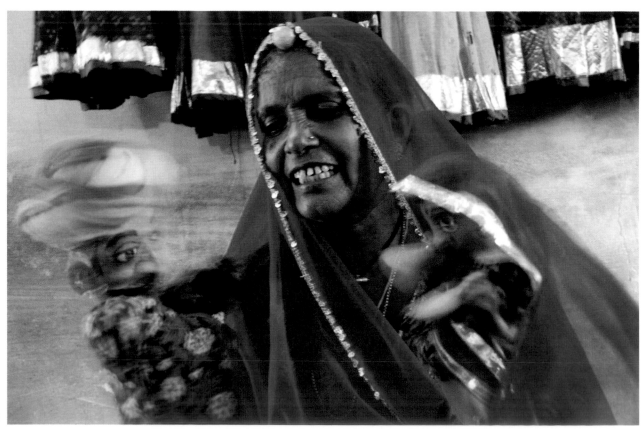

does performances in the villages, I ask to visit the communications center. The walls are hung with marionettes carved from wood plus hand puppets made with recycled paper. Each character looks like a real person. I recognize the puppet versions of Bunker Roy, but locals recognize puppets that look like their politicians, teachers, elders, policemen and midwives. Bila and Bata stage a puppet show for me.

With pride, Bila continues telling me about her skills, talents and accomplishments. "We started women's groups with a 5-rupee monthly membership fee, which we put into a group bank account to earn interest.

"And we figured out what could be done about men who came home drunk and beat the women. We went as a group and told the man to stop. If he stopped, fine. If not, we filed charges with the police.

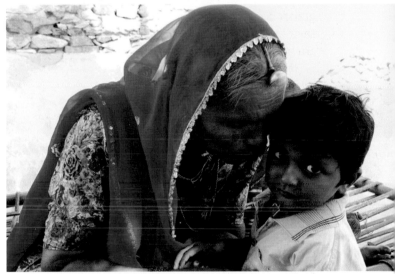

"I was elected a board member in my village, elected for village ward, and then elected *sarpanch* [mayor]," she says. The first time I saw Bila, she was riding a huge tractor, dressed in a diaphanous red sari. She radiated such energy and charisma that I would have voted for her in a minute.

Then, there is Bila's activism. "The Right of Information Act and the Employment Guarantee Act both passed in 2005. We fought and agitated in Jaipur and Delhi."

It took 5 or 6 years to get the law passed.

"For a month, we sat on the road. Made our own poems and songs and shouted, shouted, shouted. We didn't give in. Every day, we were more determined to get our rights but the government was deaf and blind.

"We were beaten by the police. Sometimes we only ate once a day but it didn't matter because we were fighting for the poor. We made so many good slogans! We chanted for accountability. Sixteen women came from my village but women came from all over Rajasthan.

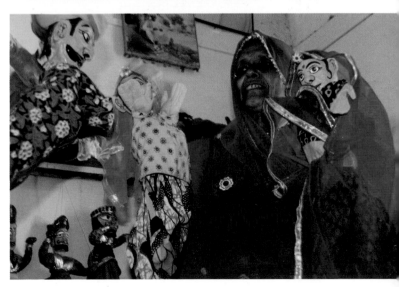

"Delhi's road was closed. The police came at night, broke our lights and drums, and put all the women in prison. We were fasting. People had flags and slogans. We struggled a lot. The government became threatened, scared.

"Finally, we won. I was so happy for the poor! Now, at least, they can eat! We read in the newspaper that the laws passed and we congratulated each other. All the workers everywhere got together and enjoyed."

I am reminded of Gandhi's words, often quoted by Bunker Roy, "First they ignore you, then they laugh at you, then they fight you, and then you win."

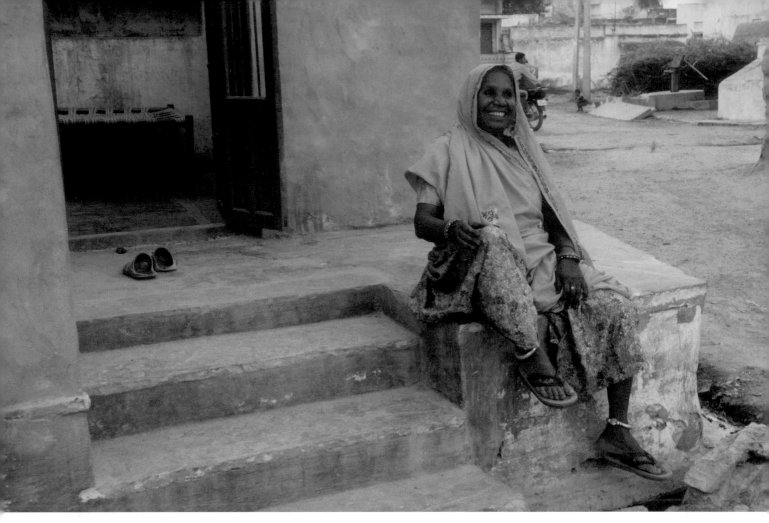

Naurti Devi, 60

4 GRANDCHILDREN

Naurti, like Bila, is an activist. She remembers, "I had been wondering why women got 3 rupees and men got 7 for working less—even for just going to sleep!

"Then a Barefoot College woman asked us, 'What are your problems?' We told her, 'We want our daily wages paid properly so we can run our families. Men don't work, but they get 7 rupees; we work on the roads all day but the village head pays only 3 rupees to women Dalits [the untouchable caste]. We—300 of us—refuse to take that."

That year, 1981, the Barefoot College puppets performed in Harmara. The women asked the lead puppet, "What should we do to get our due?" The puppet advised facetiously, "Lie down on the National Highway and stop all the trucks. The government will take notice."

A few days later, Barefoot College staffers saw several hundred women walking toward the highway to lie down because, they said, 'The puppet promised it would get us 7 rupees a day."

Persuaded to turn back, Naurti remembers, "We went to Bunker and Aruna [his wife] and asked for help. They reviewed the bills and vouchers and asked the village head, 'Why are you paying this amount?' He was speechless. The police arrested him and put him in jail."

On behalf of the women, the college staff wrote a letter to the Chief Justice of India. In an historic judgment, the Government of Rajasthan was obliged to pay all back wages—equal wages—to the women.

"In 1982, we got the money we deserved," Naurti continues. "From that point on, there was a labor law that said, 'Equal pay for men and women.' I told that story to the UNDP in New York and everyone got goose bumps." Naurti has also given speeches in Beijing, China and Hanover, Germany.

Naurti is illiterate but her grandchildren are in the fifth, eighth, and ninth grades, and one is about to finish the first year of university. Naurti says, "They should do nice things for society, better than me. I didn't go to school, but I fight for rights. My grandchildren say, 'Yes, we will carry on.'"

Meanwhile, Naurti is teaching computer science.

She never went to school, but she taught herself the English alphabet. Walking between her village and the Barefoot College three miles a day, she tapped her fingers: A-B-C-D-E (right hand), F-G-H-I-J (left hand), K-L-M-N-O (right hand), P-Q-R-S-T (left hand), U-V-W-X-Y (right hand), Z! If someone interrupted Naurti, she started over. At night, even in her dreams she chanted, "A-B-C-D-E; 1-2-3-4-5."

"I heard about a person who knew computers and asked to sit with him everyday. 'A-B-C-D-E,' I said on my fingertips. I taught my grandchildren how to use computers. Some girls from my village asked to learn from me. The Barefoot College gave me a computer and the girl students paid me 50 Rupees ($1.10) a month, which I donated to the College. In the past 6 months, I have taught 700 girls and women to use computers."

I ask her which, of all the things she has done, makes her proudest. She lifts her chin and smiles: "I am proudest of my confidence."

In February 2010, Naurti was elected sarpanch of Harmara. Hers was an unlikely win on many counts. In 1987, she had protested when an 18-year-old in her village was forced to immolate herself on her husband's funeral pyre. An upper caste sarpanch threatened to rape Naurti to punish her for her objection.

That history was not lost on Naurti's village when she ran for office all these years later. "She is committed, honest, and capable of everything. That's why 4 previous mayors are supporting her," one of them told a reporter. Her campaign expenses were funded by her fellow villagers. Naurti won by 735 votes.

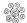

The third class of African grandmother solar students has started to arrive: 21 women from Cameroun, Ghana, Guinea Bissau, Kenya, Mauritania and Niger. At home, their villages have fewer than 150 houses. Most own at least 2 goats. Fourteen are illiterate and 9 have had some schooling.

As I read their profiles, my heart sinks. Their languages are: Jagmasani, Phulanki, Hausa, Glan, Dagare, Dupar, Kabe, Krione, Portuguese, Mounika, Arabic, Kiswahili, and Engtian.

Bata and I are equipped with Hindi, English, and my rusty French. The Indian grandmothers may teach solar engineering without words, but I can't conduct interviews without a common language. I feel as helpless as when I discovered that my electricity adapter didn't fit into the plug at the guesthouse.

To test our luck, Bata and I welcome the women from Niger. We use gestures that would win a game of charades, and we show the women their pictures on our digital cameras. The women scream with laughter when they see themselves. We depart as new best friends. But let's face it, I am in a predicament.

And then Bata, wonderful Bata, discovers that 2 African grandmothers speak English.

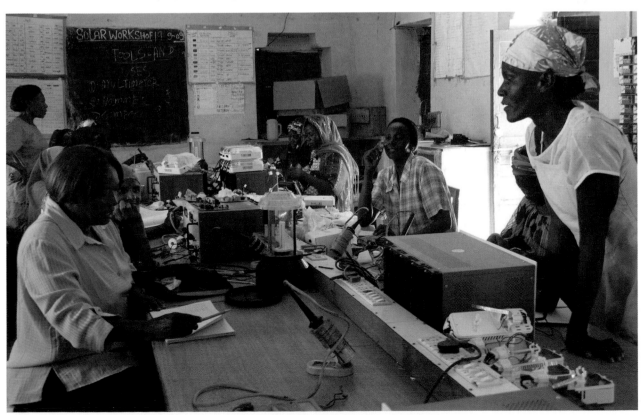

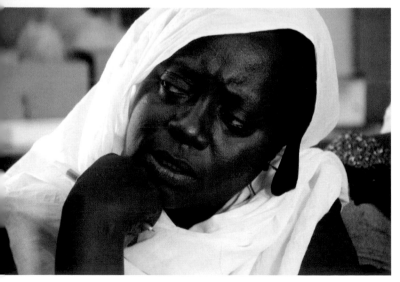

Francisca Moki, 44
2 GRANDCHILDREN

Francisca's village, Munitegae, is in Southwestern Cameroon. "My village has no electricity. Children study by kerosene lanterns. One day, a woman from UNDP came from Yaoundé. She arranged for our passports and flights and took us to the airport in Douala."

It was Francisca's first flight. "The plane was galloping. When we reached Gabon, we left some passengers. Others entered. We saw the plane lift. That airport is near the sea. The clouds are nice. The plane moves smoothly. People in Cameroon were afraid, 'What if you go and don't come back?' But no problem. We made it!

"In India, a man met us at the airport and asked, 'Are you from Cameroon?' 'Yes,' I said. He showed me my picture. 'I have come to collect you. And are there 5 women here from Guinea Bissau?' 'They are there,' I said, and went back into the airport to get them. He put us into the car and drove us to Tilonia. It was a long drive!

"I am really happy because when I got here yesterday, I asked if solar can power television. They say 'Yes.' 'What about the 'fridge?' They said, 'Yes.' I was very happy. Many people asked about the fridge."

That brings us to the subject of food. Ramadan is almost over, and I wonder what it will be like for the African Muslim women to break fast by eating dhal, especially since people in Sub-Saharan Africa love meat. "In Cameroon, we have plantains, yams, and rice. Indian food will try to change our systems but we are used to rice. We will manage," Francisca smiles.

I admire this resilient woman who is experimenting with experiences and valiantly making adjustments as she goes.

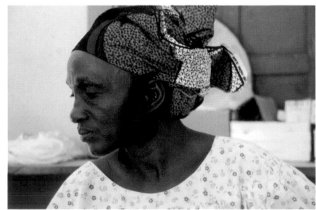

Joyce Matunga, 51

6 GRANDCHILDREN

Joyce lives in Olando, a Kenyan village near Lake Victoria that has 150 houses but no electricity or water.

Joyce's father had 3 wives and 40 children. When she was small, Joyce was a good runner, ("I won so many races!") and one day, running to the Seventh Day Adventist School, a snake wrapped around her neck and bit her in the eye. "The children ran back to my father saying, 'Joyce is dead!'

"My elder brother took me to the hospital. I was crying blood. My mother said, 'What shall I do, my beautiful daughter?!'" After several years of treatment, Joyce's sight improved enough that she could read with glasses and continue her studies. ("I liked reading so much!")

Joyce got married in 1973 when she was 15. "My first child in 1974, the second in 1976, the third in 1978, another in 1980. Still not enough. I have 9 children and all of them went to school."

About 6 weeks ago, "The headmaster of the school told me, 'In 3 days, a man called Bunker is coming here. I want to introduce you since you are in a very active women's group. Bring the proposals with you.'

Proposals? Joyce was relieved to learn that the Rain Forest Social Investment Trust, the local NGO that was working with the Barefoot College, had already written the proposals. "He was coming in 3 days, can you imagine?"

Her women's group, Achung Kenda, met at her house that evening to get organized. The next day, Joyce "carried the group's certificate and the proposals and met somebody called Sara. We talked, we talked, we talked. Sara said, 'You are going to India in September.' I said, 'What am I going to do there?' 'You will go with Phoebe.' I said, 'Let me go back and tell our group.'

"I asked the members, 'Who would you suggest go to India?' All the women said, 'Joyce, you are going. The other one...who can we choose? This one's husband is sick, the other one has small children...' Finally, everyone said, 'Phoebe Akinti. Phoebe, you are going.'

"On August 5, 20 minutes before our meeting with Bunker, I asked the head teacher to loan me a classroom. The children left. Slowly, 20 women's group members arrived. Bunker said, 'I suggest you and Phoebe.' I said, 'Oh, that was decided a long time ago.'

"I telephoned my husband who is working in Kisumu. He had no objection: 'You must go. Nothing to worry about. Go!' When we were told we were going to take an airplane from Nairobi to India, I said, 'Of all people, me?' My granddaughter said, 'Nanya, When I grow up, I will be a pilot. I will take you to India.'

"The Rain Forest people told us 'When you board the plane, tie the belt. You will be given blankets.' After some time, I began to feel very comfortable, as if I were in my own house. I said, 'Phoebe, I feel free!' We took the blankets with us when we got off in Bombay at 1:15 AM. Then we found out they didn't mean to give them to us."

Joyce and Phoebe made the return trip to Olando in March 2010. That May, as the solar equipment was en route by ship to Port Mombasa, *The Standard,* Nairobi's newspaper, reported on, "The first project of its kind in Kenya. Joyce Matunga says, 'Solar can be used to run irrigation pumps and grinding mills. This is important for increasing incomes as well as food security for vulnerable families.' Olando homes will have power by the end of 2010."

Reading that article now online, I remember Joyce imagining what it would be like when Olando got electricity. "People are very poor," she said. "They heard about solar light and that we will install it in every house. The price is high but it will be with us forever."

She continued, "When it is broken, I will tell them, 'Call me and I will come fix it. If you don't know how to light it, call me.' The village will be like a town. Everywhere there is light, is light, is light. In the homes, there will be light. The children will be able to study until they are tired! On the small roads, light. My house will be seen. Another house, it will be seen. It will be safer at night. People will come together. They will be very happy."

Grandmother Groups

The Stephen Lewis Foundations' Grandmothers to Grandmothers Campaign is receiving 100% of my author royalties from this book. Theirs is a crucially important initiative doing effective work: more than 245 Canadian Stephen Lewis Grandmother groups are collaborating with grandmothers who are caring for AIDS orphans in 15 African countries. You don't have to live in Canada to participate. Learn more at: http://www.stephenlewisfoundation.org/get-involved/grandmothers-campaign

Listed below is contact information for all the grandmother groups featured in this book. They deserve your support.

Photo by Tessa Gordon

Grandmother groups are everywhere. You can find out about some you might like to join or help at www.globalgrandmotherpower.com One example:

Soccer Grannies, Limpopo South Africa. Aged 49 to 84, they play for fitness, with more pluck than prowess. They were surprised—and delighted—to be invited to compete at the Massachusetts Adult State Soccer Association's Veterans Cup tournament in Lancaster, Massachusetts in July 2010. Their official name, Vakhegula-Vakhegula, means "grannies" in the Xitsonga dialect.

Grandmother Groups in this Book

Center for Traditional Textiles of Cusco, Nilda Callañaupa Alvarez, Avenida Sol 603, Cusco, Peru.
Tel: 51-84-228-117 or 51-84-236-880.
Email: cttcterra.com.pe
Website: **www.textilescusco.org/eng/index.html**

Freej, Mohammed Saeed Harib, Founder, Lammtara Pictures, Dubai Media City, Loft Office 3, Entrance C, Office 213, Post Office Box 502274, Dubai, UAE.
Email: lammtara@lammtarapictures.com
Tel: 971-4-37-57-478
Websites: **www.lammtarapictures.com** and **www.freej.ae/en/default.aspx**

Grandmothers Against Poverty and AIDS (GAPA), Yolisa Vivienne Budaza, Executive Director, J415 Qabaka Crescent, Eyethu, Khayelitsha 7784 South Africa. Email: info@gapa.org.za Tel: 27-364-3138 or 27-361-8326. Website: **www.gapa.org.za**

Grandmothers of the Plaza de Mayo, Estela Barnes de Carlotto, President; Virrey Cevallos 592, PB dpto 1, Buenos Aires, Argentina 1097.
Email: abuelas@abuelas.org.ar Tel: 54-11-4384-0983.
Website: **www.abuelas.org.ar**

Grandmothers to Grandmothers Campaign, Stephen Lewis Foundation, Ilana Landsberg-Lewis, Executive Director, 260 Spadina Avenue, Suite 501, Toronto, Ontario ONM5T 2E4, Canada;
Email: campaign@stephenlewisfoundation.org
Tel: 1-416-533-9292.
Website: **www.stephenlewisfoundation.org**

International Council of Thirteen Indigenous Grandmothers, Post Office Box 745, Sonora, California 95370, USA. Email: 13grandmotherscouncil@gmail.com
Website: **www.grandmotherscouncil.org**

Kokkabok Group of Housewives Spinning Local Cotton, Varunee Poolsin, 151 Loei Chiang Kan Road, Tambon Gud Bong, Meurng Loei 4200 Thailand. Email: poolsing99@hotmail or varuneepo@ gmail.com OR Ellen Agger and Alleson Kase, Tammachat Natural Textiles, 51 Main Street, Mahone Bay, Nova Scotia, BOK 2EO, Canada. Email: ask@tammachat.com Tel: 1-902-624-0427. Website: **www.tammachat.com**

Lila Pilipina, Rechilda Extremadura, Executive Director, 120A Narra Street, Baragay Amihan, Project 3, Quezon City, Philippines. Email: kuyangateng@ yahoo.com or lila.pilipina1994.gmail.com

Machsom Watch, Hanna Barag, Post Office Box 8388, Jerusalem 91082, Israel; Email: machsomwatch@gmail.com Tel: 054-5300385. Website: **www.machsomwatch.org**

Ock Pop Tok, Veomanee Douangdala, Co-Founder, 73/5 Ban Vat Nong, Luang Prabang, Lao PDR; Email: info@ockpoptok.com Tel: 856-071-253-615. Website: **www.ockpoptok.com**

San Francisco Bay Raging Grannies Action League, Email: info@raginggrannies.com Website: **raginggrannies.com**

Slow Food Ireland, Darina Allen, Ballymaloe Cookery School, Shanagarry, County Cork, Ireland; Email: darina@cookingisfun.ie Tel: 353-21-4646785. Websites: **www.cookingisfun.ie** and **www.ballymaloe.ie** and **www.slowfoodireland.com**

Storytelling Grandmothers, Natalia Porta López, General Coordinator, Abuelas Cuentacuentos, 355 José Maria Paz Street, Resistencia, Chaco, Argentina; Email: nataliapl@fundamgiardinelli.org.ar Tel: 03722-449270, Website: **www.fundamgiardinelli.org.ar/english.html**

Swaziland for Positive Living (SWAPOL), Siphiwe Hlope, Director, Nkoseluhlaza Street, Mcozini Building, First Floor-Office No. 9, Manzini, Swaziland. Email: siphiwehlope22@gmail.com Tel: 268-505-7088 or 268-50506172. Website: **www.swapol.net**

The Barefoot College, Bunker Roy, Director, Via Madanganj, Tilonia 305816, District Ajmer, Rajasthan, India. Email: bunker_roy@yahoo.com Tel: 91-01463-288205. Website: **www.barefootcollege.org**

The Grandmother Project, Judi Aubel, Executive Director, Via Aventina 30, 00153 Roma, Italia. Email: judiaubel@hotmail.com Tel: 011-39-065-743-998, Website: **www.grandmotherproject.org**

The Tenderness Line/Jalapa Guatemala, Robin Costello, Director of Communications, Plan International USA, Post Office Box 7670, 155 Plan Way, Warwick, Rhode Island 02886, USA; Email: Robin.Costello@planusa.org Tel: 1-401-738-5600 x1318. Website: **www.plan.usa.org**

Grandmother Power features groups of activist grandmothers. But individual grandmothers also cause important change, and so can you. As a 60-year-old lawyer, Olga Murray vacationed in Nepal's Himalayas, the first of many trips during which she visited orphanages, schools, and, after she broke her leg trekking, a hospital. In 1990, she founded a nonprofit, the **Nepal Youth Foundation,** which gives health support and scholarships to disabled, malnourished, and underprivileged students plus rescues indentured girls. Now 85, Olga spends 6 months a year working in Kathmandu. Her step-grandsons help. "Go out and do something for somebody," urges Olga, "It's the biggest thrill in the world." **www.NepalYouthFoundation.org**

Acknowledgements

When I met the women in Grandmother Power, *I told them that I consider this* "our book," not "my book." First, my thanks go to them for sharing their stories.

Without sensitive, intelligent interpreters, I would never have understood those stories. My talented, dedicated linguists, many of whom also fact-checked their countries' chapters, include: Bata Bhurji, India; Nilda and Flora Callañaupa, Peru; Mamadou Cissé and Fofana Boubacar, Senegal; Maria Dufourq, Guatemala; Jane Kellum, Argentina; Esau Kunene, Swaziland; Yosita Nathi, Thailand; Kat Palasi, Philippines; Pramod Sapkota, Nepal and Alicia Arias, Mexico; Thony Thongthip, Mr. Kamla and M.K. Mongkhom, Laos.

The leaders of the grandmother groups coordinated my interviews, and many fact-checked their chapters. The book wouldn't exist without: Darina Allen, Donal Lehane, Monica Murphy, Slow Food Ireland; Judi Aubel, The Grandmother Project; Hanna Barag, Machsomwatch; Yolisa Vivienne Budaza, Grandmothers Against Poverty and AIDS; Nilda Callañaupa, Center for Traditional Textiles of Cusco; Estela de Carlotto, Grandmothers of the Plaza de Mayo; Veonamee Douangdala, Ock Pop Tok; Rechilda Extremadura, Lila Pilipina; Mempo Giardinelli, Natalia Porto López, Maria Esther Allende, Storytelling Grandmothers; Mohammed Saeed Harib, Lammtara Pictures; Siphiwe Hlope, Swaziland for Positive Living; Jyoti, Thirteen Indigenous Grandmothers; Helen Muralles, Plan Guatemala; JoAnne O'Shea, Grandmothers and GrandOthers; Ruth Robertson and Gail Sredanovic, Raging Grannies; Bunker Roy, The Barefoot College; Odd Tongwarn, Kokkabok Group of Housewives Spinning Local Cotton.

Grandmother Power was enriched by the knowledge of experts who generously reviewed chapter drafts and made insightful suggestions: Estelle Freedman, Susan Krieger, Alev Lytle Croutier and Rob Sangster. Joan Chatfield-Taylor adventured with me to Israel, South Africa and Swaziland, and applied her sharp journalist's eye to both words and pictures. My husband David Hill accompanied me to Peru and the UAE, cheered me on, gave me wise editing counsel, kept the home fires burning, and welcomed me at the airport many times during three years of international travel.

Finally, I am grateful to many people all over the world who helped make connections, offered advice, contributed ideas, shared perspectives and provided context: Ellen Agger, Cecilia Isabel Aguirre Lucero, Zalman Amit, Carole Angermeir, Mary Arends-Kuenning, Judith Armatta, Zulema Artero, Mamadou Bâ, Hamaoy Baldé, Samba Baldé, Lillian Baer, Donna Baranski, George Beckley, Relda Beckley, Florigna Bello, Peter Bloch, Fariba Bogzaran, Carole Book, Cari Borja, Waraporn Buabanburt, Noura Budeiri, Elizabeth Burns, Meg Cangany, Laura Carstensen, Michelle Carty, Andrea Chow, Glen Christie, Babacar Cissé, Khady Cissé, Mamadou Cissé, Linda Clever, Craig Cohen, Michael Commons, Robin Costello, Mamadou Coulibaly, Julie Coultas, Joe Cressy, Bonnie Dahan, Mike Daly, Tahniat Darband, Wes Del Val, Nandu Devi, Nikhal Dey, Aissatou Diajhate, Siradio Diao, Fatou Diouf, Betty Doerr, Catherine Dougherty, Marge D'Wylde, Amancay Espindola, Catherine Evans, Patricia Fabricant, Simon Fale, Ellen Fish, Ginna Fleming, Marianne Friedman, Justin Fugle, Jane and Charles Gilbert, Jean Giles-Sims, Ranong Gongsan, Carmelina Nejera Gomez, Harris Gordon, Tessa Gordon, Leanne Grossman, Assiata Gueye, Jose Augusto Guimaraes de Lemos, Joanna Henry, Jill Heppenheimer, Felicity Heyworth, Kirk Hinshaw, Sharon Hogan, Paulino Huarhua, Stephen Huyler, Luciana Isacchi, Judith Jaeger, Suzanne Jamison, Mr. Ja-roon, Judith Jaslow, Pang Kamkuna, Amporn Kammanit, Judi Kanter, Rabbi Douglas Kahn, Alleson Kase, Shirley Kinoshita, Hennessey Knoop, Penelope Kokwana, Ailin Krafczuk, Miranda Kuo-Deemer, Cherryl Landayan, Ilana Landsberg-Lewis, Peter Laugharn, Maria Miel Laurinaria, Jonathan Lewis, Deborah Lindholm, Shirley Lipshitz, Will Luckman, Betty Makoni, Dolores Marengo, Regina Marler, Gillian Mathurin, Diana McDonough, Varun Mehra, Nanette Miller,

Zahra Mohamed, Maritza Morales, Sharon Moran, Daphne Muse, Mary Nacionales, Yeshi Neumann, Janis Olson, Fernando Operé, Mel O'Gorman, Sakorn Pakmee, Stacey Paynter, Ann Peden, Marilla Pivonka, Rebecca Polivy, Daniel Power, Jeevan Ram, Kavita Ramdas, Nancy Ramsey, Samantha Richardson, Braulea Rodriguez, Mayra Rodriguez, Ann Rosencranz, Stephen Rothman, Edmundo Sagastume, Gary Sanchez Rivas, Nelia Sancho, Scott Sangster, Aminata Sarr, Betsy Scarborough, Losa Schlossberg, Diana Serbe, Emily Shakespeare, Joanna Smith, Liz Spander, Molly Sterling, Brenda Sunoo, David Sweet, Tejaram, Krit Teowanichkul, Sagane Thiaw, Odd Tongwarn, Soo Tongwarn, Jabulani Tsela, Roger Valencia Espinosa, Natalie Varney, Marisol Villenueva, Shelley Waldenberg, Jenifer Wanous, Diane Jordan Wexler, Nancy Williams, Hermione Winters, Jeany Wolf, Pablo Wybert.

Bibliography

INTRODUCTION

Arrien, Angeles. *The Second Half of Life*. Louisville, CO: Sounds True, 2007.

Bolen, Jean Shinoda. *Crones Don't Whine*. San Francisco: Conari Press, 2003.

———. *Goddesses in Older Women: Archetypes in Women Over Fifty*. New York: HarperCollins, 2001.

Carstensen, Laura L. *A Long Bright Future*. New York: Broadway Books, 2009.

Francese, Peter. "The Grandparent Economy: A Study of the Population, Spending Habits and Economic Impact of Grandparents in the United States." http://www.grandparents.com/binary-data/The-Grandparent-Economy-April-2009.pdf, April 20, 2009.

Graham, Barbara, ed. *Eye of My Heart*. New York: HarperCollins, 2009.

Taylor, Paul. "Since the Start of the Great Recession, More Children Raised by Grandparents." http://www.pewsocialtrends.org/files/2010/10/764-children-raised-by-grandparents.pdf, September 9, 2010.

HIV-AIDS

Canada

Landsberg-Lewis, Ilana. *Grandmothers to Grandmothers: The Dawn of a New Movement; The Story of the Grandmothers' Gathering, August 11–13, Toronto, Canada*. Toronto: Stephen Lewis Foundation, 2007.

Lewis, Stephen. Race *Against Time: Searching for Hope in AIDS-Ravaged Africa*. Toronto: House of Anansi Press, 2006.

Swaziland

Dowden, Richard. "Swaziland's Conquering Heroines." *New Statesman,* August 19, 2002.

Epstein, Helen. *The Invisible Cure*. New York: Farrar, Straus and Giroux, 2007.

Gillooly, Jane. *Today the Hawk Takes One Chick*. DVD, 72 min. Watertown, MA: Documentary Educational Resources, 2008.

Hlophe, Siphiwe. "Swaziland Positive Living." Paper presented at the United Nations Interactive Hearings of the General Assembly, New York, June 12–14, 2010.

Phakathi, Mantoe. "African Grandmothers Demand Support in Role as Caregivers." http://www.ips.org, May 13, 2010.

"The Sorry State of Swaziland: A Boiling Pot." *Economist,* September 18, 2010.

"SWAPOL Calls for Accountability, Transparency." *Times of Swaziland,* February 4, 2011.

"Swaziland King Orders Men and Boys to Get Circumcised." http://global.post.com, July 19, 2011.

South Africa

Brodrick, Kathleen. "Grandmothers Against Poverty and AIDS: A Model of Support." Paper presented at the 8th Global Conference of the International Federation on Aging, Copenhagen, 2006.

Dowden, Richard. Africa: *Altered States, Ordinary Miracles*. New York: PublicAffairs Books, 2009.

CULTURAL PRESERVATION

Peru

Callañaupa Alvarez, Nilda. *Weaving in the Peruvian Highlands: Dreaming Patterns, Weaving Memories*. Loveland, CO: Interweave Press, 2007.

United Arab Emirates

Byrne, Michelle. "Profile of Mohammed Saeed Harib." *Time Out Dubai,* January 19, 2006.

Lawati, Abbas al-. "Grannies Poised to Become Cultural Envoys." http://gulfnews.com, October 6, 2006.

Krane, Jim. *City of Gold: Dubai and the Dream of Capitalism*. New York: Picador/St. Martin's Press, 2010.

Lutz, Meris. "UAE's *Freej* to Become First Globally Distributed Animated Arab Series." *Los Angeles Times,* January 17, 2010.

Stelter, Brian. "Dubai Superheroes: Little Old Grannies Who Wear Veils." *New York Times*, September 2, 2009.

Stubbs, Charlene. "Freej Frame." *WAFI Collection,* November/December 2007.

Wood, Jim and Nikki. "How I ligh Dubai?" *Marin Magazine*, September 2010.

ENVIRONMENT

Thailand

Agger, Ellen, and Alleson Kase. "Organic Cotton Improves Village Life. KUKKABOK Women's Cotton Group." http://www.tammachat.com.

————. *Weaving Sustainable Communities: Organic Cotton Along the Mekong.* San Francisco: Tammachat Natural Textiles/Blurb Inc., 2009.

"Fields of Mine: Na Nong Bong, Thailand." *Isaan Record,* September 30, 2011.

Kase, Alleson. "Suchada Cotton: Hearing the Story Again." *The Quilting Blog,* no. 9, December 18, 2009.

National Health Commission Office of Thailand. "Health Impact from Gold Mining in Loei Province Disclosed." http://en.nationalhealth.org.th/node/186, April 30, 2011.

Roberts-Davis, Tanya. "No Shining Legacy: Women Start Organizing Against Gold Mining in Thailand." *WRM* [World Rainforest Movement] *Bulletin,* no. 152, March 22, 2010.

Sutro, Sarah. "Indigo, Asia's Blue Gold." *Sawaddi,* Fourth Quarter, 2009.

Voss, Katalyn. "On Compassion and Morality: Divergences in Perspectives from the Poor in Thailand and the United States." http://berkleycenter.georgetown.edu, January 4, 2010.

Warren, William, and Luca Invernizzi Tettoni. *Arts and Crafts of Thailand.* San Francisco: Chronicle Books, 1996.

HUMAN RIGHTS

Guatemala

Child Rights International Network. "Guatemala: Children's Rights References in the Universal Periodic Review." http://www.crin.org, June 5, 2008.

English, Cynthia, and Johanna Godoy. "Child Abuse Underreported in Latin America." http://www.gallup.com/pol/19376/, June 4, 2010.

Valladares, Danilo. "Child Abuse Starts at Home." http://ipsnews.net, July 8 2011.

Israel

Alerts. Jerusalem: MachsomWatch, 2007.

Avni, Ronit, and Julia Bacha. *Encounter Point.* DVD, 85 min. Washington, DC: JustVision, 2007.

Ben-Ami, Jeremy. *A New Voice for Israel.* New York: Palgrave Macmillan, 2011.

Breaking the Silence. *Guided Tour in Hebron.* Documentary film, 25 min. 2008.

————. *Soldiers' Testimonies from Hebron 2005–2007.* http://breakingthesilence.org.il/testimonies/publications.

————. *Women Soldiers' Testimonies.* http://breakingthesilence.org.il/testimonies/publications, 2009.

B'Tselem. *Hebron Stories: From Bustling City Center to a Ghost Town.* Jerusalem: Israeli Information Center for Human Rights in the Occupied Territories.

Conover, Ted. "A War You Can Commute To." In *The Routes of Man: How Roads Are Changing the World and the Way We Live Today.* New York: Alfred A. Knopf, 2010.

Dolan, Sandy. *The Lemon Tree, an Arab, a Jew and the Heart of the Middle East.* New York: Bloomsbury USA, 2006.

Efrony, Neta. *Kalandia: A Checkpoint Story.* DVD, 59 min. Tel Aviv: JMT Films, 2009.

Hammer, Joshua. "Grandmothers on Guard." *Mother Jones,* March 11, 2004.

Invisible Prisoners: Palestinians Blacklisted by the General Security Services. Jerusalem: MachsomWatch, December 2009.

"Jewish Grandmothers Patrol West Bank Checkpoints." Reuters, March 19, 2007.

Keshet, Yehudit Kirstein. *Checkpoint Watch: Testimonies for Occupied Palestine.* London: Zed Books, 2006.

Miller, Aaron David. *The Much Too Promised Land: America's Elusive Search for Arab-Israeli Peace.* New York: Bantam Books, 2008.

Oz, Amos. *A Tale of Love and Darkness.* Boston: Harcourt, 2003.

EDUCATION

Argentina

Bach, Caleb. "A Chaco Wordsmith Rises to Risks." Washington, DC: Organization of American States. www.freeonlinelibrary.com, 2006.

Drazer, Maricel. "Storytelling Grandmothers Spark Interest in Reading." http://ipsnews.net/news.asp?idnews=32077, February 8, 2006.

Piette, Candace. "Argentina Aims to Rediscover a Love of Books." BBC News (Buenos Aires), April 23, 2010.

Valente, Marcela. "Grandma, Will You Read to Me?" http://ipsnews.net/news.asp?idnews=4922, November 11, 2009.

JUSTICE

Philippines

Asian Women's Fund. "Women Made to Be Comfort Women—Philippines." *Digital Museum: The Comfort Women Issue and the Asian Women's Fund.* http://www.awf.or.jp/e1/philippine-00.html.

Brown, Anthony. "Japanese Comfort Women: One Woman's Story; The Account of Felicidad de Los Reyes." Solidarity Philippines Australia Network. *Kasama* 9, no. 4 (July/August/September 2006).

"Comfort Women: The Lesson of the Past for a Peaceful Tomorrow." *Issues and Trends about Women of the Philippines.* Quezon City: Center for Women's Resources, 2003.

Gajudo, Nena et al. *The Women of Mapanique: Untold Crimes of War.* Quezon City: Asian Centre for Women's Human Rights, 2000.

Gomez, Maita. *From the Depths of Silence: Voices of Women Survivors of War.* Quezon City: Asian Centre for Women's Human Rights, 2000.

Henson, Maria Rosa. *Comfort Woman: A Filipina's Story of Prostitution and Slavery Under the Japanese Military.* Lanham, MD: Rowman & Littlefield, 1999.

Hicks, George. *The Comfort Women: Japan's Brutal Regime of Enforced Prostitution in the Second World War.* New York: W. W. Norton & Company, 1994.

Karganilla, Bernard LM, ed. *Justice and the Comfort Women.* Manila: University of the Philippines, 2003.

Niksch, Larry. "Japanese Military's 'Comfort Women' System." *Congressional Research Service Memorandum.* http://en.wikisource.org, April 3, 2007.

Nozaki, Yoshiko. "The 'Comfort Women' Controversy: History and Testimony." *Asia-Pacific Journal.* http://japanfocus.org-Yoshiko-Nozaki/2063.

Park, Erica. "The Trials of a Comfort Woman." *Senior Theses Paper 113.* Claremont, CA: Claremont McKenna College, April 25, 2011.

Sakamoto, Rumi. "The Women's International War Crimes Tribunal on Japan's Military Sexual Slavery: A Legal and Feminist Approach to 'The Comfort Women Issue.'" *New Zealand Journal of Asian Studies* 3, no. 1 (June 2001): 49–59.

Sancho, Nelia, ed. *Update on Filipina Victims of Sexual Enslavement by Japanese Armed Forces during World War II.* Manila: Lila-Pilipina, 1995.

Schellsted, Sangmie Choi, ed. *Comfort Women Speak: Testimony by Sex Slaves of the Japanese Military.* New York: Holmes & Meier, 2000.

Argentina

Agosin, Marjorie. *Women of Smoke.* Toronto: Williams-Wallace Publishers, 1989.

Arditti, Rita. *Searching for Life: The Grandmothers of the Plaza de Mayo and the Disappeared Children of Argentina.* Berkeley: University of California Press, 1999.

"Argentina's Ex-Military Leaders Tried Over Baby Thefts." BBC, February 28, 2011.

Betoldi, Marta. "In Labour." *Index on Censorship for Free Expression* 1, Inside the Axis of Evil issue (2003): 202.

Fisher, Jo. *Mothers of the Disappeared.* London: Zed Books, 1989.

———. *Out of the Shadows: Women, Resistance and Politics in South America.* London: Latin American Bureau, Research and Action, 1993.

Forero, Juan. "Orphaned in Argentina's Dirty War, Man Is Torn Between Two Families." *Washington Post,* February 11, 2010.

"Geriatric Baby Snatchers: Argentine Dictators Finally Go on Trial for Stealing Children of Tortured Political Prisoners." *Daily Mail* (UK), March 1, 2011.

Grandmothers of the Plaza de Mayo. *Missing Children Who Disappeared in Argentina between 1976 and 1983.* Buenos Aires: Abuelas de la Plaza de Mayo, 1988.

King, Marie-Claire. "An Application of DNA Sequencing to a Human Right Problem." *Molecular Genetic Medicine* 1 (1991).

———. "My Mother Will Never Forgive Them." *Grand Street* 11, no. 1 (1992): 35.

Knoop, John, and Karina Epperlein. *Awakening from Sorrow: Buenos Aires 1997.* DVD, 40 min. 2009.

Lazar, Sara. *Between M-Otherness and Identity: The Narratives of "Four Mothers" and "Abuelas de Plaza de Mayo."* Jerusalem: Harry S. Truman Research Institute for the Advancement of Peace, Hebrew University of Jerusalem, 2006.

"The Lost Generation." *Newsweek,* February 8, 1993.

Penchaszadeh, Victor B., MD. "Genetic Identification of Children of the Disappeared in Argentina." *Journal of American Medical Women's Association* 52, no. 1 (1977): 16–27.

Puenzo, Luis. *The Official Story.* DVD, 113 min.

Sherwell, Philip. "Families from Argentina's 'Dirty War'

Reunited." *Telegraph* (UK), October 28, 2007.

Sims, Calvin. "Argentine Tells of Dumping 'Dirty War' Captives into Sea." *New York Times,* March 13, 1995.

Sveaass, Nora, and Nils Johan Lavik. "Psychological Aspects of Human Rights Violations: The Importance of Justice and Reconciliation." *Nordic Journal of International Law* 69 (2000): 35–53.

Zangaro, Patricia. "Apropos of Doubt." *Index on Censorship for Free Expression* 1, Memory and Forgetting issue (2001): 168.

SPIRITUAL LIFE

Laos

Bounyavong, Douang Deuane et al. *Infinite Designs: The Art of Silk.* Vientiane, Laos: Lao Women's Union, 1995.

Flynn, Natalie. "Textile Business Shifts Role of Laotian Women." *Rutgers' Daily Targum,* October 6, 2010.

Ireson, Carol J. *Field, Forest, and Family: Women's Work and Power in Rural Laos.* Boulder, CO: Westview Press, 1996.

Ravasio, Pamela. "Threads of Beauty: Changing Laotian Women Weavers' Lives a Thread at a Time." *Hand Eye Magazine,* December 2010.

Schenk-Sandbergen, Loes. *Lao Women: Gender Consequences of Economic Transformation.* Amsterdam: International Institute for Asian Studies, 1995.

Tsomo, Karma Lekshe. "Buddhist Nuns in the Global Community." http://www.congress-on-buddhist-women.org.

Indigenous

"Grandmothers, Tell Us Your Wisdom." *World Pulse Magazine* 2 (July/August 2009).

Hungry Wolf, Beverly. *The Ways of My Grandmothers.* New York: HarperCollins, 1982.

International Council of the Thirteen Indigenous Grandmothers. http://www.grandmotherscouncil.org.

———. *Sacred Blessings, Native Songs, Stories and Lullabies.* CD. Santa Cruz, CA: Samadhi Life, 2009.

"Secret Prophecy of the Grandmothers." http://adishakti.org, February 23, 2007.

Strong, Donna. "Flordemayo: Wise Woman of the Earth." *Awareness Magazine,* July/August 2008.

Schaeffer, Carol. *Grandmothers Counsel the World.* Boston: Trumpeter Books, 2006.

Thu, Allison On. "Ceremony at the Heart of Salmon Nation." *Spirituality and Health Magazine,* July 2008.

HEALTH

Senegal

Aubel, Judi. *Dialogue to Promote Change from Within: A Grandmother-Inclusive and Intergenerational Approach to Promote Girls' Health and Well-being and to Eliminate FGM.* The Grandmother Project. February 12, 2010.

———. "Elders: A Cultural Resource for Promoting Sustainable Development."

2010 State of the World: Transforming Cultures from Consumerism to Sustainability. Worldwatch Institute. New York: W. W. Norton, 2010.

———. *Grandmothers: A Learning Institution.* Washington, DC: U.S. Agency for International Development, August 2005.

———. "Grandmothers Promote Maternal and Child Health: The Role of Indigenous Knowledge Systems' Managers." http://www.worldbankorg, 2006.

———. *The Roles and Influence of Grandmothers and Men: Evidence Supporting a Family-Focused Approach to Optimal Infant and Young Child Nutrition.* Washington, DC: U.S. Agency for International Development.

Bâ, Mariama. *So Long a Letter.* Harlow, Essex, UK: Pearson Education, 2008.

Food and Agriculture Organization of the United Nations. *Granny Power for Development: Greater Grandmother Role Seen by FAO.* Rome: FAO, June 19, 2007.

Palmer, Karen. *Spellbound: Inside West Africa's Witch Camps.* New York: Simon & Schuster, 2010.

La Rôle des Grand-Mères dans la Société Africaine. Senegal: The Grandmother Project and World Vision, 2008.

Préneuf, Flore de. "Convincing Grandmothers Key to Ending Genital Mutilation of Girls." *St. Petersburg Times,* January 31, 2010.

Walker, Alice. *Possessing the Secret of Joy.* New York: The New Press, 2008.

World Health Organization. "Female Genital Mutilation." http://www.who.int/en.

Ireland

Allen, Darina. *Forgotten Skills of Cooking: The Time-Honored Ways Are the Best—Over 700 Recipes Show You Why.* Long Beach, NY: Kyle Books, 2010.

Ganeshram, Ramin. "Pudding from the Sea." *Islands Magazine,* January 2011.

Higgins, Ria. "Relative Values: Darina Allen and Rory O'Connell." *Sunday Times* (UK), December 15, 2002.

Kierzak, Kristine M. "Irish Celebrity Chef Chooses Raw Milk." *Milwaukee Journal Sentinel,* April 7, 2010.

Moskin, Julia. "Teaching the Irish (and Others) to Love Irish Food." *New York Times,* March 31, 2010.

Ritten, Sanra. "Grandmothers Can Really Make a Difference." *Ode Magazine,* May 2009.

Sullivan, Barbara. "Nostalgic Tastes from the Julia Child of Ireland." *Chicago Tribune,* March 11, 1993.

POLITICS

USA

Major, Devorah, ed. *The Other Side of the Postcard.* San Francisco: City Lights Foundation Books, 2005.

Raging Grannies: The Action League. DVD, 30 min. Mountain View, CA: Pam Walton Productions.

Roy, Carole. *The Raging Grannies: Wild Hats, Cheeky Songs, and Witty Actions for a Better World.* Montreal: Black Rose Books, 2004.

Wile, Joan. *Grandmothers Against the War: Getting Off Our Fannies & Standing Up for Peace.* New York: Citadel Press, 2008.

ENERGY

India

Bhurji, Bata. *Barefoot Solutions to Climate Change: A Collection of 10 Films.* Tilonia, Rajasthan, India: Barefoot College.

———. *Women of Tilonia: Portraits of Change,* Parts I and II. Videos. Tilonia, Rajasthan, India: Barefoot College.

Castonguay, Sylvie. "Barefoot College, Teaching Grandmothers to Be Solar Engineers." http://www.wipo.int/wipo_magazine/en/2009/03/article_0002.html, June 2009.

Dey, Anindo. "Sati Fight to Poll Battle, She Wins Them All." *Times of India,* February 6, 2010.

Gathanju, Denis. "Kenyan Women Light Up Villages with Solar Power." *Renewable Energy World,* July 13, 2010.

"Grandmothers to Be Trained in Electrical Engineering in India." http://www. modernghana.com, June 2, 2009.

Ho, Mae-Wan, Dr. "Lighting Africa." *Institute of Science in Society Report.* http://www.i-isis.org/uk/LightingAfrica.php?printing=yes, June 4, 2011.

Johnson, George. "Plugging into the Sun." *National Geographic,* September 2009.

Lankarani, Nazanin. "Generating the Unlikeliest of Heroes." *New York Times,* April 18, 2011.

Otieno, Kepher. "'Barefoot Women' Light Up Villages Using Solar Technology." *Standard* (Nairobi), May 21, 2010.

Rossi, Vicky. "Interview with S. Srinivasan—'Vasu'—of Barefoot College." http://www.transnational.org?SAJT/tff/people/v_rossi.html, February 16, 2007.

Roy, Bunker. "Women Barefoot Solar Engineers: A Community Solution." Paper presented at the United Nations Commission on the Status of Women, 55th Session, New York, February 22–March 4, 2011.

Schumacher, E. F. *Small Is Beautiful: Economics as if People Mattered.* New York: HarperCollins, 2010.

"Solar Engineer Grandmothers." CNN. http://www.skollfoundation.org/solar-engineer-grandmothers-barefoot-college-featured-on-cnn/, February 2, 2011.

Williams, Greg. "Disrupting Poverty: How Barefoot College Is Empowering Women Through Peer-to-Peer Learning and Technology. *Wired Magazine,* April 2011.

Index